WEALTH
OF THE
ROMAN
WORLD

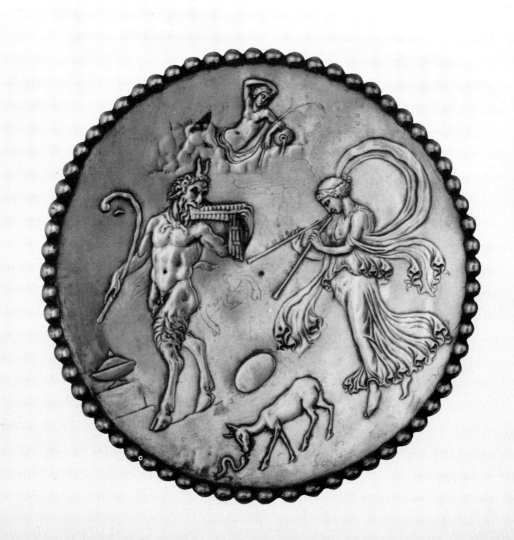

WEALTH OF THE ROMAN WORLD
AD 300-700

Edited by
J.P.C. Kent and K.S. Painter

Published for
The Trustees of the British Museum
by
British Museum Publications Limited

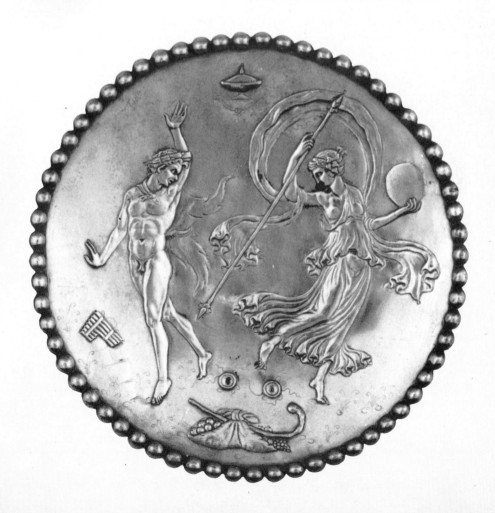

© 1977, The Trustees of the British Museum
ISBN 0 7141 0062 5 (cased)
ISBN 0 7141 0061 7 (paper)
Published by British Museum Publications Ltd.,
6 Bedford Square, London WC1B 3RA

Designed by Patrick Yapp

Set in Bembo 270
Printed in Great Britain by
Balding & Mansell Ltd., London and Wisbech

CONTENTS

Coinage and Currency, AD 300–700 *by J. P. C. Kent*

FOREWORD

'The Wealth of the Roman World AD 300–700', has been assembled to show the wealth of the ancient world as it entered into a period of barbaric invasion and taste. The thanks of the Trustees are due to all who have given so much time and thought to the concept.

In particular I should like to thank John Brailsford, Chairman of the Exhibition Committee, and his colleagues, especially Kenneth Painter, for the devoted work which has culminated in this magnificent exhibition.

A list of those who have loaned objects is given below, but we must express our special gratitude to them for allowing objects from their own exhibitions to be used in the interpretation of this theme. The manner in which they have lent such precious and fragile objects as a complement to our own material is acknowledged here with grateful thanks.

D. M. Wilson
Director of the British Museum

ACKNOWLEDGEMENTS

We gratefully acknowledge the loan of important items from the following institutions: Republic of Cyprus – The Cyprus Museum, Nicosia; France – Bibliothèque Nationale, Paris, Musée du Petit Palais, Paris, Musée du Louvre, Paris; Germany – Bayerische Hypotheken-und Wechsel-Bank, Munich; Great Britain – National Museum of Antiquities of Scotland, Edinburgh; Switzerland – Römermuseum, Augst; USA – Metropolitan Museum of Art, New York, Dumbarton Oaks Collection, Washington; USSR – State Hermitage Museum, Leningrad. Special thanks in this connection are due to the following individuals: Miss Susan Boyd, Miss Katharine R. Brown, Dr H. Cahn, Mr D. Clarke, Miss Margaret Frazer, Mr T. Hoving, Professor V. Karageorghis, Dr Anne-Marie Kaufmann, Dr M. Martin, Professor K. Nicolaou, Dr B. Overbeck, Madame J. Petit, and Mr R. B. K. Stevenson. Photographs of the loans have kindly been supplied by the institutions concerned and additionally by Photo Bulloz, Paris (84); Christian Zocher, Garching (1–9); and Elisabeth Schulz, Basel, and R. Steiger, Augst (80–87).

Three Directors of the British Museum and the Keepers and staff of almost every Department have supported this project with indulgence, kindness and hard work since its inception. Their names are too numerous to set out here; but it is only through the labours, expertise and scholarship of a very large team that this exhibition has been achieved.

PREFACE

The years AD 300–700 are for many people synonymous with the Dark Age *par excellence*, that period spanning the fall of the Roman Empire and the birth of modern Europe, with its climax in the coronation of Charlemagne in AD 800. However, the poverty in art and culture implied by the term 'Dark Age' was limited in extent, and in fact many rich and beautiful treasures date from the four centuries covered by this exhibition. In Mediterranean lands these centuries were a critical period marked by the collapse of the classical Roman Empire, the blossoming of Byzantine power and finally the westward explosion of Islam.

One of the greatest single collections of antiquities from this period of the ancient world is to be found in the British Museum. The collection is so rich that the present exhibition was restricted to only the gold and silver of the period, and even then only a selection of what was available could be included. At the same time it was decided to include if possible some of the most important and impressive objects of the period from other collections, for it was clear that they would not only enhance the exhibition but also help to stimulate that interest and discussion which the project was designed to provoke.

J. W. BRAILSFORD
Formerly Keeper of the Department of
Prehistoric and Romano-British Antiquities
in the British Museum

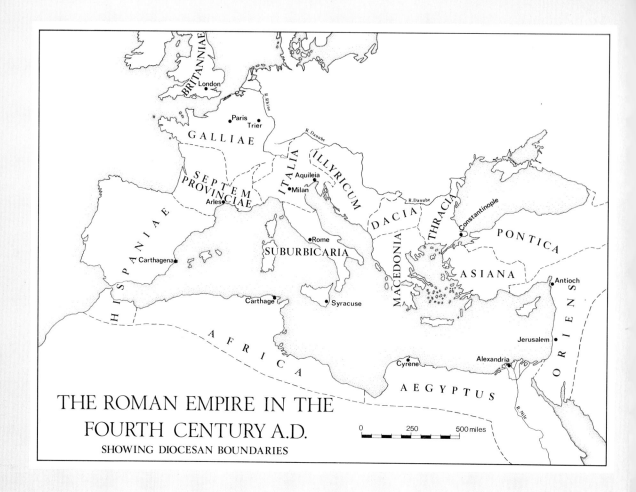

THE ROMAN EMPIRE IN THE
FOURTH CENTURY A.D.
SHOWING DIOCESAN BOUNDARIES

THE WORLD OF LATE ANTIQUITY
AD 300-700

In the year 300, the Roman Empire seemed to stand as strongly as in the days of its early greatness. The political and economic crises that had racked the Mediterranean world during the third century had been resolved by the determined action of a succession of able and ruthless autocrats. During the last quarter of the century, political and economic order was re-established, and the last of the conservative 'Restorers of the State', Diocletian (284–305), set up a form of government to guarantee its continuance.

Under the new regime, all units of administration were subdivided. Provinces were reduced in size; judicial, military and fiscal responsibilities were made more and more distinct. There were even to be four emperors, each with his territorial circumscription; Diocletian's aim was to secure efficient defence of the frontier, of the regime and of society but, in the long run, the effect was to facilitate the break-up of the Empire into two virtually independent realms. Historians have wondered whether to this division should be attributed the fall of the Western Empire, or the survival and development of the Byzantine world. Despite the tendency towards division and separation however, we must not overlook nor underestimate the equally powerful unifying effect, especially on the governing classes, of the 'idea' of Rome, eternal and universal. *Roma caput mundi* proved a dominating factor in the relations of Pope and Emperor far into the Middle Ages.

The four hundred years spanned by this exhibition may thus be seen as centuries of stress between the rival forces of dissolution and unity. It is a fascinating paradox that in succeeding centuries the onward march of political division should have been matched by the triumph of religious unity; it is a minor tragedy that the last unhappy century of the vestigial Roman Empire should have been spent as an unimportant Balkan principality, belonging to neither of the great societies that had grown out of its ruins, and that were now finally bringing about its downfall.

Although we speak of a religious crisis in the late Roman Empire, there is little real sign that the transition from paganism to Christianity was fundamentally difficult, or that, at first, the new official faith had a dominant role in the evolution of the state. There proved to be nothing in the concept of the emperor as developed by the persecutor Diocletian that was not valid for Constantine I (the Great, 306–337) and his Christian successors. The early fourth century persecutions of Christianity seem indeed to have been kept going, if not initiated, from a desire to enforce imperial discipline rather than out of religious conviction. The imposition of religious uniformity, which now embarked on a long, fitful and painful career, was not confined to the Roman Empire. The Sassanian Persians attempted it, as in due course did some of the Muslim states. Although compromise, however unwillingly conceded, always crept in, and although the immediate occasion of persecution was often political, the underlying concepts were not unworthy. They were, first, that

there was an absolute truth to find and then to follow; and secondly, that earthly society was a mirror, however imperfect, of the heavenly kingdom.

To us, this appears a classic instance of man making God in his own image; the converse seemed true to the soldiers who compelled the reluctant Constantine IV (668–685) to accept his brothers as co-emperors with the shout, 'We believe in the Trinity; we will have three emperors to reign over us.' Even in the fourth century it is probably significant that the Arian Constantius II (337–361), who believed in the subordination of the Son to the Father, promoted co-emperors only to the junior rank of Caesar, while the Catholic rulers of the second half of the century elevated their little sons to be Augustus at their side. The Son of God *sits* at the right hand of God the Father, like a full co-emperor; etiquette left a mere Caesar standing.

Ambition, coupled with exceptional energy and good judgement, reunited the divided Empire in the hands of Constantine the Great. But even he sent out his sons as viceroys to rule the provinces in his name, and when he died the Empire was formally partitioned between them. In AD 340 the division into Eastern and Western parts was accomplished. Thereafter, reunification took place only for short periods, and by chance; the division was increasingly recognized to be a political and military necessity.

Each half had its chronic problems. In the east, conflict with Persia pursued its intermittent and indecisive course. Each side could do the other a great deal of damage, and engage the major part of the attention of its military and diplomatic effort. A military solution proved possible to neither side and, after the war of 420, eighty years of warfare were followed by eighty years of peace. It was fortunate indeed that the Eastern Empire was able to confront its major barbarian crises at times when the Persian frontier was quiet, and that the barbarians were denied access to its heart-lands by the strategic situation of Constantinople.

Geography was less kind to the Western Empire. Although it was confronted by no organized power such as that of the Sassanians, it was the natural goal for the relentless migrations out of Asia. Its frontiers were under constant pressure, and it proved vulnerable to piecemeal dismemberment. With hind-sight, it is possible to see that the fall of the Western Empire, or at least its change out of all recognition, was inevitable. People after people, mostly already Christian, were admitted, more or less reluctantly, within its provinces; first they came as soldiers under Roman control, then as settlers under their own kings. During the fifth century, Britain, Africa, Spain and Gaul all passed into the hands of barbarian kings. Finally, in 476, the Roman army in Italy, itself largely barbarian, proclaimed its commander Odovacar king; there was virtually nothing left.

Of course, the Empire had not, in theory, fallen; it had been reunified under the eastern Emperor, to whom all the barbarian kings gave some kind of allegiance, however nominal. It is not without significance that in the ninth century, 'Imperator' and 'Rex' were reckoned to be translations of the Byzantine-Roman Αὐγούστος and Καῖσαρ. Much of the history of the West in the sixth and seventh centuries is about what happened when the eastern emperor tried to make good his title to the lost provinces.

The emperors of Constantinople viewed their anomalous situation with pragmatic eyes. Zeno (474–491) used it to rid the Balkans (which he could rule directly) of the Ostrogoths, and despatch them into Italy (where his sway was only nominal). Anastasius (491–518) alternately flattered and bullied these same Ostrogoths, and cultivated, as did his successors for more than a century, the growing power of the Franks in Gaul. The attempt of Justinian I (527–565) to bring back the West under direct rule was the logical outcome of this concept. Africa, Italy and part of Spain were thus recovered. Africa was regained with ease from the

Vandals. The part of Spain recaptured was little more than a bridgehead, whose

retention depended on the skilful exploitation of tensions within the Visigothic kingdom, and which proved untenable in the face of a determined counter-attack. Italy would have fallen with little more trouble than Africa, had an adequate force been deployed at the start. The invasion of the newly-won province by the Lombards shortly after Justinian's death had disastrous consequences. Political fragmentation ensued; some areas and several coastal cities with their hinterlands were held by the Romans, while the rest of the peninsula was carved up between the Lombard monarchy and its virtually independent duchies. From the coastal cities sprang the earliest Italian city-states, but the deep divisions established at this time could not be healed until the nineteenth century.

In 300 the Empire still flourished in full strength; in 400 it stood, poised on the brink of events that were to bring down its western part. By 500 it had come to terms with its new situation, but retained enough vigour not to accept its losses as irrevocable. In 600, with the Empire weakened by its effort and confronted by new barbarian foes and by the unremitting hostility of Persia, the old enemy, the stage was set for the next and most fundamental of the developments of which we must take account.

The struggle between the Empire and Persia broke out in acute form in the early seventh century. The weakness of the former was the first to be exposed, with the loss of Syria and Egypt, and the first direct threat to Constantinople. The sequel was no less dramatic. The loss of Jerusalem suddenly imparted a hitherto almost unknown religious aspect to the war; thus inspired, Heraclius (610–641) launched upon the Persians a furious counter-attack, which totally broke their power. Both 'Eyes of the World' now lay open to the fanatical assaults of the new politico-religious power of Islam. Persia was overcome and absorbed within a few years, though she passed on many of her arts to the conqueror. The Roman Empire suffered grievously. Syria and Egypt were lost before the middle of the century, Africa by its close; this time the losses were beyond recall, for the transition from Christianity to Islam proved no more difficult than had that from paganism to Christianity.

Heraclius accommodated the Empire to its new situation by a thoroughgoing reform of all branches of administration, and by a less ambitious and costly policy in the west. Even in its hour of disaster the Empire was fortunate in one thing – its ruling house. Hereditary succession had not proved successful during the hey-day of Roman rule, and in the fourth and fifth centuries had furnished a series of young men distinguished almost equally for their piety and futility, puppets in the hands of military or civilian juntas. The House of Heraclius was made of sterner stuff, guiding the fortunes of the Empire for a century with vigour and determination, and bringing it through the period of its supreme crisis to the threshold of its great medieval achievements.

The concepts of reunification and restoration of the Empire had lost none of their power in the seventh century. Constans II (641–668) adopted the name of the first Christian emperor, and placed on his bronze coins the words of Constantine's vision of 312, ἐν τούτῳ νίκα. For many years this formidable ruler fought the Lombards in Italy; his ill-success reveals the tenuous hold which the Romans still had there. The threads of his diplomacy however spread, or were believed to spread, as far to the west as ever; the nervous Franks arrested churchmen travelling from Italy to reinforce the English mission, fearing them to be envoys from the emperor to the English kings. Justinian II (685–711), the last ruler of the dynasty, must surely owe his name to the abiding hope of reconquest.

In the year 700 the Empire approached a nadir in its fortunes. Africa was falling to the Arabs, Italy to the Lombards. Though it was to be more than three hundred years before Byzantine power – as we may now properly style it – ceased to be

effective west of the Adriatic, events were steadily moving towards the end of its dominant role in Europe.

We must take a brief look at the Empire's supplanters. In the west, the great tribal migrations led to the gradual replacement of Roman provinces by tribal kingdoms. The process was, however, rarely abrupt, for the principal migrants were already Christian, and had a long history of contact with the Roman world. They were anxious to live within it – on their own terms, if possible – and to preserve and exploit its social and economic structure. The barbarians therefore long remained states within a state, retaining their own laws and becoming assimilated only gradually with the Latin-speaking provincials. A strange quirk of fate made assimilation of the Goths and Vandals peculiarly difficult, for they had been converted to the Arian sect of Christianity. The simplified explanation of the Trinity that this offered was particularly acceptable to the unsophisticated barbarians, but it created an effective gulf between them and their Roman neighbours.

The Vandals and Ostrogoths passed out of history in the sixth century, but the Visigoths survived to be converted to Catholicism, and the Franks were Catholics from the start. In Britain the Anglo-Saxon settlements were pagan, but when in 597 the missions began, there was in general a ready if uncomprehending acceptance of the Roman faith. Here was the genesis of the three greatest monarchies of western Europe, those of Spain, France and England. By 700 those of Spain and France seemed well-established; only the latter was, however, destined to survive, for in 711 Muslim invasions destroyed the Spanish kingdom of the Visigoths, and Spain was not to be reunited until after the Middle Ages.

The explosive expansion of Islam and the Arab world in the second quarter of the seventh century remains one of the most astonishing and significant facts of history. In that short time, the Sassanian Empire was destroyed, and the great and wealthy provinces of Syria and Egypt torn from the Romans. Perhaps the main result of these events was the overthrow of the political, cultural and economic unity of the Mediterranean basin that had survived for so long. The Roman Empire was so weakened that its power to impose its will in Italy was grievously impaired. By the weakening of the Roman Empire and in due course by the destruction of the Visigothic kingdom, the kingdom of the Franks was left without a rival in the Christian west, and the way to Charlemagne's coronation as emperor in 800 laid open. Thus it is clear that by the year 700 the trends by which we distinguish the medieval from the Late Antique world were already far developed. The Empire was steadily becoming what hostile westerners were to call the 'Kingdom of the Greeks'. The Muslim world and western Europe were beginning to take on the shape that they retain to this day.

GOLD AND SILVER
FROM THE LATE-ROMAN WORLD
FOURTH-FIFTH CENTURIES

Republican Rome in its infancy had little need of gold or silver. In 264 BC, however, Rome pitted herself against the might of Carthage in the first of the three Punic wars, and after a quarter of a century she won Carthage and, with it, Sicily, the first of the Roman provinces overseas. Victory brought rewards and penalties. For two centuries Rome expanded ceaselessly to east and west simply because the liabilities of one conquest – army pay, settlement of veterans and diminished home production – had to be offset by the assets of the next. By the first century BC, however, reserves and fresh supplies of precious metals had become so great that Republican Rome made the transition from a relatively plain to a luxurious standard of living.

The display of gold and silver among private citizens in the form of jewellery and plate was the natural counterpart of Imperial magnificence on an even more sumptuous scale. The vast expansion of the territory of Rome, however, led to such problems of organization that the form of government had to be changed, from Republic to Empire, and, with only minor changes, the frontier had to be stabilized. The government, led by the emperor, had to retain the enormous tracts already won, and to organize them without the Republic's opportunity for winning sudden influxes of wealth by conquest. The consequence was that close attention had to be paid to the production of gold and silver within the Empire, to ownership of the areas of production, to the control of the mine-workers on the one hand and the smiths on the other, to close supervision of the mints and their products, and to the recovery by taxation and confiscation of as much gold and silver as possible. The Roman government and economy were subjected to growing stress and strain by the third century AD. The taste for luxury resulted in the constant immobilization of gold and silver in the form of decoration, plate and jewellery, and also in the steady drain of gold over the frontiers: to the east in exchange for jewels, spices, unguents, silks and precious fabrics; to the north, presumably for furs and amber, and in all directions to buy military friendships and alliances. Political or military crises and the consequent economic inflation removed more gold and silver from circulation because of hoarding. No new sources of precious metal were found that compared with those that had relieved the earlier days of the Empire.

In the face of an impending catastrophe Diocletian, who became Augustus in AD 284, embarked on a series of thoroughgoing political, economic and military reforms. Drawing his strength from old Roman tradition, the emperor took firm control of the army and put an end to seizures of the throne by any general who could make sufficiently extravagant promises to his troops. Diocletian thus brought relative order and stability to the structure of the state. The political situation required the emperor's presence above all in the east, and so Diocletian moved his court to Nicomedia in Bithynia. In AD 305 he abdicated on grounds of ill health, and he built himself a sumptuous palace at Split, outside his native Salonae; but even in his last years, up to his death in AD 313, he maintained interest in public affairs.

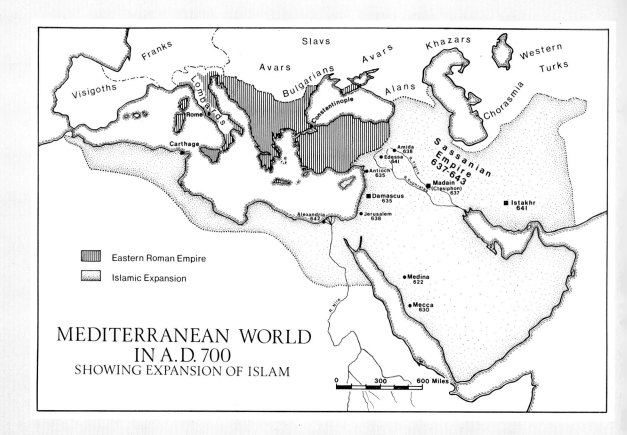

Franks

Slavs

Visigoths

Avars Bulgarians Avars Khazars Western Turks

Lombards

Rome

Alans

Chorasmia

Constantinople

Carthage

Sassanian Empire 637-643

Amida 638
Edessa 641
Antioch 635
Madain (Ctesiphon) 637
Istakhr 641
Damascus 635
Alexandria 642
Jerusalem 638

R. Tigris
R. Euphrates

|||||| Eastern Roman Empire

Islamic Expansion

Medina 622

R. Nile

Mecca 630

MEDITERRANEAN WORLD
IN A.D. 700
SHOWING EXPANSION OF ISLAM

0 300 600 Miles

In the early part of his reign Diocletian had tolerated the various creeds in quest of the hereafter; but later in his reign he began to see some groups as posing a direct conflict between their own beliefs and the need for overriding loyalty to the state. In a direct clash with Christianity he therefore ordered a return to the worship of the Roman gods, and by the edict of AD 304 he required the citizens of the Empire on pain of death to perform the prescribed sacrifices. In the west the persecution ended in AD 306; but in the east it raged until AD 313. Refusing to sacrifice to the gods, and above all rejecting the Emperor cult, the centre of official religion, the Christians came to be regarded as the most subversive element in the state. Moreover, since they advocated the equality of all men, the community of goods and the freeing of slaves, their religion had a distinctly revolutionary flavour.

What Diocletian had struggled for Constantine achieved, though by very different methods. He fortified absolute monarchy by making it hereditary. Diocletian and his predecessors had tried to unite most cults; but Christianity was bound to begin opposition to such tolerance. Constantine did not ban the traditional religions; but from AD 312 Christianity received favoured protection and status, and at the Council of Nicaea in AD 325 the emperor became the recognized head of the Church.

The political, economic and military problems of the period are reflected in the small quantity of gold- and silverwork that has survived from the late third century and the first half of the fourth century. Decorative art shows no clear division between paganism and Christianity. Hope for the hereafter, the dominant early Christian theme, was expressed in many media; but the aspiration was shared by many cults, and no specifically Christian artistic vocabulary had yet been devised. Political propaganda, on the other hand, was expressed explicitly and with clear purposes on the official artistic products of the state. A new gold coinage, for example, was invented by Constantine as a base for the reformation of the economy, and it was used to broadcast the news of the reorganization of the state. Licinius, in his struggle with Constantine for mastery of the state, gave to his supporters presents in the form of commemorative plate, of which examples survive in the dish (no. 10) of AD 317, probably from Yugoslavia, and the 'Munich' Treasure of AD 324 (nos. 1–9). Similar political presentations continued to be made throughout the period by Constantine and his successors. On a larger scale all gave generous presents of gold coins and silver bars to the troops to ensure their loyalty.

The literature of the period makes it clear that Constantine spent freely to emphasize the state support of Christianity, which was one of the major bases of his political power. The account by the historian Eusebius of the Holy Sepulchre at Jerusalem, for example, shows that in building the important church on this site (AD 326–335) no expense was spared. 'This, then, was the church which the emperor reared as a conspicuous memorial and which he adorned throughout in costly imperial fashion. He also embellished it with numerous offerings of indescribable beauty, gold and silver and precious stones set in different materials, the skilful arrangement of which in regard to size, number and variety I have no leisure at present to describe in detail'. The lavishness of all such public activities of Constantine is continuously emphasized by the contemporary writers. At the ceremony of dedication of the new capital in AD 330, we are told: 'Constantine, having built an immense, splendid and felicitous city, named it Constantinople . . . He conducted the first circus games and was the first to wear a diadem decorated with pearls and precious stones . . . He made another statue of himself of gilded wood, holding in his right hand the Tyche of this City, also gilded, and he decreed that on the day of the birthday games this wooden statue should be brought in under the escort of soldiers wearing cloaks and boots, everyone holding white tapers, and that the chariot on which the wooden statue was placed should go round the upper

turning-post and come to the part of the arena immediately in front of the imperial box, and that the reigning emperor should arise and pay homage to the statue of the Emperor Constantine and the Tyche of the City'.

Conspicuous spending was a necessary element, freely indulged, in political activities such as the foundation of cities, the building of churches, or the rewarding of officials and soldiers. A law issued by Constantine in AD 337, however, reveals that, behind the façade of military and political spending, the recovery of the state from the troubles of the third century was a slow and laborious business: 'We command that the practitioners of the arts enumerated in the appended list, whatever city they may live in, shall be exempt from all public services, on condition that they devote their time to learning their crafts. By this means they may desire all the more to become more proficient themselves and to train their sons: architects, makers of panelled ceilings, plasterers, carpenters, physicians, stonecutters, silversmiths, builders, veterinarians, stone-masons, gold-weavers, makers of pavements, painters, sculptors, makers of perforated work, joiners, mosaicists, coppersmiths, blacksmiths, marble-masons, gilders, founders, dyers in purple, makers of tessellated pavements, goldsmiths, makers of mirrors, carriage-makers, glass-makers, ivory workers, fullers, potters, plumbers, furriers'.

This law shows that there was a serious shortage of all sorts of trained craftsmen in most parts of the Empire, a legacy of the troubles of the third century. Most citizens must have found that for everyday purposes the new gold coins, the *solidi*, were too valuable. Information from papyri found in Egypt, but more or less valid for the whole Empire, provides a rough estimate of the purchasing power of the *solidus*. Bread for one year (3 lb a day) cost rather over a *solidus*, meat (1 lb a day) and wine (1 pint a day) rather under two *solidi* each, oil about three-quarters of a *solidus*. The cheapest clothing cost two-thirds to one *solidus* per garment. A common soldier received a ration allowance of four or five *solidi* a year; but we hear of men who lived on three *solidi* a year. It is difficult to be precise about the value of land, but in the west an estate (*fundus*) was normally divided into a home farm and a number of tenancies (*colonicae*). *Fundi* and rents varied; in Italy a rental value of from sixty to forty *solidi* was the mean, and many landlords owned only half, a third or even an eighth of a *fundus*. These figures serve to give some idea of the value of such treasures as that of thirty *solidi* and two pieces of silver plate, hidden in AD 350 and found in 1974 at Water Newton. This gold and silver could have paid the rent for a whole year for a very considerable property in Britain or Gaul.

In the second half of the fourth century, on the other hand, the situation had undoubtedly changed. Gold coinage was issued in quantities that rose to an extremely high volume. So many important hoards of the surviving Roman silver plate date from the later fourth and early fifth centuries that together they give a clearer picture of the silver of the period than we have of any earlier era, except the earlier part of the first century AD. The source of the precious metal is hard to define. No new mining areas are known to have been exploited, nor is the secondary working of old ones known to have been specially profitable. New taxes were invented and imposed, which were not only oppressive and unpopular, but seem to have raised negligible revenue. Some part of Constantine's expenditure came out of the reserve accumulated by Licinius, and then, after this reserve was exhausted, from the vast quantity of bullion secured by Constantine's confiscation of the pagan temple treasures.

The reason for the new prosperity may simply be that the new order brought a period of peace within the Empire. Whatever the causes, the emperors were able to pay the army and government officials and keep them loyal while they also bought off the active and immediate hostility of the powerful nations and tribes that pressed on the frontiers. Gold and silver was mainly used by the government to pay the five-

yearly donatives for the troops in the form of gold coins and silver bars, and for more casual benefactions in the form of gold brooches, gold rings, or silver plate, and only rarely for regular expenditure. The surviving hoards of plate, therefore, enriched in recent years by important finds such as the Mildenhall Treasure (nos. 54–79) and the Kaiseraugst Treasure (nos. 80–87), can be accepted confidently both as illustrations of the best products of Roman silversmiths, and also as the possessions of the more wealthy and influential members of imperial society. Only the upper classes are likely to have been able to afford the privilege and luxury of personal ownership of gold and silver like the Esquiline Treasure (nos. 88–98), which seems all to have been private property and not officially issued gifts.

The greatest number of such treasures must have been concentrated in the richest parts of the Empire; but the largest number of discoveries has been made in areas where the danger was greatest, on the borders of the Empire – in Britain, in the Danube provinces and in South Russia. Finds from the major cities and religious centres of the Empire, like Rome and Carthage, are exceptions rather than the rule. Indeed, some of the most important groups, such as the hoards of broken plate from Britain and Germany – from Traprain Law (nos. 193–199), Coleraine (nos. 200–230), Balline, Hassleben and Gross Bodungen – have been found not merely in border areas but beyond the imperial frontiers.

In style the decorated plate of the later fourth and fifth centuries shows a return to the quality and manner of the art of the first century BC and the first century AD. This revival reflects the growth in skills which rewarded Constantine's encouragement of the luxury crafts. Style, however, has so far produced little information of use in attempts to classify the objects of the fourth and fifth centuries by workshops or groups of workshops. Rome, of course, is likely to have been an important centre, and the Esquiline Treasure (nos. 88–98) was probably made there. Some at least of the pieces of the Carthage Treasure (nos. 99–102) may have been made in that city. Five objects of the fourth and fifth centuries carry imperial stamps which are best interpreted as indicating manufacture in Constantinople, and of the five three are bowls with heavily beaded rims. Heavy beading may be a distinctive indicator of production there, and, if so, pieces as important even as the Mildenhall great dish and platters should perhaps be assigned to Constantinople. From the beginning of the fourth century some ingots and plates were made for official presentation and carry stamps naming their sources, namely Sirmium (modern Sremska Mitrovica, fifty miles north-west of Belgrade) and Naissus (modern Niš, in Serbia, the birthplace of Constantine). The deductions which can be made from this evidence, however, are so meagre as to be almost misleading. A few clues are provided by individual objects, such as two from the Kaiseraugst Treasure: one dish has a careful dotted inscription giving the name of Euticius of Naissus, who is almost certainly its maker, while the richly decorated Achilles dish (no. 80) is inscribed by its maker, Pausylypos of Thessalonike. A clue to the real situation, however, is indicated by the information provided by the stamps and inscriptions of the recently found 'Munich' Treasure (nos. 1–9). They show that at Nicomedia in Bithynia there was a Workshop no. 1 and a Workshop no. 2, that at Antioch there was a Workshop no. 1, and that another piece in the same group had been made at Naissus. The complexity of organization implied by these facts shows that future research must depend on a careful assembly of all such scraps of information and not merely rest on unsupported assumptions that 'work of good quality' was made in the metropolitan areas and that other work is from 'provincial workshops'.

The 'Munich' Treasure

This treasure is unusual among hoards of Roman silver plate in that it comes not from the European provinces but from the eastern part of the Empire. Exact information about the provenance is lacking; but the state of preservation and the patina of the nine vessels indicate that they come from a single hoard. The date of deposition of the hoard was AD 324, and the date of manufacture, confirmed by the stamps and inscriptions on some of the vessels, was about two or three years earlier. The find as a whole throws new light on the official distribution of silver plate from the late Roman Imperial court, and on the location and organization of the workshops.

Although the find-place is obscure, the historical background to the hiding of the treasure is clear. When the Emperor Diocletian abdicated in AD 305, he obliged his colleague Maximian to resign with him, and a regular hand-over of power took place according to the rules of the new constitution of the Tetrarchy (the Rule of the Four Emperors). The two Caesars (junior emperors) became Augusti (senior emperors), and two new Caesars were chosen. By May 311, when Galerius died, however, Diocletian's orderly system, designed to smooth over the succession to power and to avoid civil war, was already in ruins. In 313 Constantine and Licinius emerged as allies, joint victors and emperors.

The peace between Constantine and Licinius was an uneasy one. Each realized that he could survive only if the other were removed, and in 314 open hostilities began. They were brought to a close by negotiation only after Constantine had ousted Licinius from Pannonia and Thrace and gained control of the whole of the European part of the Empire. This time a 'Pentarchy' was established, with two Augusti and two Caesars; but now the Caesars were the real sons of the Augusti. Constantine nominated his two sons Crispus and Constantine II, Licinius his infant son Licinianus, also known as Licinius II.

The new peace was as transient as the old. From 320, relations between the rulers of east and west became tense, and in 324, in a short war terminated by a decisive battle at Chrysopolis, on the Asiatic shore of the Bosphorus, Constantine overthrew Licinius and his infant son. Both died in captivity shortly afterwards.

The treasure includes pieces manufactured both for Licinius and for Constantine. The recipient, therefore, may well have been an important person in the territory over which the final struggle occurred in 324, and the war of that year is the most likely occasion in which such an official might have had to take steps for his own and his property's safety.

1 Licinius I bowl made c. AD 321/22, deposited c. 324
D 17·9 cm. WT 323·3 g.
Silver bowl with simple curved profile. The marks of working show that it was first raised and then polished on the lathe. In the centre is a stamped medallion within two deep lathe-cut circles, bearing a full-face portrait bust of Licinius I. The emperor is shown bareheaded and bearded, wearing armour and a military cloak *(paludamentum)* fastened by a round brooch with three pendants. Encircling the bust is the inscription: LICINIVS AVG OB D V LICINI FILI *(Licinius Augustus ob diem quinquennaliorum Licinii, filii sui* – the Emperor Licinius on the occasion of the celebration of five years' rule by his son Licinius). On the outside of the bowl, near the rim, is a small round stamp: *NIKO/AIΔ/A*. The first and last lines *NIKO-A* mean that the bowl was made in Workshop no. 1 *(officina A)* of the mint at Nicomedia in Bithynia. The letters *AIΔ* in the middle line are probably the abbreviated name of the official in charge, perhaps the frequent late Roman name *Αἰδήσιος* (Aedesios).

Licinius I was Augustus from AD 308 to 324. Licinius II was born in July or August 315. He was proclaimed Caesar on 1 March 317. The inscription round the portrait therefore refers to 1 March 322, and this bowl and (2) and (3) were made in 321/22.
Provenance: 'Munich' Treasure.
Bibl. Overbeck, *Argentum*, p. 23.
Bayerische Hypotheken-und Wechsel-Bank, Munich. No. 1.

2 Licinius II bowl made c. AD 321/22, deposited c. 324
D 17·9 cm. WT 321·74 g.
Silver bowl identical in form and technique to bowl no. 1, but within the central medallion, with its beaded border, is a full-face portrait of the young Licinius II. He is shown bareheaded and wearing armour beneath his cloak, which is fastened by a round brooch with pendants. The surrounding inscription reads: LICINIVS CAES OB D V SVORVM *(Licinius Caesar ob diem quinquennaliorum suorum* – the Junior Emperor Licinius on the occasion of the celebration of five years' rule). On the outside is a stamp similar to that on bowl no. 1: *NIKO/EYT/NEB*. This is a much more difficult stamp, and only some points can be conjecturally interpreted. Some general conclusions, however, can be drawn. *NIKO* again certainly stands for Nicomedia. *EYT* is again probably the name of an official, but the abbreviation cannot be expanded with certainty; some possible names of the period are Eutolmios, Eutropios and Eutychianos. If the *B* of *NEB* signifies a numeral, the Greek for 2, and therefore Workshop no. 2 of the mint, *NE* can be expanded to *N[ομισμάτων] 'E[ργαστήριον]*, or Coin Workshop. It is possible that *N* might be the abbreviation of another name, like *EYT*, but this seems much less likely.
Provenance: 'Munich' Treasure.
Bibl. Overbeck, *Argentum*, pp. 23, 29.
Bayerische Hypotheken-und Wechsel-Bank, Munich. No. 2.

3 Licinius II bowl made c. AD 321/22, deposited c. 324
D 18·7 cm. WT 315·11 g.
Silver bowl resembling the two from Nicomedia (1, 2) in form and technique. The medallion, again surrounded by a beaded border, bears the full face bust of the junior emperor, like bowl no. 2. The brooch is shown in greater detail and has four round knobs on the rim. The inscription reads: LICINIVS CAES OB D V SVORVM, as on bowl no. 2. On the outside there is a similar round stamp, reading: *ANT/EYCTO/A*. Accordingly, the bowl was made in *ANT[IOXIA/A*, Workshop no. 1 of the mint at Antioch. The name of the official responsible was most probably *Εὐστόχιος* (Eustochios).

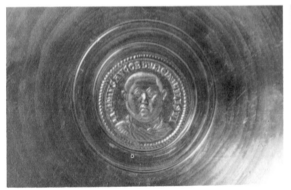

1 (detail)

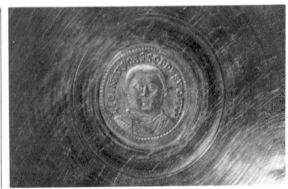

2 (detail)

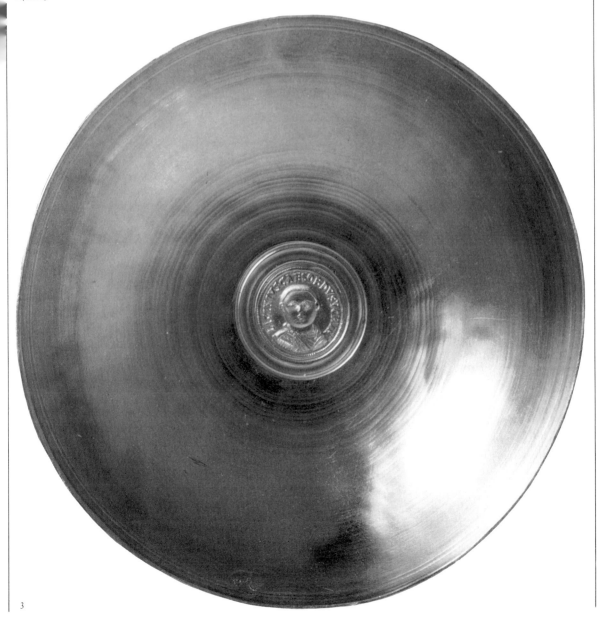

3

Provenance: 'Munich' Treasure.
Bibl. Overbeck, *Argentum,* p. 29.
Bayerische Hypotheken-und Wechsel-Bank,
Munich. No. 3.
Colour plate.

4 Vota bowl, mentioning two Caesars made *c.* AD 321/22, deposited *c.* 324

D 22·5 cm. WT. 470·3 g.

Silver bowl, very similar in form and technique to the first three bowls already described, but lacking the figured representation in the centre. Instead, two lathe-turned grooves serve as guidelines for an inscription cut on the inner surface of the bowl. This reads: VOTIS X CAESS NN (*Votis decennalibus* [*duorum*] *Caesarum nostrorum),* which may be translated: 'On the celebration of the tenth anniversary of our two junior emperors'. On the outside of the bowl is the pointillé inscription NAIS, showing that the bowl was made at Naissus (modern Niš, in Yugoslavia). The inscription refers only to two Caesars, not to the full number – Crispus and Constantine II with Licinius II. The last-named was not born until AD 315, so the celebration of ten years' rule cannot refer to him. The place of manufacture, Niš, was in the province of Moesia which, from 315, lay in the part of the Empire controlled by Constantine.

Provenance: 'Munich' Treasure.
Bibl. Overbeck, *Argentum,* p. 29.
Bayerische Hypotheken-und Wechsel-Bank,
Munich. No. 4.

5 Vota bowl, mentioning one Caesar made *c.* AD 321/22, deposited *c.* 324

D 24·4 cm. WT (surviving metal) 421·09 g.

Silver bowl very similar to 4; some portions are missing and have been restored. The vessel has been very carefully finished, and has a lathe-turned groove defining the rim, and double lines bordering the inscription. This is in double-line letters and reads: VOTIS X CAESARIS NOSTRI (*Votis decennalibus Caesaris nostri* – on the celebration of the tenth anniversary of our junior emperor). Because some fragments of the bowl are missing, part of an inscription on the outside is lost; the remaining text reads . . . *XIAC,* lightly and carelessly incised. The most probable restoration of the inscription is [*ANTIO*]*XIAC* (from Antioch). The original weight of the bowl would have been greater than that given above. The bowl is to be connected with Licinius II because it mentions the *vota decennalia* of only one Caesar. The workshop inscription [*ANTIO*]*XIAC* shows that we are dealing with the Caesar of the eastern part of the Empire. The gold coinage of Licinius II is inscribed SIC V – SIC X. This votive vessel, like the Constantinian piece from Niš, names the *vota decennalia suscepta,* the new vows for the ten-year jubilee. Like the bowls with the portraits of Licinius, it is to be dated to the period 321/22.

Provenance: 'Munich' Treasure.
Bibl. Overbeck, *Argentum,* p. 39.
Bayerische Hypotheken-und Wechsel-Bank, Munich. No. 5.

Licinius II never in fact attained the tenth anniversary prayed for here. Having been made Caesar in AD 317, he was killed in 325.

6 Flat silver dish with fluted rim deposited *c.* AD 324

D 25·3 cm. WT (in present condition) 396·72 g.

Flat dish, raised and turned on a lathe, with a low scalloped or fluted rim. There are lathe-turned grooves on the interior surface, and the centre is decorated with a simple incised rosette of fifteen petals. A few small fragments are missing; the original weight will have been a little more than that given above.

Provenance: 'Munich' Treasure.
Bibl. Overbeck, *Argentum,* p. 39.
Bayerische Hypotheken-und Wechsel-Bank, Munich. No. 6.

Two plates closely resembling this example were found at Cervenbreg in Bulgaria. They are each stamped in the centre with a portrait of Licinius and an inscription celebrating his *decennalia.* The style of the portrait is reminiscent of that on coins struck in Heraclea (see F. Baratte, 'Les Ateliers d'Argenterie au Bas-Empire', in *Journal des Savants* (1975), p. 19). A third plate of the same type, but highly decorated), has been published since 1827 as part of the Esquiline Treasure (no. E.C. 311). Monsieur Baratte has pointed out, however, that the plate is from the Mâcon Treasure, deposited about AD 270.

7 Silver bowl deposited *c.* AD 324

D 21·4 cm. WT (in present condition) 308·63 g.

Bowl with curved profile, footring and broad horizontal rim edged with beads. There is a very slight weight loss due to missing fragments.

Provenance: 'Munich' Treasure.
Bibl. Overbeck, *Argentum,* p. 39.
Bayerische Hypotheken-und Wechsel-Bank,
Munich. No. 7.

8 Silver bowl deposited *c.* AD 324

D 14 cm. WT 162·14 g.

Bowl which, apart from its smaller size, closely matches no. 7, and presumably formed part of a set with it. On the exterior base is a pointillé inscription: *OK ΓΟΣΓΡΓ. OK* is presumably to be read as δ[*λως*] κ[*αθαροῦ ἀργυρίου*], 'entirely of fine silver'. This reading is confirmed by a similar inscription on a plate in the Treasure of Malaia Pereshchepina (Poltava Province). The rest of the inscription is then clearly to be interpreted as statements of weight: ΓΟ-ὄγγια (Latin *uncia),* Σ – *Greek figure 6, therefore 6 ounces;* ΓΡ-γράμμα (*Latin scripulum),* Γ – *Greek figure 3, therefore 3 scripula.*

Provenance: 'Munich' Treasure.
Bibl. Overbeck, *Argentum,* pp. 39–40.
Bayerische Hypotheken-und Wechsel-Bank,
Munich. No. 8.

9 Small silver bowl deposited *c.* AD 324

D 12·3 cm. WT 125·97 g.

Small bowl, similar in form to (7) and (8) but without the beaded rim.

Provenance: 'Munich' Treasure.
Bibl. Overbeck, *Argentum,* p. 40.
Bayerische Hypotheken-und Wechsel-Bank,
Munich. No. 9.

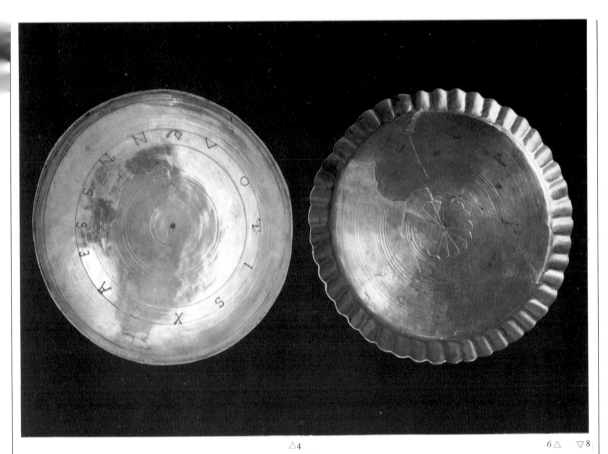

△4 6△ ▽8

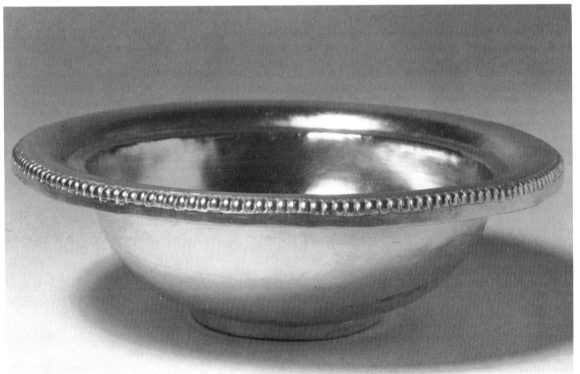

Anniversary Dishes

The so-called *largitio* plates, which were distributed on the occasion of imperial anniversaries, form an important class of late-Roman silver. The earliest of the series are the group including no. 10, which were found in Yugoslavia and celebrate the *decennialia* of Licinius in AD 317. Of the same type are the dishes in the 'Munich' Treasure (nos. 1–9).

The finest of the imperial commemorative plates are the picture dishes with scenes, in relief or engraving, representing the Emperor and other members of the ruling house. The best known is the Plate of Theodosius I found near Merida in Spain, on which the inscription refers to the Emperor's ten-year anniversary in AD 388. Of the same class is the engraved dish (no. 11) with an emperor on horseback, probably Constantius II.

10 Silver largitio bowl of the Emperor Licinius AD 317
D 17·7 cm.

Shallow bowl with an engraved laurel wreath in the centre, surrounding the inscription: SIC X SIC XX (as ten, so twenty), an expression of Licinius's desire that his reign should last a further ten years. Around the rim is the inscription: LICINI AVGVSTE SEMPER VINCAS and the stamp: NA (= Naissus)

ISS

This is one of five similar bowls, all made at Naissus to the order of Licinius to celebrate his tenth anniversary.

Provenance: Made at Niš (Naissus) in Yugoslavia and found there in 1901.

Bibl. Tait, *Ant. J* (1970), pt ii, p. 344; Camber, *Burl. Mag.* February 1972, pp. 92–3; F. Baratte, 'Les Ateliers d'Argenterie au Bas-Empire', in *Journal des Savants* (1975), pp. 200–202 (with bibliography).

BM (M & LA) 1969, 9–4, 1.

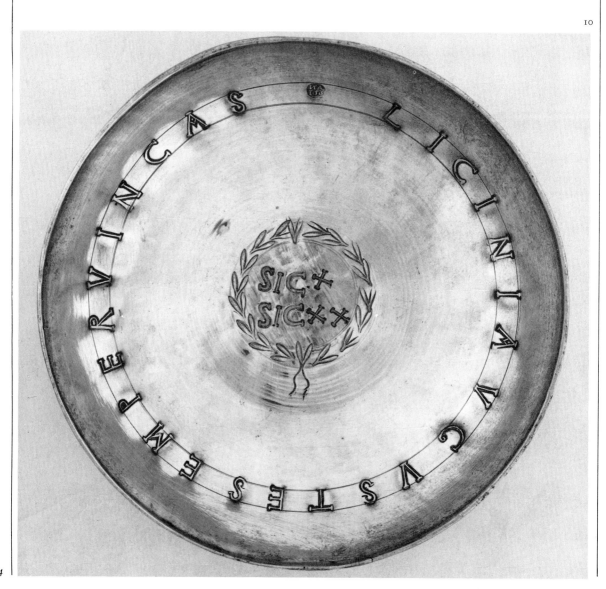

11 Silver dish with the triumph of Constantius II

mid-fourth century AD

D 24·8 cm. WT 660 g.

Dish decorated with turning on the rim: the reverse is plain, with no foot, but with a suspension-ring. The engraved decoration, enriched with gilding and niello, which survives only in part, shows the emperor mounted, his horse trampling underfoot the shield of a vanquished enemy. To the left of the group is a guard with a shield bearing the *chi-rho* monogram, to the right is the figure of Nike crowning the Emperor with a wreath and holding a palm branch in her left hand.

Provenance: Found in 1891 at Kertch in a cemetery of the fourth and fifth centuries.

Bibl. L. Matzulewitsch, *Byzantinische Antike* (1929), pp. 95ff., pl. 23; W. Grünhagen, *Der Schatzfund von Gross Bodungen* (1954), p. 18; A. Banck, *Byzantine Art in the Collections of the USSR* (1966), no. 1.

Leningrad, Hermitage Museum.

Two other vessels have been found at Kertch with inscriptions celebrating the *vicennalia* of Constantius in AD 343. The linear style of the decoration of this piece, and particularly the representation of the emperor as an abstract, hieratic image, is a remarkable foreshadowing of sixth–seventh century work. It has been suggested that it is provincial work of the Black Sea area; but there is no evidence that the art of the capital was necessarily homogeneous. The identification of the Emperor as Constantius II is supported by a fragmentary engraved and inscribed glass cup, found in the Roman forum, which Salomonson argues convincingly to have been made, when the Emperor visited Rome in AD 357, to celebrate the thirty-fifth anniversary of his Caesarship.

11

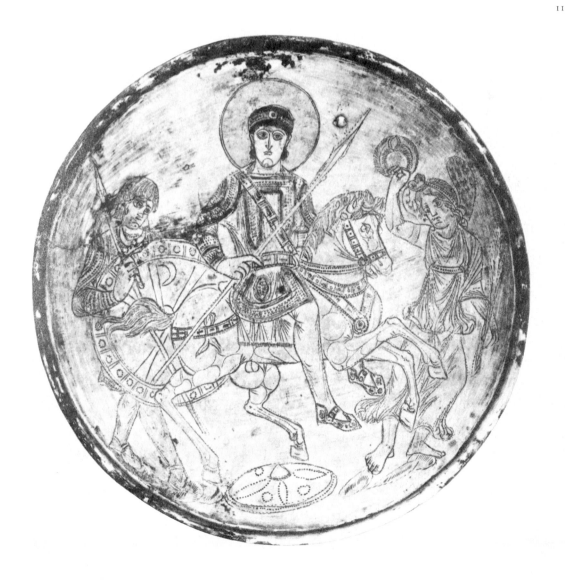

Silver Ingots

Officially stamped ingots, whether of gold or silver, occur comparatively frequently at the end of the fourth century. They were probably made because in the later Empire, unlike earlier times, the Treasury required large sums in gold and silver for payment to its soldiers and officials. In the development of the financial system the *comes sacrarum largitionum*, 'Count in charge of the sacred distributions', became the principal officer because payments took place on the Emperor's birthday, with supplementary payments on the occasion of imperial accessions and five-yearly celebrations. The five-yearly donative consisted of five gold solidi per man; but the accession donative, at least between AD 361 and AD 518, is known to have been five gold solidi and one pound of silver. The practice of presenting pounds of silver is known to be earlier than AD 361, and it is closely related to the official distribution of plate, both in silver and also perhaps in other expensive materials, such as figured cut glass (see A. Oliver, 'Tapestry in Glass', in *Journal of Glass Studies* XVII, 1975, pp. 68–70).

12 Silver ingot fourth century AD
L 12·3 cm. W 7 cm. WT 317 g.
Silver ingot of hide or double-axe form, without inscription. An extra 'plug' of silver has been inserted in one of the corners.
Provenance: Pit 265, Richborough, Kent.
Bibl. Painter, *JBAA* 28 (1965), p. 12, no. 4; Cunliffe, *Rich.* 5, p. 107, no. 243; Painter, *Ant. J* 52 (1972), p. 87, no. 5.
BM (P & RB), loaned by the Ministry of Works (now Department of the Environment).
Loan 27.10.1953.

13 Silver ingot fourth century AD
L 12 cm. W 9·8 cm. WT 319·47 g.
Silver ingot of double-axe (hide) form, stamped with the inscription: EX OFF/CVRMISSI in two lines.
Provenance: Kent.
Bibl. Painter, *Ant. J* 52 (1972), p. 84 and p. 87, no. 8.
BM (P & RB) P.1970.7–2.1

14 Silver ingot fourth century AD
L 10·1 cm. W 7 cm. WT 301 g.
Silver ingot of double-axe (hide) shape, stamped with the inscription: EX OF FL/HONORINI in two lines.
Provenance: Found at the Tower of London, September 1777, in digging of foundations.
Bibl. Milles, *Archaeologia* 5 (1779), pp. 291–305; Willers, *Num. Zeit.* 31 (1899), p. 367; Painter, *JBAA* 28 (1965), p. 12, no. 5; Painter, *Ant. J* 52 (1972), p. 87, no. 9.
BM (P & RB) OA.247.

Belt-Plates, Rings and Brooches

Besides gifts of plate, emperors and other public figures used jewellery such as rings and brooches to bestow favours and to spread propaganda. Rings like those which follow, for example, were probably presented by the Emperors Diocletian (AD 284–305) and Constantine (AD 306–37) to officers in the army. The brooches have a larger surface for adornment and some examples have extensive inscriptions, whether political or religious. At the same time, however, it

14

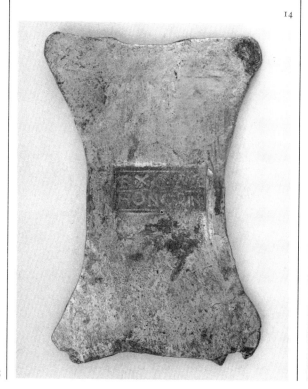

16

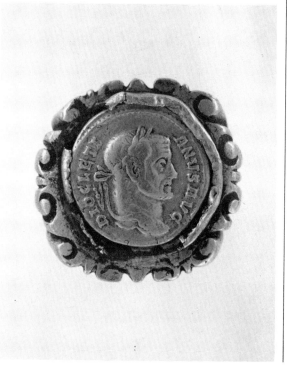

is clear that belt-buckles of certain types, strap-ends, and 'cross-bow' brooches, whether in precious metal or bronze, are primarily equipment of soldiers and officials. Study of this equipment and of the sites at which most examples have been found suggests that the bulk of the objects were manufactured in the state factories of Pannonia or Illyricum and that they were part of the uniform of regular soldiers serving in the defence of the Roman frontiers during the second half of the fourth century.
Bibl. G. Behrens, 'Römische Fibeln mit Inschriften', in *Reinecke Festschrift* (Mainz, 1950), pp. 1–12; R. Noll, 'Eine goldene "Kaiserfibel" aus Niederemmel vom Jahre 316', in *Bonner Jahrbücher* 174 (1974), pp. 221–44; F. Baratte, 'Les Ateliers d'Argenterie au Bas-Empire', in *Journal des Savants* (1975), p. 204; and C. J. Simpson, 'Belt-Buckles and Strap-Ends of the Later Roman Empire', in *Britannia* VII (1976), pp. 192–223.

15 Gold ornamental panel fourth century AD
H 5 cm.
Square panel in pierced work with a pearl border. On the front, against a trellis background, is a woman on horseback, accompanied by a lion. On the back, which is soldered on to the front, is a diaper pattern of leaves framed by a pearled border.
Provenance: Found with the plate of a gold buckle (EC 253), three fragments of a similar gold buckle (EC 254), part of a gold necklace (EC 255) and six *aurei* of Constantius in Asia Minor.
Bibl. Dalton, *EC Cat.*, no. 252; Volbach, *ECA*, p. 333, pl. 119.
BM (M & LA) AF 332. Bequeathed by Sir Augustus Wollaston Franks.

The precise function of this finely worked piece of jewellery is uncertain; but it may well have served as a belt mount.

16 Gold finger-ring Roman, early fourth century AD
D 2·7 cm. WT 27·53 g.
Finger-ring with a circular bezel in which is set an aureus of the Emperor Diocletian (AD 284–305). The reverse of the coin is inscribed:

VIRTVS MILITVM
A

Bibl. Marshall, *FR Cat.*, no. 264.
BM (G & R) 264 F. Bequeathed by Sir Augustus Wollaston Franks.

17 Gold finger-ring Roman, fourth century AD
D 2·8 cm. WT 10·95 cm.
Finger-ring inscribed FIDEM on the bezel and CONSTANTINO round the hoop. A number of such rings have been found. They were perhaps presented by the Emperor Constantine (AD 306–37) to officers in the army.
Bibl. Marshall, *FR Cat.*, no. 649.
BM (G & R) 649 F. Bequeathed by Sir Augustus Wollaston Franks.

18 Gold brooch Roman, third–fourth century AD
L 4·6 cm.
Crossbow-type fibula, richly decorated with granulation. A safety chain is attached to it.
Provenance: Felegyhaza, Hungary.
Bibl. Marshall, *J. Cat.*, no. 2853.
BM (G & R) 1900.7–30.2.

17

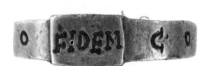

18

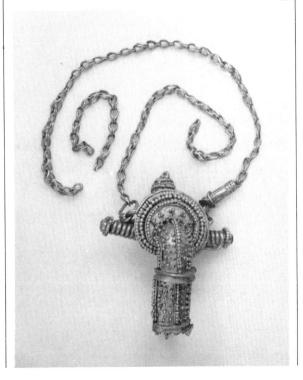

19 Gold brooch Roman, fourth century AD

L. 7·5 cm.

Crossbow-type fibula with decoration in niello.

Provenance: Perhaps from Trier, Germany.

Bibl. Marshall, *J. Cat.,* no. 2856.

BM (G & R) F 2856. Bequeathed by Sir Augustus Wollaston Franks.

20 Gold crossbow brooch fourth century AD

L 7·8 cm.

Gold crossbow brooch with acorn-shaped knob terminals, each with a beaded collar below. Along the back of the bow and the foot is a line of small impressed triangles. Where the bow joins the foot, there is a triangular plate bordered with circular cutouts and with scalloped edges. The pin is missing.

Provenance: Odiham, Hampshire.

Bibl. Birch, *Arch. J* 2 (1846), p. 46; Brailsford, *Ant. RB '64,* fig. 10, no. 28.

BM (P & RB) 1844.7–9.1.

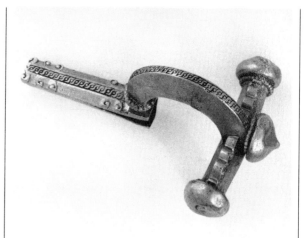

19

21 Gold crossbow brooch fourth century AD

L 7·9 cm.

Gold crossbow brooch with six-faceted, acorn-shaped terminals above beaded collars. The sides, crest and foot are decorated with hatched and plain triangles. Along the edges of the foot are cusped motifs, and there is raised ornament on the arms. One terminal screws into position, the screw having a left-hand thread (similar brooches from Richborough all have screws with left-hand threads). The pin is missing.

Provenance: Moray Firth, Scotland. Found in 1847.

Bibl. Higgins, *GRJ,* pl. 64.C.

BM (P & RB) 1962.12–15.1 (formerly 1922.4–12.1). Previously in the Ashburnham Collection.

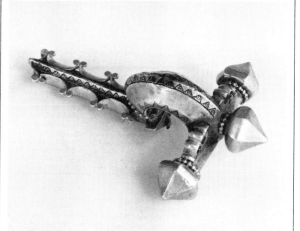

22 Gold brooch fifth century AD

L 1·8 cm.

Fibula of the crossbow type; the bow is spindle-shaped and the stem hexagonal in section. On the front of the stem is an inscription in niello:

$$+\Theta Y \; XAPIC \; \text{(Grace of God)}$$

This fibula exemplifies the appearance of Christian sentiments on the luxury jewellery of late antiquity. The pin is missing.

Bibl. Dalton, *EC Cat.,* no. 264.

BM (M & LA) AF 336. Bequeathed by Sir Augustus Wollaston Franks.

21 △ ▽ 23

23 Silver-gilt brooch fourth century AD

L 6·7 cm.

Silver brooch with traces of gilding. The bow is in the form of an animal head (horse or boar), the eyes of which are inlaid with dark blue glass. Beneath the animal head is a disc bearing a punched monogram cross which covers the spring of the brooch; three knob terminals project around it.

Provenance: Probably Sussex.

Bibl. Toynbee, *AB,* p. 344, pl. LXXIX.c.

BM (P & RB) 1954.12–6.1.

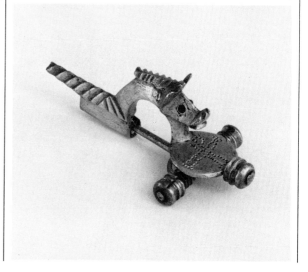

24 Silver brooch Roman, third–fourth century AD

L 5·9 cm.

Fibula with plain bow, having a knob at one end and protection for the pin (now missing) at the other.
Provenance: Said to be from Austria-Hungary or Germany.
Bibl. Marshall, *J. Cat.*, no. 2852.
BM (G & R) 1860.6–9.4.

25 Silver brooch Roman, fourth century AD
L 6·8 cm.
Crossbow-type fibula.
Bibl. Marshall, *J Cat.*, no. 2857.
BM (G & R) 1872.6–4.770.

The Water Newton Hoard: 4th century AD

In February, 1975, this hoard came to light in a ploughed field at Water Newton, Huntingdonshire, the Roman town of *Durobrivae*. On 10 September 1975, the jury at a Coroner's inquest declared the find to be Treasure Trove and thus the property of the Crown.

The treasure contains nearly thirty objects, though some of them are badly damaged. Nine items are vessels – bowls, jugs, a two-handled cup and a strainer – while the rest are small triangular plaques of thin metal, representing stylized leaves. Except for one small gold plaque, everything is made of silver. Many of the objects bear the *chi-rho* monogram, standing for Christ's name, while two bowls and one plaque have longer inscriptions in Latin. One of these, on a bowl, reads, 'I, Publianus, honour your sacred shrine, trusting in you, O Lord'.

The reason for the hiding of the objects in antiquity is not certain. One motive might have been to protect them from damage by members of other cults. Another might have been to protect them from thieves or from raiders coming from outside the Empire. A treasure found at Water Newton in 1974 was hidden in AD 350. This was the beginning of a period of fifteen years when the Roman army in Britain was unable to control its foes. A third reason for the concealment of the Christian silver might have been official persecution of the religion. Christians in Britain suffered in such attacks, of which the best known is that launched throughout the Empire by Diocletian in AD 303 and 304. This sort of action would have been good reason to hide the Water Newton treasure, no matter whether the concealment was at this precise time in the fourth century or not.

Before the discovery of the Water Newton Christian silver the earliest known Christian religious treasures dated from the sixth century AD. The Water Newton treasure is the earliest known group of Christian silver from the whole Roman Empire.
Bibl. K. S. Painter, *The Water Newton Early Christian Silver*. London, 1977.

26 Decorated silver jug fourth century AD
H 20·3 cm. D *c.* 11·6 cm (max.), 6·5 cm (rim). WT 534 g.
Silver jug, originally provided with one handle, now missing; slight solder marks remain. The lower attachment was a heart-shaped escutcheon. There are two marks on the rim for a horizontal attachment, and the handle no. 34 belongs to this jug. The vessel has an everted and upstanding

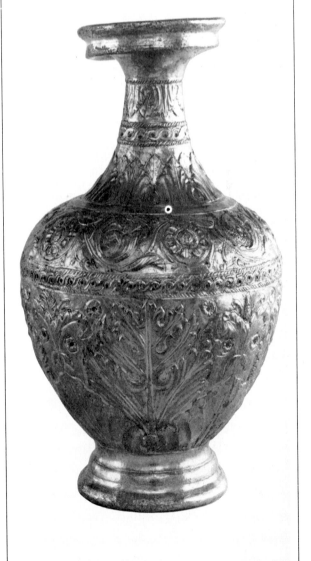

26

rim, a slender neck, ovoid body and high, neatly profiled footring. The neck has three zones of decoration: the upper one of pendant leaf-forms below a roped border, giving an ovolo-like effect; a narrow border of S-meanders between roped lines; a lower zone of upright, basically acanthus-type leaves. There is a narrow plain zone on the shoulder, and three further zones on the body. The uppermost, at the shoulder, consists of a leaf-scroll with acanthus leaves and nine to ten petalled flower rosettes in alternate curves; the centres of the flowers and the acanthus buds are decorated with tiny rings. Below this zone, at about the point of maximum diameter, is a narrow dividing border like that on the neck – S-meanders between roped lines. The lowest zone, *c.* 7·5 cm. deep, contains upright acanthus buds and fully opened leaves interspersed with some small, simple rosettes.
Provenance: Water Newton, Huntingdonshire.
BM (P & RB) P.1975.10–2.1. Treasure Trove.

27 Decorated silver bowl fourth century AD
H *c.* 10 cm. D *c.* 18–19 cm. WT 220·4 g (including fragments).
Lower area from a bowl in thin sheet silver, elaborately decorated in repoussé worked from the outside to give interior decoration in relief. The vessel is very damaged, and there are about fifty fragments from it. The base is slightly dished and the profile curves in slightly towards the top, probably ending in a small plain upright or everted rim. Two rings and fragments of chain may belong to the bowl. The rings have overlapped ends like many late Roman finger-rings; the smaller one is riveted to a portion of plain rim, the rivet being decorated with a seven-petalled rosette. There are nine zones of decoration from the rim downwards: (1) astragalus border between dotted lines; (2) four rows of leaf-tips in scale pattern; (3) astragali between dotted lines; (4) deep zone of circles with dotted borders, containing five central dots divided by upright leaf-tips and once by opposed peltae with leaf-tips; (5) astragali between dotted lines; (6) as (4) except for the pelta motif; (7) three rows of astragali; (8) herringbone pattern; (9) astragali.
Provenance: Water Newton, Huntingdonshire.
BM (P & RB) P.1975.10–2.2. Treasure Trove.

28 Silver bowl fourth century AD
L *c.* W *c.* 16 cm. WT 258·3 g (including fragments).

Damaged silver bowl, undecorated, with slightly everted rim and dished base.
Provenance: Water Newton, Huntingdonshire.
BM (P & RB) P.1975.10–2.3. Treasure Trove.

29 Inscribed silver bowl fourth century AD
H *c.* 12·4 cm. D *c.* 15 cm. WT 260·5 g (including fragments).
Deep, basin-shaped bowl with slightly dished base, made of very thin metal (under 1 mm). The rim is everted, with a flat zone beneath, *c.* 2·5 cm deep, bearing the inscription. The vessel is badly damaged, and only about half remains. One of the broken fragments is from the rim and bears part of the inscription. The lettering is double-line, in neat characters *c.* 1·3 cm high, with serifs; what survives reads: . . . RVNT (*chi-rho* with alpha and omega) INNOCENTIAETVIVINTIA . . .
Provenance: Water Newton, Huntingdonshire.
BM (P & RB) P.1975.10–2.4. Treasure Trove.

30 Inscribed silver bowl fourth century AD
H 11·5 cm. D 17 cm. WT 662·9 g (including fragments).
Deep bowl with slightly dished base and slightly concave rim. One side and part of the base are damaged. On the exterior base, in neat letters *c.* 7 mm high, is inscribed the name PVBLIANVS. Round the rim is a long inscription in letters of the same type and size: (*chi-rho* with alpha and omega) SANCTVM ALTARE TVVM D (*chi-rho* with alpha and omega) OMINE SVBNIXVS HONORO.
Provenance: Water Newton, Huntingdonshire.
BM (P & RB) P.1975.10–2.5. Treasure Trove.

The inscription forms a line of Latin verse, a dactylic hexameter. The meaning appears to be, 'I, Publianus, relying on You, honour Your holy sanctuary, O Lord'. The wording recalls that of the Roman Canon of the Mass. *Subnixus* apparently means, 'subject to You (Lord)', or even 'Your servant', suggestive of the bowing of the celebrant over the altar and the kneeling of the congregation. *Altare* recalls the Introit prayer in the Tridentine Mass, 'introibo ad altare Dei', which means entering the sanctuary, not the altar itself.

31 Silver cup fourth century AD
H 12·5 cm. D 11 cm. WT 315·7 g (including handles).
Cup of kantharos form with two ogival handles (found

30

31

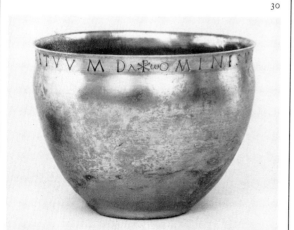

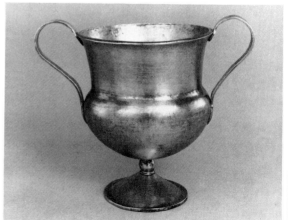

detached). There is no decoration, but the external surface has been burnished; the interior shows hammer marks. The position of the handles is indicated by marks where they were soldered in position. The rim is thickened and neatly finished. The low conical foot also has a thickened rim, and is attached to the body by a square-ended rivet. The slight knob between base and cup shows some green corrosion. The handles are of simple flat section, the basal attachment shaped to a simple drop shape.

Provenance: Water Newton, Huntingdonshire.
BM (P & RB) P.1975.10–2.6. Treasure Trove.

32 Silver dish with chi-rho fourth century AD

H 5·3 cm. D c. 27 cm (base), 33·5 cm (rim). WT 1304·7 g.
Large, deep dish with straight, everted sides and a small, flat horizontal rim c. 8 mm wide. There is a central depression 3 mm in diameter, from turning the vessel, and a second, smaller point close to it, which is the centre of a broad circular groove 11·2 cm in diameter, and of a further grooved circle 20·3 cm in diameter. The whole interior of the base is covered with areas of very light concentric 'engine-turning'. Within the inner circle, a large chi-rho is lightly incised, the rho having a very curved 'tail'. An omega is present but there is no trace of an alpha. To either side are an alpha and an omega, lightly engraved.

Provenance: Water Newton, Huntingdonshire.
BM (P & RB) P.1975.10–2.7. Treasure Trove.

33 Silver jug fourth century AD

H 10·5 cm (rim to break). D 6·3 cm (across rim). WT 151 g.
Mouth and neck of a large spouted jug, roughly hacked from the body. Several simple horizontal lines encircle the neck, and there are holes in the rim (for the attachment of a lid?). There is a small fragment which has been torn from the neck.

Provenance: Water Newton, Huntingdonshire.
BM (P & RB) P.1975.10–2.8. Treasure Trove.

34 Silver handle attachment fourth century AD

L c. 4·8 cm. W 2·3 cm. WT 9·3 g.
Half of a silver handle attachment from the rim of a vessel. Originally thought to belong to the spouted jug (33), it is in fact from the decorated jug (26). The handle has been wrenched out of shape when broken. It has a stylized foliate design, cast and pierced.

Provenance: Water Newton, Huntingdonshire.
BM (P & RB) P.1975.10–2.1. Treasure Trove.

35 Silver strainer with chi-rho fourth century AD

L 20·2 cm. D 6 cm (bowl). WT 64·4 g (incl. rim).
Strainer with the bowl pierced by two circles and twelve radiating lines of small holes; each radiating line ends in a group of four holes. There is a separate silver ring with a segmented pattern on the surface, which fits the rim of the bowl. The handle has been broken and repaired in antiquity with three large rivets. Its borders are decoratively notched, and the terminal is a disc of 1·9 cm diameter, bearing an engraved chi-rho, alpha and omega within a circle of punched dots. There is a handle attachment with engraved decoration.

Provenance: Water Newton, Huntingdonshire.
BM (P & RB) P.1975.10–2.9. Treasure Trove.

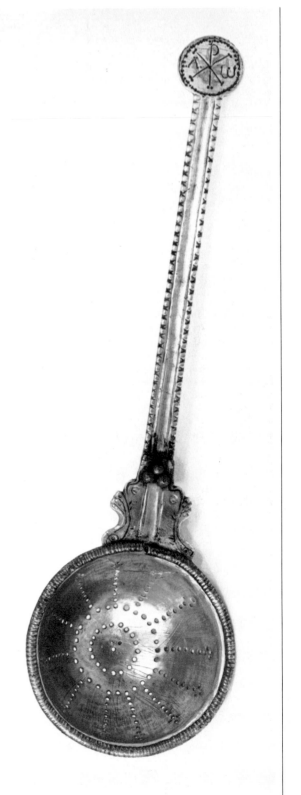

35

36 Silver plaque with chi-rho fourth century AD

L 13·1 cm. W c. 9 cm (top of triangle). D 4·8 cm (chi-rho medallion).

Plaque in the form of an inverted triangle with a central rib and lines in relief, like a leaf or feather. At the upper end is a medallion, demarcated by circle of small repoussé beads, containing a simple chi-rho and alpha and omega in relief. In the centre is a small hole, punched from the front. The chi-rho, is gilt. There are two broken fragments from the tip of the triangle. There is a possibility that the gold disc (37) fits on to the 'back' of this plaque.

Provenance: Water Newton, Huntingdonshire.

BM (P & RB) P.1975.10−2.10. Treasure Trove.

Colour plate.

37 Gold disc with chi-rho fourth century AD

D 4·9 cm. WT 4·5 g.

Disc of very thin sheet gold with a central hole of 2 mm diameter. The hole is punched from the side on which the decoration is concave; this is also the way in which the chi-rho reads correctly. The rho has a slight 'tail' and the omega is upside-down. There is a plain circle round the monogram, and a ring of punched dots at the edge.

Provenance: Water Newton, Huntingdonshire.

BM (P & RB) P.1975.10−2.11. Treasure Trove.

Colour plate.

38 Silver plaque with chi-rho and inscription fourth century AD

Remaining fragments: W 10 cm. H 8·7 cm. D 5·5 cm (medallion).

Very damaged silver plaque of inverted triangle form. Along the upper edge runs a two-line inscription in relief; the letters are uneven and some are mirror-reversed:

ANICILLAVOTVͯMQVO [D]

PROMISITCONPLEVIT

Below this is an attachment-hole (nearly 3 mm in diameter) pierced from the front, and a simple circle in relief containing a chi-rho. The rho has a distinct 'tail'; the omega is on the left and has the form M; the alpha is broken away.

Provenance: Water Newton, Huntingdonshire.

BM (P & RB) P.1975.10−2.12. Treasure Trove.

The inscription means, 'Anicilla has fulfilled the vow which she promised'.

39 Silver plaque with chi-rho fourth century AD

L 11·2 cm. W 10·5 cm. D 5·5 cm (chi-rho medallion).

Plaque of inverted triangle form, with leaf or feather pattern radiating to each corner. There is a pinhole in the centre of the chi-rho and another in the lower point. The chi-rho is surrounded by a double circle in relief. The rho is mirror-reversed and the omega (on the left) is shaped like an E on its side.

Provenance: Water Newton, Huntingdonshire.

BM (P & RB) P.1975.10−2.13. Treasure Trove.

40 Silver plaque with chi-rho fourth century AD

L 6·7 cm (existing). W 5·9 cm. D 3·8 cm (chi-rho medallion).

Small triangular plaque with leaf patterns in the corners only and no pinhole. A simple repoussé chi-rho is shown within a plain circle. The rho has a 'tail', the alpha is a plain Latin A.

The outlines have been sharpened by scratches on the right side.

Provenance: Water Newton, Huntingdonshire.

BM (P & RB) P.1975.10−2.14. Treasure Trove.

41 Fragment of silver plaque fourth century AD

L 7·4 cm. W c. 4·5 cm.

Narrow triangular plaque, presumably broken, with a central rib and lines in a leaf or feather pattern. A pinhole c. 3 mm in diameter has been pierced from the back.

Provenance: Water Newton, Huntingdonshire.

BM (P & RB) P.1975.10−2.15. Treasure Trove.

42 Silver plaque with chi-rho fourth century AD

L 6·8 cm. W 5·2 cm.. D 2·5 cm (chi-rho medallion).

Small triangular plaque with leaf patterns in relief at the corners. A small circle contains a simple chi-rho without alpha or omega; the rho has a slight 'tail'. In the centre of the chi-rho is a small pinhole pierced from the back.

Provenance: Water Newton, Huntingdonshire.

BM (P & RB) P.1975.10−2.16. Treasure Trove.

43 Silver plaque fourth century AD

L 7·8 cm. W c. 4 cm.

Small broken triangular plaque with leaf pattern in relief, and a pinhole in the central rib, pierced from the back.

Provenance: Water Newton, Huntingdonshire.

BM (P & RB) P.1975.10−2.17. Treasure Trove.

44 Silver and gilt plaque with chi-rho fourth century AD

L 15·7 cm. W 11·3 cm. D 7 cm (chi-rho medallion).

Triangular plaque with leaf or feather pattern in repoussé. A large gilt medallion contains a chi-rho in very bold relief, with alpha and omega. The rho has a 'tail'.

Provenance: Water Newton, Huntingdonshire.

BM (P & RB) P.1975.10−2.18. Treasure Trove.

Colour plate.

45 Silver plaque with chi-rho fourth century AD

L 4·9 cm. W 3·5 cm. D 2·5 cm (chi-rho medallion).

Small triangular plaque with leaf pattern. The chi-rho is simple, the rho lacking an added 'tail', and the alpha having a dot rather than a bar.

Provenance: Water Newton, Huntingdonshire.

BM (P & RB) P.1975.10−2.19. Treasure Trove.

46 Silver plaque fourth century AD

L 5·8 cm. W 3·8 cm.

Damaged triangular plaque with repoussé ribs in leaf or feather pattern and without pinholes.

Provenance: Water Newton, Huntingdonshire.

BM (P & RB) P.1975.10−2.20. Treasure Trove.

47 Silver plaque with chi-rho fourth century AD

L 6 cm. W c. 4·5 cm. D c. 2·8 cm (chi-rho medallion).

Triangular plaque, the point at the top, decorated with leaf pattern and a medallion containing a chi-rho of which the monogram is in intaglio and the alpha and omega in relief. The rho has a 'tail'. The sides close to the medallion have an inner border of small beads.

Provenance: Water Newton, Huntingdonshire.

BM (P & RB) P.1975.10−2.21. Treasure Trove.

48 Silver plaque with chi–rho fourth century AD
L 8 cm. W 6·4 cm. D 4·2 cm (chi-rho medallion).
Triangular plaque, the point at the top. The upper part has repoussé ribs in a leaf pattern. The chi-rho medallion is in relief, but lacks a bold outer circle; there is merely a line incised on the back. The rho has a 'tail'; the alpha is somewhat distorted. In the lower two corners of the plaque are two small fronds or leaves. The edges of the plaque have an inner beaded border in the lower area.
Provenance: Water Newton, Huntingdonshire.
BM (P & RB) P.1975.10–2.22. Treasure Trove.

49 Silver plaque fourth century AD
L 7 cm. W 6 cm.
Triangular plaque with ribbed pattern, based on lines extending into each corner.
Provenance: Water Newton, Huntingdonshire.
BM (P & RB) P.1975.10–2.23. Treasure Trove.

50 Silver plaque fourth century AD
L 3·8 cm. W 2·9 cm.
Fragment of a triangular plaque decorated with ribs in leaf or feather pattern.
Provenance: Water Newton, Huntingdonshire.
BM (P & RB) P.1975.10–2.24. Treasure Trove.

51 Silver plaque fourth century AD
L 8 cm. W 4·5 cm.
Triangular plaque with rather faint leaf pattern.
Provenance: Water Newton, Huntingdonshire.
BM (P & RB) P.1975.10–2.25. Treasure Trove.

52 Silver plaque fourth century AD
L 5·6 cm. W 2·4 cm.
Small triangular plaque with bold centre rib and branching lines. There is a small pinhole near the base of the triangle.
Provenance: Water Newton, Huntingdonshire.
BM (P & RB) P.1975.10–2.26. Treasure Trove.

53 Silver plaque fourth century AD
L 7 cm. W 4 cm.
Damaged triangular plaque with ribs in leaf or feather pattern.
Provenance: Water Newton, Huntingdonshire.
BM (P & RB) P.1975.10–2.27. Treasure Trove.

The Mildenhall Treasure
4th century AD (c. AD 360)

The Mildenhall Treasure is of major importance for the late Roman period. Found at an uncertain date in the 1940s at Mildenhall, Suffolk, it consists of over thirty items of silver tableware – platters, bowls, spoons and goblets – most of them richly decorated. The most impressive piece in the hoard is the Great Dish, almost two feet in diameter, weighing over eighteen pounds, and the most beautiful object to survive from Roman Britain. The style of the objects indicates a fourth-century date, and the 360s in particular are a very likely time for them to have been hidden, while Pictish and Scottish raiders were harassing the coasts and borders of the province of Britain.

The mixture of pagan and Christian motifs may seem surprising; but the hoard was not intended for any religious purpose, and even a Christian owner would not have had such splendid pagan pieces melted down merely on account of their ornament.

Though many families possessed silver plate, a set of this quality would have belonged to a person of outstanding wealth and status. An inscription on the back of one of the platters (no. 55) suggests that the Great Dish and matching platters may even have belonged to the Eutherius who was one of the highest officials of the Emperor Julian (AD 360–363). There is no evidence that Eutherius himself ever visited Britain; but we may speculate that perhaps he gave these pieces to Lupicinus, a Christian and a general in the pagan Julian's entourage. In AD 360 Julian sent Lupicinus from Gaul to Britain to deal with barbarian attacks. Lupicinus was presumably successful, and he returned to Gaul after a few months; but Julian's elevation to the throne led to the fall from favour and to the arrest of the Christian general. If Lupicinus were the owner of the Mildenhall silver, it is unlikely that he would ever have been able to return to collect it from its place of safekeeping.

Bibl. Brailsford, *MT*; Brailsford, *Ant. RB '66*, pp. 38–40; Dohrn, *Mitt. DAI 2* (1949), p. 67; Hull, *RE Cat.*; *FK 2*; Schoppa, *KR*; Toynbee, *ARB*, pp. 169–71, no. 106, and pls 113–19, 124; Toynbee, *AB*, pp. 308–12; Strong, *GSP*, especially p. 182 ff; Painter, *BMQ* 37 (1973), p. 154; K. S. Painter, *The Mildenhall Treasure*. London, 1977.
BM (P & RB) 1946.10–7.1–34. Treasure Trove.

54 Silver dish (the Great Dish) fourth century AD
D 60·5 cm. WT 8·256 kg.
Silver dish with relief decoration and some engraved detail. The central feature is a mask of Oceanus, with dolphins in his hair. Surrounding this is a circular frieze of Nereids and fantastic marine beasts. The outer frieze depicts a Bacchic revel, and includes Bacchus himself with a panther, a drunken Hercules supported by two satyrs, Silenus, Pan and dancing satyrs and maenads. There is an outer border of large beads.
Provenance: Mildenhall, Suffolk.
Bibl. Brailsford, *MT*, no. 1; Painter, *BMQ* 37 (1973), no. 1; and see general references.
BM (P & RB) 1946.10–7.1. Treasure Trove.
Colour plate.

55 Silver platter fourth century AD
D 18·8 cm. WT 539 g.
Small round platter with relief decoration consisting of Pan, holding a pedum and playing the syrinx, and a maenad playing the double flute. In the field are a reclining water nymph and a fawn or roe deer with a snake. Some details are engraved, and the rim is bordered with large beads. On the back is the graffito ευθηριον (of Eutherios). This platter and the matching Bacchic platter (no. 56) are decorated in the same style as the Great Dish (no. 54).
Provenance: Mildenhall, Suffolk.
Bibl. Brailsford, *MT*, no. 2; Painter, *BMQ* 37 (1973), no. 2; and see general references.
BM (P & RB) 1946.10–7.2. Treasure Trove.
Colour plate.

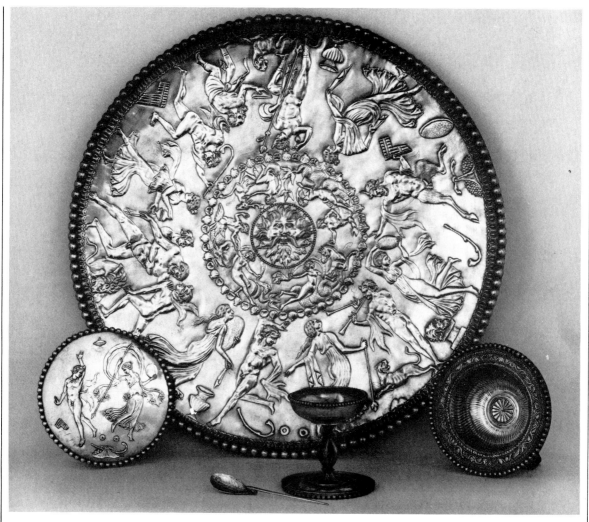

56 Silver platter fourth century AD

D 18·5 cm. WT 613 g.

Small round silver platter with relief decoration: a dancing satyr and a dancing maenad, the latter with thyrsus and tambourine. There are other Bacchic motifs in the field – a syrinx and a skin full of fruit, with a pedum. There is fine engraved detail on the maenad's garment, as well as engraved ornament in the field. On the back is the name ενθηριου (of Eutherios) as a graffito, as on the matching platter (no. 55).

Provenance: Mildenhall, Suffolk.

Bibl. Brailsford, *MT*, no. 3; Painter, *BMQ* 37 (1973), no. 3; and see general references.

BM (P & RB) 1946.10–7.3. Treasure Trove.

Colour plate.

57 Silver and niello dish fourth century AD

D 55·6 cm. WT 5·023 kg.

Large circular silver dish with a flat rim edged with a beaded border. The rim and a circular area in the centre of the dish are decorated with an incised pattern filled with niello. The design is basically geometric, but includes rosette motifs.

Provenance: Mildenhall, Suffolk.

Bibl. Brailsford, *MT*, no. 4; Painter, *BMQ* 37 (1973), no. 10; and see general references.

BM (P & RB) 1946.10–7.4. Treasure Trove.

58 Silver bowl (with lid) fourth century AD

H 19·1 cm (with lid). D 23 cm. WT 1·013 kg.

Flanged silver bowl with a deep lid (no. 59). The flange is ornamented with an incised foliate scroll design, originally inlaid with niello. Around the edge is a bead-and-reel border. There is an incised design of eight radiating leaves within the centre of the bowl. It seems unlikely that the vessel was originally intended to be covered.

Provenance: Mildenhall, Suffolk.

Bibl. Brailsford, *MT*, no. 5; Painter, *BMQ* 37 (1973), no. 4; and see general references.

BM (P & RB) 1946.10–7.11. Treasure Trove.

Colour plate.

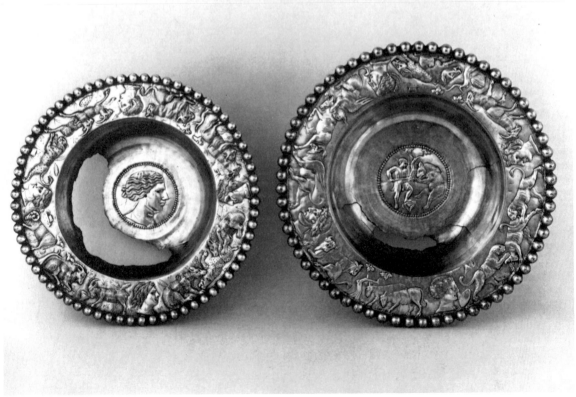

59 Silver lid or cover fourth century AD

D 19·5 cm. WT 840 g.

Domed silver lid, fitting somewhat imprecisely over the
bowl (no. 58). There is a lower zone of relief ornament with
engraved details, in the form of centaurs and wild beasts
(bears, lions, etc.), divided into groups by profile masks. This
frieze is surmounted by an ovolo. The upper part of the cover
bears a stylized leaf pattern, executed in broad, shallow
grooves. The original knob or handle appears to have been
replaced by a small silver-gilt statuette (most of the gilding is
lost) of a youthful seated triton blowing a conch shell.

Provenance: Mildenhall, Suffolk.

Bibl. Brailsford, *MT*, no. 6; Painter, *BMQ* 37 (1973), no. 5;
and see general references.

BM (P & RB) 1946.10–7.12. Treasure Trove.

Colour plate.

60 Silver bowl fourth century AD

H 9·6 cm. D 30 cm. WT 1·718 kg.

Silver bowl with a broad, flat rim or flange, edged with large
beads. The rim bears relief decoration of animals (bulls,
boars, leopards, goats, sheep and griffins) and trees, divided
into four groups by large profile heads. There is a centre
medallion in relief, showing a hunter spearing a bear. On the
underside of the rim are two inscriptions; one is incised and
seems to be a proverb, the other, dotted, is a weight.

Provenance: Mildenhall, Suffolk.

Bibl. Brailsford, *MT*, no. 7; Painter, *BMQ* 37 (1973), no. 6;
and see general references.

BM (P & RB) 1946.10–7.5. Treasure Trove.

61 Silver bowl fourth century AD

H 8·6 cm. D 26·8 cm. WT 1·271 kg.

Silver bowl with a broad, flat rim or flange, edged with large
beads. The rim bears relief decoration of wild animals and
human heads. The central medallion bears a female head in
relief. On the underside of the rim is a dotted inscription,
probably giving a weight.

Provenance: Mildenhall, Suffolk.

Bibl. Brailsford, *MT*, no. 8; Painter, *BMQ* 37 (1973), no. 7;
and see general references.

BM (P & RB) 1946.10–7.6. Treasure Trove.

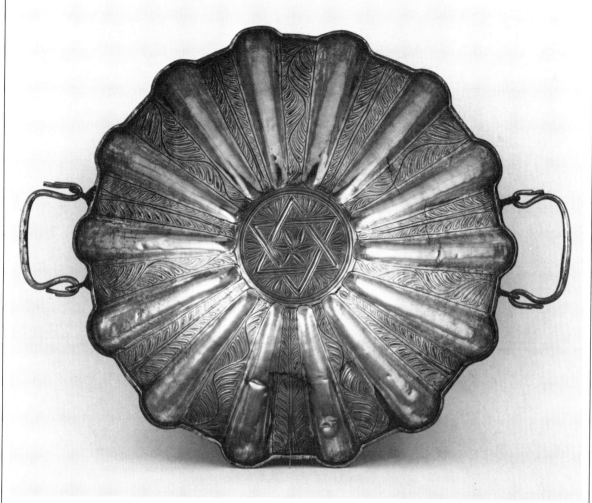

66–67△ ▽70–71

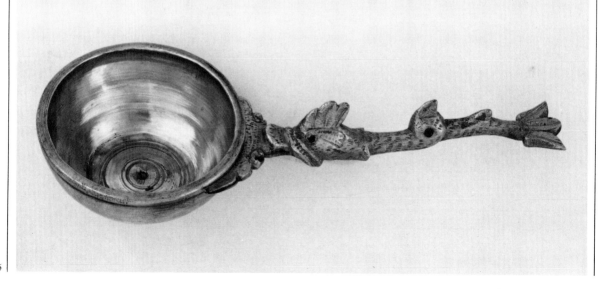

62 Silver bowl fourth century AD

H 8·6 cm. D 26·8 cm. WT 1·320 kg.

Silver bowl with a broad, flat rim or flange, edged with large beads. The animal frieze on the rim consists of bears, deer, horses, leopards, bull and boars, interspersed with human heads. The central medallion is of a draped female head, probably representing Olympias, mother of Alexander the Great.

Provenance: Mildenhall, Suffolk.

Bibl. Brailsford, *MT*, no. 9; Painter, *BMQ* 37 (1973), no. 8; and see general references.

BM (P & RB) 1946.10–7.8. Treasure Trove.

63 Silver bowl fourth century AD

H 8·6 cm. D 26·8 cm. WT 1·301 kg.

Silver bowl with a broad, flat rim or flange, edged with large beads. The animal frieze on the rim includes goats, sheep and bears attacking deer. The central medallion is decorated with a helmeted male head, perhaps Alexander the Great.

Provenance: Mildenhall, Suffolk.

Bibl. Brailsford, *MT*, no. 10; Painter, *BMQ* 37 (1973), no. 9; and see general references.

BM (P & RB) 1946.10–7.7. Treasure Trove.

64 Silver bowl fourth century AD

H 5·8 cm. D 16·8 cm. WT 615 g.

Silver bowl with flat rim or flange, edged with beads. The rim has elaborate relief decoration of a vine-scroll containing leaves, flowers, grapes, birds and rabbits. The interior of the bowl is decorated with shallow, curved flutings, and there is a central rosette motif with sixteen petals, surrounded by a double beaded circle. On the base of the bowl is a scratched inscription, apparently giving the weight.

Provenance: Mildenhall, Suffolk.

Bibl. Brailsford, *MT*, no. 11; Painter, *BMQ* 37 (1973), no. 11; and see general references.

BM (P & RB) 1946.10–7.9. Treasure Trove.

65 Silver bowl fourth century AD

H 5·8 cm. D 16·8 cm. WT 627 g.

Silver bowl with flat rim or flange, edged with beads. The rim is decorated with a vine-scroll in relief, containing some motifs additional to those on the matching vessel (no. 64). The fluted bowl and central rosette are closely similar to those of no. 64. A lightly scratched graffito on the base probably gives the weight.

Provenance: Mildenhall, Suffolk.

Bibl. Brailsford, *MT*, no. 12; Painter, *BMQ* 37 (1973), no. 12; and see general references.

BM (P & RB) 1946.10–7.10. Treasure Trove.

66/67 Fluted silver bowl with handles fourth century AD

H 11·1 cm. D 40·8 cm. WT 1·575 kg.

Fluted bowl (no. 66) with swing handles (no. 67). The radial panels are alternately flat and concave, the flat areas being engraved with foliate designs, alternately on straight and undulating stems. The circular centre panel has a star formed of two interlocking triangles; the spaces are filled with leaf designs and, centrally, a rosette. The two handles have pear- or leaf-shaped attachments, while the loops have swan's-head terminals. They were attached by soldering, not riveting.

Provenance: Mildenhall, Suffolk.

Bibl. Brailsford, *MT*, nos 13 (bowl) and 14–15 (handles); Painter, *BMQ* 37 (1973), no. 13 (bowl and handles); and see general references.

BM (P & RB) 1946.10–7.15 (bowl), 1946.10–7.16–17 (handles). Treasure Trove.

68 Silver goblet fourth century AD

H 11·7 cm. D 9·7 cm (bowl), 11·5 cm (base). WT 391 g.

Silver goblet of shallow bowl form with a beaded rim. The stem has baluster mouldings, with four decorated square-sectioned rods enclosing it. The top and bottom of the stem have foliate terminals. The wide, flat base has a beaded rim and is engraved with foliate patterns on the underside, so that when it is reversed, the goblet is equally well or better adapted for use as a small pedestalled platter. The base and bowl are riveted to the stem.

Provenance: Mildenhall, Suffolk.

Bibl. Brailsford, *MT*, no. 16; Painter, *BMQ* 37 (1973), no. 14; and see general references.

BM (P & RB) 1946.10–7.13. Treasure Trove.

69 Silver goblet fourth century AD

H 11·7 cm. D 9·7 cm (bowl), 11·5 cm (base). WT 383 g.

Silver goblet of shallow bowl form with a beaded rim. The form and decoration are exactly similar to those of no. 68.

Provenance: Mildenhall, Suffolk.

Bibl. Brailsford, *MT*, no. 17; Painter, *BMQ* 37 (1973), no. 15; and see general references.

BM (P & RB) 1946.10–7.14. Treasure Trove.

70 Silver bowls of five ladles fourth century AD

D each 5·7 cm. WT each from 35 g to 46 g.

Silver ladle-bowls, originally soldered to cast dolphin-shaped handles (no. 71). The bowls are hemispherical in form, with flattened bases and thickened rims, like miniature paterae. There are concentric grooves in the bases.

Provenance: Mildenhall, Suffolk.

Bibl. Brailsford, *MT*, nos 18–22; Painter, *BMQ* 37 (1973), nos 16–20; and see general references.

BM (P & RB) 1946.10–7.18–22. Treasure Trove.

71 Four silver-gilt ladle-handles fourth century AD

L each 9·5 cm (when complete). WT each 36 g.

Silver-gilt handles belonging to the silver ladle-bowls (no. 70). One is damaged. The dolphin shape, and the crescentic attachment for fitting the handle to the rim of the bowl, are cast. There are incised and dotted details on the bodies of the animals, and the eyes were originally inlaid with a substance which is now lost.

Provenance: Mildenhall, Suffolk.

Bibl. Brailsford, *MT*, nos 23–6; Painter, *BMQ* 37 (1973), nos 21–4; and see general references.

BM (P & RB) 1946.10–7.23–26. Treasure Trove.

72 Silver spoon fourth century AD

L 18·6 cm. WT 25 g.

Silver spoon with oval bowl. Within the bowl is the inscription: PAPITTEDO VIVAS (Pappitedo, may you live long). The handle is joined to the bowl by an openwork scroll motif; the end nearest the bowl is twisted, while the other

end is plain and tapering.

Provenance: Mildenhall, Suffolk.

Bibl. Brailsford, *MT*, no. 27; Painter, *BMQ* 37 (1973), no. 25; and see general references.

BM (P & RB) 1946.10–7.28. Treasure Trove.

73 Silver spoon fourth century AD

L 18·8 cm. WT 25 g.

Silver spoon with pear-shaped bowl, inscribed: PASCENTIA VIVAS (Pascentia, may you live long). The handle is plain and tapering; it is of square section with bevelled edges, and is attached to the bowl by an openwork scroll.

Provenance: Mildenhall, Suffolk.

Bibl. Brailsford, *MT*, no. 28; Painter, *BMQ* 37 (1973), no. 26; and see general references.

BM (P & RB) 1946.10–7.27. Treasure Trove.

74 Silver spoon fourth century AD

L 20·1 cm. WT 27 g.

Silver spoon with pear-shaped bowl, plain tapering handle and openwork scroll attachment. In the bowl is inscribed the chi-rho monogram between alpha and omega.

Provenance: Mildenhall, Suffolk.

Bibl. Brailsford, *MT*, no. 30; Painter, *BMQ* 37 (1973), no. 28; and see general references.

BM (P & RB) 1946.10–7.29. Treasure Trove.

75 Silver spoon fourth century AD

L 20·6 cm. WT 35 g.

Silver spoon of exactly similar form and decoration as no. 74.

Provenance: Mildenhall, Suffolk.

Bibl. Brailsford, *MT*, no. 31; Painter, *BMQ* 37 (1973), no. 29; and see general references.

BM (P & RB) 1946.10–7.30. Treasure Trove.

76 Silver spoon fourth century AD

L 20·4 cm. WT 25 g.

Silver spoon of exactly similar form and decoration as no. 74.

Provenance: Mildenhall, Suffolk.

Bibl. Brailsford, *MT*, no. 29; Painter, *BMQ* 37 (1973), no. 27; and see general references.

BM (P & RB) 1946.10–7.31. Treasure Trove.

77 Silver spoon fourth century AD

L 16·7 cm. WT 20 g.

Silver spoon with pear-shaped bowl and tapering handle. The form is precisely like that of no. 78, but the foliate ornament on each side of the central lines in the bowl is based on an undulating stem. This parallels the second foliate pattern on the large fluted bowl (no. 66).

Provenance: Mildenhall, Suffolk.

Bibl. Brailsford, *MT*, no. 34; Painter, *BMQ* 37 (1973), no. 32; and see general references.

BM (P & RB) 1946.10–7.32. Treasure Trove.

78 Silver spoon fourth century AD

L 16·3 cm. WT 17 g.

Silver spoon with pear-shaped bowl and plain tapering handle of bevelled-square section, attached by an openwork scroll. The interior of the bowl is decorated with two straight grooves down the centre and a leaf pattern curving in from each side. The decoration is very similar to the foliate ornament on the fluted bowl (no. 66).

Provenance: Mildenhall, Suffolk.

Bibl. Brailsford, *MT*, no. 33; Painter, *BMQ* 37 (1973), no. 31; and see general references.

BM (P & RB) 1946.10–7.33. Treasure Trove.

79 Silver spoon fourth century AD

L 17·2 cm. WT 18 g.

Silver spoon of exactly similar form and decoration as no. 78.

Provenance: Mildenhall, Suffolk.

Bibl. Brailsford, *MT*, no. 32; Painter, *BMQ* 37 (1973), no. 30; and see general references.

BM (P & RB) 1946.10–7.34. Treasure Trove.

◁ 72–79 (clockwise)

The Kaiseraugst Treasure

The Treasure was found in December 1961 and January 1962, after a bulldozer had disturbed the ancient ground surface and scattered the hoard of silver and gold plate and coins. These had evidently been buried in a chest within the walls of the late Roman fortress at Kaiseraugst, near Basle, in AD 350/51. The fortress is part of the Roman military defensive system along the Rhine-Danube frontier.

The area was disturbed several times by civil wars in the middle of the fourth century. After the death of Constantine, the rule of the Empire was eventually divided between his three surviving sons, Constantine II, Constantius II and Constans. Struggles for power with each other and with the usurper Magnentius left the Roman Empire united again under one emperor, Constantius II, by 353. Yet another war, however, subsequently broke out, between Constantius and Julian the Apostate. Any of these crises could have led to alarm at Kaiseraugst in 340, or more particularly between 350 and 353 and in 361.

The whole Treasure consists of 257 items, comprising a luxurious table service and 187 silver coins and medallions. It is so rich that it was first supposed to have belonged to the Emperor Julian himself. The manufacture of two of the plates in the Eastern Empire, at Thessalonica and Naissus, and also the use of pagan and Homeric themes in the decoration, were invoked as supporting arguments in this attribution. The quantity of precious metal, however, does not restrict ownership necessarily to members of the royal house, and the freshness of the stamps and of the coins makes burial in 350/51 much more likely than in 361. The Kaiseraugst Treasure remains, nevertheless, the largest late Roman hoard yet discovered, undoubtedly the possession of one of the leading figures of the period.

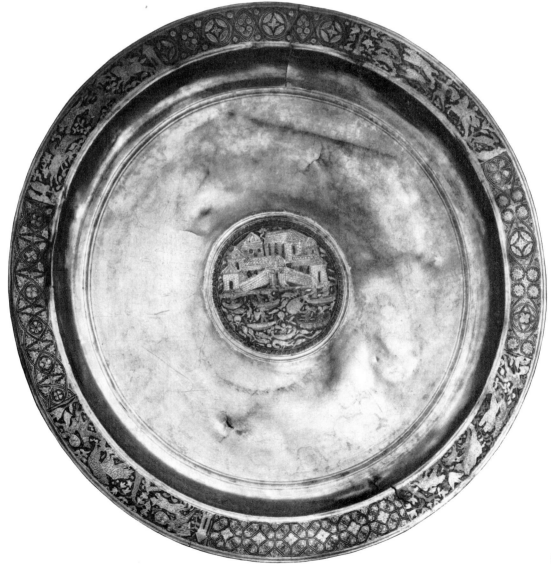

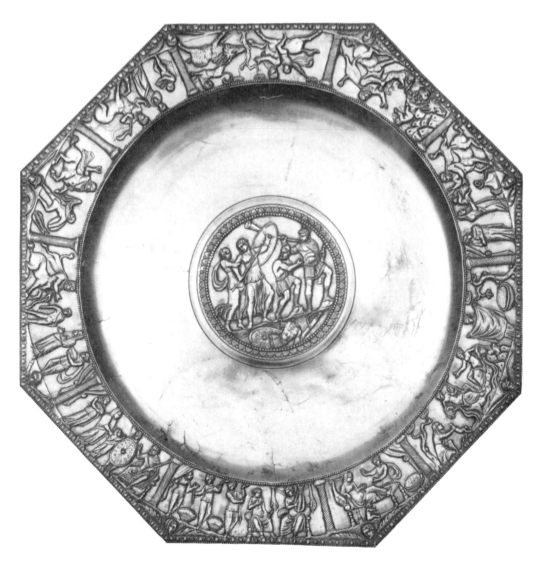

80 Achilles Dish deposited in AD 350/51
D 53 cm (dish). WT 4645 g.
Silver eight-sided platter. On the rim are scenes from the life of Achilles. The central roundel shows the dramatic moment when Odysseus and Diomedes discover Achilles hiding among the daughters of Lykomedes. The base has a footring and two inscriptions: (a) 'Made by Pausylypos in Thessalonica, 15 pounds'; (b) '17 pounds, 4 ounces, 15 grains'. Technically the differing inscriptions of weight on the base demonstrate that the decoration in relief was not cast, but cut out of the solid metal. The scenes are from a widespread cycle of illustrations of the story of Achilles.
Provenance: Late Roman fort, Kaiseraugst, Switzerland.
Bibl. Laur-Belart, *SSK*, pp. 8–13.
Römermuseum, Augst, Switzerland. Inventory no. 62.1.

81 Silver dish deposited in AD 350/51
D 58 cm (dish), 16·3 cm (central medallion). WT 4775 g.
Silver dish with central medallion containing a scene of a coastal city reserved against niello and partly gilded. The sea is filled with a crowd of sea creatures and Cupids fishing from decorated boats. On the back are inscribed the graffiti 'Aquilini' and '*TON*'. The decorated rim is divided into eight sections, in which geometric patterns alternate with hunting scenes.
Provenance: Late Roman fort, Kaiseraugst, Switzerland.
Bibl. Laur-Belart, *SSK*, pp. 14–17.
Römermuseum, Augst, Switzerland. Inventory no. 62.2.
Colour plate.

The best-known example of the use of niello and gilding for figured scenes is the dish found near Cesena (Bolognese) and now in the Bibliotheca Malatestiana there. The Cesena dish seems to have survived above ground for a long time until it was buried at the time of the Gothic War between AD 538 and 553. Elaborate use of gilt and niello is characteristic of the period both for floral geometric ornament and for figured scenes. We may compare the fine niello dish from the Mildenhall Treasure (no. 57). A somewhat later example of the same style and technique is the Anastasius Dish found in the Sutton Hoo burial (no. 236).

82 Silver spoon deposited in AD 350/51

L 10 cm.

Silver spoon with large bowl and swan's head handle, the neck being curved back on itself, sideways along the rim. This type is rare, but the Kaiseraugst Treasure has fourteen examples. The other main fourth-century type has a smaller bowl, a long handle, and decoration at the junction between bowl and handle. The spoons with large bowls found at Canterbury in 1962 have handles turned back in an S-bend but not sideways along the rim like the Kaiseraugst spoon, although examples of the latter type are known from Hof Iben, Vermand, Canoscio, Traprain Law (no. 198) and northern Syria. The bird's head spoons from Spontin at Namur, on the other hand, although now damaged, may have had handles turned back in an S-bend.

Provenance: Late Roman fort, Kaiseraugst, Switzerland.

Bibl. Laur-Belart, *SSK*, pp. 31–2. Canterbury: Painter, *JBAA* 28 (1965), pp. 7–8; Vermand: Eck, *Vermand*, pp. 207–8 and pl. XX, no. 35; Canoscio: Giovagnoli, *Riv. Arch. Cr.* 12 (1935), pp. 313–28; Traprain Law: Curle, *TT*, pp. 67–8, nos 102–3; northern Syria: Dodd, *BST*, p. 32; Spontin: Dasney, *Ann. Namur* 53 (1966); Böhme, *Jahrb. Mainz* 17 (1970), p. 194.

Römermuseum, Augst, Switzerland. Inventory no. 62.10.

83 Utensil with Christogram deposited in AD 350/51

L 20·7 cm.

Silver eating utensil with twisted stem. At one end is a miniature spoon; at the other is a pointed spatula pierced with a chi-rho. Close analogies to the Kaiseraugst implements are to be found in the Canterbury and St Ninian's Isle Treasures; single finds are known from Richborough, Dorchester (Dorset), Ireland and the Crimea. It has been suggested that the prong and disc might have been suitable for dividing the Host into tiny particles and picking them up from the altar at Mass. A liturgical use is, however, unproven, and such implements have most recently been explained as toothpicks.

Provenance: Late Roman fort, Kaiseraugst, Switzerland.

Bibl. Laur-Belart, *SSK*, p. 30. Canterbury and other find-places: Painter, *JBAA* 28 (1965), pp. 8–9; Wilson, *St. Nin.*, pp. 57–8 and 115–18; Martin, *Germania* 54 (1976).

Römermuseum, Augst, Switzerland. Inventory no. 62.21.

84 Silver spoon deposited in AD 350/51

L 19 cm.

Silver spoon with elongated pear-shaped bowl joined to the handle at its pointed end by means of a pierced scroll

attachment. This spoon is of the type characteristic of late hoards. The handle is generally square in section, tapering to a point. The bowl is sometimes canted at an angle to the handle. This basic shape appeared in the second century but the later spoons are larger and more elaborate in the detail of the attachment. Twenty-two spoons of this kind were found at Kaiseraugst.
Provenance: Late Roman fort, Kaiseraugst, Switzerland.
Bibl. Laur-Belart, *SSK*, pp. 31–2; Strong, *GSP*, pp. 204–5.
Römermuseum, Augst, Switzerland. Inventory no. 62.47.

85 Fish dish deposited in AD 350/51
L 26 cm. WT 463 g.
Rectangular silver dish, with a semicircular projection at each end, decorated with a device of three leaves at each corner. In the centre is engraved a fish with a worm in its mouth. The central decoration and the unusual projection at each end may mean that the dish was designed expressly for the serving of fish.
Provenance: Late Roman fort, Kaiseraugst, Switzerland.
Bibl. Laur-Belart, *SSK*, p. 28.
Römermuseum, Augst, Switzerland. Inventory no. 62.25.

86 Silver statuette deposited in AD 350/51
H 12·6 cm (figure), 1·3 cm (base).
Statuette of Venus on a solid base. She has gilded hair, a braid of which is held in her left hand, while her raised right hand holds a mirror. Roman figurines of Venus represent, in the main, two familiar Graeco-Roman types. One is that of Venus Anadyomene, braiding her hair as she rises from the sea, as here. The second is that of Venus Pudica, with one arm covering her body. The type of Venus Anadyomene is derived from the Cnidian Aphrodite of the mid-fourth century BC. Miniature copies in bronze had a wide distribution in the Roman period and were made both in Italy and in the provinces. This example is unusual in being of silver. It may have been made in Italy as early as the first or second century AD; but it is probably contemporary with the rest of the Kaiseraugst Treasure.
Provenance: Late Roman fort, Kaiseraugst, Switzerland.
Bibl. Laur-Belart, *SSK*, p. 33.
Römermuseum, Augst, Switzerland. Inventory no. 62.59.

87 Silver ingot deposited AD 350/51
L 13·4 cm. W 8·6 cm. WT 951 g.
Silver ingot with the portrait stamp of the Emperor Magnentius for AD 350. The ingot is also stamped with the name GRONOPI, and with the pointillé inscription of weight, P III (3 pounds). Three ingots were found in the hoard, this and one other being complete. The second complete ingot weighs 947 g, giving a standard of about 316 g per Roman pound. More than forty silver ingots are now known from the Roman provinces in Europe. It seems likely that all such ingots were distributed as imperial donatives to troops in the fourth century. They are related to presentation silver plate and other gifts of this type.
Provenance: Late Roman fort, Kaiseraugst, Switzerland.
Bibl. Laur-Belart, *SSK*, p. 34; Painter, *Ant. J.* 52.
Römermuseum, Augst, Switzerland. Inventory no. 62.244.

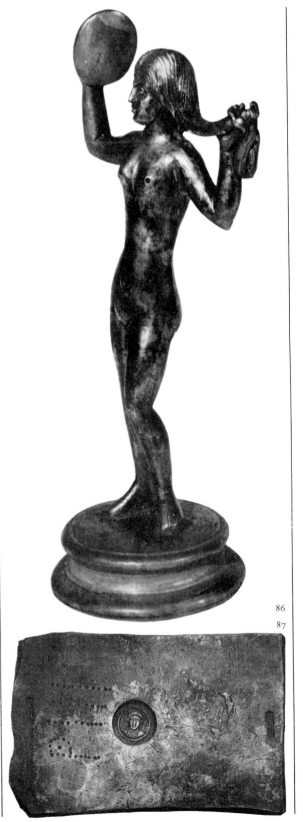

86

87

The Esquiline Treasure

This silver treasure was found on the Esquiline Hill in Rome in 1793, 'presso il Monistero delle Religiose Minime . . . presso le radici del colle oltre la Subura . . .'. The greatest part is in the British Museum; but one saucepan (no. 94) belongs to the Musée du Petit Palais in Paris, and a pouring vessel in the shape of a female head has found its way to the Museo Nazionale in Naples. Formerly in the collections of the Baron von Schellersheim and the Duc de Blacas, who had been French Ambassador at Rome and at Naples and died in 1839, the Treasure was purchased from the then Duke in Paris in 1866.

The treasure may be dated to the second half of the fourth century by the bridal casket with the portrait of Projecta and her husband Secundus, for Projecta's epitaph was written by Pope Damasus himself (AD 366–384). The fact that Pope Damasus wrote Projecta's epitaph, which at one time was in the church of S. Martino ai Monti, near the place where the treasure was found, indicates that she was a member of a distinguished family. So, too, was her husband, probably L. Turcius Secundus, a member of the leading family of the Turcii.

The other objects in the treasure must be of about the same date as the casket. The reason for the deposit of the treasure is not known; but it is not likely to be later in date than the Sack of Rome by the Visigothic king, Alaric, in AD 410. The special importance of the Esquiline Treasure lies in the fact that the objects are among the few attributable to the workshops of the city of Rome in the fourth century.
Bibl. E. Q. Visconti, *Lettera su di una Antica Argenteria nuovamente scoperta in Roma.* Rome, 1793. O. M. Dalton, *Catalogue of the Early Christian Antiquities in the British Museum.* London, 1901, pp. 61–77. M. T. Tozzi, 'Il Tesoro di Proiecta', in *Rivista di Archaeologia Cristiana* ix (1932), pp. 279–314. S. Poglayen-Neuwall, in *Römische Mitteilungen* (1930), p. 124. C. Nordenfalk, *Die Spätantiken Zierbuchstaben.* Stockholm, 1970, p. 83.

88 The Casket of Projecta late Roman, late fourth century AD
L 54·9 cm. W 43·1 cm. H 27·9 cm.
Oblong silver casket, embossed and partly gilt, with lid of truncated form and body of corresponding shape. On the lid, within a wreath, are the half-length, full face figures of a man and a woman, identified by an inscription on the edge of the lid which reads in full: SECUNDE ET PROIECTA VIVATIS IN CHRISTO (Secundus and Projecta, may you live in Christ). On the back of the lid is a scene which has been interpreted as the leading of the bride to her wedding, *deductio sponsae*, suggesting that the casket was a marriage gift. The rest of the lid is decorated with mythological scenes.

The panels of the casket body are decorated in low relief in the same manner as the lid; they show, however, a single series of scenes, interpreted as a representation of the bathing and dressing rituals which took place on the eve of a traditional Roman wedding.
Provenance: Esquiline Hill, Rome.
Bibl. Dalton, *EC Cat.*, no. 304; Poglayen-Neuwall, *Röm. Mitt.* 45 (1930), pp. 124–37; Tozzi, *Riv. Arch. Cr.* 9 (1932), pp. 279–313; Strong, *GSP*, pp. 185 and 207; Buschhausen, *Sp. Met.*, pp. 210–14 (with very full bibliography).
BM (M & LA) 66.12–29.1. Collection of the Duc de Blacas (1866).

One of the most important examples of late Roman silver, the Casket of Projecta is renowned not only on account of its magnificence but also because of its fusion of pagan and Christian elements.

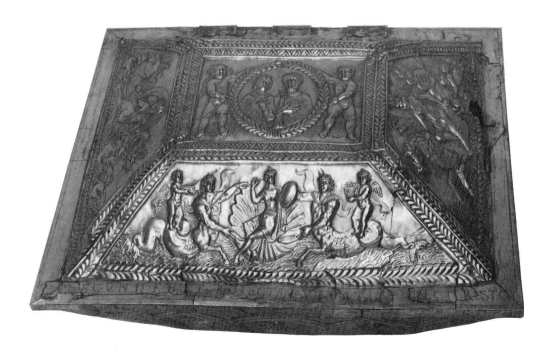

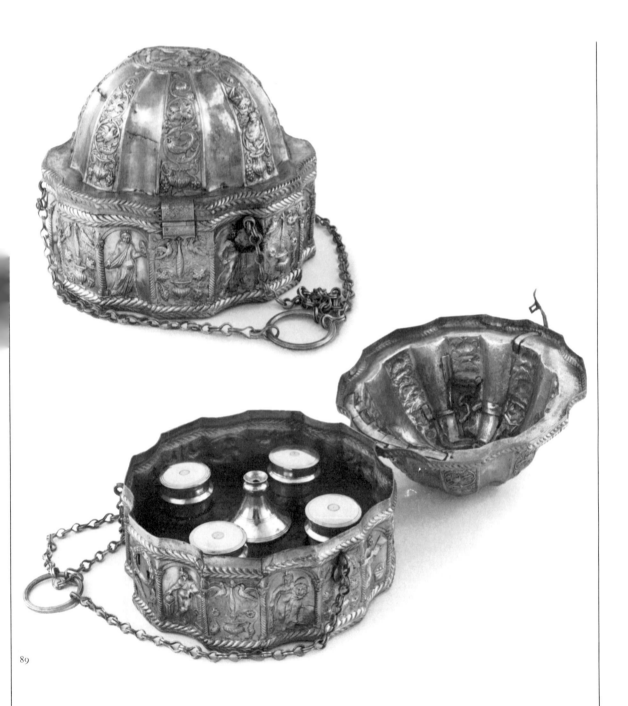

89

89 Domed silver toilet casket late fourth century AD
H 25·4 cm. D 33 cm.
Casket with hinged, dome-shaped cover, the whole
suspended by three chains uniting in a large ring. The sides of
the dome are shaped alternately as broad flutes and flat panels.
In the flutes on the sides of the base, which is similarly
fashioned, stand figures of the Muses. Within the casket is a
set of five cylindrical silver bottles with lids, apparently
intended for oils and perfumes.
Provenance: Esquiline Hill, Rome.

Bibl. Dalton, *EC Cat.*, no. 305; Poglayen-Neuwall, *Röm.
Mitt.* 45 (1930), pp. 124–36, pl. 34; Strong, *GSP*, p. 207, pl.
68; Buschhausen, *Sp. Met.*, pp. 213–17 (with very full
bibliography).
BM (M & LA) 66.12–29.2. Collection of the Duc de Blacas.

This casket is shown being carried by one of the female
servants on the back panel of the body of the Casket of
Projecta; it was, therefore, likewise associated with her
marriage to Secundus, perhaps as a gift.

90 Embossed silver flask late fourth century AD

H 34·3 cm.

Silver flask with embossed ornament consisting of six zones of spiral scrolls diminishing in size towards top and bottom. In the four largest zones are figures of genii engaged in various tasks; in the others, as well as in the interstices, are representations of animals. The flask is a well preserved example of the table silver in the late Roman Empire.

Provenance: Esquiline Hill, Rome.

Bibl. Dalton, *EC Cat.,* no. 306; Poglayen-Neuwall, *Röm. Mitt.* 45 (1930), pp. 124–36, pl. 36; Strong, *GSP,* p. 191, pl. 55.b.

BM (M & LA) 66.12–29.4. Collection of the Duc de Blacas.

91 Rectangular silver dish late fourth century AD

L 17·8 cm.

Shallow dish with footring. The border is pierced with double bow spiral openings; at each corner is a projecting leaf. In the centre is a monogram within a laurel wreath in gold with a nielloed outline. The monogram is to be deciphered as 'Projecta Turci', and indicates that the dish belonged to the Projecta mentioned in the inscription on the large Casket of Projecta (no. 88).

Provenance: Esquiline Hill, Rome.

Bibl. Dalton, *EC Cat.,* no. 312; Strong, *GSP,* p. 194.

BM (M & LA) 66.12–29.15. Collection of the Duc de Blacas.

92 Circular silver dish late fourth century AD

D 16 cm.

Flat dish with footring. In the centre is the same monogram as in no. 91, indicating that the dish belonged to the Projecta mentioned on the Casket of Projecta (no. 88). On the underside, near the rim, is a scratched inscription indicating that this dish and the three of the same type in the Esquiline Treasure collectively weighed five Roman pounds.

Provenance: Esquiline Hill, Rome.

Bibl. Dalton, *EC Cat.,* no. 316; Strong, *GSP,* pp. 20 and 194.

BM (M & LA) 66.12–29.11. Collection of the Duc de Blacas.

93 Circular silver dish late fourth century AD

D 24·3 cm.

Circular dish with footring. This is a minor, but nonetheless superbly made example of the silver plate in the Esquiline Treasure.

Provenance: Esquiline Hill, Rome.

Bibl. Dalton, *EC Cat.,* no. 320.

BM (M & LA) 66.12–29.9. Collection of the Duc de Blacas.

94 Silver saucepan fourth century AD

L 37 cm.

The vessel is a shallow bowl with a narrow horizontal rim and a small handle. The rim is decorated with a series of little scallop-shells in relief, and the inside of the bowl is treated as a large scallop-shell with a fine relief depicting Venus attended by two *putti,* one holding a lotus flower and the other a mirror. The handle is also decorated with a relief showing the standing figure of Adonis with a dog at his feet.

Provenance: Esquiline Hill, Rome.

Bibl. E. Q. Visconti, *Lettera intorno ad una antica supelletile d'argento scoperta in Roma nell'anno 1793* (2nd ed., Rome, 1827), p. 21, pl. XXIII; Gusman, *ADR,* pl. 26; Volbach,

92
91

47

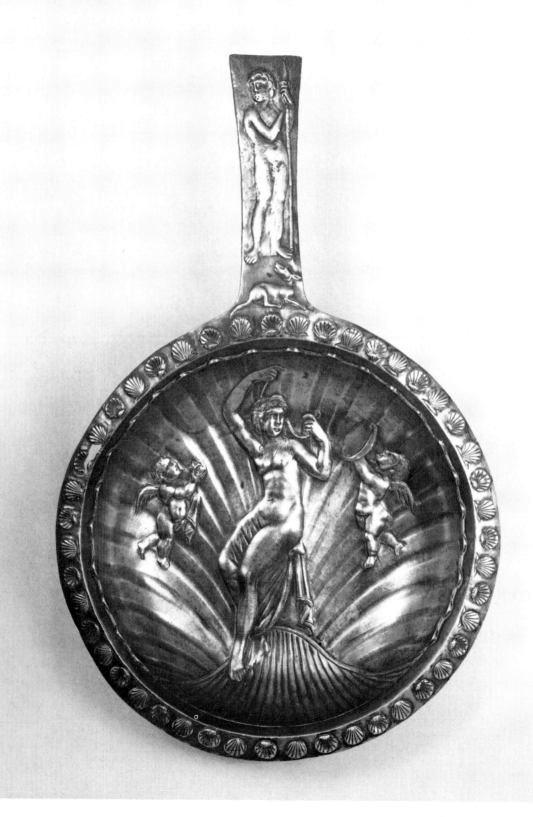

ECA, p. 333, no. 118; Strong, *GSP*, pp. 192–3.
Paris, Musée du Petit Palais, Collection Dutuit.

This piece was found with others in the excavations after the initial discovery of the treasure: 'Gli scavi, che si vanno a bella posta continuando nel luogo della scoperta, han fornito pur ora de' nuovi pezzi di nobil suppellettile, che avendo io osservati quasi appena usciti alla luce, le anderò quì enumerando . . .' (Visconti, *op. cit.*, p. 20). Saucepans with a single figure decorating the handle were in use from the third century on. Late examples are one from Perm in the Hermitage Museum, decorated on the rim and inside with Nilotic scenes, and with a figure of Neptune on the handle, and one from Cherchel in Algeria, now in the Louvre, which is dated by its stamps to the first half of the sixth century.

95 Circular silver bowl late fourth century AD

D 12 cm.
Circular silver bowl on a low footring, the outside vertically fluted. This too is a minor but excellent piece from the Esquiline Treasure.
Provenance: Esquiline Hill, Rome.
Bibl. Dalton, *EC Cat.*, no. 321; Strong, *GSP*, p. 201.
BM (M & LA) 66.12–29.8. Collection of the Duc de Blacas.

96 Inscribed silver knife handle fourth century AD

L 6·8 cm.
Silver knife handle, octagonal in section, the surface covered with engraving. On one side are engraved the letters *MH ΛΥΠI* and on the other *CEAYTON [= Μή λύπει σεαυτόν]*
Provenance: Esquiline Hill, Rome.
Bibl. Dalton, *EC Cat.*, no. 331.
BM (M & LA) 66.12–29.50. Collection of the Duc de Blacas.

A rare object, indicative of the extent of Greek influence on the patrician classes of the Roman Empire.

97 Silver-gilt statuette fourth century AD

H 5·4 cm.
Silver-gilt statuette of the *Tyche* of Rome, probably intended originally as an ornament for a chair. This is one of four similar statuettes in the Esquiline Treasure, representing personifications of the four principal cities of the Roman Empire: Rome, Constantinople, Alexandria, Antioch.
Provenance: Esquiline Hill, Rome.
Bibl. Dalton, *EC Cat.*, no. 332; Poglayen-Neuwall, *Röm. Mitt.* 45 (1930), pl. 35.
BM (M & LA) 66.12–29.21. Collection of the Duc de Blacas.
Colour plate.

98 Silver horse trappings fourth century AD

L 63·5 cm.
Silver horse trappings, partly gilt, consisting of nine connected plates and a buckle. Four of the plates are embossed – three with lion heads and one with an eagle – and five are decorated with pelta-like ornaments. From the plates with lion heads hangs a leaf-shaped projection, and from the plate with the eagle an inverted crescent. This is one of six closely related sets of trappings in the Esquiline Treasure.
Provenance: Esquiline Hill, Rome.
Bibl. Dalton, *EC Cat.*, no. 338.
BM (M & LA) 66.12–29.25. Collection of the Duc de Blacas.

Decorative trappings for the necks of horses demonstrated the wealth and standing of the owners but also symbolized the affection and esteem bestowed on the animals (see J. M. C. Toynbee, 'Graeco-Roman Neck-Wear for Animals', in *Latomus* XXXV, 1976, pp. 269–75). Horses that drew triumphal chariots were garlanded, and favourite race-horses, too, are frequently depicted on mosaics with ornamental circlets of metal round their necks. The scene most vividly recalled by these trappings, however, is of the late-fourth-century senator clattering through the streets of Rome, mounted on a richly caparisoned horse, and accompanied by armies of slave attendants – 'equo falerato insidens, discurrensque per silices, multa post se nunc usque trahit agmina servulorum' (Ammianus Marcellinus XXVI 3, 5).

98

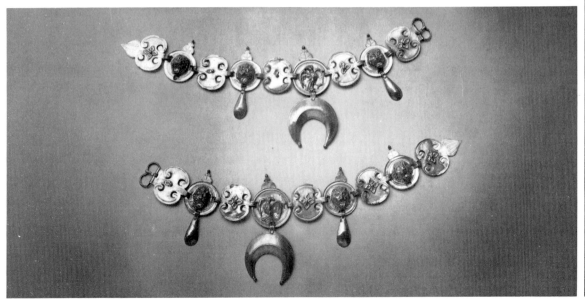

The Carthage Treasure 4th to early 5th centuries

Found on the Hill of St Louis, Carthage.

The Cresconii, named on one of the dishes (no. 100), were a well known and important family in North Africa in the fourth and fifth centuries, while Carthage itself was still the second city in the Western Empire. Various known members of the family include: a *comes metallorum* of the Western Empire in AD 365; a highly distinguished civil servant, who in AD 390 took to Symmachus the imperial letter appointing him consul for AD 391; and an augur and duumvir at Timgad in the mid-fourth century.

The reason for the deposition of the treasure is not known; but it may have been at a moment of violence between the Donatists and Catholics, particularly during the campaign against the Donatists led by Augustine of Hippo from AD 393 onwards. The peak of the campaign came in the Conference of Carthage in AD 411. The Cresconii were evidently Catholics, for after the Conference some Donatists defected and in Cuicul (Djemila) Cresconius, the Catholic bishop, erected a large and ornate basilica for former Donatists, with an inscription in mosaic claiming that unity had been secured. Equally, however, the treasure may have been hidden at a time of danger from barbarians, for in AD 429 the Vandals crossed the Straits of Gibraltar and swept into Africa. In AD 439 Gaiseric, king of the Vandals, captured Carthage itself and established a kingdom, a little larger than modern Tunisia, which lasted until Justinian's time.

99

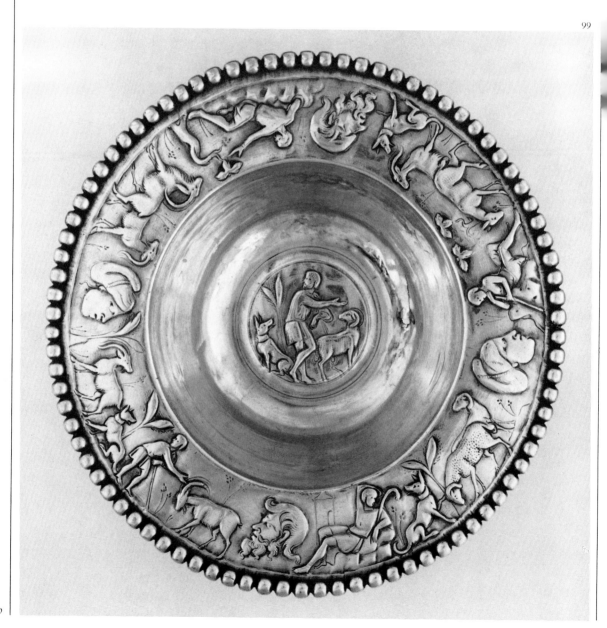

99 Chased silver bowl *c.* AD 400

H 5·7 cm. D 17·5 cm.

Silver bowl with a broad, flat edge ornamented with four pastoral groups chased in low relief. Each group is separated from the next by four profile masks, male and female alternately. In the bottom, on a circular medallion, is the figure of a shepherd standing between a ram and a dog. This bowl illustrates the persistence of pagan iconography almost a century after the adoption of Christianity as the official religion of the Roman Empire.

Provenance: Hill of St Louis, Carthage.

Bibl. Dalton, *EC Cat.*, no. 356.

BM (M & LA) Dalton, *EC Cat.*, no. 356. Bequeathed by Sir Augustus Wollaston Franks.

100 Inscribed silver dish *c.* AD 400

H 3·2 cm. D 13·6 cm.

Flat silver dish. In the centre, within turned and gilt concentric circles, is inscribed:

D. D. ICRESCONI CLARENT.

Provenance: Hill of St Louis, Carthage.

Bibl. Dalton, *EC Cat.*, no. 358.

BM (M & LA) Dalton, *EC Cat.*, no. 358. Bequeathed by Sir Augustus Wollaston Franks.

The Cresconi are an identifiable North African family of the period around AD 400, and this dish is thus an important documentary item.

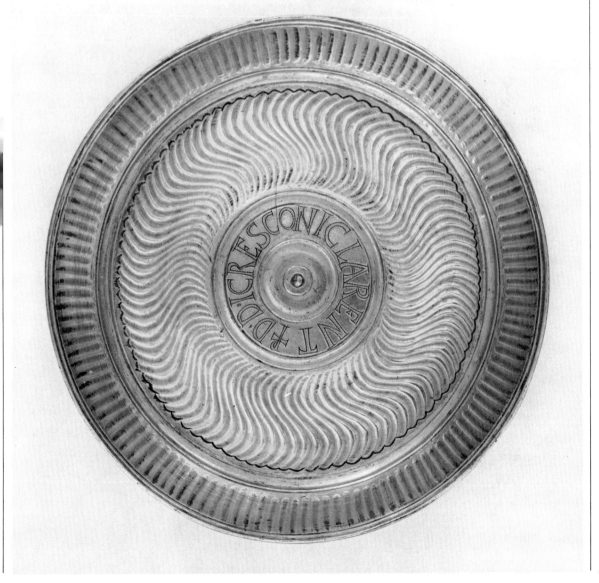

101 Covered silver bowl *c.* AD 400

H 11·4 cm. D 12·4 cm.

Silver bowl on a high tapering foot, the exterior of both bowl and foot being vertically faceted. The bowl has a flat, saucer-shaped cover with a low rim, which is similarly faceted.

Provenance: Hill of St. Louis, Carthage.

Bibl. Dalton, *EC Cat.*, no. 361.

BM (M & LA) Dalton, *EC Cat.*, no. 361. Bequeathed by Sir Augustus Wollaston Franks.

An example of an unusual type of vessel, this is also one of the most perfect pieces of late antique design.

102 Silver spoon *c.* AD 400

L 15·2 cm. D 6·3 cm (bowl).

Spoon with a deep circular bowl joined to a short handle by means of a square plate. On the plate is engraved a cross between two scrolls, the motif being inlaid with niello. This is an example of an unusual spoon shape characteristic of the Carthage Treasure.

Provenance: Hill of St Louis, Carthage.

Bibl. Dalton, *EC Cat.*, no. 364.

BM (M & LA) Dalton, *EC Cat.*, no. 364. Bequeathed by Sir Augustus Wollaston Franks.

Vessels and Plate

The importance of silver plate in the domestic, political and economic life of the Roman Empire cannot be overestimated. The evidence of literary and legal texts gives proof of the vast quantity of silver in private hands, the changes in fashion, the enthusiasm of collectors, the ostentation of owners. The collections of Temple Treasuries and Town Councils swelled the amount of Roman plate to immense proportions, and a trade highly organized for mass-production was needed to satisfy the demand.

The later periods in the history of Roman silver are by no means so well represented by surviving plate as the earlier centuries, although a large number of finds over the whole Roman Empire and even outside its frontiers have been made during the last two hundred years. In the case of fourth- and fifth-century AD hoards Britain has been one of the richest sources; but the hoards of this period, though mainly confined to the West, are a good deal more widely distributed than those of the third century AD. Their contents combine to give a fairly thorough idea of the silver fashions in the late Empire, and the number of important discoveries made outside the frontiers is a reminder that fine table silver played an important role in Roman trade and diplomacy abroad.

A complete set of domestic plate, known as a *ministerium*, comprised *argentum escarium* (eating silver) and *argentum potorium* (drinking silver). Sacrificial implements used in domestic cult would also be included in the inventory of silver plate, and many articles of domestic furniture *(suppellectilis)* and toilet vessels used by women might also be made of silver. The presence of religious subjects on any particular vessel does not itself show that it served a religious purpose; but the notably large number of religious scenes on the handles of surviving saucepan-shaped vessels suggests that the type had an important place in religious cult. The shrines of the Roman Empire also contained large treasuries of silver objects which were not used in religious ritual but were domestic plate dedicated to the god.

103 Silver dish (the Mileham Dish) fourth century AD
L 37·5 cm. W 37·5 cm. WT 2·150 kg.
Square silver dish with circular central depression. The rim is edged with large beads. The centre of the bowl and the flat rim are decorated with engraving in various stylized leaf and leaf-scroll designs.
Provenance: Mileham, Norfolk. Found in December 1839 at Second Alder Carr, between Mileham and Longham, near East Dereham.
Bibl. Archaeologia 29 (1841), p. 389, pl. 42; Walters, *SP Cat.*, no. 87.
BM (P & RB) 1840.11–1 L.1.

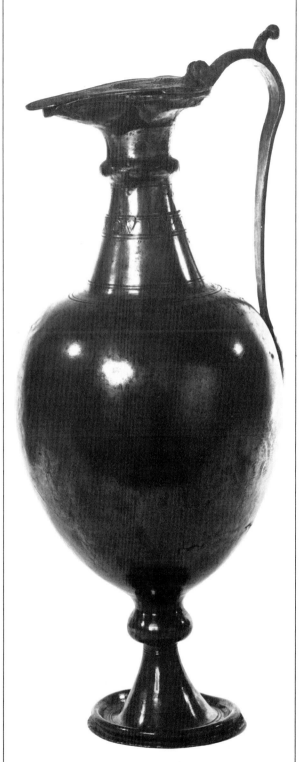

104 Silver jug fourth century AD

H 36 cm.

Silver jug with bulbous body, narrow tapering neck, and horizontal spout fitted with a hinged lid. The handle arches above the level of the neck and then curves downwards to join the body at its widest point. There is a ball stem, and the foot has a simple roll moulding. An inscription in nielloed letters on the neck reads: VIVAS IN CHRISTO QVINTA (Quinta, may you live in Christ). The lid is decorated with a plant motif.

Provenance: Venticane, near the ancient Aeclanum, southeast of Beneventum, Italy.

Bibl. Odobesco, *TP*, p. 14, fig. 18.a; Strong, *GSP*, p. 190. Paris, Bibliothèque Nationale, Cabinet des Médailles.

This is one of three main types of jug of the fourth and fifth centuries AD. The others are (a) a tall, slim vessel with ovoid body, long tapering neck, and flat mouth with upright rim; (b) ovoid body on footring, with narrow neck, usually with a roll moulding and a vertical rim. A spouted jug and one of the slender type were found in the catacombs of Kertch with dishes commemorating the *vicennalia* (twenty-year celebrations) of Constantius II in AD 343.

105 Silver ewer early fifth century AD

H 12·7 cm.

Silver ewer with roped ornament around the neck. On the sides, worked in low relief and subsequently engraved, are two scenes: the first is Christ healing the blind, but the second is more problematical, since it would appear to show Christ giving the scroll of the law to St Peter. In traditional early Christian iconography it is St Paul who receives the scroll of the law and St Peter who receives the keys.

Provenance: In the collection of Monsignor Leone Strozzi in Rome early in the eighteenth century; subsequent history unknown.

Bibl. Tonnochy, *BMQ* 18 (1952), pp. 16–17.

BM (M & LA) 1951. 10–10. 1.

This piece is of major importance as an example of the migration of Christian figurative motifs into the realm of the applied arts.

106 Silver skillet fourth–fifth century AD

L 11·4 cm (handle). D 13·2 cm (rim).

Skillet with plain silver bowl. The handle is inlaid (apparently in gold) with an incomprehensible inscription. Above and below this are lines of deeply engraved spirals inlaid with niello (missing in places); together these give the effect of a broken meander pattern. The edges of the handle bear a bold engraved line and incisions, giving a milled appearance. There are five motifs of concentric circles inlaid with niello: three at the end of the handle, and one at each side where it widens to join the bowl.

Provenance: Unknown, possibly Wales.

Bibl. Brailsford; *Ant. RB '66*, fig. 18, no. 7.

BM (P & RB) 1942.1–7.1.

107 Silver ladle fourth–fifth century AD

L 22·6 cm. W 14 cm. H 4·7 cm.

Silver ladle, the rim of the bowl formed into a star pattern with small knobs on the points. The bottom is decorated

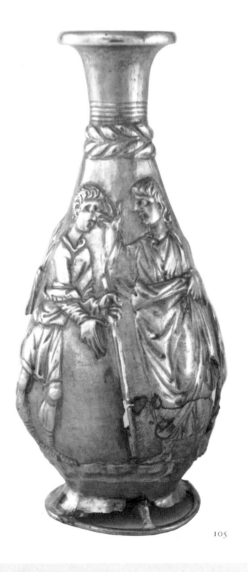

105

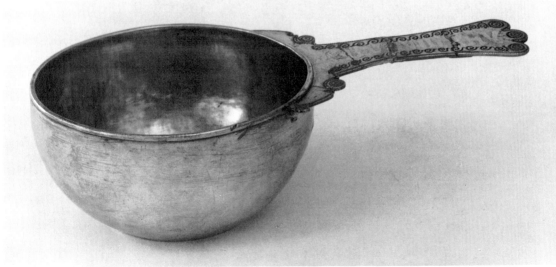

106

with palmettes and rosettes, and the handle is in the form of a dolphin. This piece belongs to a series of small dolphin-handled ladles of the fourth–fifth century; there are five in the Mildenhall Treasure, one in the Traprain Hoard, and seven of a slightly different form in the Carthage Treasure. This Louvre piece is like one of five objects from the Tyskiewicz Collection and is said to come from Torre del Greco or Carthage. The latter provenance is likely, as the five include two more small ladles like those from the Carthage Treasure.

Provenance: Probably Carthage, Tunisia.

Bibl. De Ridder, *Bij. Ant.*, no. 1985; Strong, *GSP*, p. 193. Paris, Louvre, Département des Antiquités grecques et romaines. Bj 1985. Formerly in the Tyskiewicz Collection.

108 **Silver spoon** fourth century AD

L 19·4 cm. WT 27·8 g.

Silver spoon with pear-shaped bowl joined to the handle by means of a pierced scroll attachment. The handle is square-sectioned, tapering to a point. Engraved in the bowl is a chi-rho monogram between alpha and omega.

Provenance: Biddulph, Staffordshire.

Bibl. Painter, *Ant. J* 51 (1971), pp. 323–4; Painter, *Riv. Arch. Cr.* 49 (1973), p. 195. Painter, *Ant. J* 55 (1975), p. 62.

BM (P & RB) P.1971.5–1.1.

The spoon is the survivor of a hoard of four spoons found at Whitemore Farm, Biddulph. The find-place suggests a possible direct link between Chester and Buxton. The style of the lettering may indicate that the spoon was made in the East Mediterranean.

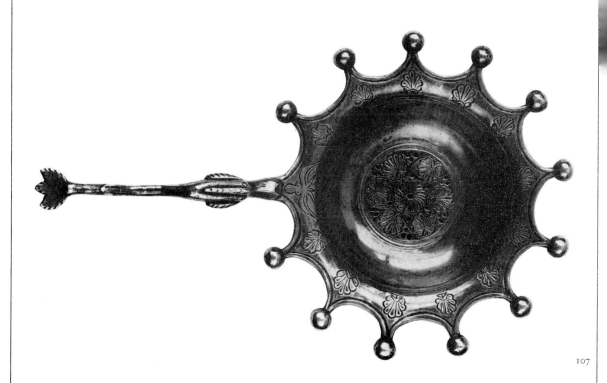

107

108

Silver Spoons from Dorchester, Oxfordshire

Of the five spoons in this hoard two have openwork or incised ornament at the junction between bowl and handle, while three have animal-head decoration. No precise dating can be attempted of spoons with openwork or incised ornament; but the presence of similar examples may be noted in the Kaiseraugst hoard, deposited in AD 350, the Canterbury hoard, deposited after AD 393, and the Coleraine hoard, deposited after AD 407, and probably after AD 420.

The spoons with animal-head decoration are a more distinctive type. The nearest parallels to the examples in this group are to be found in the Dorchester (Dorset) hoard, deposited after AD 395, and the Canterbury hoard. Parallels are to be found in the objects from the cemeteries at Vermand and Saint Quentin. Dalton, in publishing the Dorset spoons, suggested that the animal-head decoration indicates a Teutonic source. Direct parallels, however, do not occur merely in the north-west of the Empire. They are to be found in Rome and in Kertch in the Crimea. This suggests that they come from the same workshops as the other silver plate of the period, and the decoration is undoubtedly in the main stream of Roman art.

109 Silver spoon fourth century AD

L 16·5 cm.
Silver spoon with broad oval bowl and short tapered handle, twisted for rather more than half its length. Mouldings separate the plain and twisted areas. The openwork scroll attachment joining bowl and handle is in the form of a very stylized bird, its feathers marked with short incisions, and a dot and circle for the eye.
Provenance: Dorchester, Oxfordshire.
Bibl. Franks, *Proc. Soc. Ant.*, 2nd series, 5 (1870–3), p. 321.
BM (P & RB) 1872.7–25.5.

110 Silver spoon fourth century AD

L 20·4 cm.
Silver spoon with pear-shaped bowl. The handle is square-sectioned and twisted for somewhat under half its length. The tip of the handle is plain and tapering. Simple mouldings divide the twisted portion from the scroll attachment to the bowl and from the tip of the handle. The scroll attachment is very simple and stylized, but was probably intended as an animal head (compare no. 111).
Provenance: Dorchester, Oxfordshire.
Bibl. Franks, *Proc. Soc. Ant.*, 2nd series, 5 (1870–3), p. 321.
BM (P & RB) 1872.7–25.4.

111 Silver spoon fourth century AD

L 21·7 cm.
Silver spoon with narrow pear-shaped bowl. The handle is of square section and twisted at the end nearer the bowl; the twisted part is divided from the plain tapering tip by a neat astragalus-like moulding. The openwork scroll attaching the handle to the bowl has been decorated with incised lines and forms a tiny, very stylized, animal head (lion or panther).
Provenance: Dorchester, Oxfordshire.

Bibl. Franks, *Proc. Soc. Ant.*, 2nd series, 5 (1870–3), p. 321.
BM (P & RB) 1872.7–25.3.

112 Silver spoon fourth century AD

L 17·5 cm.
Silver spoon with plain tapered handle and pear-shaped bowl. The scroll attachment at the base of the handle is cast in one with it, and is not pierced; it has merely an engraved crescentic motif.
Provenance: Dorchester, Oxfordshire.
Bibl. Franks, *Proc. Soc. Ant.*, 2nd series, 5 (1870–3), p. 321.
BM (P & RB) 1872.7–25.2.

113 Silver spoon fourth century AD

L 19·7 cm.
Silver spoon with pear-shaped bowl and plain tapering handle. A simple scroll motif attaches the bowl to the handle.
Provenance: Dorchester, Oxfordshire.
Bibl. Franks, *Proc. Soc. Ant.*, 2nd series, 5 (1870–3), p. 321.
BM (P & RB) 1872.7–25.1.

Jewellery

For many centuries in the Roman world jewellery was one of those luxuries under official disapproval, and surviving examples are very scarce. However, with the inauguration of the Empire in 27 BC and the annexation by Rome of most of the Hellenistic world, the old austerity was quickly put aside. The jewellery of the early Empire was in many respects simply a Hellenistic continuation. Gradually, however, other influences made themselves felt, and by the fourth century much Roman jewellery was anticipating the Byzantine style which was to follow.

Jewellery of the early Empire was essentially gold jewellery. By the fourth and fifth centuries AD, however, an increasing emphasis had been placed on stones for their own sake, and less pains were taken over the working of the gold in which they were set. Here for the first time the very hardest stones were used: diamonds occasionally, although uncut; sapphires, and, above all, emeralds, from the newly discovered Egyptian mines in the Red Sea hills, which were used in the natural hexagonal prisms in which these stones are found.

One form of gold-working which did become particularly popular at this period is a kind of metal-fretwork, called by the Romans *opus interrasile*, in which patterns are cut out of sheet gold with a chisel. Inlaying was still practised. Enamel was sometimes used, especially in the Celtic area, and a related form of decoration, niello, made its first appearance.

The chief centres of production were probably Alexandria and Antioch, and also Rome itself, whither many immigrant craftsmen from the Greek east had migrated. We have evidence that goldsmiths and silversmiths were now organized in guilds, like medieval craftsmen, and recent study of inscriptions of jewellers who worked at Rome suggests that after the Neronian fire their quarters were shifted from the Via Sacra to a location between the Forum Boarium and the Forum Holitorium.

114 Gold bracelet fourth century AD

D 6 cm.

Gold band decorated in *opus interrasile* with scenes of vintage and hunting, possibly representing the four seasons.

Bibl. Marshall, *J Cat.*, no. 2817.

BM (G & R) F 2817. Bequeathed by Sir Augustus Wollaston Franks.

115/116 Pair of gold bracelets fourth–fifth century AD

D 5.8 cm.

Bracelets comprising a double gold band with a square bezel setting for a blue glass inlay (missing from one bracelet). The lower section of the double band is secured by pins and can be removed when the bracelet is put on.

Bibl. Marshall, *J Cat.*, nos. 2818–19.

BM (G & R) F 2818, F 2819. Bequeathed by Sir Augustus Wollaston Franks.

117 Gold-headed pin fourth century AD

L 5.3 cm.

Pin found with a silver ring (no. 139). The slender shank is of bone, the slightly pointed knob being of gold.

Provenance: Found in April 1925 at the Roman villa, Bays Meadow, Droitwich, Worcestershire.

BM (P & RB) 1928.7–14.2. Given by H. R. Hodgkinson.

118 Enamelled silver pin fourth century AD

L 6 cm. W 1.2 cm (head).

Silver pin with flattened ring head, its upper curve cast with bead-like swellings; the lower area is flattened and decorated with red enamel, leaving a reserved pattern. This pattern is a symmetrical scroll with a central pelta and two curving side lobes.

Provenance: Found at Oldcroft, near Lydney, Gloucestershire, in a large coin hoard deposited in AD 354–9.

Bibl. Johns, *Ant. J* 54 (1974), p. 295.

BM (P & RB) P.1973.8–1.1. Treasure Trove.

This is the first pin of its type to be found in a well-dated association. The type is a proto-handpin, ancestral to the handpins of the Dark Ages, but also closely related to enamelled objects of the pre-Roman and early Roman Iron Age.

119 Gold finger-ring early fourth century AD

D 1.5 cm. WT 4.53 g.

Finger-ring with stilted bezel springing from the hoop. The bezel is set with blue glass, facet-cut in imitation of a natural sapphire crystal.

Provenance: Catania, Sicily.

Bibl. Marshall, *FR Cat.*, no. 799.

BM (G & R) 799 F. Bequeathed by Sir Augustus Wollaston Franks.

120 Gold finger-ring early fourth century AD

D 2.2 cm. WT 14.45 g.

Finger-ring with a square bezel engraved with portrait busts of a man and a woman. The bezel is inscribed: SPERATV[S] BENERIAE.

Bibl. Marshall, *FR Cat.*, no. 208.

BM (G & R) 208 F. Bequeathed by Sir Augustus Wollaston Franks.

121 Gold finger-ring early fourth century AD

D 2.3 cm. WT 5.57 g.

Finger-ring with shouldered hoop and rectangular open-work bezel set with an emerald.

Bibl. Marshall, *FR Cat.*, no. 794.

BM (G & R) 794 F. Bequeathed by Sir Augustus Wollaston Franks.

122 Gold finger-ring early fourth century AD

D 1.8 cm. WT 4.21 g.

Finger-ring having a shouldered hoop and green glass inlay in the bezel.

Bibl. Marshall, *FR Cat.*, no. 795.

BM (G & R) 795 F. Bequeathed by Sir Augustus Wollaston Franks.

Rings from Sully Moors

These four gold finger-rings were found with a hoard of silver and gold coins (latest issue AD 306) in October, 1899, at Sully Moors, near Cardiff, Wales. No. 125 is one of only eighteen cameos known from Roman Britain; the commonest design on these cameos is of Medusa.

123 Gold ring fourth century AD

D 2·6 cm. WT 11·4 g.

Gold ring found with three other rings (nos. 124–6) and silver and gold coins (latest issue AD 306). This ring is elliptical and projects below the shoulders, which are of simple stylized leaf shape, pierced and incised. The rectangular bezel has a raised oval setting for a stone, now missing.

Provenance: Found in October 1899 at Sully Moors, near Cardiff, Wales.

Bibl. Marshall, *FR Cat.,* no. 797; *Num. Chron.,* 3rd series, 20, p. 64.3, pl. III, fig. 10; *Arch. Anz.* (1901), p. 160; Smith, *Ant. Rom.,* pp. 65–6.

BM (P & RB) 1900.11–23.1. Treasure Trove.

124 Gold ring fourth century AD

D 2·7 cm. WT 12·44 g.

Gold ring found with no. 123, two other rings (nos. 125–6) and silver and gold coins. The form of this ring is elliptical, projecting on either side below the shoulders, which are of very simple leaf shape. Both hoop and shoulders have incised decoration. The oval bezel is externally angled to make an octagon; the setting is a plain nicolo paste.

Provenance: Found in October 1899 at Sully Moors, near Cardiff, Wales.

Bibl. Marshall, *FR Cat.,* no. 796; *Num. Chron.,* 3rd series, 20, p. 63.1; *Arch. Anz.* (1901), p. 160; Smith, *Ant. Rom.,* pp. 65–6.

BM (P & RB) 1900.11–23.2. Treasure Trove.

125 Gold ring fourth century AD

D 2·4 cm. WT 6·86 g.

Gold ring found with no. 123, two other rings (nos. 124, 126) and silver and gold coins. This ring has a narrow hoop and shoulders of simplified vine-leaf form. The bezel is a raised oval setting with an impressed, foliated border and contains an onyx cameo depicting a frontal Medusa head.

Provenance: Found in October 1899 at Sully Moors, near Cardiff, Wales.

Bibl. Marshall, *FR Cat.,* no. 544; *Num. Chron.,* 3rd series, 20, p. 63.2, pl. III, fig. 9; *Arch. Anz.* (1901), p. 160; Smith, *Ant. Rom.,* pp. 65–6.

BM (P & RB) 1900.11–23.3. Treasure Trove.

126 Gold ring third–fourth century AD

D 2·6 cm. WT 11·33 g.

Gold ring found with no. 123, two other rings (nos. 124, 125) and silver and gold coins. The hoop is plain, the shoulders having simple raised panels. The bezel is square and has an engraved raised plate within a square wall; the engraving shows a cockerel walking to the left.

Provenance: Found in October 1899 at Sully Moors, near Cardiff, Wales.

Bibl. Marshall, *FR Cat.,* no. 203; *Num Chron.,* 3rd series, 20, p. 64.4, pl. III, fig. 11; *Arch. Anz.* (1901), p. 160; Smith, *Ant. Rom.,* pp. 65–6.

BM (P & RB) 1900.11–23.4. Treasure Trove.

127 Gold ring fourth century AD

D 2·1 cm. WT 8·48 g.

Gold ring with flat polygonal hoop, expanding to a flat area set with a burnt sard (?), which is faceted and of long hexagonal form. The centre of the stone is engraved with an anchor, and round its edge is an inscription in relief:

M IBI VIVAS

Provenance: Found in 1844 on top of the Gogmagog Hills, Cambridgeshire.

Bibl. Marshall, *FR Cat.,* no. 651; *Arch. J* 17 (1860), p. 75; *CIL* 7, no. 1303.

BM (P & RB). Bequeathed by Sir Augustus Wollaston Franks. Formerly in the Braybrooke Collection.

128 Gold ring fourth century AD

H I cm. D 2·2 cm.

Gold ring with faceted and pierced hoop. The openwork forms an inscription, *ΦΙΛΤΡΟΝ ΠΟΛΕΜΙΟΥ*, between borders of peltae or leaf-like motifs.

Provenance: Found at Corbridge, Northumberland, in 1935.

Bibl. Charlesworth, *Arch. Ael.*, 4th series, 39 (1961), p. 24, no. 6.

BM (P & RB), loaned by the Ministry of Works (now Department of the Environment). Loan 12.2.1947.

129 Gold finger-ring fourth century AD

D 2·5 cm. WT 12·83 g.

Finger-ring with pyramidal rectangular bezel, bearing an engraving of a panther.

Provenance: Cologne, Germany.

Bibl. Marshall, *FR Cat.*, no. 204.

BM (G & R) 204 F. Bequeathed by Sir Augustus Wollaston Franks.

130 Gold finger-ring fourth century AD

D 1·9 cm. WT 4·98 g.

Finger-ring with flat hoop and openwork shoulders. The bezel is set with a sardonyx cameo of a female bust.

Provenance: Milan, Italy.

Bibl. Marshall, *FR Cat.*, no. 572.

BM (G & R) 572 F. Bequeathed by Sir Augustus Wollaston Franks.

131 Gold finger-ring fourth century AD

D 2·2 cm. WT 3·43 g.

Finger-ring composed of four oval and four figure-of-eight shaped plates. On the ovals are engraved designs of an insect flying.

Bibl. Marshall, *FR Cat.*, no. 207.

BM (G & R) 207 F. Bequeathed by Sir Augustus Wollaston Franks.

132 Gold finger-ring fourth century AD

D 3·5 cm. WT 8·81 g.

Finger-ring with the hoop composed of six settings, containing two emeralds, a sapphire, two garnets and a carnelian. Between the settings are single openwork letters, together reading ATVSII.

Bibl. Marshall, *FR Cat.*, no. 857.

BM (G & R) 857 F. Bequeathed by Sir Augustus Wollaston Franks.

133 Gold finger-ring fourth century AD

D 2·3 cm. WT 14·7 g.

Finger-ring with octagonal hoop of seven openwork compartments. The bezel is inscribed:

ΑΦΡΟΔ
ΓΕΝΕΤ
ΔΟΣ

Bibl. Marshall, *FR Cat.*, no. 643.

BM (G & R)

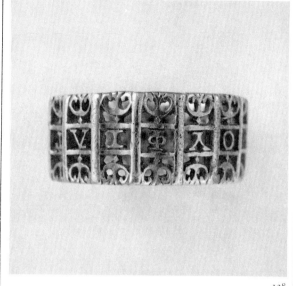

128

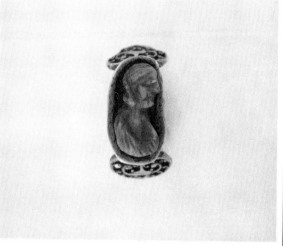

130 △ ▽ 133

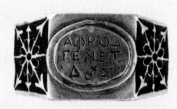

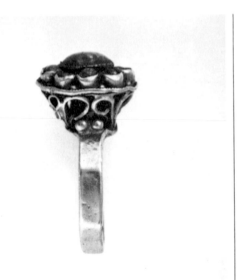

138

140

134 Gold ring fourth–fifth century AD
D 2·8 cm.
Gold ring with a hoop of three elements, and shoulders decorated with double spirals of beaded wire and pellets. The bezel is deep and oval, surrounded by a roped border, and contains a gold inset with clasped hands in relief within a beaded border. The bezel may be secondary, replacing a gem.
Provenance: Found unstratified during the 1935 excavations of the Roman fort at Richborough, Kent.
Bibl. Bushe-Fox, *Rich.* 4, p. 126, pl. XXXV, no. 93; Brailsford, *Ant. RB '64*, p. 26, fig. 13.7.
BM (P & RB) 1936.2–4.1. Given by HM Commissioners of Works.

135 Gold finger-ring fifth century AD
D 2·1 cm. WT 4·92 g.
Finger-ring with openwork hoop and a carnelian intaglio (of earlier date) showing a female bust.
Provenance: Athens, Greece.
Bibl. Marshall, *FR Cat.*, no. 558.
BM (G & R) 558 F. Bequeathed by Sir Augustus Wollaston Franks.

136 Gold finger-ring fourth–fifth century AD
D 3·2 cm. WT 4·53 g.
Finger-ring with hoop composed of three gold wires soldered together. The rectangular bezel is inscribed (in reverse) MACRIOLA.
Bibl. Marshall, *FR Cat.*, no. 653.
BM (G & R) 653 F. Bequeathed by Sir Augustus Wollaston Franks.

137 Gold signet ring fifth century AD
D 2·5 cm.
Ring with hoop formed from seven oval medallions separated by pairs of pellets. Each medallion is engraved in intaglio with a standing figure in a long mantle. The bezel is engraved with a throned figure of the beardless Christ, the right hand raised in a gesture of benediction.

Provenance: Izmir (formerly Smyrna), Turkey.
Bibl. Dalton, *EC Cat.*, no. 190.
BM (M & LA) AF 288. Bequeathed by Sir Augustus Wollaston Franks.
 Possibly intended for ecclesiastical use, this ring is very similar in shape to certain gold marriage rings of the fifth century.

138 Gold finger-ring fifth century AD
D 2·2 cm. WT 9·52 g.
Finger-ring having an octagonal hoop. The round bezel is set with a circular ornament of green glass, surrounded by ten pearls in gold settings.
Bibl. Marshall, *FR Cat.*, no. 867.
BM (G & R) 867 F. Bequeathed by Sir Augustus Wollaston Franks.

139 Silver ring fourth century AD
D 2·5 cm.
Silver ring found with a gold-headed pin (no. 117). The ring has a plain flat hoop and a small square raised bezel engraved with a bird (crane?) within a punched border.
Provenance: Found in April 1925 at the Roman villa, Bays Meadow, Droitwich, Worcestershire.
BM (P & RB) 1928.7–14.1. Given by H. R. Hodgkinson.

140 Silver ring fourth century AD
L 1·9 cm (bezel). D 2·2 cm.
Silver ring of elliptical form, with bold incised ornament on the hoop and on the shoulders, which are of stylized leaf form. The bezel is an octagon of oval shape, set with a gold gem decorated with clasped hands in relief, surrounded by a beaded border.
Provenance: Found in 1906 at Grovely Wood, Wiltshire, with another ring, pottery and coins; the coins date the deposit to *c.* AD 395.
Bibl. Smith, *Ant. Rom.*, pp. 66–7.
BM (C & M) 1911.10–26.1.

Silver Rings from Amesbury

These rings were found in 1843, at Amesbury, Wiltshire, inside a pot together with a hoard of coins, the latest being issues of Theodosius I (AD 379–395). The similarities of these rings in style and execution suggest that the three were made by the same craftsman, perhaps for the same customer on commission.

The Roman practice of wearing finger-rings for sealing purposes is well attested. By the end of the third century BC, for example, Roman consuls were wearing signet rings with a distinctive device. Sardonyx and garnet became popular as seal-stones; but many signet-rings, like these from Amesbury, continued to have intaglios cut in metal bezels. There was no break in the tradition in the following centuries, and, although the bezels were occasionally set with intaglio gems, more frequently the flat surface of a metal bezel was engraved. The Roman practice lived on in Gaul under Frankish rule, often reaching the highest levels of craftsmanship. In this period widespread illiteracy made the seal indispensable, and the signet-ring continued without a break through the early Middle Ages in the West.

141 142 143

141 Silver ring fourth century AD

D 2·5 cm. WT 0·33 g.

Silver ring found with two other rings (nos 142, 143) and a hoard of coins ranging from Postumus to Theodosius I (AD 379–395). The hoop is flat, and the shoulders are decorated with raised bands, incised and dotted ornament. Engraved in the square bezel is a griffin-like creature, with dotted lines above and below it.

Provenance: Found at Amesbury, Wiltshire, in 1843.

Bibl. Marshall, *FR Cat.*, no. 1207; *Proc. Soc. Ant.*, 1st series, 4 (1859), p. 27, fig. 3.

BM (P & RB) 1857.6–30.1. Presented by Sir Edmund Antrobus.

142 Silver ring fourth century AD

D 2·5 cm. WT 8·55 g.

Silver ring found with two others (nos 141, 143) and a hoard of coins. This ring has a plain, flat hoop and plain shoulders. The square bezel is engraved with four helmets, facing one another in pairs. There is a dotted line border.

Provenance: Found at Amesbury, Wiltshire, in 1843.

Bibl. Marshall, *FR Cat.*, no. 1206; *Proc. Soc. Ant.*, 1st series, 4 (1859), p. 27, fig. 1.

BM (P & RB) 1857.6–30.2. Presented by Sir Edmund Antrobus.

143 Silver ring fourth century AD

D 2·5 cm. WT 8·1 g.

Silver ring found with two others (nos 141, 142) and a hoard of coins. The hoop is plain and flat, slightly angular on the outside. The shoulders are decorated with triangular areas of raised silver globules, and engraved dotted lines. The square, raised bezel is engraved with a reclining or fallen stag and a bird.

Provenance: Found at Amesbury, Wiltshire, in 1843.

Bibl. Marshall, *FR Cat.*, no. 1205; *Proc. Soc. Ant.*, 1st series, 4 (1859), p. 27, fig. 2.

BM (P & RB) 1857.6–30.3. Presented by Sir Edmund Antrobus.

THE COLOUR PLATES

LIST OF COLOUR PLATES

NOTE: *All coins are enlarged to 1½ × original size*

54 (detail) ▷

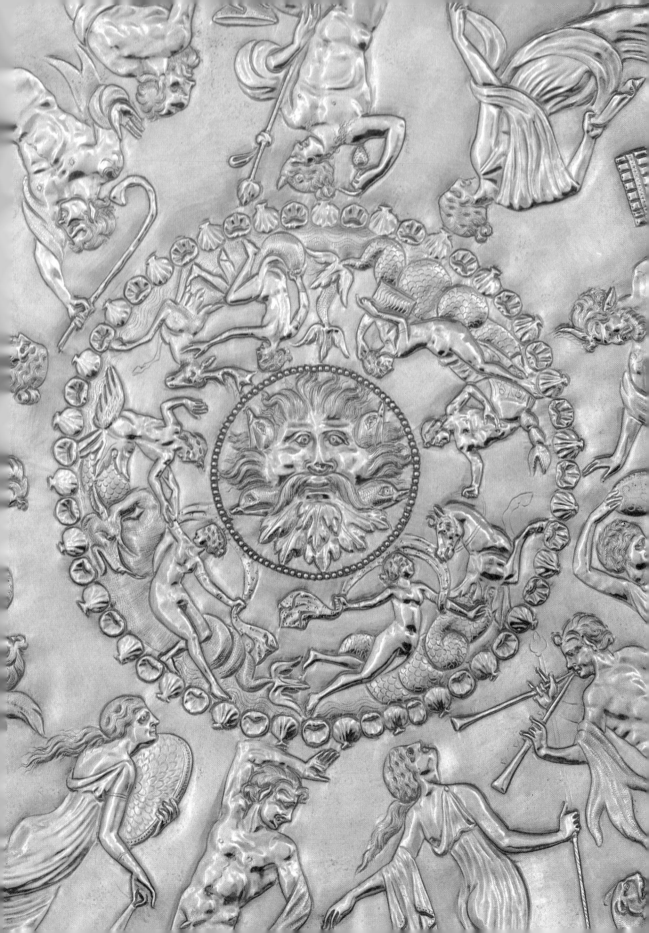

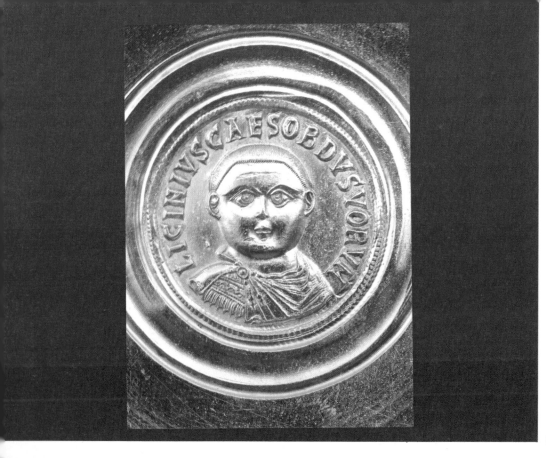

3 (*detail*)

36, 37, 44

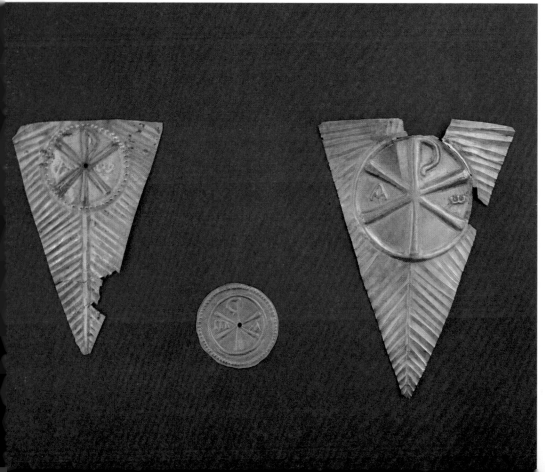

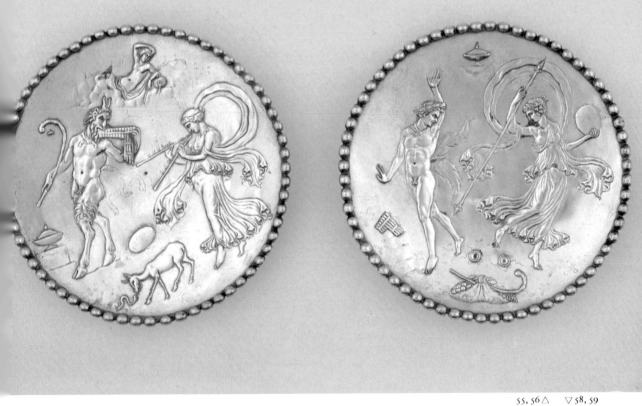

55, 56 △ ▽ 58, 59

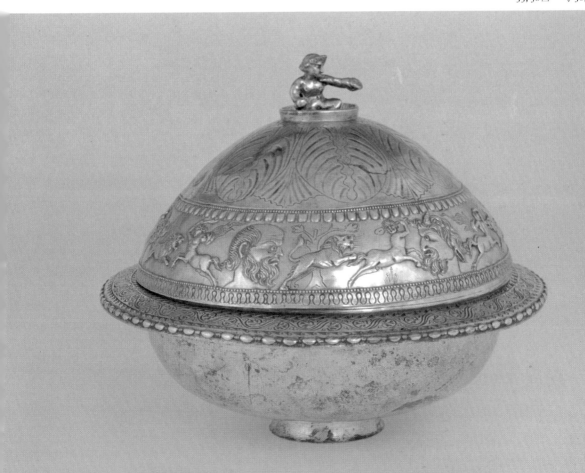

81 (*detail*)

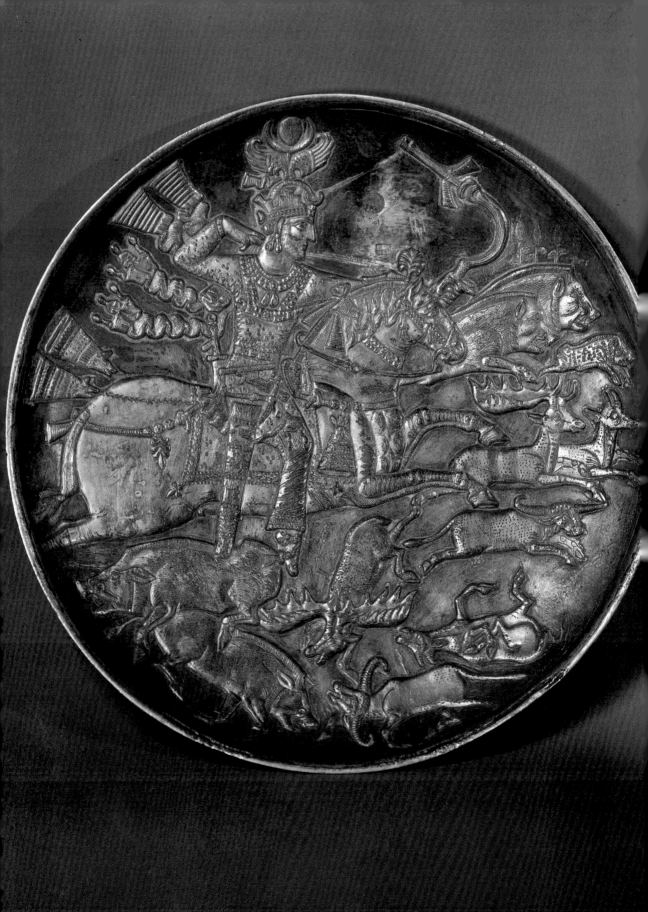

249 △ ▽250–291

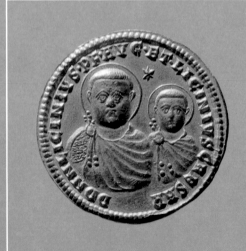
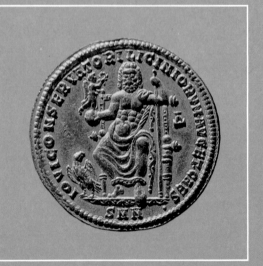

373

392

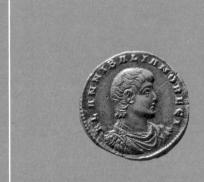
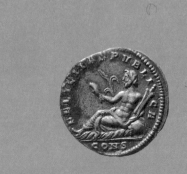

395

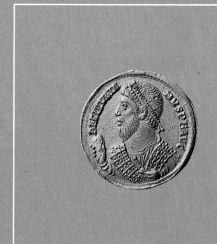

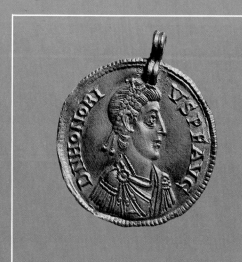
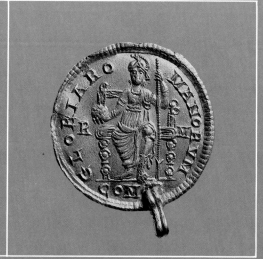

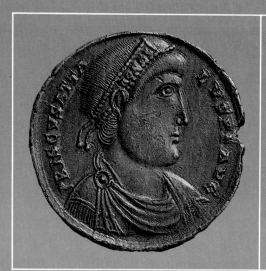
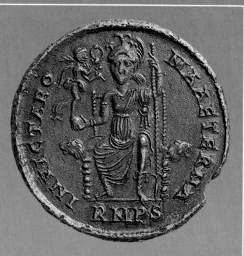

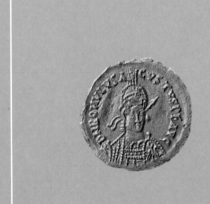
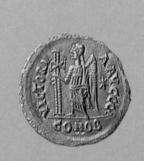

595

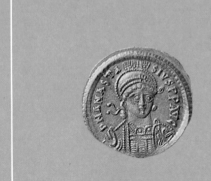
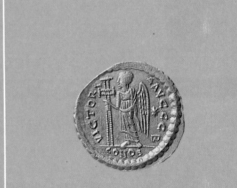

625

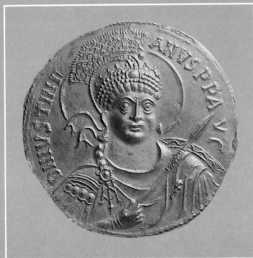
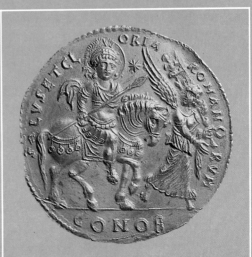

674

723

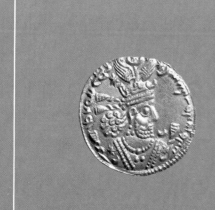
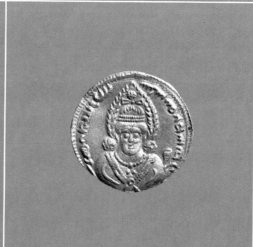

764

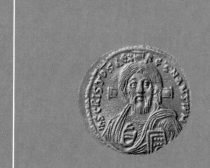
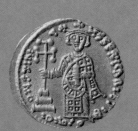

771

GOLD AND SILVER
FROM THE LATE-ROMAN WORLD
SIXTH-SEVENTH CENTURIES

In the fourth century the deepest division in the society of the Roman world was between north and south. The peoples of the frontier provinces were increasingly threatened by the barbarian tribes across the northern borders. The civilians of the Mediterranean were all of them equally distant from the military court that paced up and down the northern highroads. This whole tendency during the third century for the Roman Empire to become a military autocracy was reversed, however, as a result of the quiet revolution of the fourth century begun by the Emperor Constantine. By the end of the fifth century the Roman army had been rivalled as a political force by a body of high administrators, palace officials and retired bureaucrats resident in Constantinople. The two greatest emperors of the period, Anastasius (AD 491–518) and Justinian (AD 527–565) were both civilians of the new type. Anastasius had been a palace official until late middle age, and Justinian, though the nephew of a Latin soldier from the Balkans, had become thoroughly 'civilized'. The heights of statecraft and culture reached under these two remarkable men sum up the slowly matured achievement of the civilian governing class. In the course of the fifth century the Roman Empire had found its way to a new identity, as the Empire no longer of Rome but of Constantinople.

The shift of emphasis within the Empire to a division between east and west took place slowly but certainly. In AD 410, for example, when Rome was sacked, three days of public mourning were declared at Constantinople. The eastern emperor, Theodosius II, did little else to help the western capital; but his ministers soon took good care to surround Constantinople with great walls. Constantinople was now clearly the ruling city, in which the emperor resided, and where government was administered. Compared with the ancient Christian centres, on the other hand, Constantinople was a newcomer, lacking status. At the Council of Chalcedon in AD 451, therefore, the Emperor Marcian took advantage of a dispute within the church to humble the Patriarch of Alexandria, and so to secure the position of Constantinople as the leading Christian city of the Empire. The prestige of the Emperor was from then onwards increased by religious uncertainties, for all attempts to achieve unity in the church passed through the court at Constantinople. The extent to which the western and eastern halves of Christendom drifted apart is demonstrated by the response of Anastasius (AD 491–518) to a delegation of bishops from Rome who tried in AD 517 to instruct him that he should impose the Catholic faith on his provincials. Anastasius made it clear that it was not his business to outlaw half his empire; it was more appropriate to find a formula by which the beliefs of his subjects could be blended. Rome and the Roman church was now one faction among many, while Constantinople, as the residence of the Emperor, was not only the ruling city, the centre of government, but also the holy city, the centre of the church.

Scots

Picts

Britons

Anglo-Saxons

Jutes

Saxons

Thuringians

Franks

Alamanni

Baiovarii

Lombards

Gepids

Antae

Avars

Burgundians

Slavs

Suevi

Ostrogoths

Ravenna

Constantinople

Visigoths

Rome

Antioch

Vandals

Carthage

Vandals

Jerusalem

Alexandria

The Roman Empire

THE ROMAN EMPIRE
IN A.D. 526

0 250 500 miles

The golden age coincided with the reign of Justinian (AD 527–565) and his consort Theodora. The age is marked by the personalities of its leading figures partly because their features are so familiar. Their mosaic portraits have faced each other for fourteen centuries across the apse of S. Vitale at Ravenna. The Emperor Anastasius had been a great builder. He executed a great programme of public works, including the fortress city of Dara and the Long Wall of Thrace, which formed the outer defence of Constantinople. Justinian, whose ambition it was to reconstitute the Roman Empire in its entirety, was an even greater builder. In Constantinople alone he is said to have built or restored upward of thirty churches, and Sancta Sophia in that city represents the supreme creation of Byzantine architecture.

In the military and political spheres the age of Justinian was a remarkably prosperous one. Italy, Dalmatia and Sicily, previously lost to the Goths, were all restored to the Empire by AD 554; North Africa was conquered, and in AD 550 Justinian founded a province in what is now Andalusia in Spain, which remained under the control of Constantinople for the next seventy years. In the east the Persians were driven out of Asia Minor, and the eastern bounds of the Empire were established almost as widely as they had been in the days of Imperial Rome.

The military and political success depended on a period of commercial prosperity; the result was that Constantinople rapidly became the administrative and social centre to which gold was attracted by every device at her disposal. The large and constant importation of luxuries had to be paid for. Constantinople did, it is true, have industries of her own – cotton, linen, silk and metalwork; but the articles made at Constantinople often stayed there. The best was reserved in particular for the imperial court and the enrichment of a growing number of increasingly magnificent churches. Therefore the multitude of imports – Chinese silk, Indian ivory and jewels and spices, and Russian furs – could be paid for only in gold.

The basis of Byzantine stability, in consequence, was the maintenance of a large and pure gold currency. The gold must to some extent have been obtained on very favourable terms where its price was comparatively cheap. Two such areas could be exploited. One was the easily accessible Caucasus and Central Asia. Here, for goods or services, as when Byzantine craftsmen were employed to build and fortify a Khazar town on the Sea of Azov, gold from the Urals could be released in return, while the gold of the Caucasus was open to entrepreneurs from Trebizond itself. The second area lay in Africa, and consisted of Nubia and Ethiopia; but much of this African gold probably never got much farther than Egypt and Syria. Sometimes the coffers of the central treasury were swollen by booty, as when a large part of the Persian royal treasure fell into the hands of Heraclius (AD 610–641). A further source was the rigorous system of taxation designed to extract all possible gold from the possession of private citizens. The reserves might vary; but, even after the Arabs had overrun Egypt in the middle of the seventh century, Byzantine gold coinage continued equally pure, however much its volume might tend to alter. Indeed, it is likely that the Arabs, enriched by Syrian and Egyptian gold and thus taking it westward in their swift passage along the north coast of Africa into Spain, actively benefited Byzantium; the gold thus introduced into western Europe enabled western courts to trade it back to Constantinople for the Byzantine luxuries which they required.

The evidence of the currency does not stand alone. It is confirmed by our knowledge of the immense wealth in precious metals which could be accumulated by the Byzantine emperors and even by their subjects. The Emperor Anastasius at his death in AD 518 left 320,000 lbs of gold in the treasury. To figures such as these are to be added private holdings and church treasures. Paul the Silentiary described Sancta Sophia immediately after its rededication in AD 562, and he includes an account of

the furnishings of the church, as well as its structure: 'Our Emperor [Justinian] has not spared an abundant enrichment of silver The sanctuary is all fenced with a cover of silver. Not only upon the walls which separate the priest from the choir has he set plates of silver, but the six pairs of columns, too, he has completely covered with silver And above the altar of gold rises an indescribable tower, reared on fourfold arches of silver And on columns of gold is raised the all-gold slab of the holy table, standing on gold foundations, and bright with the glitter of precious stones . . .'. For Ravenna we have the exact cost of the building by a wealthy banker, Julianus, of one of the churches, S. Vitale, between AD 526 and 548: 'In Ecclesius's time the church of the blessed martyr Vitalis was founded by Julianus the banker together with the bishop himself According to the epitaph recording the holy memory of the founder, 26,000 gold solidi were expended for the church of the martyr Vitalis'. The same man, Julianus the banker took part in the erection of four other churches at Ravenna and Classis. The Emperor himself took a hand in beautifying the Basilica Ursiana, the cathedral of Ravenna, built by Bishop Ursus in the late fourth or early fifth century: 'Moved by charity, Justinian bestowed upon the blessed Victor the entire tax-revenue of Italy for one year. When Victor had received this, he removed the old wooden ciborium and made one of two thousand pounds of silver From the remainder he made various vessels for the bishop's table . . .'.

This culture of the sixth and seventh-century empire was, above all, Christian. Whether secular or religious, however, all the arts – architecture, sculpture, painting and mosaics were brought to an extraordinary degree of excellence. Constantinople was the dominating influence, no longer the child or companion of Italy, as it had been some two hundred years earlier. This domination can be demonstrated particularly from the silverwork, for a relatively large number of single pieces and treasures survive. Some pieces can be dated from coins that either are part of the ornament or else belong to the same find. Occasionally pieces are dated by the identity of the donor. A strong chronological framework is supplied by the many plates and vessels carrying imperial stamps, which not only date them with the ruler's monogram but also permit an attribution to the workshop of the imperial court. The first organized system of stamps was instituted by Anastasius (AD 491–518), and it can hardly be coincidence that this emperor was also responsible for the most far-reaching monetary reforms since Constantine the Great. Among these reforms were basic changes in design such as the placing on bronze coins of the mark of value in Greek letters. The use of Greek lettering on the coins matches the change from Latin to Greek inscriptions on the silver stamps of Anastasius; but if there is a connection between stamps and coins, it is all the more noteworthy that the stamps do not show the device of the mint. The mint mark was not required on the stamps of Anastasius because they come from only one locality, Constantinople. The monetary reforms of Anastasius were elaborated by Justinian (AD 527–565), who established a system that endured, virtually unchanged, well into the seventh century, and it was this same emperor who established the five-stamp control on silver which lasted until the reign of Constans II (AD 641–668).

Study of the imperial stamps on silver leads to the conclusion that they were applied by a single group of officials in Constantinople, and that they were not used in other centres of the Empire. Stamps used in centres outside the capital were sometimes similar to, but clearly did not belong to, the imperial series. Two reservations, however, should be borne in mind. First, though the objects were stamped in Constantinople, they were not necessarily decorated there. Some silver objects with stamps show a provincial style, and stamped objects found among the silver treasures of Syria belong to Syrian workshops and exhibit distinctive Syrian styles. Indeed, a silversmith in the provinces could order the finest silver from the

capital, cut into the desired shape and guaranteed in quality by the stamps, and then decorate it to the satisfaction of his clients at home. Secondly, although the date at which an object was stamped is clearly identifiable, the object was not necessarily decorated until some years after it had been stamped.

In spite of its origin in Constantinople the plate and jewellery of the capital is known from finds made elsewhere. An example is the large silver-gilt dish (no. 301) refurbished and dedicated by Paternus, Bishop of Tomi on the Black Sea in the last decade of the reign of Anastasius. Its repoussé decoration consists of a central chi-rho monogram flanked by alpha and omega, with an inhabited vine scroll round the rim. This is the language of symbolism. At the same time figured pieces show the old classical tradition to have been very strong in the capital and in provincial centres where the influence of the capital was dominant. On the Conceşti amphora (no. 296) the subject matter is drawn direct from pagan mythology. In some fields of art Constantinople was open to influences from all the known world, and manuscript illustrations, for example, tend rather to reflect the oriental side of Byzantine artistic achievement. At the same time, however, the silver and gold show that Constantinople was still the natural guardian of the classical heritage.

Two of the most outstanding treasures which illustrate the hybrid nature of metropolitan art and culture at this time are those found in Cyprus in 1899 and 1902 (nos. 174–192). The first includes two plates, a censer and twenty-four spoons. The second consists of a series of plates, some decorated with scenes of the life of David, five flasks, and a girdle made up from a medallion and coins of Maurice Tiberius, Justin, Justinian and Theodosius. One of the plates carries control marks of Maurice Tiberius (AD 582–602); but most were stamped in the reign of Heraclius, after AD 610. Pieces securely associated and identified in groups such as these make it possible to classify isolated finds. An example is the gold marriage belt from Antioch (no. 164), now in the Dumbarton Oaks Collection. This depends for its dating on comparison with the girdle from the 'Second Cyprus Treasure' (no. 191), while the marriage scenes on the large plaques of the Dumbarton Oaks belt have their closest analogy on the scene of the marriage of David (no. 180) on one of the plates from the same Cyprus treasure. The belt also illustrates neatly the complete fusion of Christian and classical culture at this time. The belt is a secular object decorated with unambiguously Christian themes, and yet the smaller plaques carry pagan heads, which can be matched most easily on Byzantine silver plates in the Hermitage Museum collection. Such use of pagan figure subjects is typical of the decoration of metalwork in the Christian world of seventh-century Byzantium and shows how deeply its culture was rooted in the classical period.

Justinian's reign was patently a Golden Age, and the gold and silver treasures of the sixth and seventh centuries are there to prove it. The second part of his reign, however, was beset by administrative, political and military problems. Justinian solved the problems, but at the cost of the participation in government of the educated governing classes of the Greek world. His financial officers collected the taxes; but the increasing professionalism of this and all aspects of government now and throughout the sixth century brought to a halt the steady press of talented young gentlemen to Constantinople. By the end of the century the policies of Justinian left his successors no choice but to behave as and to be autocrats, particularly in the face of the threats to the frontiers by two military empires, the Avars to the north and Persia to the east. Territorially Justinian had attempted to reassert the Roman control of the western world; but his western wars involved neglect of the eastern garrisons, and in AD 540 the Shah of Persia, Khusro I, fell on Antioch, the second city of the Empire. He plundered it and marched slowly home again, emptying the cities of northern Syria with impunity. The war in Italy was instantly relegated to a backwater. Justinian and his successors were henceforth

preoccupied with surviving threats closer to home. It is significant that the Byzantine art of professional diplomacy dates from this period and that of the whole great net of imperial roads only one was maintained, the highway leading across Asia Minor to the eastern frontier.

Byzantium was not dead. It lived on as a great world power, and the walls round Constantinople were not finally breached by an enemy until 1453. Byzantium from the sixth and seventh centuries was nevertheless a power of the Near East, quite distinct from Christendom in the West in spite of their links. The gold and silver of the sixth and seventh centuries show that the decline of the Roman Empire was only relative and by no means absolute; but a consumer economy so luxuriously unbalanced inevitably fell into difficulties, and the wonder is that it lasted as long as it did. Heavy imports, a remarkable scale of luxury, frequent and costly wars and subsidies to foreign powers seemed for a considerable time to cause no very serious damage. Yet by the end of the seventh century Byzantium had lost its position as the dominant world power. It had become only one of the three major power-blocks which were to shape the European, Mediterranean and Near Eastern world as we know it today.

Christian Gold and Silver

From the fourth century onwards a good deal of plate was being made for religious use, and from the time of Constantine the churches were vastly enriched with precious vessels. Most of the earliest vessels to have survived, however, belong in date to the sixth and seventh centuries, not to the earlier period.

Jugs were used at the Mass both for pouring wine and washing hands. Incense burners, lamps and candlesticks were also to be found in the churches, while reliquary caskets became more frequent in use.

The 'Riha' Treasure and the 'Stuma' Treasure

Riha is near Aleppo, 60 km south-east of Antioch, in Syria. The 'Riha' Treasure includes a paten, chalice and fan, now in the Dumbarton Oaks Collection. It is probable that the Riha pieces were originally part of a larger treasure which includes both the so-called 'Stuma' Treasure, now in the Archaeological Museum in Istanbul, and also another chalice now in the British Museum, making a total number of eight pieces.

The control stamps suggest that these related pieces were made in Constantinople during the sixth century. If so, the silver- and goldsmiths of Constantinople were working in two quite distinct styles during this period. One of the patens from the Stuma Treasure, for example, is decorated with a relief of the Communion of the Apostles similar to that of the Riha paten, and is of approximately the same date, for the control stamps, though slightly different, are of the same emperor, Justin II (AD 565–578). Yet the two pieces are stylistically different. The faces on the Stuma paten are full and rounded, while the faces on the Riha paten are long and emaciated.

The pieces in this group give us some idea of the splendour of the service in the sixth century, when the use of silver liturgical implements, gilded and often nielloed, was particularly popular in the Byzantine church. The objects in the two groups belonged to the same church and were presented by the same donors, and they include pieces stamped late in the reign of Justin II (AD 577) and in the reign of Tiberius Constantine. Among all the objects one factor stands out clearly: objects of fine technical quality and distinctive style are found with objects of indifferent workmanship and less distinguished style. The differences between them must be due at least to different hands being concerned in their execution, if not to different workshops. Here the documentation of the inscriptions on the Riha and Stuma patens, the inscriptions on the Abegg vessels together with evidence offered by Imperial stamps during this period, suggests that the real difference was between the work of an Imperial workshop and the work of a shop in Syria.

The stamps and inscriptions together lead to the conclusion that Megalos was a Syrian residing in Constantinople in the Imperial service and that one of his duties was to guarantee the quality of Imperial silver by means of his personal stamp. They suggest that, although Megalos acquired his titles and influence in the capital, he donated offerings of silver treasure in remembrance of his family to his home church in Syria. In this church were also two silver objects donated by Sergius the silversmith, one, the Stuma paten, very closely resembling the Riha paten, and almost, but not quite, contemporary with it, the other, the lamp in the Abegg Collection, presented several years later, when Sergius had acquired a new title: *tribounos*. These relationships provide initial evidence for discrimination between silver workshops of the sixth century in Syria and in Constantinople.

144 Silver-gilt paten AD 565–578

D 35 cm. WT 904 g.

Silver-gilt paten with parcel-gilt repoussé relief in the centre depicting the Communion of the Apostles. They are grouped to either end of a cloth-covered altar furnished with four liturgical vessels. Christ himself celebrates the Communion, and is represented twice: once serving bread to the six Apostles on the left, and again offering wine to the six on the right. In the exergue below are two more liturgical vessels, a ewer and a basin used for washing the hands. Around the raised rim is a Greek inscription in niello: 'For the peace of the soul of Sergia, daughter of Ioannes, and of Theodosius, and for the salvation of Megalos and Nonnous and their children'. On the underside are four, or possibly five, control stamps of the Emperor Justin II.

Provenance: Riha, near Aleppo, Syria.

Bibl. Dodd, *BSS*, p. 94, no. 20; Dodd, *BST*, p. 34ff.; Ross, *DO Cat.* 1, no. 10.

Washington, DC, Dumbarton Oaks Collection. 24.5. Bliss Collection (1924).

The inscription may be derived from the Dismissal in the liturgy of the Syrian Jacobites (founded by Jacob Baradaeus, Bishop of Edessa, in 542). This would indicate that the paten may have been ordered in Constantinople (evidenced by the control stamps) by a Syrian, who had the type of inscription that was familiar to him placed upon it.

145 The Riha *flabellum* AD 565–578

W 25·5 cm. H 30·9 cm. WT 485 g.

Silver liturgical fan with peacock-feathered border. In the centre is a tetramorph having four wings (with eyes) covering most of the figure except the face, hands and feet, and flanked by flaming wheels (cf. Ezekiel I: 5 ff.). There are four control stamps of the Emperor Justin II. The decoration of the peacock-feathered border cuts into the cross stamp at the top, indicating that the silver was stamped before being decorated.

Provenance: Riha, near Aleppo, Syria.

Bibl. Dodd, *BSS*, p. 96, no. 21; Ross, *DO Cat.* 1, no. 11.

Washington, DC, Dumbarton Oaks Collection. 36.23. Bliss Collection (1936).

A *flabellum* almost identical with this one is in the 'Stuma' Treasure, but the control stamps are not from the same years and the two pieces are not from the same hand. These fans, originally intended to keep flies from the bread and wine during Mass, were later relegated to purely formal use in processions. The Riha and Stuma fans are the earliest known pair in existence.

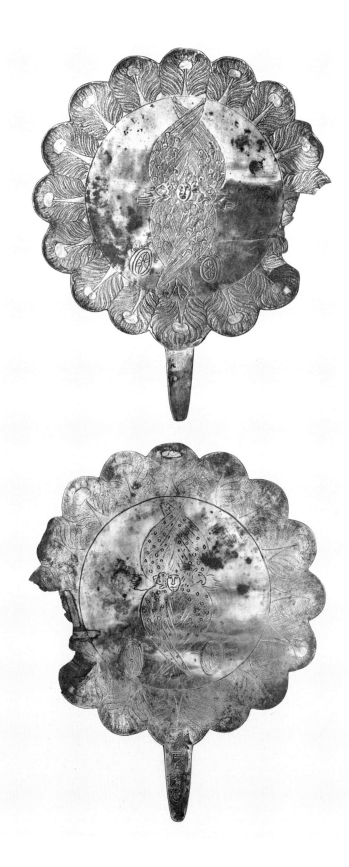

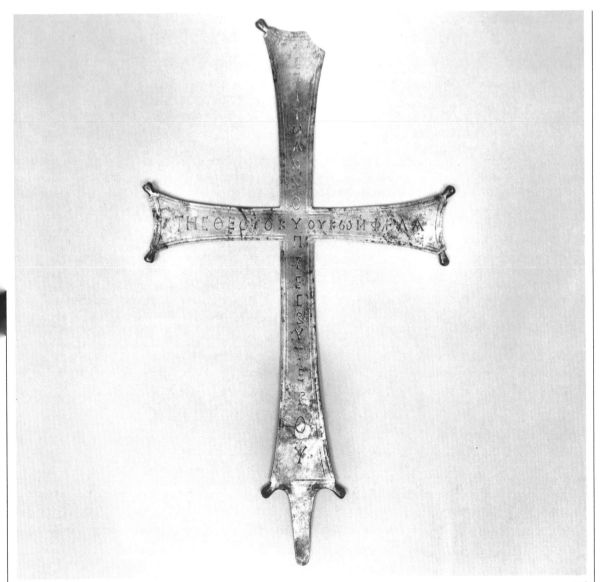

146

The Phela Treasure

The Phela Treasure is named from the inscriptions on the cross (no. 146) and another piece from the same find. The village of Phela has not been identified; but the treasure is said to have been found near the Syrian coast between Banyas (ancient Balanea-Leucas) and Djeble (Gabala). The cross was found with two patens, two fragmentary chalices, and a fragment of another vessel.

146 Silver cross late sixth or early seventh century AD
W 28·4 cm. H 47·6 cm. WT 565 g.
Silver cross with flaring arms ending in small knobs at the eight outer corners, and a tongue at the foot designed to fit into a standard for use in processions, or into a base when placed on an altar. It has a simple border of two parallel engraved lines. The four arms are inscribed in Greek: + ΕΠΙ

ΙѠΑΝΝΟΥ ΠΡΕСΒΥΤΕΡΟΥ (vertically); ΤΕС ΘΕΟΤΟΚΟΥ ΚѠΜ[η]С ΦΕΛΑ (horizontally), which is translated: 'In the time of the priest Ioannes. [An offering to the church] of the Mother of God of the village of Phela'. The reverse is plain, except for a single engraved outline. There are no control stamps on the cross, which may indicate that it was made in Syria. The elegant outline (cf. the cross on a paten also in the Phela Treasure with control stamps of Justin II) and the fine lettering point to a late sixth-to early seventh-century date. The Phela cross is finer than two from Hama, but an example found at Luxor (in the Coptic Museum, Cairo) is superior to it. A bronze cross of similar form is known, and is now in the Detroit Institute of Arts.
Provenance: Syria (Phela Treasure).
Bibl. Ross, *DO Cat.* 1, no. 14.
Washington, DC, Dumbarton Oaks Collection. 55.17. Given by John S. Newberry (1955).

The Antioch Treasure

This treasure was discovered in 1910 by local Arab labourers digging a well near Antioch in Syria at a spot traditionally held to be the site of an ancient cathedral. The objects in the treasure are all of the sixth century, except for the silver cup (no. 147) which has become known as the 'Chalice of Antioch'. The reputation of the treasure, and of the Chalice in particular, was damaged at an early stage by over-zealous admiration which in turn provoked violently opposed views. Some scholars considered the chalice unusual and therefore suspected forgery. Others presumed it was the Holy Grail – with the inner cup having been used at the Last Supper, and the outer, ornate shell added in the first century to enshrine the precious vessel.

Controversy has spilled over into discussion both about the findspot and even about the composition of the hoard. Mr C. Leonard Woolley, in *The Times Literary Supplement* of 10 July 1924, stated that the chalice was found in a small mound close to Ma'arit il Na'aman, a village situated south of Aleppo, about a hundred miles from Antioch. This claim was firmly refuted by the owners and at an Open Meeting in the same year of the Society for the Promotion of Roman Studies. The composition of the hoard has equally been disputed, and even in recent years it has been suggested that the Antioch Treasure and the Hama Treasure (also found in Syria in 1910, at Hama; now in the Walters Art Gallery, Baltimore) are all one find.

The passage of time has allowed a calmer examination of the evidence to take place. Extreme views about the place of discovery and the composition of the group have now been abandoned, and the Treasure of Antioch is now valued on its own remarkable merits.

Bibl. J. J. Rorimer, 'The Authenticity of the Chalice of Antioch', in Dorothy Miner (ed.), *Studies in Art and Literature for Belle da Costa Greene*. Princeton, 1954, pp. 161–8; Bayard Dodge, 'The Chalice of Antioch', in *Bulletin of the Near East Society* III (1950), no. 5, pp. 3f.; no. 6, p. 10; E. C. Dodd, *Byzantine Silver Stamps*. Bern, 1961, p. 20; E. C. Dodd, *Byzantine Silver Treasures*. Bern, 1973, pp. 18–23.

147

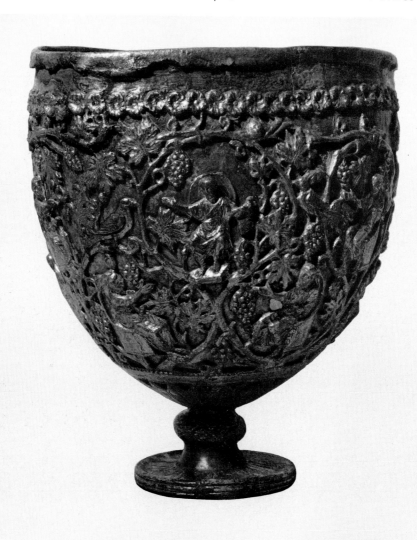

147 The Antioch Chalice *c.* AD 400

H 19 cm. D *c.* 7·5 cm (foot), 15·0 cm (original max.).
Silver-gilt cup comprising an undecorated inner silver cup set into an outer cup. The latter is decorated with silver openwork enriched with gilding, and formed in a series of grapevines among which appear birds, animals and insects. The grapevines encircle twelve male figures – ten apostles and two representations of Christ.
Provenance: Near Antioch, Turkey.
Bibl. Rorimer, *SAL*, pp. 161–8; Rorimer, *MMAC*, pp. 132–4; Beckwith, *ECBA*, pl. 47; Ostoia, *TCMMA*, p. 25, no. 6.
New York, Metropolitan Museum of Art, the Cloisters. 50.4.

This cup has attracted a great deal of attention since its discovery because the decoration suggests that the vessel may be one of the earliest known surviving Christian chalices. It has been the subject of a vast literature, partly owing to an early thesis that the inner cup is none other than the Holy Grail used at the Last Supper. Although scholars today do not accept such an early date, there is as yet no universal agreement on an alternative date for this chalice. Most probably it was created in the late fourth or early fifth century AD. Another theory is that it is a product of the first half of the sixth century.

148/149 Silver book-covers *c.* AD 600

148 H 27·3 cm. W 21·6 cm. 149 H 27·0 cm. W 21·6 cm.
Pair of silver book-covers, each showing a bearded saint within an arch. One saint holds a book, the other holds a cross. The upper corners of each plaque show a pair of confronted peacocks, and a border of vine-scrolls enclosing grape clusters, leaf forms and bird forms in a frame. The vines each spring from a kantharos at the centre of the plaque base, the two strands meeting at a cross in the centre of the top element in each border.
Provenance: Near Antioch, Turkey.
Bibl. Rorimer, *SAL*, p. 161 ff.; Beckwith, *ECBA*, p. 27, pls 48–9.
New York, Metropolitan Museum of Art. 50.5.1, 2.

148

149

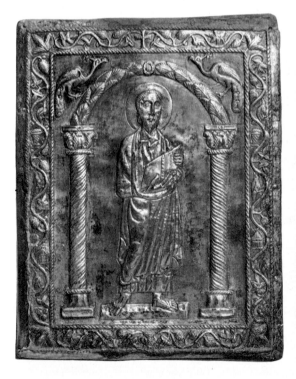

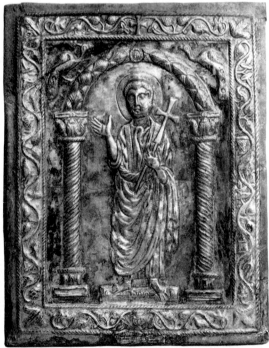

The Lampsacus Treasure

The treasure was found at Lampsacus on the Hellespont and was acquired in 1848. The importance of the group is that it dates from one of the most important reigns in Byzantine history and that it was made in Constantinople.

Of the individual objects the candlestick is of outstanding significance because the only parallel (now in the Dumbarton Oaks Collection), which was found in Antioch and is dated to the reign of Phocas (AD 602–610), was stamped with the name *Theoupolis* (Antioch) at that city. Only one other object, a lamp of the same date found at Hama, Syria, is known with that name-stamp. These latter stamps seem to indicate a control system set up in Antioch and based on the one that used Imperial stamps. That only two such stamps survive suggests that this local system of control did not function very efficiently or for very long. The comparatively crude workmanship of the Syrian stamps and objects serves very well to emphasize the quality of the Lampsacus Treasure.

150 Silver bowl AD 613–629/30

D 15·7 cm.

Silver bowl with an inscribed gilt cross on the interior. The arms of the cross extend to the rim, and in the centre is a nielloed monogram. On the underside of the bowl are five control stamps of the reign of the Emperor Heraclius.

Provenance: Lampsacus on the Hellespont.

Bibl. Dalton, *EC Cat.*, no. 379; Dodd, *BSS*, no. 52.

BM (M & LA) 48.6–1.13. Given by Earl Cowley.

Although the purpose of this bowl may have been liturgical, its significance is as an example of the silverware produced during the reign of Heraclius, one of the high-water marks of Byzantine work in precious metals.

151 Silver candlestick or lamp stand *c.* AD 550–565

H 21 cm.

Undecorated tripod lamp stand or pricket candlestick with baluster-moulded stem. It stands on a hexagonal expanding base stamped on the underside with five control stamps not earlier in date than the second half of the reign of the Emperor Justinian I.

Provenance: Lampsacus on the Hellespont.

Bibl. Dalton, *EC Cat.*, no. 376; Dodd, *BSS*, no. 19.

BM (M & LA) 48.6–1.1. Given by Earl Cowley.

An outstanding and rare object, this provides a rare insight into the lavishness of Byzantine metalwork during what is generally regarded as one of the Byzantine Empire's most successful reigns. Such a candlestick is shown on the paten from Riha (no. 144).

150▽ 151▷

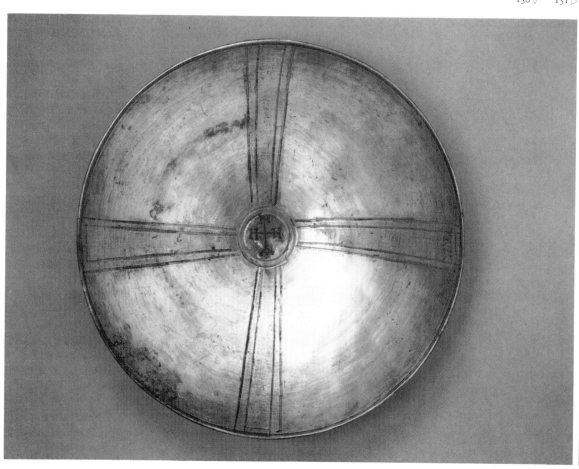

152 Silver spoon *c.* AD 600

L 23·4 cm.

Spoon with pear-shaped bowl, engraved on the underside with a symmetrical design and attached to a baluster-moulded handle by means of a disc. The disc is engraved with a monogram, originally nielloed, probably to be deciphered as MARKOC.

Provenance: Lampsacus on the Hellespont.

Bibl. Dalton, *EC Cat.,* no. 381.

BM (M & LA) 48.6–1.8. Given by Earl Cowley.

This piece shows the persistence of late antique spoon design into the seventh century AD.

The inscriptions on this and other spoons naming the Apostles and Evangelists may have been souvenirs of holy places, and it has further been suggested that spoons inscribed with the names of the Apostles could conceivably have been obtained by pilgrims at the Church of the Holy Apostles in Constantinople.

153 Silver dish with Crucifixion, Resurrection and Ascension seventh century AD

D 22 cm.

Silver dish decorated with three medallions containing figured scenes. These depict (1) the Crucifixion, (2) the Maries at the empty sepulchre of Christ, and (3) the Ascension. The Crucifixion scene shows Christ wearing a long robe, the *colobium,* instead of the loincloth frequent in such scenes. The style, though somewhat more primitive, resembles that of the Rabbula Gospels, a manuscript written and illuminated at Zagba, in eastern Syria, in 586. In these Gospels, too, Christ wears the *colobium* in the Crucifixion scene. The garment is also seen in the decoration of objects such as metal flasks for holy oil and water, made in Palestine and taken home by pilgrims.

Provenance: Perm (now Molotov) Province, USSR.

Bibl. Rice, *ABE,* p. 41, pl. 31; Smirnov, *VS,* no. 38, pl. XV.

Leningrad, State Hermitage Museum.

153

155

The Albanian Treasure

A number of gold and silver objects, including four gold cups, were found in the vicinity of a Roman road near Durazzo in Albania. The presence on the cup (no. 154) of a figure named as Cyprus may supply a clue for its dating. After the Council of Ephesus, in AD 431, the Metropolitan See of Cyprus declared its independence from that of Antioch, and the name of Cyprus was probably used here to emphasize its importance. In such a case, the cup might have been made in Cyprus before AD 647, when the Arabs invaded the island and destroyed the capital, Constantia (formerly Salamis). Three of the four gold cups are in the Metropolitan Museum, New York, the fourth being in the Archaeological Museum, Istanbul. The appearance of the treasure in Albania might be connected with the Byzantine campaigns against the Balkan Slavs and Avars in the last decade of the sixth century.

154 Gold cup c. AD 600

H 16·8 cm.
Gold cup on conical foot. It is decorated in repoussé with four female personifications of imperial cities and metropolitan sees, identified by inscriptions in Greek, below the rim, as Constantinople, Cyprus, Rome and Alexandria.

Provenance: Roman road near Durazzo, Albania.
Bibl. Strzygowski, *AIV,* pp. 3–10, pl. II; Ostoia, *TCMMA,* p. 56, no. 23.
New York, Metropolitan Museum of Art. 17.190.1710. Given by J. Pierpont Morgan (1917).

155 Silver chalice c. AD 550

H 12·7 cm.
Silver chalice with large deep bowl; the stem has a knop and the foot is trumpet-shaped. Below the lip is the inscription:

+*ΥΠΕΡ ΕΥΧΗC CΕΡΓΙΟΥ ΚΑΙ ΙΩΑΝΝΟΥ*

Provenance: Aleppo, Syria.
Bibl. Dalton, *EC Ant.,* p. 108, fig. 65; Dodd, *BST,* pp. 14–15.
BM (M & LA) 1914.4–15.1.

This is one of a clearly defined group of similarly shaped chalices, now divided between various private and public collections and thought to have been made in Syria in the sixth century for presentation to local churches.

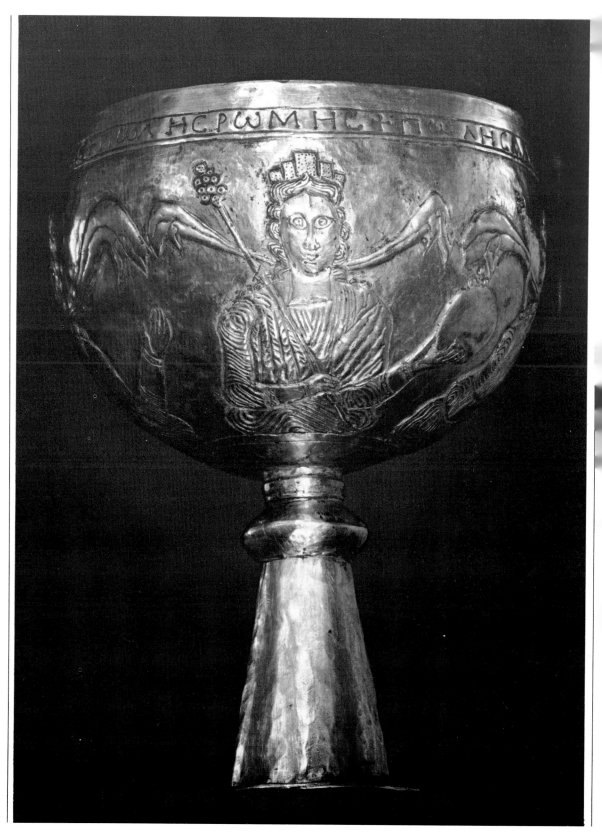

Reliquary Caskets

Reliquary caskets form an important little group among the surviving Christian silver. Before the *Pax Ecclesiae* the rites with which the martyrs had been honoured in the cemeteries had been of a discreet kind. The community honoured their martyrs in the same way as families honoured their dead, but with the triumph of the Church, things became quite different. Each church was proud of its martyrs, and believing with some justification that the list was now complete, a liturgical calendar was drawn up, and each saint was celebrated on the anniversary of his death. The Church also began to honour them with sanctuaries which grew in size and wealth in order to receive the crowds who came on pilgrimage. The fame of the martyrs often spread beyond their city and country. They were venerated as powerful intercessors, and their lives were widely read and often embellished by numerous legends. Both at the sites of their martyrdom and at sites elsewhere it became the practice to honour their bodies or dismembered relics brought from

elsewhere. The cult of relics spread quickly both in the east and the west of the Empire, and fine containers in precious materials – ivory, gold or silver – were made to hold them. Such caskets were decorated with themes from the regular repertoire of early Christian subjects, found for example in wall-paintings in the catacombs and on sarcophagi, and the scenes are the promises that the dead take with them into the next life. There they will observe the realization of the promises, because the miraculous aid that the God of the Old Testament so often gave to his people and the help given by Christ to those he met were guarantees of future salvation.

156 Silver-gilt plaque from reliquary casket sixth-century AD

W 26 cm. H 30 cm.

Parcel-gilt silver plaque decorated in repoussé. The scene shows St Simeon Stylites squatting on his pillar, having outfaced the Devil as a great snake. Clients could consult him by climbing the ladder on the left. At the bottom of the plaque is an inscription in Greek, making the dedication in the name of Euchariston: Εὐχαριστῶν τῷ Θ[ε]ῷ καὶ τῷ /ἁγίῳ Συμεῶνι στυ[λίτῃ] προσήνεγκαι.

Christian hermits and ascetics were well established by the fifth century, when the 'Stylite' saints, who lived on top of pillars, were among their most typical representatives. Their founder Simeon (c. 396–459) occupied a fifty-foot column in the mountainous hinterland of Antioch for forty years. He attracted many pilgrims, and exercised great influence. The remains of the church and monastery built around his pillar

still stand at Qal'at Sim'an.

Provenance: Syria, perhaps from Hama.

Bibl. De Ridder, *Bij. Ant.,* no. 2180; Lassus, *Mon. Piot* 51 (1960), pp. 129–48, pl. VIII; Buschhausen, *Sp. Met.,* pp. 257–9, no. B.25.

Paris, Louvre, Département des Antiquités grecques et romaines. Bj 2180.

157 Silver reliquary casket *c.* AD 600

L 12 cm. W 5·5 cm. H 5·7 cm.

Silver reliquary casket, parcel-gilt. On the cover is the resurrection of Lazarus. On the front is shown the Adoration of the Magi; on the back, the three Hebrews in the fiery furnace. Heavy rope ornament surrounds the scenes. The casket is probably from a church, perhaps that of St Giovanni Battista. A similar casket comes from Henchir Zirar, near Carthage, and another, from the treasury of Sancta Sanctorum, is in the Vatican. The reliquaries in Grado are also related and, though one is oval and one round in form, all have scenes of a similar nature to the Castello di Brivio casket. The affinities suggest a north Italian origin and a date in the second half of the fifth century.

Provenance: Castello di Brivio, Lombardy, Italy.

Bibl. De Ridder, *Bij Ant.,* no. 1951; Lauer, *Mon Piot* 13 (1906), pp. 229–40; Strong, *GSP,* pp. 186–7; Buschhausen, *Sp. Met.,* no. B.14; Volbach, *ECA,* no. 120.

Paris, Louvre, Département des Antiquités grecques et romaines, Bj 1951. Collection Gilbert.

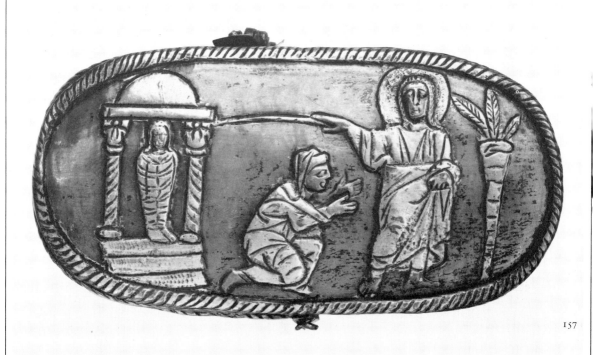

157

Secular Gold and Silver

The culture of the Roman Empire in the sixth and seventh centuries was above all Christian. Secular arts as well as religious were brought to an extraordinary degree of excellence, and Constantinople was now the dominating influence. This domination can be demonstrated particularly from the silver-work. A relatively large number of single pieces and treasures has survived, and a strong chronological framework is supplied by the many vessels carrying imperial stamps. The system of stamps began in the time of Anastasius (AD 491–518) and lasted until the reign of Constans II (AD 641–668).

Plate of the sixth and seventh centuries was for the most part made of silver; but the use of gold was widespread for jewellery from the fourth to the seventh centuries AD, and silver was used only rarely. A variety of different techniques from the preceding period continued to be practised; but an essential characteristic of the period was the growth in the use of *opus interrasile*, the technique of chiselling or cutting through a thin sheet of gold in order to produce an openwork pattern. Precious and semi-precious stones were also much in vogue, and, especially in Egypt, the combination of pearls, sapphires and emeralds was particularly popular.

Christian motifs, used either for purposes of identity, or, more commonly, for protection against sickness or ill-fortune, made their appearance on jewellery at least as early as the third century AD. After the official recognition of Christianity by Constantine the Great in the fourth century, such images became very much more numerous, and by the sixth and seventh centuries appeared on secular jewellery of considerable lavishness. New shapes and new types of jewellery, such as the pectoral cross (no. 162), were also devised in order to satisfy the demand for a specifically Christian form of amulet.

158 Silver saucepan *c.* AD 527–65

L 15 cm (handle), 32 cm (overall). W 18 cm. H 9 cm. D 16 cm. WT 1670 g.

Silver saucepan with gilded relief of fishermen and sea creatures on the outside of the bowl. A figure of Neptune, standing on the back of a dolphin and holding a trident, decorates the handle. The wide and rather clumsy arms of attachment end in eagle heads, while the rest of the space is taken up with two dolphins flanking a shell. There are five control stamps of the Emperor Justinian, four on the bottom of the bowl and one on the back of the handle. The stamps must have been applied before the bowl was finished, since one of them is cut by the incised circles on the bottom of the bowl. This vessel is in the same tradition as saucepans of the fourth and fifth centuries, and the single figure decorating the handle can be paralleled on third-century examples. The control stamps, however, date this piece to the first half of the sixth century. The shallow saucepan from the Esquiline Treasure (no. 94) has a handle of similar form.

Provenance: Cap Chenoua, near Cherchel, Algeria.

Bibl. De Ridder, *Bij. Ant.*, no. 1983; Matzulewitsch, *Byz. Ant.*, p. 8, no. 15 (with bibliography); Dodd, *BSS*, no. 14; Strong, *GSP*, p. 192.

Paris, Louvre, Département des Antiquités grecques et romaines. Bj 1983.

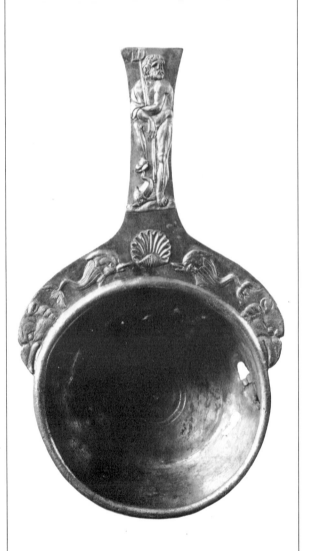

158

159 Foot of a silver dish AD 565–578

D 5 cm.

Foot of a silver dish bearing on the underside five control stamps of the Emperor Justin II.

Bibl. Dodd, *DO Papers* 18, p. 237.

BM (M & LA) 1962.2–4.1.

An apparently unique example of a footring which has survived the dish to which it originally belonged.

160 Silver dish with Meleager and Atalanta
AD 613–629/30

H 1·2 cm (footring). D 12·5 cm (footring), 27·8 cm (dish). WT 1523 g.

Shallow silver dish with footring. The repoussé decoration, with some engraved details, shows Meleager and Atalanta resting after a hunt. They are flanked by two attendants; one on the left, standing under a tree, holds a hare in his hands, while the other holds one of the two horses. There are two hounds and a hunting net in the foreground, and a building in the distance. On the rim is a band of turning, and on the base are five control stamps of the Emperor Heraclius. The story represented here is that of Meleager and Atalanta. Oeneus, father of Meleager, had forgotten to sacrifice to the goddess Artemis, and she therefore sent a great wild boar to ravage the country. Meleager gathered huntsmen and hounds from many cities. When the boar-hunt began, Atalanta was the first to wound the beast. Meleager, who loved her, adjudged her the spoils when he himself killed the boar.

Bibl. Matzulewitsch, *Byz. Ant.*, p. 2, no.1, p. 9 ff. and p. 45 ff., pl. I; Dodd, *BSS*, p. 176, no. 57; Banck, *BACU*, no. 94.

Leningrad, State Hermitage Museum. ω1.

The subject of this dish symbolizes the strand of late Roman culture based on a synthesis of classical and Christian traditions. These traditions came together during the fourth

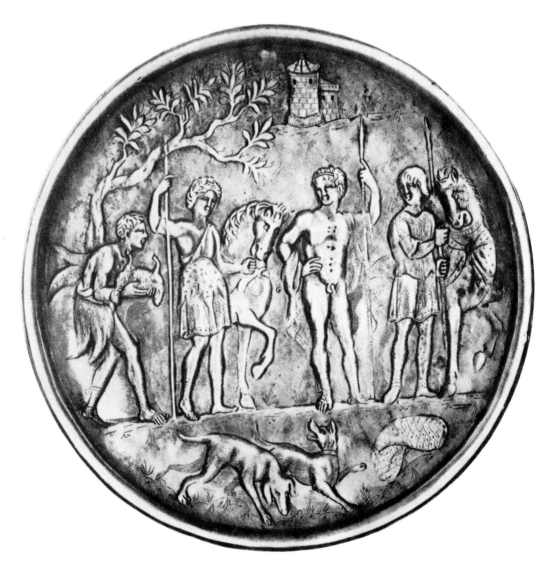

and fifth centuries and were given institutional form largely in the reign of Justinian. While accepting a specifically Christian view of the world, men still read the pagan classics. Classical mythology and philosophy provided for the educated symbols which complemented the code of Christianity, and citations from Homer figure side by side in literature with those from the *Psalms*. At the same time, the classics were appreciated as works of literature and art quite independently of their content.

161 Silver flask with Nereids and sea monsters

AD 641–651

Base 9·2 by 6·8 cm. W 4·8 cm (narrow sides).
H 25·2 cm. D 13·5 cm (flat sides). WT 1132 g.

Silver flask with flat sides; the lid and handle are missing. The neck flares towards the rim, and is ornamented at the base with a moulded collar. There are two loops soldered on at the rim for attaching a lid, and another for a handle at the side. The base of the vessel is pyramidal. On each circular side of the flask is a scene in repoussé depicting a Nereid on a sea monster. On one side the Nereid is full face and holds a mirror; on the other she is seen from behind. Gulls are shown on the narrow sides. On the base are four control stamps of the Emperor Constans II. The place, date and circumstances of discovery are not known. The probable find-place is the neighbourhood of Perm, where the flask was purchased. The Nereids, daughters of the sea god Nereus, lived with their father in the depths of the sea. One of them, Thetis, married Peleus, a mortal, and was the mother of Achilles.

Provenance: Probably found in Perm (now Molotov) Province, USSR.

Bibl. Matzulewitsch, *Byz. Ant.*, p. 5 ff., no. 8, pp. 89–91, pls 19–21; Dodd, *BSS*, p. 215, no. 75; Banck, *BACU*, nos 95–8. Leningrad, State Hermitage Museum. ω256.

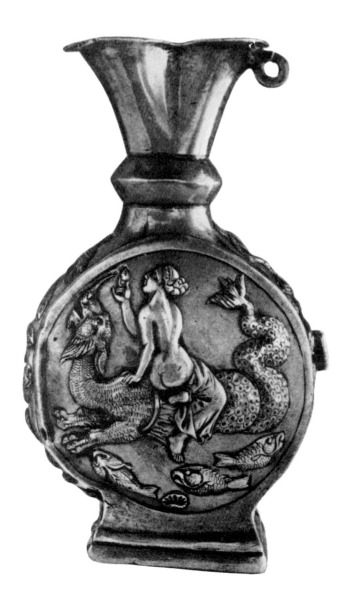

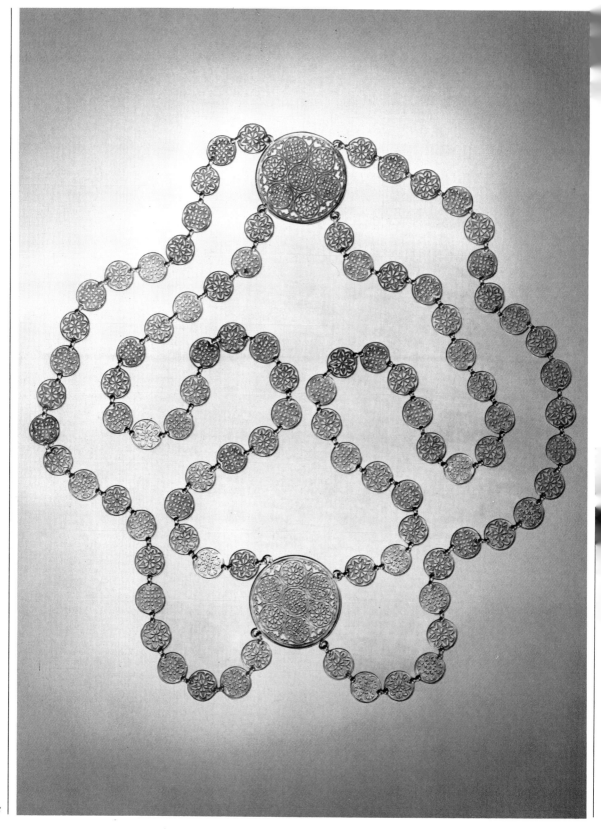

162 Gold pectoral cross sixth–seventh century AD

H 7·9 cm.

A fine and well preserved example of an early Byzantine pectoral cross. In the centre is the crucified Christ, clothed in a long *colobium*. The arms of the cross have rounded ends; at the extremities are medallions with personifications of the sun and moon and figures of the Virgin, St John and the soldiers casting lots. On the back is a champlevé diaper motif, probably at one time filled with niello. There is a broad fluted ring at the top for suspension.

Provenance: Perhaps Athens.

Bibl. BMQ 15 (1941–50), p. 76; Ross, *DO Cat.* 2, p. 22.
BM (M & LA) 1949.12–3.1.

163 Gold breast chain sixth century AD

L 73·4 cm.

There are four long chains, each of twenty-three gold discs pierced with formal foliage patterns. The chains are attached at both ends to two larger discs with similar piercing, one worn at the front and the other at the back.

Provenance: Egypt.

Bibl. Dalton, *East Chr.*, p. 324; Dennison, *GT*, p. 149.
BM (M & LA) 1916.7–4.1.

One of the largest and most important pieces of Byzantine gold jewellery to have survived, its very size suggests that it might have been intended to decorate a statue rather than for personal use. It was clearly intended, nevertheless, to be worn in the same manner as the chains seen on some Romano-Egyptian terracotta figures (e.g. figure no. 1877.11–12.34 in the BM collections).

164 Gold marriage belt *c.* AD 600

L 75·5 cm. D 4·8 cm and 2·5 cm (plaques).

Gold belt composed of two large circular plaques and twenty-one small ones, all pressed from moulds or medallions. The two large plaques represent the *dextrarum iunctio*: Christ is in the centre, with the bridegroom on his right and the bride on his left, joining their right hands before

him. The figure of Christ has a cross nimbus, and a small equal-armed cross appears on each side, above the heads of the bride and groom. To the left is the inscription *EK ΘEOY*, to the right *OMONYA*, and below *XAPIC YΓIA* (From God, concord, grace, health). There is an inner beaded border and a separate outer one attached by gold rivets. The belt is fastened by two hooks on one of the large plaques which fit into rings on the other; from each plaque hangs a leaf-like pendant, also pressed in a mould. The twenty-one smaller plaques represent busts of Dionysiac figures, six types being distinguishable. They are: (1) a middle-aged bearded man facing three-quarters left; (2) a youthful figure facing three-quarters left, wearing a *chiton* with a round fibula on the right shoulder, and holding what appears to be a thyrsus; (3) a full face bust of a youth wearing a wreath-like headdress of leaves; (4) a bust of a youth with a staff or sceptre on the right; (5) a bust of a youth with a staff or sceptre on the left; (6) a bust of an older bearded man with an ornament in his hair and a thyrsus on the left. These smaller plaques have a plain moulding as an inner border, and a beaded outer one. At each side two rings are soldered to the backs of the plaques to link them together.

Provenance: Said to have been found at Antioch, Turkey.

Bibl. Ross, *DO Cat.* 2, no. 38.

Washington, DC, Dumbarton Oaks Collection. 37.33. Bliss Collection (1937).

Belts, as well as rings, seem to have been customary wedding gifts, and other examples are known. The life of St Alexius relates that the saint presented a ring and a belt to his bride in the nuptial chamber. Since only the Greek text uses the word for belt, it may be that the custom was Greek rather than Syrian. The fact that St Alexius gave the belt to his bride in the wedding chamber suggests that the custom was not part of the marriage ceremony. The Dumbarton Oaks girdle is one of the most important examples of sixth–seventh century metalwork to have survived, and in its dignified traditional style and beauty of execution it ranks with the dishes from Constantinople found in Cyprus.

◁ 163

164

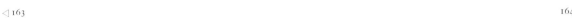

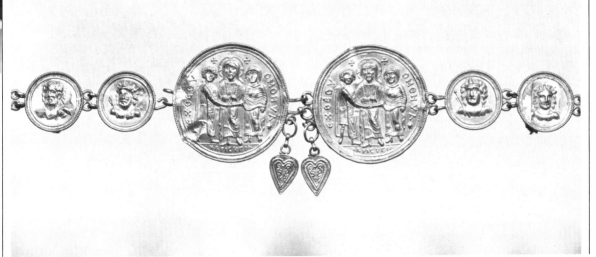

165 Gold marriage ring seventh century AD

D 1·9 cm.

On the lobed bezel are shown four figures standing on the exergue, the two in the centre being Christ and the Virgin, the two on the outside the bride and bridegroom. Beneath the exergue the word *OMONYA* (Concord) is inscribed. Scenes from the life of Christ appear on the seven facets of the hoop. The engraving on the bezel and the hoop is nielloed throughout. This example is characteristic of seventh-century marriage rings.

Bibl. Dalton, *EC Cat.*, no. 129; Ross, *DO Cat.* 2, p. 58.

BM (M & LA) AF 231. Bequeathed by Sir Augustus Wollaston Franks.

166/167 Pair of gold earrings sixth century AD

H 10 cm.

Earrings in the form of a gold ring with three gold chains hanging from it, suspended from loops. At the end of each chain is an openwork bead and a pearl.

Provenance: Fayoum, Egypt.

Bibl. Marshall, *J Cat.*, nos. 2581–2.

BM (G & R) F 2581, F 2582. Bequeathed by Sir Augustus Wollaston Franks.

168/169 Pair of gold earrings sixth century AD

D 4 cm.

Earrings in the form of a ring from which hang six pendants (one now missing); these take the shape of a gold bead and a pearl.

Bibl. Marshall, *J Cat.*, nos. 2681–2.

BM (G & R) F 2681, F 2682. Bequeathed by Sir Augustus Wollaston Franks.

170 Gold bracelet possibly from Syria, fifth–sixth century AD

D 7·2 cm.

Gold hoop with plain tubular edges enclosing a band worked in low relief with pairs of confronted swans and peacocks. The front consists of a circular medallion opening on a hinge and flanked on either side by a square setting, now empty. In the centre of the medallion is a low relief representation of the Virgin with both hands raised (orans).

Provenance: Purchased in Cairo.

Bibl. Garrucci, *AC* 6, pl. 479, fig. 24; Froehner, *Gol.*, no. 198; Dalton, *EC Cat.*, no. 279.

BM (M & LA) AF 351. Bequeathed by Sir Augustus Wollaston Franks.

The pair to this very fine bracelet was in the Dzialinski Collection at Goluchow Castle, Poland, until 1939 (see *Bibl.*).

171/172 Pair of gold bracelets first half of seventh century AD (probably after 615 and before 640)

D 11 cm.

Pair of gold bracelets, each made in the same way and comprising a hoop and a separate central element set with coins. The hoop is tubular, with three rows of beading on the outside and a herringbone pattern on the inside, alternately plain and beaded. At the back on the inside is a repoussé cross. The terminals are short and plain tubes, beaded at each end and closed by a disc with two rings for attachment to the central element. This has one large and four small coins, each set in a frame with a border of gold beading; they are joined at the back by eight gold trefoils with globules in the centres, and between the trefoils are single gold globules. At the back, the coin settings are joined by four curved wire strips and six small plain gold discs. The coins on the bracelet (38.64) are: Phocas (602–610), solidus of Constantinople; Phocas, tremissis of Constantinople; Maurice Tiberius (582–602), tremissis of Constantinople; Maurice Tiberius, tremissis of Constantinople. The coins on the second bracelet (38.65) are: Phocas, solidus of Constantinople; Heraclius (610–641), tremissis of Constantinople; Phocas, two tremisses of Constantinople; Heraclius, tremissis of Constantinople. The coins give the bracelets a *terminus post quem* of the reign of Heraclius, but they were certainly made before the Arab invasion of Egypt in 640. There is comparable material from various parts of Egypt, and this type of jewellery may have been made there. The style is, however, heavily dependent on Constantinople.

Provenance: Said to have been found in Egypt, either in the Fayoum or at Behnesa (the ancient Oxyrhynchus).

Bibl. Ross, *DO Cat.* 2, no. 46.

Washington, DC, Dumbarton Oaks Collection. 38.64–5. Bliss Collection (1938).

173 Gold bracelet *c.* AD 625

H 2·6 cm (setting). D 8 cm.

Gold bracelet comprising several elements, the principal one being a pair of splendid panthers springing from a hinge at the back and supporting a box-like setting with a very high bezel, probably for a cabochon. The hind feet of the panthers rest on a plain section with rings forming the hinge, held by a pin. Their forefeet rest on rings which fit into others on each side of the box-like setting to form two hinges with pins. Both pins hold a pearl at each end. The sides and bottom of the setting are in openwork.

Provenance: Said to have been found at Hadra, Egypt.

Bibl. Ross, *DO Cat.* 2, no. 47.

Washington, DC, Dumbarton Oaks Collection. 38.66. Bliss Collection (1939).

This is one of the most elaborate bracelets to survive from the Byzantine period. It is said to have been found at Hadra near Alexandria, a provenance which may indicate that it was made in Egypt. The date of the bracelet depends on that of several closely related pieces, such as the pair from Egypt set with coins of Heraclius (171–172).

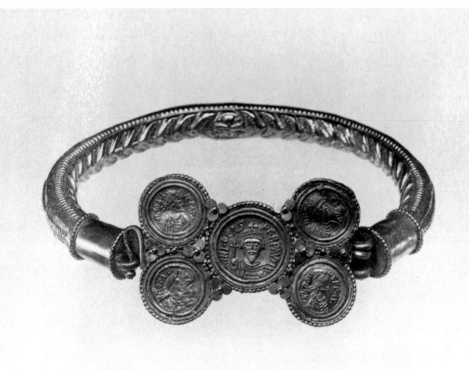

172△ ▽173

The Cyprus Treasures

Concealment and Discovery. Lambousa is the Byzantine popular name of ancient Lapethos, which flourished on the northern coast of Cyprus for about a thousand years. The Byzantine town was completely destroyed by the Arabs during their attack on the island in AD 653–654. Out of its ashes sprang the twin townships of Karavas and Lapethos. The ruins of Lambousa were used as quarries for the new settlements and it was during the quarrying of building material from the ruins that two important treasures were discovered by the villagers of Karavas.

The 'First Cyprus Treasure' was discovered at the end of the nineteenth century and eventually found its way to the British Museum. The latest dated object is the bowl with St Sergius in its centre, on the base of which are control stamps of the years AD 641–651. The 'Second Cyprus Treasure' was discovered in February, 1902, in two lots. The first consisted of gold objects and was found in a pot hidden under a floor. The second consisted of silver plates and was discovered walled up in a niche. The police confiscated a part of the treasure, which now belongs to the National Museum of Cyprus, Nicosia. The biggest lot found its way to Paris, and it was eventually donated to the Metropolitan Museum of New York in 1917.

The two treasures reflect the riches of Lambousa in the sixth and seventh centuries and the close connections of Cyprus with Constantinople during that period. The Arabs must have known about the riches of the town when they were setting their terms for the surrender of Lambousa during their siege of AD 653–4. Under the circumstances a great number of the inhabitants must have hidden parts of their treasures, hoping to retrieve them when the storm was over.

Character of the Treasures. The 'First Cyprus Treasure' (also known as the 'Lambousa Treasure') may have belonged to a church. In the 'Second Cyprus Treasure', on the other hand, there is nothing which proves that any of the objects were originally made for religious uses. The worldly character of the jewellery is obvious, and the decoration of domestic plate with biblical subjects must have been by no means unusual at a time when Christian designs loomed so large alike in the major and minor arts. It is, moreover, possible that both discoveries were one treasure belonging in antiquity to an extremely wealthy individual.

The 'David Plates' in the Second Treasure deserve special comment. All bear the five control stamps of the Emperor Heraclius (AD 610–641), and are dated between AD 613 and 629–630. The subjects on the dishes have evident affinities to the illuminated Byzantine Psaltery of the ninth to twelfth centuries and also to the carved wooden doors of the Church of St Ambrose at Milan, which may date from the close of the fourth century. Six of the nine subjects chosen for the doors correspond with the series on the silver dishes, and it would therefore appear that a regular David cycle must already have been in use. It has sometimes been assumed that, because no existing Greek psalter is earlier than the ninth century, the illustration of the Psalms in manuscripts appeared at that time as something new. The relationship, however, of the compositions of the scenes on the plates to the scenes on such monuments as the doors of St Ambrose, and to the illus-trations in the manuscripts, shows that in the sixth century there were in circulation pictures of the story of David closely similar in conception to those in favour in the tenth and eleventh centuries. It also supports the theory that in the fourth and fifth centuries there existed illustrated Psalters, which are now lost.

The nine David plates are unique among surviving Byzantine and Roman vessels because of their narrative relationship. It is known that silver vessels were made for display in Roman homes and that show-plates were even made in pairs. The complex unity of the David set, however, is unprecedented, and it is not unlikely that the commission came from some important member of the court or perhaps from the reigning Emperor Heraclius himself. The stimulus for making this unique and luxurious group may even have been a specific historical event from the life of the Emperor. In AD 627 Heraclius, during his campaign against the Persian Emperor Khusro, fought the Persian general Razatis in single combat, beheading his opponent, as David did Goliath. Support for this theory of a contemporary identification of Heraclius and Razatis with David and Goliath seems to come from a description of the battle by Fredegar, chronicler at the Burgundian court of the Merovingian King Dagobert in AD 629. If the news was of such importance as to be conveyed to the far west of Europe in two years, the victory must surely have been of even greater renown in Constantinople. The David plates, on the evidence of the stamps, were made in Constantinople between AD 613 and 629–630, and their commissioning and manufacture are difficult to dissociate from the same triumphal event.

Bibl. O. M. Dalton, 'A Byzantine Silver Treasure from the district of Kerynia, Cyprus, now preserved in the British Museum', in *Archaeologia* LVII (1900), pp. 159–74; O. M. Dalton, 'A Second Silver Treasure from Cyprus', in *Archaeologia* LX (1906), pp. 1–24; A. and J. Stylianou, *The Treasures of Lambousa.* Nicosia, (1969); S. H. Wander, 'The Cyprus Plates: The Story of David and Goliath', in *Metropolitan Museum Journal* 8 (1973), pp. 89–104; S. H. Wander, 'The Cyprus Plates and the *Chronicle* of Fredegar', in *Dumbarton Oaks Papers* 29 (1975), pp. 345–6.

174 Silver dish AD 578–582

D 27·1 cm.

Circular silver dish with a central cross within a border of ivy leaves. The dish has a low, flat footring; on the bowl's underside are five control stamps of the Emperor Tiberius II Constantine.

Provenance: Lambousa, Cyprus.

Bibl. Dalton, *EC Cat.*, no. 397; Dodd, *BSS*, no. 28; Stylianou, *Lam.*, p. 61, fig. 10; Dodd, *BST*, pp. 27–8. BM (M & LA) 99.4–25.1.

It has been suggested that this dish was intended for use as a paten; this view, if accepted, would make the dish a very early example of that type of liturgical vessel.

175 Silver bowl AD 641–651

D 24·7 cm.

Silver bowl with central medallion surrounded by a band of nielloed ornament. In the medallion, in low relief, is the full face bust of a nimbate saint, probably either St Sergius or St Bacchus. On the underside are five control stamps of the Emperor Constans II.

Provenance: Lambousa, Cyprus.
Bibl. Dalton, *EC Cat.*, no. 398; Dodd, *BSS*, no. 78; Stylianou, *Lam.*, p. 61, fig. 9.
BM (M & LA) 99.4–25.2.
Colour plate.

The purpose of this dish, which comes from the so-called 'First Cyprus Treasure', is uncertain, but it may have been liturgical. This is one of the finest and best preserved pieces in the Treasure.

176 Hexagonal silver censer AD 602–610
D 10·6 cm.
Silver vessel designed to be suspended by means of chains, now missing. On each side is a medallion containing a nimbed bust, as follows: Christ, the Virgin, St Peter, St Paul, St John the Evangelist, St James. On the base is a set of control stamps of the reign of the Emperor Phocas.
Provenance: Lambousa, Cyprus.
Bibl. Dalton, *EC Cat.*, no. 399; Dodd, *BSS*, no. 35; Stylianou, *Lam.*, p. 61, figs 2–8; Dodd, *BST*, p. 48, fig. 40.
BM (M & LA) 99.4–25.3.

One of the major pieces in the so-called 'First Cyprus Treasure', this is among the earliest and finest of Byzantine censers.

177 Silver spoon c. AD 600
L 22·8 cm.
Spoon with pear-shaped bowl engraved on the underside with a foliate design and attached to the handle by means of a vertical disc. The handle, of hexagonal section, is engraved and nielloed with two pairs of letters separated by a cross: *AY +AA*.
Provenance: Lambousa, Cyprus.
Bibl. Dalton, *EC Cat.*, no. 400.
BM (M & LA) 99.4–25.4.

This is one of the simpler spoons from the so-called 'First Cyprus Treasure'.

178 Silver spoon c. AD 600
L 25·4 cm.
Spoon with pear-shaped bowl engraved on the underside with a foliate design and attached to a baluster handle by means of a vertical disc. The interior of the bowl is embossed with the figure of a running ram.
Provenance: Lambousa, Cyprus.
Bibl. Dalton, *EC Cat.*, no. 414.
BM (M & LA) 99.4–25.23.
Colour plate.

The spoon is one of the most characteristic from the so-called 'First Cyprus Treasure'.

176

179 The David Plates: David and Goliath AD 613–629/30

D 49·4 cm (plate), 20·7 cm (footring).

Large silver plate with footring, decorated with three scenes in relief. The top scene is the meeting of David and Goliath and shows the two men addressing one another in dispute, with a personification of the valley, in the Hellenistic manner, seated between them. The middle scene shows the actual fight between the two. Goliath, in full armour, attacks David from the right with a spear. David blocks Goliath's spear with his cloak wrapped round his left arm; his right hand is just about to sling the deadly stone at the giant Philistine. Behind David two armed soldiers stand in readiness; behind Goliath two armed soldiers are shown in retreat.

The attitudes of the four soldiers prepare us for the result of the fight. In the bottom scene Goliath is on the ground in a dramatic fall. David has detached Goliath's sword and is about to slay him (I Sam. 17: 40–51). On the base are five control stamps of the Emperor Heraclius.

Provenance: Lambousa; from the 'Second Cyprus Treasure'.
Bibl. Dodd, *BSS*, p. 178, no. 58; Stylianou, *Lam.*, pp. 33–7 and 62, pl. 25, no. 7; Ostoia, *TCMMA*, no. 21; Weitzmann, *MMJ* 3 (1970), pp. 97–111; Wander, *MMJ* 8 (1973), pp. 89–104.
New York, Metropolitan Museum of Art. 17.190.396. Given by J Pierpont Morgan.

This is the largest and most beautiful of the David Plates in the 'Second Cyprus Treasure'.

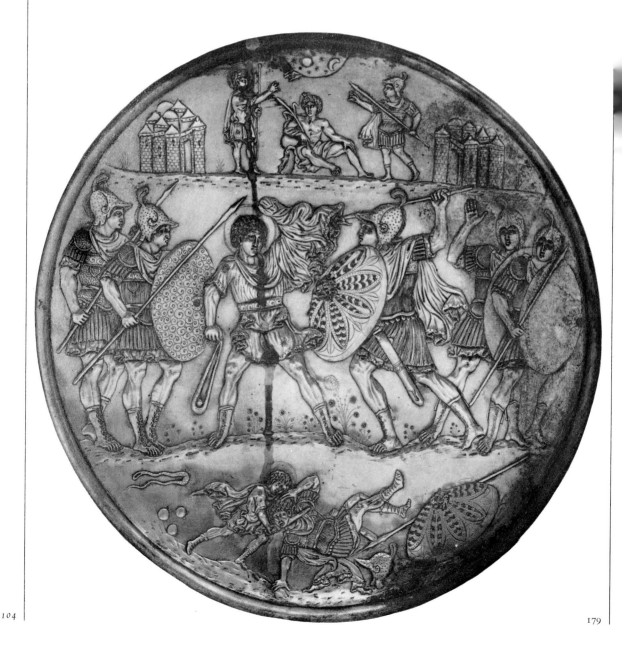

180 The David Plates: Marriage of David and Michal

AD 613–629/30

D 26·8 cm (plate). D of footring 11·8 cm.

Silver plate of footring, with relief depicting Marriage of David and Michal (I Sam. 18: 20–29). David and Michal join their right hands while King Saul presides between them. Two pipers play music on either side. There are five control stamps, damaged during the hammering of the relief.

Provenance: Lambousa; from the 'Second Cyprus Treasure'.

Bibl. Dodd, *BSS*, no. 59; Stylianou, *Lam.* pp. 37–9, 62–3, pl. 22, no. 8.

Nicosia, National Museum of Cyprus. J. 452.

The scene derives from Roman prototypes where Concordia-Homonoia or Juno-Pronuba usually presides over the marriage. In later representations the place of the goddess is taken by the father or guardian of one of the couple, or by Christ.

181 The David Plates: Introduction of David to Saul

AD 613–629/30

D 26·5 cm (plate). D of footring 12 cm.

Circular silver dish with relief of the meeting of David and Saul (I Sam. 16: 21). There are five control stamps: (a) a square with the monogram of Heraclius, inscribed in Greek, (cross) *Co(m)itas*; (b) a long stamp with the bust of Heraclius, and the monogram in Greek, *Theodorou*, and inscribed in Greek, *(Sch)ol(a)s(ticis)*; (c) a cruciform with flared arms, inscribed in Greek, (cross) *Co(smas)*; (d) under the centring point and close to the long stamp part of a hexagonal outline can be seen; under the long stamp are the remains of the inscription in a round stamp. It is difficult to determine whether the stamps were applied before or after the plate was decorated; but, since it belongs to a set, it was probably decorated at the same time as its companion pieces, that is, after the stamps had been applied.

Provenance: Lambousa; from the 'Second Cyprus Treasure'.
Bibl. Dodd, *BSS*, no. 60.
New York, Metropolitan Museum of Art. 17.190.397. Gift of J. Pierpont Morgan.

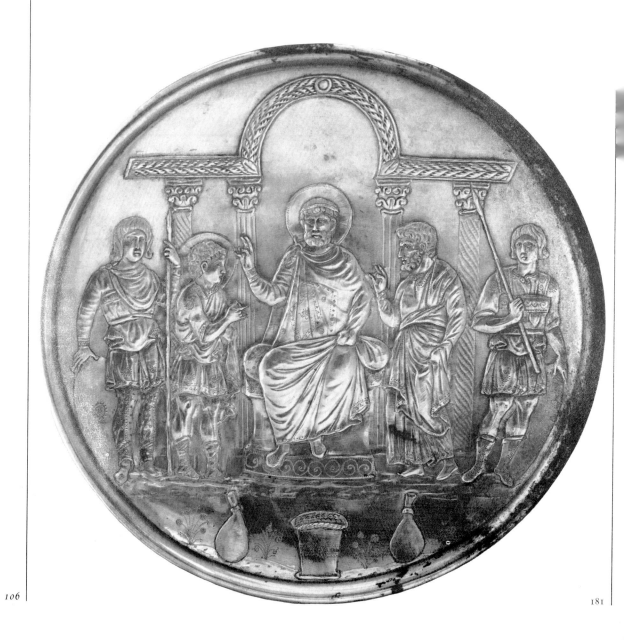

182 The David Plates:
David trying on Saul's Armour

AD 613–629/30

D 26 cm (plate). D of footring 12 cm.

Circular silver dish with relief of David trying on Saul's armour (I Sam. 17: 38). Dodd comments, 'This plate shows particularly well the technique of joining together two sheets of silver after the relief has been moulded. Inside the footring the relief is revealed in repoussé; but on the outside the plate is perfectly smooth. Breaks in the silver are visible on the rim and on the footring where the second sheet has been joined to the first. This technique was used for all the David plates'. Four stamps are visible – a round, a square, a long, and a cruciform. These stamps appear to have been applied before the decoration of the plate, since the cross stamp is clearest where the relief has been hollowed out to form David's head. They are almost identical with the corresponding stamps on the matching pieces.

Provenance: Lambousa; from the 'Second Cyprus Treasure'.
Bibl. Dodd, *BSS*, no. 61.

New York, Metropolitan Museum of Art. 17.190.399. Gift of J. Pierpont Morgan.

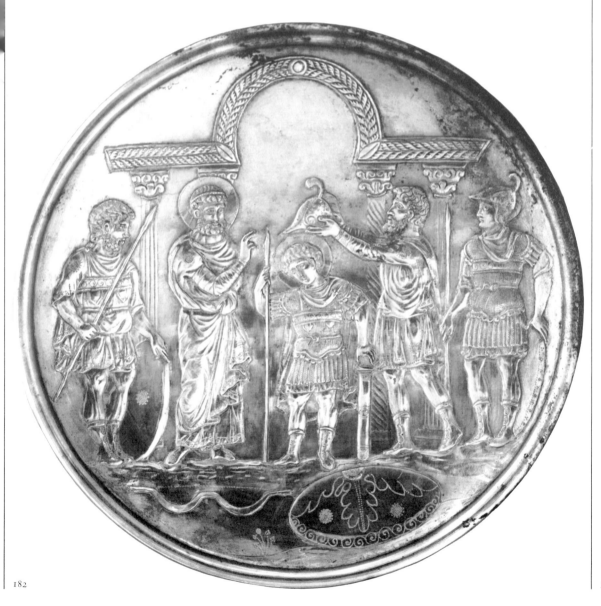

182

183 The David Plates: Anointing of David

AD 613–629/30

D 26 cm (plate). D of footring 12 cm.

Silver plate with footring, decorated with relief of the anointing of David (I Sam. 16: 12–13). The scene takes place before a classical portico. David stands in the centre, turned to the left to face Samuel, who pours the oil over his head. David's father Jesse stands behind him, and two of his brothers watch from either end. There are five control stamps of the Emperor Heraclius.

Provenance: Lambousa; from the 'Second Cyprus Treasure'.

Bibl. Dodd, *BSS*, p. 186, no. 62; Stylianou, *Lam.*, pp. 23–5 and 62, pl. 19, no. 2.

New York, Metropolitan Museum of Art. 17.190.398. Given by J Pierpont Morgan.

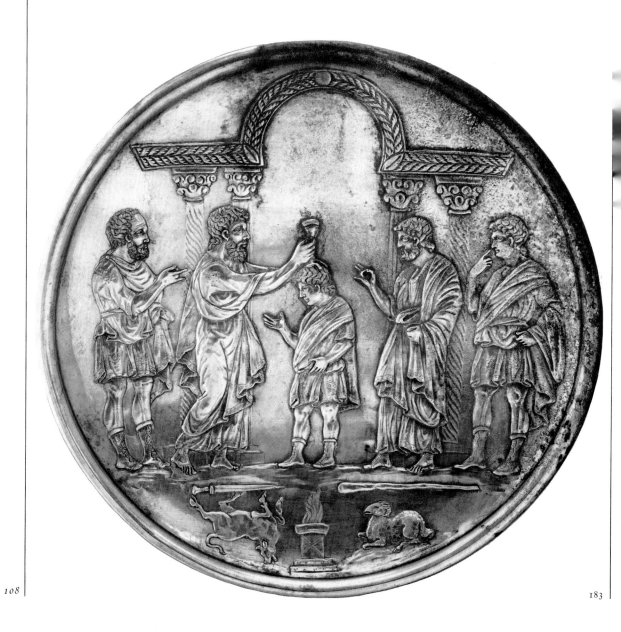

184 The David Plates: David slaying the Lion

AD 613–629/30

D 14 cm (plate). D of footring 6·5 cm.

Circular silver dish with relief of David slaying the lion
(I Sam. 17: 34–36). There are five stamps on the base – a
round, a square, a long, and two cruciform, almost identical
with the stamps on the matching pieces. The centring point
cuts into the cross stamp, and, since this plate belongs to a set,
it was probably decorated at the same time as its companion
pieces, that is, after the stamps were applied.

Provenance: Lambousa; from the 'Second Cyprus Treasure'.
Bibl. Dodd, *BSS*, no. 63.

Metropolitan Museum of Art, New York No. 17.190.394.
Gift of J. Pierpont Morgan.

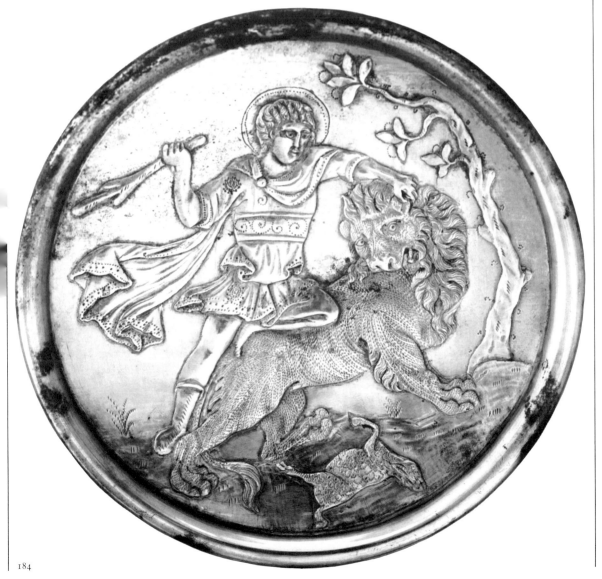

184

185 The David Plates: David and the Soldier

AD 613–629/30

D 14 cm (plate). D of footring 6·5 cm.

Circular silver dish with relief of David and the soldier (I Sam. 30: 11ff.). On the base five stamps are distinctly visible – a round, a square, a long, and two cruciform, all nearly identical with the corresponding stamps on the other plates in the David set. In addition a sixth stamp, hexagonal, can be discerned beneath the round stamp in the centre. Like the other pieces in the set, this plate was probably decorated after it was stamped.

Provenance: Lambousa; from the 'Second Cyprus Treasure'.

Bibl. Dodd, *BSS*, no. 64.

Metropolitan Museum of Art, New York No. 17.190.395. Gift of J. Pierpont Morgan.

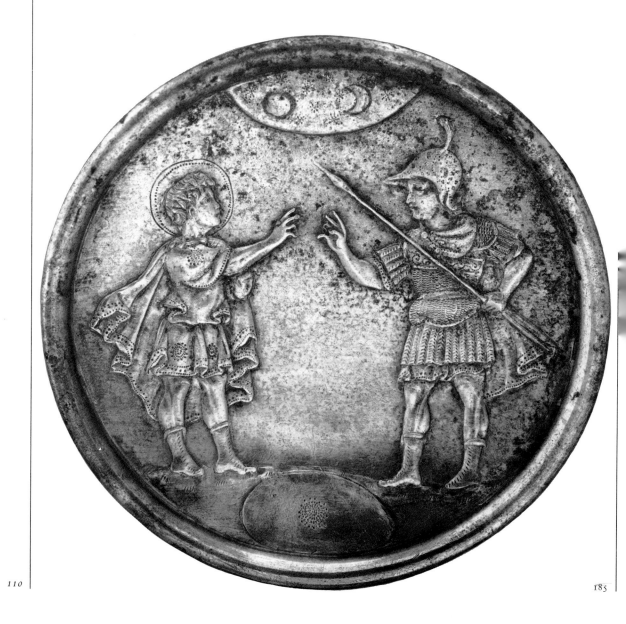

AD 613–629/30

D 14 cm (plate). D of footring 6·5 cm.

Silver dish with footring, with relief of David as shepherd. The messenger arrives running and addresses David on the right who sits holding his harp. In the foreground are two sheep (I Sam. 16: 11–12).

Provenance: Lambousa; from the 'Second Cyprus Treasure'.

Bibl. Dodd, *BSS*, no. 65; Stylianou, *Lam.* pp. 21–3, pl. 18, no. 1.

Nicosia, National Museum of Cyprus. J. 454.

187 The David Plates: David Slaying the Bear

AD 613–629/30

D 14 cm. D of footring 6·5 cm.

Silver plate on footring with relief of David slaying the bear (I Sam. 17: 36). David faces left, kneeling with his left knee on the back of the bear, holding its mane with his left hand. His right hand is about to smite the beast with a stick. There are five control stamps. Like other plates in this set this piece was probably decorated after it was stamped.

Provenance: Lambousa; from the 'Second Cyprus Treasure'.

Bibl. Dodd, *BSS*, no. 66; Stylianou, *Lam.* pp. 31, 62, pl. 22, no. 5.

Nicosia, National Museum of Cyprus. J. 453.

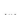

188 Silver Plate with Niello Monogram AD 602–c. 605
D 44 cm (plate). D of footring 19·4 cm.
Silver plate with central wreath of leaves and cruciform monogram in niello, framed by two gilded bands. Its control stamps date it in the reign of the Emperor Phocas (AD 602–610).
Provenance: Lambousa; from the 'Second Cyprus Treasure'.
Bibl. Dodd, *BSS*, no. 33; Stylianou, *Lam.* pp. 41–3, 63, pl. 30, no. 10.
Nicosia, National Museum of Cyprus. J. 455.

189 Silver plate with niello cross AD 613–629/30
D 36·8 cm (plate). D of central roundel 10 cm. D of footring 15·4 cm.
A large silver dish on a footring, with a niello cross in the centre, surrounded by a floral wreath. Its control stamps are of the time of the Emperor Heraclius.
Provenance: Lambousa; from the 'Second Cyprus Treasure'.
Bibl. Dodd, *BSS*, no. 54; Stylianou, *Lam.* pp. 43, 63, pl. 31, no. 11.
Nicosia, National Museum of Cyprus. J. 456.

190 Gold necklace with cross c. AD 600
L 91·5 cm.
Gold necklace consisting of two parts: a chain with filigree heart-shaped links, and ten hollow hexagonal cylinders strung on a swivelled chain. Eleven pendants are hung between the cylinders, and a cross cast in solid gold is suspended in the centre. It is flanked by two hollow leaf-shaped repoussé ornaments and eight hollow miniature amphorae of three different shapes, also worked in repoussé and decorated with ornamental patterns and cross-hatching in relief. The clasp of the necklace is an openwork circle.
Provenance: Lambousa, Cyprus.
Bibl. Dalton, *BAA*, pp. 541–2; Stylianou, *Lam.*, pp. 53 and 64, pl. 40, no. 17; Ostoia, *TCMMA*, no. 20.
New York, Metropolitan Museum of Art. 17.190.151. Given by J Pierpont Morgan (1917).

The style and technique of this and six other items of gold jewellery found in the 'Second Cyprus Treasure' reflect earlier prototypes of Hellenistic and Roman times, and were common in the Near East during the sixth and seventh centuries. It has been suggested that these Cypriot examples may have been made in Lambousa itself.

191 Gold belt c. AD 583
L 64·8 cm. H 6·4 cm.
Gold belt composed of four mounted consular medallions and twelve solidi. The four medallions bear the bust of the Emperor Maurice Tiberius (AD 582–602) and were issued at Constantinople. The coins are of Theodosius II, Justin I and Justinian, Justin II and Tiberius II, and Maurice Tiberius. A thirteenth coin belonging to the same belt is in the Nicosia Museum.

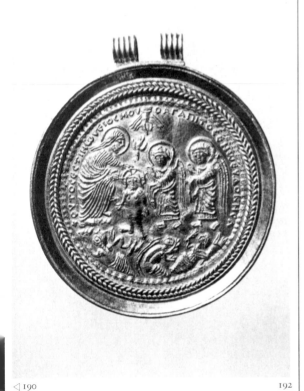

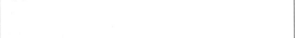

Provenance: Lambousa, Cyprus.
Bibl. Grierson, *Num. Chron.* 15 (1955), pp. 55–70, pls VI–VII; Ross, *DO Papers* 11 (1957), pp. 247–61; Grierson, *DO Papers* 15 (1961), pp. 221–4; Stylianou, *Lam.*, pp. 49–53 and 64, pls. 37, 38 and 39, no. 16.
New York, Metropolitan Museum of Art. 17.190.147.

The only two comparable belts are the marriage belts in the Dumbarton Oaks Collection (no. 164) and the Louvre. These, however, are only comparable in concept because they are made of moulded plaques, whereas this girdle is apparently unique in being made up of coins and medallions which were struck, and there is no reason to suggest that this was a marriage belt like the other two.

Recent studies have shown that the style of the medallions in this girdle is comparable to that of the Epiphany medallion (no. 192), also from the 'Second Cyprus Treasure' and now in the Dumbarton Oaks Collection. The Epiphany medallion, too, was mounted by the same goldsmith as the medallions and coins of the girdle. They seem to have been struck at more or less the same time and presented to the same person – an official of high rank. The Epiphany medallion was probably made to commemorate the baptism of Maurice Tiberius's son, which is thought to have taken place at the festival of the Epiphany in AD 584. It is likely, therefore, that the medallions in the girdle were struck to commemorate the first consulship of Maurice Tiberius in 585 rather than the second in 602. The coins in the girdle from the earlier reigns are rare, but the majority, from the reign of Maurice Tiberius, occur frequently.

192 Gold 'encolpium' (Epiphany medallion) *c.* AD 583/4
L 32·5 cm (each chain), 8·5 cm (total length of triple links). D 6·5 cm (*encolpium*), 1·5 cm (small discs). WT 109 g (*encolpium*).
This unique twelve-solidi medallion is framed as a pendant, with chains and additional pieces. The obverse of the medallion bears the Virgin and Child enthroned, attended by the Archangels, and an abbreviated birth of Christ with the adoration of the Magi. The reverse shows the baptism of Christ, with personifications of the river Jordan. On the obverse is inscribed in Greek: *X|ριστ|ε Ο Θ|εο|C HMωN| BOHΘICON HMIN* (Christ, our God, help us). The inscription either side of the baptism reads: + *OYTOC ECTIN ω YEIOC MOY|O AΓAΠITOC EN ω EYΔOKHCA* (This is my beloved Son in whom I am well pleased – *Matthew* 3 : 17).
Provenance: Lambousa, Cyprus.
Bibl. Ross, *DO Cat.* 2, no. 36.
Washington, DC, Dumbarton Oaks Collection. 55.10. Formerly in the collection of Josef Strzygowski.

It is generally accepted that the medallion was issued at Constantinople by the Emperor Maurice Tiberius on the baptism of his son Theodosius at the feast of Epiphany, AD 584. This valuable medallion must have been issued only to a small number of courtiers and other high officials. It demonstrates strong influence of religious iconography on Imperial medallions in the late sixth and seventh centuries. Numerous imitations exist in thin sheet gold with pressed relief; such pseudo-medallions were also made in southern Italy, and were even imitated by the barbarian tribes. This example from the 'Second Cyprus Treasure', however, is the only original one known to survive.

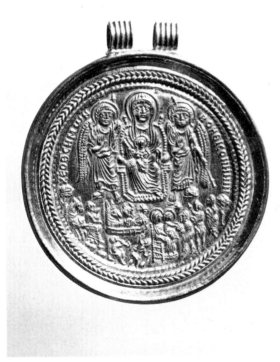

◁ 190

192

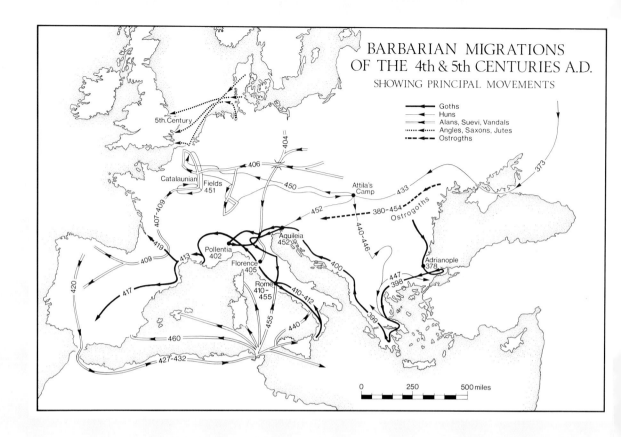

BARBARIAN MIGRATIONS
OF THE 4th & 5th CENTURIES A.D.
SHOWING PRINCIPAL MOVEMENTS

Goths
Huns
Alans, Suevi, Vandals
Angles, Saxons, Jutes
Ostrogths

5th.Century

404

406

450

Attila's
Camp

433

373

Catalaunian

Fields
451

452

380-454
Ostrogoths

407-409

419

Aquileia
452

440-446

Pollentia
402

Florence
405

413

400

447

Adrianople
378

409

398

Rome
410-
455

410-412

399

420

417

455

440

460

427-432

0 250 500 miles

GOLD AND SILVER
FROM THE LATE-ROMAN WORLD
BEYOND THE FRONTIERS

At the moment of the collapse of the Roman Empire in the west gold and silver had been used for over 4000 years to measure and store wealth. It was prized not only for its relative scarcity but also for its ease of working and its intrinsic beauty. During this long period of time world stocks had steadily accumulated to a massive figure. Its form might be constantly changing, from vessels to coins or jewellery or back again. With the decline of one power and the growth of another precious metal was always on the move, its economic gravity varying from time to time. Such transitions, however, had not normally been very abrupt; and it is doubtful if the use and availability of gold and silver had ever previously been subjected to the shocks and uncertainty, fear and sheer loss of technical culture which beset the Western Empire of Rome from the fifth century onwards.

It is difficult to imagine the speed and chaos which marked the barbarian invasions of Europe at this time. At the end of the fourth century the Visigoths had ravaged Greece and, under Alaric, passed from Greece to Italy, withdrawing from there to Gaul and then to Spain only when Rome was pillaged and Alaric himself dead. Gaul itself, in the early fifth century, had been invaded also by the Alani, Suevi and Burgundi. The Burgundi settled easily in the Rhône valley – the Roman policy of subsidy and 'friendship' brought a curious dividend in the ease with which they adopted a romanized existence there. To meet the others the Emperor Honorius had to buy the help of the Visigoths themselves, at the price of Aquitania. Spain finally absorbed the Alani, Suevi and Vandals, the last of whom crossed into Roman Africa. In northern Gaul the pressure came from the Merovingian Franks who, though they successfully supported Rome against another and far more terrible menace from Attila and the Huns, ended up in control of all Gaul save Burgundy, until even Burgundy fell to them later. Thus the three greatest provincial areas of the Roman west, Gaul, Spain and Africa, were lost. Britain had been given up earlier. Italy had already served as a corridor for invaders, and the Balkan provinces north-west of Greece proper were yet another gateway along which fresh migrations were to travel into the ferment of Central Europe, forming a pattern of the most fluid and restless change.

The collapse of the Roman Empire in the west had simple and sharp effects on the production and behaviour of gold and silver. Production, transport, central control and redistribution broke down. In general, however, even though the previous Roman-controlled flow of gold and silver had effectively stopped, the invaders possessed some quantity of it. They started coinages of their own with very little delay and thus they probably set free much currency, which until then had been hoarded away out of fear and lack of confidence. Mints were set up in many places; some operated by civic authorities, some by the churches, and some by the kings themselves. Theodebert I (534–547) summoned up enough courage to banish from his coins the almost sacredly traditional portrait and name of the Byzantine

emperors, ruling far off at Constantinople, in favour of his own.

The coinage serves as a very useful guide to the quantity of precious metal in circulation and the directions which it took in commerce. Without such a guide the evidence would be scanty indeed.

On the northern and western fringes of the Empire silver plate was being produced – though in very small quantities – which followed prevailing Roman fashions but contained strong elements of local style. The gold jug and dish from the Treasure of Petrossa are both closely related to Roman fifth-century designs; but some of the ornament is of local inspiration, as is the decoration of much of the Albanian Treasure (no. 154). Some at least of the vessels of the Carthage Treasure were probably produced in that city in the fourth century, and plate was certainly being manufactured there in the time of Justinian. One stamped silver plate (now in Turin) depicting a Nereid riding on a sea monster, dated December 541, probably commemorates the fall of the Vandal Kingdom to Belisarius in December, 533.

Whether the silversmith returned to Carthage with Belisarius or whether production continued during Vandal rule cannot be known; but there are plates from Valdonne in France which bear imitation Imperial stamps most probably related to Merovingian coins of the mid-seventh century. At the same time silver from the Byzantine Empire was reaching the most far-flung corners of the known world. Some travelled as objects of trade, and some as gifts from people of consequence; for example, the presents sent by the popes to English kings and queens mentioned by Bede.

One of the most remarkable north-western groups of such silver is that made in the Byzantine Empire and found in the Sutton Hoo ship-burial in 1939 and deposited about AD 625. The great silver dish (no. 236), 27 inches in diameter, bears under its base the control stamps of the Emperor Anastasius (AD 491–518). The fluted bowl with a classical head (no. 237) should be compared with the fluted bowls in the Mildenhall (no. 66) and Esquiline Treasures (no. 95). The set of ten silver bowls (nos. 241–7), nine inches in diameter, are each decorated with an equal-armed cross, and are paralleled in treasures, like the Lampsacus Treasure, that have a specifically Christian character, and may themselves have Christian significance. They can hardly have been made before AD 600. The spoons (nos. 239, 240) are of a well-known late-classical type. All these silver objects demonstrate dramatically the manner in which even a remote seventh-century Anglo-Saxon royal house had its eyes turned towards the centre of the Roman world. At the same time, however, the contrast between the haphazard collection of silver plate, of various dates and of varying quality, and the masterpieces of gold jewellery, which have every appearance of having been made in one workshop and perhaps by one goldsmith, shows how the social, political and economic picture of the late Roman world in the west had changed radically by the seventh century.

Very little jewellery has survived, considering the wide area of Europe that is involved. Nevertheless it is from the jewellery that remaining details of the picture of gold and silver in the West must be drawn. Its motifs and its general treatment are very often un-Roman; but its level of technical skill, at any rate down to about AD 700, is such as to suggest that the delicate working of the metal was admired and prized by the new 'barbarian' kings. The most obvious contrast is between the scale of the work undertaken at this time and that of the Graeco-Roman era. Then the possession of many a small object of gold or silver lay within the reach of large numbers of fairly wealthy owners. Now the range of ownership appears to have been restricted to a few, whose precious possessions were not only substantial in actual size but also of frequently remarkable magnificence in relation to other metalwork of the time. The gold jewellery, for example, in the Sutton Hoo ship-burial had evidently been made for kingly state and pleasure, but for plate those

burying the king had to use Roman plate of considerable age before it was interred. Towards AD 700, however, there was not enough gold available in the European kingdoms either to furnish or to guarantee an economy based on gold coins. As a result the Merovingian coinage of France at this time declines from gold into silver. The supply of gold in the West had reached a point of scarcity at which gold currency in the true sense became impossible and even gold jewellery became very rare. This western lack of gold was to continue more or less acutely for five centuries from *c.* AD 700.

Apart from the plate produced and used within the Roman Empire the work of her craftsmen was exported and imitated beyond the eastern frontiers as well. Roman influence is particularly strong in work of Sassanian origin, and Sassanian metalwork must have played a part in the development of Roman plate, particularly in the eastern provinces. The meeting of the two worlds is symbolized in the remarkable amphora from the Conceşti hoard, which, with its apparent Graeco-Persian affinities, looks like the work of a silversmith outside the main stream of Roman metalwork.

To the east of the Roman Empire there had been a great renaissance of Persian power at the beginning of the third century AD, for the Parthian rulers had been bad administrators of the territory, and power had become divided among many small potentates. Their Persian successors, a family of rulers called the Sassanids, created a strong state which became a leading world power from the third to the seventh centuries AD. The Sassanids regarded themselves as the rightful heirs to the ancient Persian Empire of Cyrus and Darius, and imitated its administration with great success. Unfortunately the strength of the Sassanian state was sapped by the unending wars in which its rulers indulged. Much defensive warfare had to be carried on against the raids of nomad tribes from Turkestan, but the senseless and destructive battles, lasting for some four centuries, against the late Roman Empire, in which neither side was strong enough to gain a decisive victory, brought no permanent advantage to Persia.

In many ways the Sassanian period (AD 224–642) nevertheless witnessed the highest achievement of Persian civilization. The Sassanian dynasty, like the Achaemenid, originated in the province of Fars in the heartland of Iran, and Ardashir and his successors, having wrested the Persian kingdom from the Parthian Arsacids, set out to emulate their predecessors, the Achaemenids. At its greatest the Sassanian Empire stretched from Syria to north-west India, and its influence was felt far beyond these political boundaries.

Consciously looking back to the greatness of the Achaemenian Empire, to a far greater degree than the Parthians, the Sassanian kings developed a strong centralized control of their empire from the capital at Ctesiphon. The efficiency of administration allowed not only military successes and imperial expansion, but also large-scale building and irrigation works. The major rival of Rome, and later of Byzantium, the Sassanian kingdom also had contacts towards the east, with a well-established trade across central Asia to China. There was always danger along the northern and eastern frontiers of Persia from a variety of groups threatening danger, repeating a familiar pattern in the history of Western Asia. Along the western frontier, similarly, there was constant tension with the Roman Empire. In the third century, however, the Sassanian forces were more than a match for the Roman. The culminating event is commemorated symbolically in Sassanian sculpture by the relief at Naqsh-i-Rustan, where the Roman Emperor Valerian is shown kneeling at the foot of the victor Shapur I in AD 260. The military basis of the Sassanian ruling classes is demonstrated by the gold and silver which they lavished on their swords.

The silversmiths of the Sassanians were extraordinarily skilful. Sophisticated techniques of figures added in relief and of partial gilding were used. The beauty of

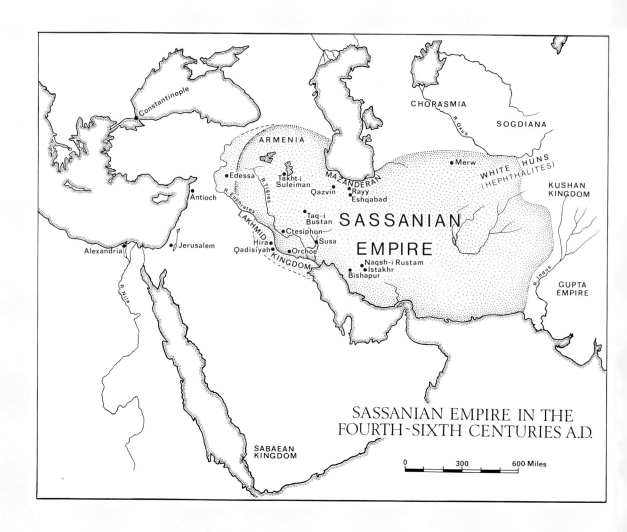

CHORASMIA

SOGDIANA

•Merw

WHITE HUNS
(HEPHTHALITES)

KUSHAN
KINGDOM

ARMENIA

MAZANDERAN

•Edessa

Takht-i
Suleiman

Qazvin
•Rayy
Eshqabad

SASSANIAN
EMPIRE

Antioch

Taq-i
Bustan
•Ctesiphon
Susa

•Jerusalem

Hira•
Qadisiyah•
•Orchoe

Naqsh-i Rustam
•Istakhr
Bishapur

Alexandria•

LAKHMID

KINGDOM

GUPTA
EMPIRE

Constantinople

R.Oxus

R. Euphrates

R.Tigris

R. Nile

R.Indus

SABAEAN
KINGDOM

SASSANIAN EMPIRE IN THE
FOURTH-SIXTH CENTURIES A.D.

0 300 600 Miles

the products gave Sassanian silver a widespread influence, felt as far away as China, where motifs were copied during the early T'ang dynasty. There was direct borrowing from the classical world, as may be seen in the depiction on a silver dish of the Triumph of Dionysos. Even detailed technical practices were copied and used: a Sassanian phalera in the Dumbarton Oaks Collection, for example, has three stamps of the late seventh or early eighth century, which are directly linked to those used in Constantinople itself. At the same time, however, stylistic techniques of Persia and the Near East, such as frontal representation, were taken into the Roman repertoire, perhaps because of the change of style of government.

The relationships and differences between Roman and Sassanian art are demonstrated in the silver-ware and the coins just as much as in the better-known sculptured rock reliefs. Sassanian reliefs may have been inspired in overall design by Roman triumphal reliefs, but the manner of treatment and presentation is very different. Roman reliefs are pictorial records always with an attempt at realism. The purpose of Sassanian reliefs is the glorification of the monarch: divine and royal personages are portrayed on a scale larger than those of inferior persons; compositions are as a rule symmetrical; human figures tend to be stiff and heavy, and there is an awkwardness in the rendering of anatomical details. There is no attempt at portraiture either in the sculptures or in the royal figures depicted on metal vessels or in the heads on the obverses of coins. Each emperor is distinguished merely by his own particular form of crown (Shapur II, AD 307–379, dish with hunting scene (no. 304), and coins; Bahram Gur, AD 421–439, dish with lion-hunt scene (no. 307), and coins). Eastern influence may well be held to be responsible for similar tendencies at work in the Roman Empire itself as early as the fourth century. The Constantius II dish (mid-fourth century) from Kertch, for example, has just this tendency of presenting a living imperial icon, a far cry from the first century figure of Augustus on the Ara Pacis. The Emperor has been transformed into an abstract, hieratic image, whose precise features are of less concern to the artist than the evocation of the concept of imperial power, presented in the Persian manner.

By the seventh century both the Byzantine Empire and the Persians were so exhausted that they fell victims to the Muslim Arabs, who, fired by the message of Islam, carried everything before them. The Arabs, whom the Persians should have been able to defeat without difficulty, crushed the mighty Persian state in the course of a few years and gradually overran much of central Asia and western India. In the west the Arabs pushed on to the Straits of Gibraltar and in AD 711 crossed into Spain. In the east the Arab conquest wholly dislocated the structure on which Byzantine prosperity had been based. In their sweep to the west they quickly absorbed great accumulations of gold, some of which in other circumstances would normally have been traded back into Constantinople. Persia had employed a silver currency, and her wealth of gold had accumulated into a great reserve, which fell into Arab possession. In Syria, likewise, they could appropriate the great stores of gold, whether coined or in the form of luxury articles, which assiduous traders and middle-men had built up over centuries. The same applied to Egypt, and besides this there was immense Islamic activity in the fresh exploitation of Egyptian, Nubian and Ethiopian gold-bearing areas, not so much in the reopening of old mines as in the easier search for rich alluvial deposits.

The Arab conquest of Persia and Syria in the seventh century AD was immediately reflected in the establishment of a gold coinage of great purity (about 97 per cent), and subsequently great profusion, which quickly attained the status of a major international medium, ultimately rivalling and even exceeding that of Byzantium in its range and penetration. For the Arab invaders the possession of large stocks of captured gold offered either the transition to instant habits of personal luxury or the opportunity of taking from the Byzantine Empire whatever could be taken of her

widespread commercial contacts. They chose the latter course, and in so doing set themselves up as a trading race of an extraordinary activity and success. At the end of the seventh century the first Arab gold coins appeared under the Caliph Abd-el-Malik at Damascus, the immensely rich capital of the Umaiyad dynasty: at first they imitated contemporary Byzantine types, but almost at once changed to the form in which Arabic dinars were to be famous for hundreds of years to come, not only in the Levant and Africa but in Europe as well, with all pictorial ornament religiously excluded in favour of quotations from the Koran. The character of the Islamic coinage was not affected by the overthrow of the Umaiyads by the Abbasids: indeed, the main result was that the Umaiyads then spread farther westward, taking with them both gold and the habit of gold currency, until they finally crossed into Spain and set themselves up in Andalusia, where they minted gold profusely from the early tenth century onwards.

The conquest of Persia in the fourth century BC by Alexander the Great had inaugurated the spread of Hellenistic art into Western Asia; but the East only accepted the outward form of this art and never really assimilated its spirit. Already in the Parthian period Hellenistic style was being interpreted freely by the peoples of the Near East. Throughout the Sassanian period there was a continuing process of reaction against it, and the art of the Sassanian period revived forms and traditions native to Persia.

The Sassanian Empire fell in AD 642 to the attacks of the Muslim Arabs, who had speedily emerged as the major force in the Near East. The artists and craftsmen, however, put themselves at the disposal of the new rulers and the needs of the new religion, and it was through them that traditional Persian ornament came to have a profound influence on Islamic art. The metalworkers, like their fellow-artists, carried on the great traditions of their predecessors, and in the early Islamic period it is often difficult to distinguish whether a vessel is of Sassanian or early Islamic date since techniques, shapes and decoration underwent little change.

The Traprain Law Treasure

Most hoards of Roman gold and silver have been found within the boundaries of the Empire, presumably concealed by their owners to save them from theft or destruction. The Traprain Law hoard, which contains fragments of over one hundred silver vessels, came to light in the frontier zone and may be loot from Roman Britain, where the existence of fine silverware in the late antique period is attested by finds such as those from Mildenhall and Corbridge. Similar hoards of broken silver have been found outside the Empire at Coleraine and Balline in Ireland, Gross Bodungen in Germany and Høstentorp in Denmark. The broken vessels in these hoards have generally been regarded as loot, destined by their barbarian owners for the melting-pot.

It is noteworthy, however, that this broken silver is frequently associated with coins and with metal ingots. Possibly the broken vessels were exported in this condition, being regarded, like the coinage and ingots, as a form of currency. Within the frontier they may be compared, for example, with the hoard of gold coins found at Water Newton in 1974, which included two pieces of broken silver plate, carefully folded. These are best explained as having the same significance as the coins with which they were buried. The fact, therefore, that most known hoards of broken silver have been found outside the Imperial frontiers is not necessarily of significance in considering their use.

193 Figured silver flagon fourth century AD, deposited in the early fifth century

H 21 cm.

Silver, parcel-gilt flagon of ovoid form with a slender neck and flaring mouth. There is a small vertical rim. The base is formed of large beads hammered from within, and the neck is encircled by a knob in the form of a laurel wreath. The repoussé decoration is in two main zones: the upper, narrower one represents the pastoral paradise; the lower contains four Biblical scenes – the Fall, the Betrayal, the Adoration of the Magi, and Moses striking water from the rock. Gilding on the human figures is restricted to the garments. The original gilding was lost during the conservation process, but subsequently accurately restored. This is one of five figured flasks or flagons in the Treasure. The scenes recall Romano-Christian carved sarcophagi.
Provenance: Traprain Law, East Lothian, Scotland.
Bibl. Curle, *TT*, pp. 13–19, no. 1; Toynbee, *AB*, p. 313.
National Museum of Antiquities of Scotland, Edinburgh, GVA 1.

194 Silver goblet fourth century AD, deposited in the early fifth century

H 10·4 cm. D 8·6 cm (rim), 10·4 cm (foot).

Silver goblet on a baluster stem, with a wide, flat base-plate. The shallow cup is gilded on the interior, and has a slight external moulding at the edge. The stem is formed of four vase-shaped elements, and the foot has a grooved edge. On the underside of the base is the graffito CON, probably the first syllable of the owner's name, e.g. Constantinus or Constantius. The base-plate was found detached and folded, but has been restored to its correct position. Six cups are represented in the hoard. A pair of similar goblets was found

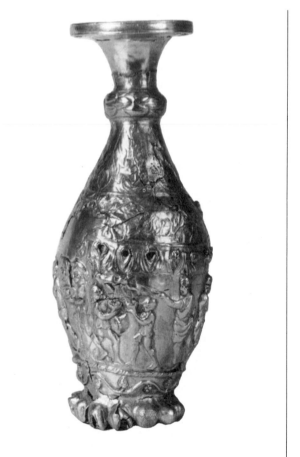

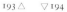
193 △ ▽ 194

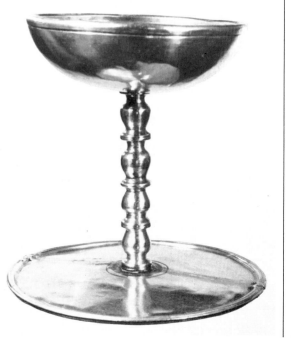

in the Mildenhall Treasure (nos. 68,69), but other examples in silver are apparently unknown. It has been suggested that the goblets could also be inverted to form small pedestalled dishes. The cups are fourth-century tableware, not chalices.

Provenance: Traprain Law, East Lothian, Scotland.
Bibl. Curle, *TT*, p. 29, no. 13; Strong, *GSP*, p. 187.
National Museum of Antiquities of Scotland, Edinburgh, GVA 13.

195 Fragmentary silver basin fourth century AD, deposited in the early fifth century
W 3·8 cm (rim). D *c.* 50 cm.

Three fragments from a large silver bowl or basin. The largest piece has a 20·3 cm curve of rim, and gives the profile almost to the centre. The flat horizontal rim is edged with solid-cast beads and decorated with stylized foliate motifs between large letters forming an inscription; each letter is gilded and placed within an incised circle. The main part of the bowl is formed of plain curved flutes with rounded ends, while the centre has a zone of small repoussé bosses surrounding some feature now lost – perhaps an *emblema,* a human bust or some other object cast in the round. Such an *emblema* could well have been of gold. The surviving groups of letters on the three pieces of rim read, respectively, SAVI, TISAL and P. One arrangement of the two larger pieces would allow for the word VIVATIS. There are no fewer than fifty bowls in the Traprain Treasure, including both complete and fragmentary examples. Their diameters range from 14 cm to 53·4 cm. Bowls showing the curved fluting occur at other sites in this period (e.g. Mildenhall).

Provenance: Traprain Law, East Lothian, Scotland.
Bibl. Curle, *TT*, p. 32, no. 19.
National Museum of Antiquities of Scotland, Edinburgh, GVA 19A–C.

196 Silver bowl fourth century AD, deposited in the early fifth century
H 6·6 cm. D 16·5 cm.

Small silver bowl with a beaded rim and separate footring. The raised beads on the rim indicate use as a food vessel, not a drinking cup. Six bowls of this size and type, and fragments of two others, were found in the hoard.

Provenance: Traprain Law, East Lothian, Scotland.
Bibl. Curle, *TT*, p. 34, no. 23.
National Museum of Antiquities of Scotland, Edinburgh, GVA 23.

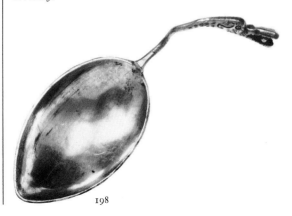
198

197 Scalloped silver bowl fourth century AD, deposited in the early fifth century
H 6·3 cm. D 30·5 cm.

Shallow scalloped or fluted silver bowl. The twenty-four radial panels are alternately flat areas, decorated with stylized foliate or geometric designs, and plain flutes with rounded ends. In the centre of the bowl is a roundel engraved with a Nereid riding on a marine panther, and surrounded by shells and dolphins among the waves. On the outside of the bowl are three of the four original handle-mounts; they are pointed ovoid bosses with hooks in the form of swans' heads emerging from the upper edge. They would have supported swing handles, like those on the similar bowl from the Mildenhall Treasure (nos. 66, 67). This type of bowl is characteristic of the fourth century; further examples are known from the Esquiline Treasure and from Weiden, near Cologne.

Provenance: Traprain Law, East Lothian, Scotland.
Bibl. Curle, *TT*, pp. 36–9, no. 30; Toynbee, *AB*, p. 313; Strong, *GSP*, p. 202; Grünhagen, *Gr. Bod.*
National Museum of Antiquities of Scotland, Edinburgh, GVA 30.

198 Silver spoon fourth century AD, deposited in the early fifth century
L 8·9 cm (bowl).

Silver spoon with a large oval bowl, somewhat pointed, and a short handle in the form of a swan's head. The swan holds in its bill a small spherical object, perhaps a fruit. Originally the bird's head was probably turned back sideways to the edge of the bowl, as in other examples of this type of spoon. On the base of the bowl is a graffito reading CAVIMMIXOVIVS. There are two main types of large spoon with bird's head handles in fourth-century hoards. One type, as instanced in those from Hof Iben, Vermand and Canoscio, has the handle turned sideways, and the Traprain piece probably belongs to this group. The other type has the handle curved in an S-shaped bend; there are examples from Spontin, Namur and Canterbury.

Provenance: Traprain Law, East Lothian, Scotland.
Bibl. Curle, *TT*, p. 67, no. 102; Painter, *JBAA* 28 (1965), p. 7; Painter, *JRS* 56 (1966), p. 221.
National Museum of Antiquities of Scotland, Edinburgh, GVA 102.

199 Silver spoon fourth century AD, deposited in the early fifth century
L 13·4 cm. D 6·5 cm (bowl).

Silver spoon with a deep circular bowl and a handle in the form of a dolphin. The bowl has a slightly inturned rim. The long, slender dolphin grasps the rim of the bowl in its mouth. Circular spoons or ladles, some with dolphin handles, occur in other hoards of the period. The five ladles in the Mildenhall Treasure (nos. 70, 71) have dolphin handles of somewhat different form from the Traprain piece. The seven ladles in the Carthage Treasure (no. 102), and examples from Canoscio and Desana, have similar bowls but plainer handles.

Provenance: Traprain Law, East Lothian, Scotland.
Bibl. Curle, ·*TT*, p. 70, no. 106; Strong, *GSP*, p. 193.
National Museum of Antiquities of Scotland, Edinburgh, GVA 106.

The Coleraine Hoard

Deposited after *c.* AD 410, and possibly after 420. This hoard of late Roman *hacksilber* and 1506 coins was found at Ballinrees, Coleraine, Co. Londonderry, N. Ireland. One of the latest hoards from Roman Britain (although technically found outside the province), its character and provenance suggest that it is piratical loot taken in the troubled years of the early fifth century.

Bibl. (Main articles citing earlier publications) Walters, *SP Cat.*, p. 52; Mattingley *et al.*, *Antiquity* 11 (1937), pp. 39–45; PAINTER, *JBAA* 28 (1965), pp. 1, 6, 7; Painter, *Ant. J* 52 (1972), pp. 84–92; Böhme, *Ger. Grab.*, pp. 81–3.

200 Part of silver ingot deposited after *c.* AD 410, possibly after 420

L 6·9 cm. W 7·7 cm. WT 151·75 g.

Part of flat, double-axe shaped silver ingot, stamped:

[. . OFF]

CVRMISSI

The upper line is partly obliterated by damage at the edge of the cut. The other portion of this ingot is no. 202.

Provenance: Ballinrees, Coleraine, N. Ireland.

Bibl. Walters, *SP Cat.*, p. 52, no. 195, fig. 54; Mattingley *et al.*, *Antiquity* 11 (1937), pp. 43–4, pl. VI; Painter, *Ant. J* 52 (1972), pp. 85–6 and 88, pl. XXVIII (d).

BM (M & LA) 1855.8–15.1.

Only one other ingot with this inscription is known (from Kent), apparently produced from the identical stamp.

201 Half of silver ingot deposited after *c.* AD 410, possibly after 420

L 5·3 cm. W 5·75 cm. WT 70 g.

Half of double-axe shaped silver ingot with the stamped inscription:

EX OF PA

TRICI

The ingot fragment has been pierced by an irregular hole, and one corner cut away.

Provenance: Ballinrees, Coleraine, N. Ireland.

Bibl. Mattingly *et al.*, *Antiquity* 11 (1937), pp. 43–4, pl. VI; Walters, *SP Cat.*, p. 52, no. 196, fig. 55; Painter, *Ant. J* 52 (1972), pp. 85 and 88, pl. XXVIII (d).

BM (M & LA) 1855.8–15.2.

202 Part of silver ingot deposited after *c.* AD 410, possibly after 420

L 8·65 cm. W 5·55 cm. WT 160 g.

Part of flat, double-axe shaped silver ingot, the remaining portion being no. 200.

Provenance: Ballinrees, Coleraine, N. Ireland.

Bibl. Walters, *SP Cat.*, p. 52, no. 7; Mattingly *et al.*, *Antiquity* 11 (1937), pp. 43–4, pl. II; Painter, *Ant. J* 52 (1972), p. 88.

BM (M & LA) 1855.8–15.3.

203 Silver ingot deposited after *c.* AD 410, possibly after 420

L 13 cm. W 3·5 cm. WT 328·5 g.

Flat, bar-shaped silver ingot.

Provenance: Ballinrees, Coleraine, N. Ireland.

Bibl. Walters, *SP Cat.*, p. 52, no. 198; Mattingly *et al.*, *Antiquity* 11 (1937), pl. II; Painter, *Ant. J* 52 (1972), p. 88.

BM (M & LA) 1855.8–15.4.

204 Silver ingot deposited after *c.* AD 410, possibly after 420

L 12·85 cm. W 3·5 cm. WT 339·5 g.

Flat, bar-shaped silver ingot.

Provenance: Ballinrees, Coleraine, N. Ireland.

Bibl. Walters, *SP Cat.*, p. 52, no. 199; Mattingly *et al.*, *Antiquity* 11 (1937), pl. II; Painter, *Ant. J* 52 (1972), p. 88.

BM (M & LA) 1855.8–15.5.

205 Silver ingot deposited after *c.* AD 410, possibly after 420

L 8·1 cm. W 1·5 cm. WT 57·5 g.

Bar-shaped silver ingot.

Provenance: Ballinrees, Coleraine, N. Ireland.

Bibl. Walters, *SP Cat.*, p. 52 ff.; Mattingly *et al.*, *Antiquity* 11 (1937), pl. II; Painter, *Ant. J* 52 (1972). p. 88.

BM (M & LA) 1855.8–15.6.

206 Silver ingot deposited after *c.* AD 410, possibly after 420

L 8·45 cm. W 1·45 cm. WT 55 g.

Bar-shaped silver ingot.

Provenance: Ballinrees, Coleraine, N. Ireland.

Bibl. Walters, *SP Cat.*, p. 52 ff.; Mattingly *et al.*, *Antiquity* 11 (1937), pl. II; Painter, *Ant. J* 52 (1972), p. 89.

BM (M & LA) 1855.8–15.7.

207 Silver ingot deposited after *c.* AD 410, possibly after 420

L 8·1 cm. W 1·45 cm. WT 51·5 g.

Bar-shaped silver ingot.

Provenance: Ballinrees, Coleraine, N. Ireland.

Bibl. Walters, *SP Cat.*, p. 52 ff. Mattingly *et al.*, *Antiquity* 11 (1937), pl. II; Painter, *Ant. J* 52 (1972), p. 89.

BM (M & LA) 1855.8–15.8.

208 Silver bar deposited after *c.* AD 410, possibly after 420

L 9·9 cm. W 1·25 cm. WT 35 g.

Silver bar, hammered flat, with planishing marks on one face.

Provenance: Ballinrees, Coleraine, N. Ireland.

Bibl. Walters, *SP Cat.*, p. 53, no. 203; Mattingly *et al.*, *Antiquity* 11 (1937), pl. II.

BM (M & LA) 1855.8–15.9.

209 Fragment of silver spoon deposited after *c.* AD 410, possibly after 420

L 9·05 cm (max.). W 3·25 cm (max.). WT 22·25 g.

Fragment of bowl and stem of silver spoon, flattened.

Provenance: Ballinrees, Coleraine, N. Ireland.

Bibl. Walters, *SP Cat.*, p. 53, no. 205; Mattingly *et al.*, *Antiquity* 11 (1937), pl. II; Painter, *JBAA* 28 (1965), p. 7.

BM (M & LA) 1855.8–15.10.

210 Fragment of silver spoon deposited after *c.* AD 410, possibly after 420

L 7·5 cm (max.). W 3·5 cm (max.). WT 22·5 g.

Fragment of bowl and stem of silver spoon, twisted and flattened.

Provenance: Ballinrees, Coleraine, N. Ireland.

Bibl. Walters, *SP Cat.*, p. 53, no. 204; Mattingly *et al.*, *Antiquity* 11 (1937), pl. II; Painter, *JBAA* 28 (1965), p. 7.

BM (M & LA) 1855.8–15.11.

211 Fragment of silver-gilt buckle late fourth century AD, deposited after *c.* AD 410, possibly after 420

L 5·1 cm (max.). W 3·6 cm (max.). WT 18 g.
Fragment of silver-gilt buckle with integral plate, inlaid with niello, and decorated with chip-carving of rosette, star, tendril ornament and guilloche. The decoration is bordered with beading and tendrils.
Provenance: Ballinrees, Coleraine, N. Ireland.
Bibl. Walters, *SP Cat.,* p. 53, no. 206, fig. 56; Mattingly *et al., Antiquity* 11 (1937), p. 45, pl. IV; Böhme, *Ger. Grab.,* p. 83, pl. B, fig. 35.
BM (M & LA) 1855.8–15.12.

212 Silver-gilt mount late fourth century AD, deposited after *c.* AD 410, possibly after 420
L 7·75 cm. W 2·4 cm. WT 21·5 g.
Rectangular silver-gilt mount, probably from the mouth of a scabbard. It is inlaid with niello, and decorated with chip-carved scroll ornament contained in a beaded and arcaded border.
Provenance: Ballinrees, Coleraine, N. Ireland.
Bibl. Walters, *SP Cat.,* p. 53, no. 207, fig. 57; Mattingly *et al., Antiquity* 11 (1937), p. 45. pl. IV.
BM (M & LA) 1855.8–15.13.

213 Silver-gilt scabbard bridge late fourth century AD, deposited after *c.* AD 410, possibly after 420
L 6·9 cm (max.). W 3·95 cm (max.). WT 25 g.
Scabbard bridge of silver-gilt with chip-carved rosette, and stamped and punched ornament.
Provenance: Ballinrees, Coleraine, N. Ireland.
Bibl. Walters, *SP Cat.,* p. 53, no. 208, fig. 58; Mattingly *et al., Antiquity* 11 (1937), p. 45, pl. IV.
BM (M & LA) 1855.8–15.14.

214 Silver rim fragment deposited after *c.* AD 410, possibly after 420
L 7 cm. W 3·65 cm. WT 71 g.
Beaded rim fragment from silver dish.
Provenance: Ballinrees, Coleraine, N. Ireland.
Bibl. Walters, *SP Cat.,* p. 54, no. 209; Mattingly *et al., Antiquity* 11 (1937), pl. I.
BM (M & LA) 1955.8–15.15.

215 Silver rim fragment deposited after *c.* AD 410, possibly after 420
L 8·6 cm (max.). W 2·45 cm (max.). WT 61·25 g.
Beaded rim fragment from silver dish.
Provenance: Ballinrees, Coleraine, N. Ireland.
Bibl. Walters, *SP Cat.,* p. 54, no. 210; Mattingly *et al., Antiquity* 11 (1937), pl. I.
BM (M & LA) 1855.8–15.16.

216 Silver rim fragment deposited after *c.* AD 410, possibly after 420
L 3·65 cm (max.). W 3·05 cm (max.). WT 24·5 g.
Beaded rim fragment from silver dish.
Provenance: Ballinrees, Coleraine, N. Ireland.
Bibl. Walters, *SP Cat.,* p. 54, no. 211; Mattingly *et al., Antiquity* 11 (1937), pl. I.
BM (M & LA) 1855.8–15.17.

217 Silver rim fragment deposited after *c.* AD 410, possibly after 420
L 9·5 cm (max.). W 3·25 cm (max.). WT 49 g.
Beaded rim fragment from silver dish.
Provenance: Ballinrees, Coleraine, N. Ireland.
Bibl. Walters, *SP Cat.,* p. 54, no. 212; Mattingly *et al. Antiquity* 11 (1937), pl. I.
BM (M & LA) 1855.8–15.18.

218 Silver rim fragment deposited after *c.* AD 410, possibly after 420
L 6·1 cm (max.). W 2·3 cm (max.). WT 23·25 g.
Beaded rim fragment from silver dish, with engraved diaper pattern of lentoid leaves and, in the central spaces, rosettes.
Provenance: Ballinrees, Coleraine, N. Ireland.
Bibl. Walters, *SP Cat.,* p. 54, no. 213; Mattingly *et al., Antiquity* 11 (1937), pl. I.
BM (M & LA) 1855.8–15.19.

219 Silver rim fragment deposited after *c.* AD 410, possibly after 420
L 5·25 cm (max.). W 3·20 cm (max.). H 1·95 cm (max.). WT 53·50 g.
Beaded rim fragment from silver dish, with engraved and pricked design of flowers, leaves and tendrils.
Provenance: Ballinrees, Coleraine, N. Ireland.
Bibl. Walters, *SP Cat.,* p. 54, no. 214; Mattingly *et al., Antiquity* 11 (1937), pl. I.
BM (M & LA) 1855.8–15.20.

220 Silver base fragment deposited after *c.* AD 410, possibly after 420
L 7·5 cm (max.). W 4·9 cm (max.). WT 93 g.
Base fragment from silver dish, with part of the footring, much distorted.
Provenance: Ballinrees, Coleraine, N. Ireland.
Bibl. Walters, *SP Cat.,* p. 54, no. 216; Mattingly *et al., Antiquity* 11 (1937), pl. I.
BM (M & LA) 1855.8–15.21.

221 Silver base fragment deposited after *c.* AD 410, possibly after 420
L 4·25 cm (max.). W 3·95 cm (max.). WT 22 g.
Base fragment from silver dish with part of the foot beneath, decorated with incised scroll and linear ornament.
Provenance: Ballinrees, Coleraine, N. Ireland.
Bibl. Walters, *SP Cat.,* p. 54, no. 217; Mattingly *et al., Antiquity* 11 (1937), pl. I.
BM (M & LA) 1855.8–15.22.

222 Silver rim fragment deposited after *c.* AD 410, possibly after 420
L 6·7 cm (max.). W 3·25 cm (max.). WT 50·5 g.
Grooved rim fragment from silver dish.
Provenance: Ballinrees, Coleraine, N. Ireland.
Bibl. Walters, *SP Cat.,* p. 54, no. 218; Mattingly *et al., Antiquity* 11 (1937), pl. I.
BM (M & LA) 1855.8–15.23.

223 Silver base fragment deposited after *c.* AD 410, possibly after 420

L 6·5 cm (max.). W 5·85 cm (max.). WT 67·5 g.
Base fragment from silver dish with engraved concentric circles, and crooked footring beneath. A lattice pattern is lightly incised on the underside.
Provenance: Ballinrees, Coleraine, N. Ireland.
Bibl. Walters, *SP Cat.*, p. 54, no. 219; Mattingly *et al.*, *Antiquity* 11 (1937), pl. I.
BM (M & LA) 1855.8–15.24.

224 Silver fragment deposited after *c*. AD 410, possibly after 420
L 5·1 cm. W 2·6 cm. WT 23 g.
Silver fragment decorated in low relief with a draped figure in motion, one arm extended. Traces of punched detail survive on the drapery.
Provenance: Ballinrees, Coleraine, N. Ireland.
Bibl. Walters, *SP Cat.*, p. 54, no. 221; Mattingly *et al.*, *Antiquity* 11 (1937), pl. I.
BM (M & LA) 1855.8–15.25.

225 Silver fragment from dish deposited after *c*. AD 410, possibly after 420
L 4·5 cm (max.). W 4·25 cm (max.). WT 51 g.
Fragment from silver dish, parcel-gilt, decorated with human head and shoulders, facing right, in low relief within an outer border of beading and egg-and-dart pattern on a punched ground.
Provenance: Ballinrees, Coleraine, N. Ireland.
Bibl. Walters, *SP Cat.*, p. 54, no. 220, fig. 61; Mattingly *et al.*, *Antiquity* 11 (1937), pl. I.
BM (M & LA) 1855.8–15.26.

226 Silver fragment of handle (?) deposited after *c*. AD 410, possibly after 420
L 3·7 cm. W 2·25 cm. WT 45 g.
Fragment possibly from silver handle, parcel-gilt, with incised and punched vine-scroll ornament between two zones of gilding.
Provenance: Ballinrees, Coleraine, N. Ireland.
Bibl. Walters, *SP Cat.*, p. 54, no. 216, fig. 60; Mattingly *et al.*,

Antiquity 11 (1937), pl. I.
BM (M & LA) 1855.8–15.27.

227 Silver fragment deposited after *c*. AD 410, possibly after 420
L 8·15 cm (max.). W 7·55 cm (max.). WT 134·5 g.
Silver fragment, much distorted, possibly from a box, with incised and pricked decoration consisting of two rectangular panels. One contains a foliage rosette with punched vine tendrils, the other a diaper pattern of lentoid leaves with rosettes in the spaces; the panels are separated by cabled and plain frames, all within an outer border of leaves on a pricked ground.
Provenance: Ballinrees, Coleraine, N. Ireland.
Bibl. Walters, *SP Cat.*, p. 55, no. 222, fig. 62; Mattingly *et al.*, *Antiquity* 11 (1937), p. 43, pl. I.
BM (M & LA) 1855.8–15.28.

228 Silver knob deposited after *c*. AD 410, possibly after 420
L 1·45 cm. W 1·45 cm. WT 21·75 g.
Silver knob, distorted and damaged at both ends.
Provenance: Ballinrees, Coleraine, N. Ireland.
Bibl. Mattingly *et al.*, *Antiquity* 11 (1937), pl. I.
BM (M & LA) 1855.8–15.29.

229 Silver siliquae mid-fourth to early-fifth century AD
Thirty-one clipped silver siliquae covering the period from the reign of Constantius II to that of Honorius.
Provenance: Ballinrees, Coleraine, N. Ireland.
Bibl. Mattingly *et al.*, *Antiquity* 11 (1937), pp. 39–42.
BM (M & LA) 1855.8–15.30.

230 Silver bowl deposited after *c*. AD 410, possibly after 420
H 11 cm. D 18 cm.
Hemispherical silver bowl reconstructed from many pieces. It is decorated with simple punched and incised geometric and conventionalized tree ornament.
Provenance: Ballinrees, Coleraine, N. Ireland.
Bibl. Walters, *SP Cat.*, p. 55, no. 223, fig. 63; Mattingly *et al.*, *Antiquity* 11 (1937), p. 43, pl. III.
BM (M & LA) 1855.8–15.31.

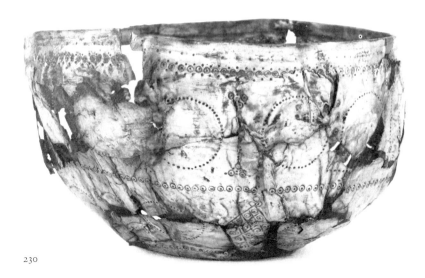

230

The New Grange Finds

This group of finds is important because of the rarity of Roman material from Ireland and because New Grange is Ireland's most important prehistoric site. New Grange is one of the three great neolithic burial-mounds (Dowth, Knowth and New Grange), which stand with their satellite mounds at the Bend of the Boyne, ten miles upstream from the mouth of the River Boyne, just at the river's tidal limit.

The hoard was first reported and described by Lord Conyngham in 1842, the year of its discovery, as having been found together by a labourer 'within a few yards of the entrance to the New Grange caves.' The five objects were acquired by the British Museum in 1884. They form a comparatively homogeneous find. The chain and bracelets may be dated to the third century AD, and the rings to the fourth or fifth.

The nature of the deposit is harder to determine than its approximate age. Is it a votive offering to a still-venerated deity outside his yet-hallowed sanctuary? Does it represent a family treasure secreted in an easily recognized spot in troubled times? Or is it a pirate's hoard or a raider's loot buried near a conspicuous landmark and never reclaimed?

The most attractive suggestion made so far is that it was a votive offering to the deity of Brugh-na-Bóinne. Veneration in Roman times of ancient sites is attested from many parts of the classical world. Not least is the evidence provided by the councils of the Christian Church at Arles (452), Tours (567), Nantes (658), and Toledo (681 and 682), whose decrees inveigh against the continued worship of trees, fountains and stones. Such strictures would not have been necessary if these pagan rites were not still being practised. The need for the strictures is confirmed by the value of the offering made to the god at New Grange.

231 Gold ring fourth century AD
D 2·5 cm. WT 8·48 g.
Gold ring, found with another ring (no. 232), two bracelets (nos. 234, 235) and a necklace (no. 233). The hoop is thin and flat, with longitudinal grooves. On either side of this ribbon of gold is attached beaded wire, which is formed into spirals at the shoulders (one spiral is missing). There is further decoration of small globules of gold. The broad oval bezel is surrounded by a roped border, and contains a badly cracked plain blue stone (nicolo).
Provenance: Found in 1842 at New Grange, Co. Meath, Ireland.
Bibl. Marshall, *FR Cat.*, no. 870; *Archaeologia* 30 (1843), p. 137, pl. XII.3; Fairholt, *Misc. Graph.*, pl. XVII; Coker, *Londes, Cat.*, pl. 1, fig. 5; Topp, *Bull. Lond. Inst. Arch.* 12 (1956), p. 53.
BM (P & RB) 1884.5–20.6. Formerly in the Londesborough Collection.

232 Gold ring fourth century AD
D 2·5 cm. WT 11·98 g.
Gold ring, found with another ring (no. 231), two bracelets (nos, 234, 235) and a necklace (no. 233). The hoop is formed of three beaded wires attached to one another. The shoulders are decorated with double spirals of beaded wire and small pellets. The oval bezel is incised round the edge to give a roped effect, and contains an undecorated blue (nicolo) stone.
Provenance: Found in 1842 at New Grange, Co. Meath, Ireland.
Bibl. Marshall, *FR Cat.*, no. 869; *Archaeologia* 30 (1843), p. 137, pl. XII.5; Fairholt, *Misc. Graph.*, pl. XVII; Coker, *Londes. Cat.*, pl. 1, fig, 5; Topp, *Bull. Lond. Inst. Arch.* 12 (1956), p. 53.
BM (P & RB) 1884.5–20.5. Formerly in the Londesborough Collection.

233 Gold necklace third century AD
L 35·9 cm. WT 11·46 g.
Gold necklace, found with two rings (nos. 231, 232) and two bracelets (nos. 234, 235). It is formed of a chain of double wire links in the shape of a figure of eight, and has a hooked fastening.
Provenance: Found in 1842 at New Grange, Co. Meath, Ireland.
Bibl. Marshall, *J Cat.*, no. 2744; *Archaeologia* 30 (1843), p. 137, pl. XII.1; Fairholt, *Misc. Graph.*, pl. XVII.3; Coker, *Londes. Cat.*, no. 124; Topp, *Bull. Lond. Inst. Arch.* 12 (1956), p. 53.
BM (P & RB) 1884.5–20.4. Formerly in the Londesborough Collection.

234 Gold bracelet third century AD
D *c.* 8 cm (longest dimension). WT 20·66 g.
Gold bracelet, found with another bracelet (no. 235), two rings (nos. 231, 232) and a necklace (no. 233). It is made of two-strand twisted wire, with a hook-and-loop fastening. The shape is oval rather than round.
Provenance: Found in 1842 at New Grange, Co. Meath, Ireland.
Bibl. Marshall, *J Cat.*, no. 2796; *Archaeologia* 30 (1843), p. 137, pl. XII.4; Fairholt, *Misc. Graph.*, pl. XVII; Coker, *Londes. Cat.*, no. 128; Topp, *Bull. Lond. Inst. Arch.* 12 (1956), p. 553.
BM (P & RB) 1884.5–6.2. Formerly in the Londesborough Collection.

235 Gold bracelet third century AD
D 5·6 cm. WT 25·7 g.
Gold bracelet, found with another bracelet (no. 234), two rings (nos. 231, 232) and a necklace (no. 233). It is formed of two wires twisted together, with a fastening of two hooked ends. There are small spheres of gold applied at the point where the twisted wires start.
Provenance: Found in 1842 at New Grange, Co. Meath, Ireland.
Bibl. Marshall, *J Cat.*, no. 2795; *Archaeologia* 30 (1843), p. 137, pl. XII.2; Fairholt, *Misc. Graph.*, pl. XVII.5; Coker, *Londes. Cat.*, no. 129; Topp, *Bull. Lond. Inst. Arch.* 12 (1956), p. 53.
BM (P & RB) 1884.5–6.1. Formerly in the Londesborough Collection.

231–5 ▷

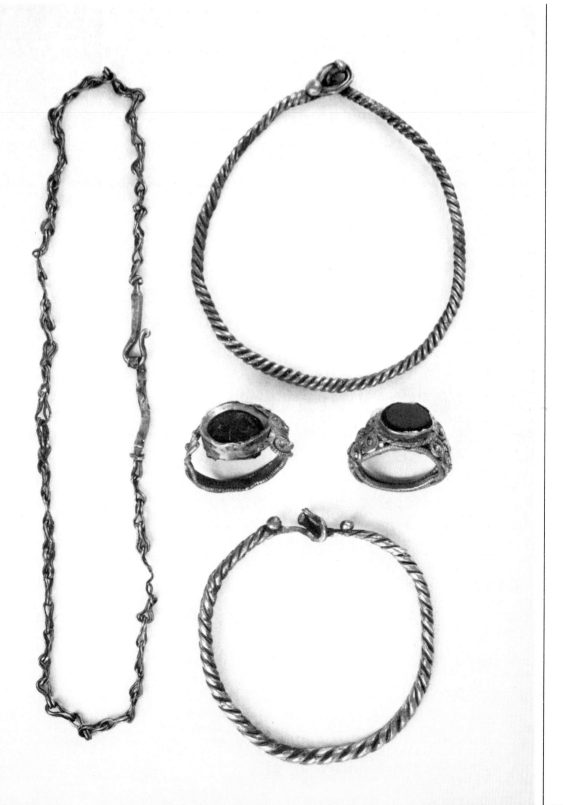

The Sutton Hoo Ship-Burial

Found in 1939, in Suffolk, this royal grave, the only royal burial of its era to survive intact, contained rich and varied treasures. The evidence strongly suggests that it is the burial of King Raedwald of the East Angles, who died in AD 625/6. The most striking elements in this treasure are the great gold buckle, the locally-made gold jewellery and sword-fittings set with garnets, and the purse, shoulder-clasps and pyramids set with glass mosaic. The reconstructed helmet and shield, pieces of the greatest rarity, are both of east Scandinavian origin and part of a complicated chain of evidence which suggests that the East Anglian royal house may originally have come from that country. Attention may also be drawn to the chain-work, cauldrons, and, above all, to the unique stone sceptre surmounted by a stag.

Besides this astonishing assemblage of objects the treasure, buried under a mound in a ninety-foot long rowing boat, contained an important group of Byzantine silver. The bulk of the gold jewellery has every appearance of having been made in one workshop, perhaps even by one goldsmith. The silver, on the other hand, seems to be a haphazard collection of pieces of different dates and from different sources. With the other objects of foreign origin in the grave they illustrate in a striking manner the far-flung connections of a seventh-century Anglo-Saxon royal house.

Bede mentions presents sent by popes to English kings and queens. It is not clear whether the silver is of sufficient merit to have been gifts from people of consequence or whether it should be considered to have found its way to England by trade, like the Red Sea cowrie shells and 'Coptic' bowls found in Saxon graves. The sixteen pieces of East Mediterranean silver are nevertheless one of the most remarkable features of the burial, for the very quantity of such silver in this deposit is unprecedented among graves in Europe which have come down to us from the Migration, Merovingian or Viking periods. Particularly striking in their own time must have been the Anastasius dish (no. 236) with its control stamps and roundels depicting, amongst other things, *Urbs Roma* and *Constantinopolis*, the fluted bowl with the female head at the centre (no. 237), and the spoons with Greek inscriptions (nos. 239, 240).

Yet other objects in the burial, however, reveal influences at work in a creative way between the late Roman and northern worlds, including the sceptre, the shoulder-clasps, the shield, the helmet (no. 292) and the purse (no. 249) (see R. L. S. Bruce-Mitford, 'Late Antique Influences in the Sutton Hoo Burial', in *Union Internationale des Sciences Pré- et Protohistoriques – IXe Congrès*, Nice, 1977, pp. 107–12). Comments on the helmet (no. 292) and the purse (no. 249) are made below.

Physically, the Sutton Hoo sceptre has nothing classical about its appearance, for the heads are Germanic in style, while the stag which surmounts it seems likely to be a late Celtic work of art from a northern or western workshop in the British Isles. The concept of the sceptre, however, and its general formal characteristics find their best parallels in the Consular and Imperial sceptres of the late Roman period, particularly for example those associated with the consulships of Boethius (AD 487), Areobindus (AD 506), Clementinus (AD 513), Anastasius (AD 517), Magnus (AD 518), and the emperor

himself *c.* AD 500 (R. Delbrueck, *Die Consulardiptychen*, pls. 7v, 9v, 11r, 16r, 20v, 22r and 51).

The pair of gold shoulder-clasps are each decorated with cloisonné garnets and millefiori glass. The 'carpet-pattern' design of the clasps is the earliest example in a pagan Saxon context of decoration which later becomes typical of the decorative pages of rich gospel books like those of Durrow, Lindisfarne and Kells. The clasps were fittings to join the front and back of a two-piece garment, and ultimately they copied the hinged shoulder-fittings of the leather or metal cuirass of Roman parade-armour of high-ranking commanders and as seen on Imperial effigies until the late-Roman era (see O. Gamber, 'The Sutton Hoo Military Equipment – an attempted reconstruction', in *Journal of the Arms and Armour Society* V, 1966, pp. 265–89).

The shield was undoubtedly manufactured in east Scandinavia. It and other shields from east Scandinavia (Vendel, Valsgärde) are perhaps more distantly related, however, to a distinctive group of shields from Bavaria, Switzerland and North Italy (e.g. from Stabio, Lucca and Ischl an der Als), of which the decoration shows that they were most likely produced in Byzantine workshops, perhaps in Ravenna for Lombardic clients.

The helmet, like the shield, is copied directly from those of the late Roman world. Like the late Roman helmets it was silvered externally, and its similarities in features of design with both infantry and cavalry types from Constantinian workshops help to clinch the origins of the northern 'Vendel' type group of helmets in the products of the late-Roman/Byzantine workshops. The gold purse, by contrast, is a barbarian object; but the deposition of the coins in the grave is a direct continuation of the classical practice of Charon's obol.

The Sutton Hoo ship-burial reflects Anglo-Saxon court culture of the 620s. It is the only Germanic royal burial to have come down unrobbed to us from the Migration, Merovingian or Viking periods. What is most remarkable about the burial in the present context is the extent to which the objects discussed above illustrate a transmission of craft traditions and of the concept of symbols of authority from the late Roman world into the milieu of early Germanic courts.

236 The Anastasius dish reign of Anastasius I (AD 491–518) H 6·35 cm (footring). D 71·8 cm (dish), 27·94 cm (footring). WT 5640 g.

Shallow silver dish with flat rim decorated with lightly incised geometric and foliate designs in two bands, one on the rim and one an inner border, with both bands quartered by figured medallions. The four medallions in the rim decoration each enclose a running figure. The four medallions of the inner border contain, alternately, the figure of a seated Tyche (perhaps representing Constantinople) and a running figure holding an unidentifiable object in her hands. An incised central roundel contains a bird in a medallion framed by two octagonal stars, one within the other. The dish stands on a footring, which frames four control stamps on the underside; these include the monogram of Anastasius or Justinian, and two of the four are inscribed DN ANASTA[S] / IVS PP AV[G]. One also has the name ΘѠMA.

Provenance: Sutton Hoo, near Woodbridge, Suffolk.

Bibl. Kitzinger, *Antiquity* 14 (1940), pp. 40–50, pls. X, D and E, XVI, XVII, XVIII; Dodd, *BSS*, pp. 6–7 and 58–9; Strong, *GSP*, p. 195; Bruce-Mitford, *SH*, pp. 35–6 and 65–6, pl. 20. BM (M & LA) 1939.10–10.20. Inv. 76. Presented by Mrs E. M. Pretty, JP.

Stamps of the reign of Anastasius I occur on this and four other silver vessels. The stamps of Anastasius were the forerunners of a new system of control marks introduced in the reign of Justinian I (AD 527–565), a system which was established so securely that it survived, with very few changes, for one hundred and fifty years. The dish, which is exceptionally large of its kind, is shown by its stamps to have been made in Constantinople; but the quality of the minute conventional ornament has led to some speculation that it may have been decorated elsewhere by a craftsman working in a conservative style.

237 Fluted silver bowl fourth century AD
H 2 cm (footring). D 39·4–40·7 cm (dish).
Silver bowl with flat rim, lightly fluted sides, and central relief ornament of a classical female head in left profile framed by a floral border of *kymation* type. On the underside are a pair of drop handles with circular escutcheons, now detached, and a footring. The dish has been damaged by burial.
Provenance: Sutton Hoo, near Woodbridge, Suffolk.
Bibl. Kitzinger, *Antiquity* 14 (1940), pp. 50–2, pls V and XIV; Bruce-Mitford, *SH*, pp. 36 and 66, pls 29–30; Strong, *GSP*, pp. 183 and 201.
BM (M & LA) 1939.10–10.21. Inv. 77. Presented by Mrs E. M. Pretty, JP.

This bowl is the second largest of the silver pieces from the Sutton Hoo burial. It is clearly not of the same school or style as the Anastasius Dish. It should be compared with the fluted bowls in the Mildenhall, Traprain and Esquiline Treasures, though the two drop handles lack the grace and movement of the elegant swan's neck handles of the Mildenhall piece. After the end of the fourth century fluted vessels became less common, although the type survived into later centuries.

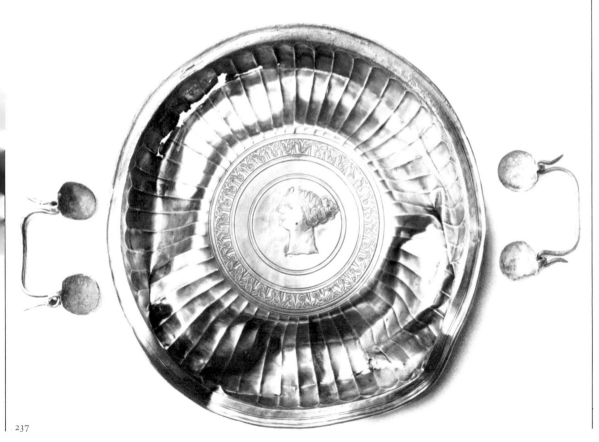

237

238 Silver ladle fifth century AD
L 16·5 cm (handle without bowl). H 4·8 cm (bowl).
Ladle with sturdy horizontal handle which has decorative moulding ending in a hinged ring. Now detached, the handle was originally riveted to the bowl, which has a beaded, outcurved rim and pronounced carination halfway down, both ornamented with parcel-gilt triangles. The base ring of the Anastasius dish was driven into the bowl when the burial chamber collapsed.
Provenance: Sutton Hoo, near Woodbridge, Suffolk.
Bibl. Kitzinger, *Antiquity* 14 (1940), p. 61; Bruce-Mitford, *SH*, pp. 36 and 69, fig. 27, pl. 25 c.
BM (M & LA) 1939.10–10.24. Inv. 90. Presented by Mrs E. M. Pretty, JP.

The vessel recalls the Coptic bronze ladles of similar shape (see Strzygowski, *CK*, pl. 28).

239 'Paulos' spoon sixth century AD
L 9 cm (bowl), 25·4 cm (overall).
Silver spoon with pear-shaped bowl joined to a moulded handle by a plain disc which terminates under the bowl in an ornamental tail. A cross and 'Paulos', in Greek lettering, are engraved on the handle near the bowl. The spoon is cast in one piece and is very like, but not identical to, the 'Saulos' spoon (no. 240).
Provenance: Sutton Hoo, near Woodbridge, Suffolk.
Bibl. Kitzinger, *Antiquity* 14 (1940), pp. 58–61, fig. 5; Kaske,

239 △ ▽ 240

Speculum 42 (1967), pp. 670–2; Bruce-Mitford, *SH*, pp. 30 and 68–9, pl. 25.a, fig. 26; Sherlock, *Speculum* 47 (1972), pp. 91–5.

BM (M & LA) 1939.10–10.23a. Inv. 88. Presented by Mrs E. M. Pretty, JP.

The 'Paulos' and 'Saulos' spoons, the set of ten silver bowls inscribed with equal-armed crosses (nos. 241–7), and the gold cloisonné scabbard-bosses (designed around a specifically Christian form of the cross) raise directly the question of the Christian element present in the Sutton Hoo burial. The spoons were placed in the burial immediately beside the bowls. The Christian reference in the spoons is evident, for association in the pair of St Paul's unredeemed name with that by which he became known as a Christian may be a specific reference to conversion. The Christian significance of the set of shallow cross-bearing bowls is supported partly by the context in which they were found, alongside the spoons, and partly by the specifically Christian nature of similar bowls, for example in the Lampsacus Treasure (no. 150). The scabbard and its fittings are local East Anglian work, and there is no pre-Raedwald East Anglian context for such a demonstration of Christian influence in a royal sword.

These hints of Christian influence, however, do not demonstrate the Christianity of the deceased or of the nature of the burial. Indeed, the extreme richness and splendour of the furnishing of the burial, with its great ship, as distinct from being furnished at all, combined with the location of the burial in unconsecrated ground, is against its being that of a Christian. What the objects do call to mind are the exotic presents from popes to royal converts or potential converts recorded in Bede (Bk. I, xxxii; II, x and xi). It is precisely to this category that Raedwald belonged. He is said by Bede to have been converted to Christianity when on a visit to Kent. On his return home he was seduced from the faith by his wife and certain evil teachers. The hints of Christianity contained in these objects, therefore, help to strengthen the suggestion that it was Raedwald who was buried at Sutton Hoo. His conversion wilted before the paganism of his wife, and Raedwald could well have been buried in a tumulus at Sutton Hoo for the very reason that he was more pagan than Christian.

240 'Saulos' spoon sixth century AD
L 9 cm (bowl), 25.4 cm (overall).
Silver spoon with pear-shaped bowl, closely resembling no. 239. A cross and 'Saulos', in Greek lettering, are crudely engraved on the handle near the bowl. The spoon is cast in one piece; 'S' could be a misplaced attempt at 'P'.
Provenance: Sutton Hoo, near Woodbridge, Suffolk.
Bibl. Kitzinger, *Antiquity* 14 (1940), pp. 58–61, fig. 5; Kaske, *Speculum* 42 (1967), pp. 670–2; Bruce-Mitford, *SH*, pp. 30 and 68–9, pl. 25.a, fig. 26; Sherlock, *Speculum* 47 (1972), pp. 91–5.
BM (M & LA) 1939.10–10.23b. Inv. 89. Presented by Mrs E. M. Pretty, JP.

Several explanations have been offered regarding the inscriptions on these (nos. 239 and 240) and other spoons naming the Apostles and Evangelists. Diehl (*Syria* 11, 1930, pp. 209–15) wrote that such spoons may have been souvenirs of holy places, as were the pilgrims' *ampullae*, and Kitzinger further suggests that spoons inscribed with the names of the Apostles could conceivably have been obtained by pilgrims at the Church of the Holy Apostles in Constantinople.

It has also been suggested that the two spoons from Sutton Hoo, one being inscribed with the name of Paul, the other with the name Saul, may have been presents given at the baptism of an adult convert. Kaske has argued, however, that the Sutton Hoo spoons both bear the name Paul. On one the name is engraved in evenly spaced, orthodox letters of regular size, whereas on the 'Saul' spoon it is less skilfully done. It could be that the first letter, S (*sigma*), is really a P (*pi*) misplaced. If it were the case that both the spoons bear the name Paulos, the spoons would not need to be seen as a pair, or as having reference to conversion. None the less, it remains true that the names can be read as Saulos and Paulos, and the allusion to conversion may well have been deliberate. The case for a deliberate reference to conversion is weakened by Dr Kaske's acute observations, but not necessarily destroyed.

241 Silver bowl from a set of ten sixth century AD
H 5.4 cm (internal). D *c*. 22 cm. WT 308 g.
Spun silver bowl with external hammer marks. The internal decoration consists of four cross-arms with a crude semi-geometric floral pattern, radiating from a central roundel filled by a star of David around a lobed rosette. Shading is carried out in punch-marking. In the roundel are small trefoils. This bowl matches no. 242.
Provenance: Sutton Hoo, near Woodbridge, Suffolk.
Bibl. Kitzinger, *Antiquity* 14 (1940), pp. 52–7, pl. XIX, fig. 4; Bruce-Mitford, *SH*, pp. 29–30 and 66–8, pls 29–30, fig. 25.
BM (M & LA) 1939.10–10.22a. Inv. 78. Presented by Mrs E. M. Pretty, JP.

The first eight bowls comprise four pairs; but the designs of the last two differ. These bowls, paralleled in treasures like that of Lampsacus which have a specifically Christian character, probably themselves have Christian significance. They are unlikely to have been made much before AD 600.

242 Silver bowl from a set of ten sixth century AD
H 4.5 cm (internal). D *c*. 22 cm.
Spun silver bowl similar to no. 241 and with identical decoration. There is corrosion damage to the central roundel.
Provenance: Sutton Hoo, near Woodbridge, Suffolk.
Bibl. As for no. 241.
BM (M & LA) 1939.10–10.22h. Inv. 84. Presented by Mrs E. M. Pretty, JP.

243 Silver bowl from a set of ten sixth century AD
D 20.5 cm by 20.7 cm.
Spun silver bowl with internal decoration of four cross-arms with a crude, compass-drawn pattern, radiating from a roundel filled by a star of David surrounding an eight-lobed rosette. There is no shading; within the roundel are punched circles in rosette and floral motifs. A small patch is riveted on to the rim. This bowl forms a pair with another, damaged bowl in the set.
Provenance: Sutton Hoo, near Woodbridge, Suffolk.
Bibl. As for no. 241.
BM (M & LA) 1939.10–10.22b. Inv. 83. Presented by Mrs E. M. Pretty, JP.

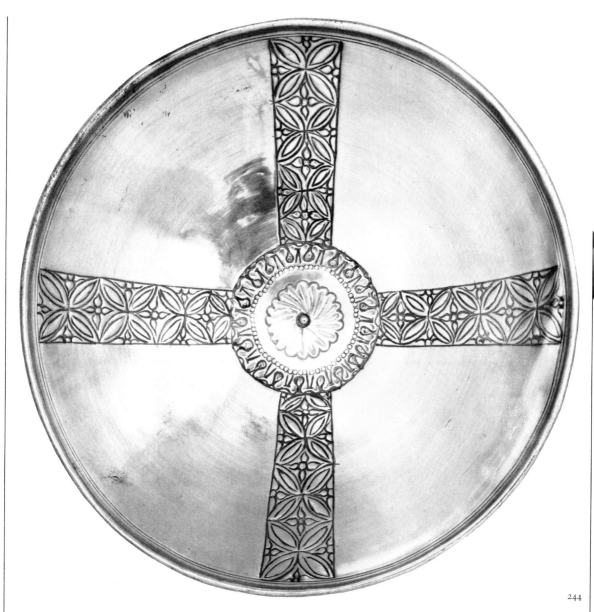

244

244 Silver bowl from a set of ten sixth century AD
H 5·4 cm (internal). D 22·4 cm. WT 282 g.
Spun silver bowl with internal decoration of four tapering cross-arms in semi-geometric floral pattern, radiating from a central roundel with a *kymation*-derived border around a swirled rosette with a central silver stud. This bowl matches no. 245.
Provenance: Sutton Hoo, near Woodbridge, Suffolk.
Bibl. As for no. 241.
BM (M & LA) 1939.10–10.22c. Inv. 79. Presented by Mrs E. M. Pretty, JP.

245 Silver bowl from a set of ten sixth century AD
H 5·4 cm (internal). D 22·1 cm by 22·9 cm. WT 283 g.
Spun silver bowl similar to no. 244 in form and decoration, but with no central stud.

Provenance: Sutton Hoo, near Woodbridge, Suffolk.
Bibl. As for no. 241.
BM (M & LA) 1939.10–10.22d. Inv. 82. Presented by Mrs E. M. Pretty, JP.

246 Silver bowl from a set of ten sixth century AD
H 4·7 cm (internal). D 22·6 cm by 22·5 cm. WT 296 g.
Spun silver bowl with internal decoration of short cross-arms with stiff floral ornament, radiating from a large roundel where a band of blank arcading surrounds a wheel rosette. There is punched shading on the roundel. This bowl matches another in the set.
Provenance: Sutton Hoo, near Woodbridge, Suffolk.
Bibl. As for no. 241.
BM (M & LA) 1939.10–10.22f. Inv. 80. Presented by Mrs E. M Pretty, JP.

247 Silver bowl from a set of ten sixth century AD

H 4·8 cm (internal). D 22 cm. WT 243·5 g.

Spun silver bowl with internal chased decoration of four cross-arms with stiff floral ornament, radiating from a central wheel rosette with stippled shading in the segments. Part of the rim is missing. There is no exact pair to this design.

Provenance: Sutton Hoo, near Woodbridge, Suffolk.

Bibl. As for no. 241.

BM (M & LA) 1939.10–10.22g. Inv. 81. Presented by Mrs E. M. Pretty, JP.

248 Small silver bowl fifth–sixth century AD

H 3·25 cm (bowl), 1 cm (footring). D 7–8 cm (in buckled state).

Plain silver bowl with narrow horizontal rim, formerly standing on a footring, now detached. The bowl is buckled.

Provenance: Sutton Hoo, near Woodbridge, Suffolk.

Bibl. Kitzinger, *Antiquity* 14 (1940), p. 61; Bruce-Mitford, *SH*, pp. 36 and 69, pl. 25.b.

BM (M & LA) 1939.10–10.25. Inv. 91. Presented by Mrs E. M. Pretty, JP.

249 Gold Purse-Lid sixth century AD

L *c.* 19 cm. W *c.* 8·3 cm (without hinges).

Purse, represented by the gold frame of the lid; oblong, with straight top with three hinged attachments for straps, double curved below with a hinged tongue projecting centrally; within the frame seven ornamental plaques and four circular studs; all inlaid in cloisonné technique with garnets and millefiori glass.

Provenance: Sutton Hoo, near Woodbridge, Suffolk.

Bibl. Bruce-Mitford, *SH*, pp. 32, 73–4, pl. G.

BM (M & LA) 1939.10–10.2. Inv. 2, 3. Presented by Mrs E. M. Pretty, JP.

Colour plate.

The material of the lid, in which the ornamental plaques and studs were sunk, was probably bone or ivory. The lid hinges at the top on three gold plates, which were riveted to leather straps depending from the belt. The purse itself was probably a pouch-like bag hanging below the lid, the sliding catch being permanently attached to the mouth of the bag. The purse contained thirty-seven gold coins, three blank flans and two gold billets (nos. 250–91).

The use of garnets calls for particular comment (see B. Arrhenius, *Granatschmuck und Gemmen aus nordischen Funden des frühen Mittelalters*, 1971). In the fifth, sixth and early seventh centuries the exuberant use of garnet in complex cloison cells reached a high degree of perfection – a characteristic feature of the Migration Period jeweller's art in western Europe. All the garnet used had to be imported, probably from the area around north-west India, and is striking evidence of the long-distance trade in luxury goods of the period. Garnet can be split in the horizontal plane; but sheets so formed have to be cut individually to shape for the patterned cells. Cabochon stones are ground and polished to shape.

The jewelled plaques of the purse-lid fall into three pairs, with one double plaque. The double plaque at the top, with symmetrical pairs of animals, is flanked by a hexagonal pair notable for their intricate cloisonné. The outer plaques below show a man standing between two rampant animals, reminiscent of the 'Daniel in the Lion's Den' subject found on Frankish buckles, but more likely to be a Scandinavian design

with a possible Eastern origin. The two central plaques in the lower register represent a bird of prey swooping on a duck.

The purse as a whole forms the most attractive and sumptuous trapping ever found in a Teutonic grave.

250–291 Gold coins, blanks and ingots seventh century AD

(a) Thirty-seven gold Merovingian tremisses.

WT 1·05 g–1·389 g. D 10–15 mm.

(b) Three blank gold flans of coin size.

WT 1·09 g–1·46 g. D 10–12 mm.

(c) Two small gold ingots.

WT 4·97 g. and 5·21 g. L 11 mm and 17 mm.

Provenance: Sutton Hoo, near Woodbridge, Suffolk.

Bibl. Bruce-Mitford, *SH*, pp. 54–9.

BM (M & LA) Presented by Mrs E. M. Pretty, JP.

Colour plate.

All these objects were found in the purse (no. 249). The coins are all of Continental origin, and struck at mints located in areas occupied or controlled at the time by the Merovingian Franks, that is, generally speaking, within the area comprised by modern France, Belgium, the Rhineland and Switzerland. The obverses of all but two carry heads. The reverses of all but three carry either some variety of a cross on a globe or on steps, or else an equal-armed cross. Only one coin, struck at Clermont-Ferrand, can be identified with a king, Theodebert II (AD 595–612). Most of the coins have an estimated date within a thirty-year period, *c.* AD 585–615, and the outliers fall best into place between *c.* 615 and *c.* 625. It has been concluded that it would be possible and natural for the hoard to have reached East Anglia in the 615–620 period, to have been kept for a few years, receiving in addition the ingots, blanks and perhaps two of the coins, and then to have been buried in AD 625/6. A later date for the burial of the coins is possible; but the hints of Christianity in the midst of pagan burial-practices, combined with the deposition of regalia, makes it likely that the mound is the burial-place of King Raedwald, the greatest figure of the Wuffinga dynasty, and that the date of the burial is indeed AD 625/6.

The nature of the hoard is also remarkable. No two of the thirty-seven coins come from the same mint, and the hoard contains no geographical concentrations, however small. The hoard was contained in a purse; but this need not imply that currency was in use, for all sorts of scrap – gold, jewels, small ingots of gold and silver, rings and implements also exceptional in that it cannot be a merchant's hoard because it occurs in an area where coins were neither minted nor used at the time of its deposition, and because it came from a king's burial. The contents of the purse, moreover, are miserly in relation to the treasure as a whole, scarcely adding up in weight to a single minor piece of jewellery. This has led to the compelling idea that what was significant about the coins to those who put them in the purse was not so much their value as their number. This is brought up to forty by the provision of the three blanks, the same as the number of oarsmen thought to have been needed for the ship. The coins and blanks, then, are likely to have been pay for the oarsmen, while the two ingots, eight times the average weight of the coins, would, as Grierson suggested, be the pay of the steersman, who would also be the captain.

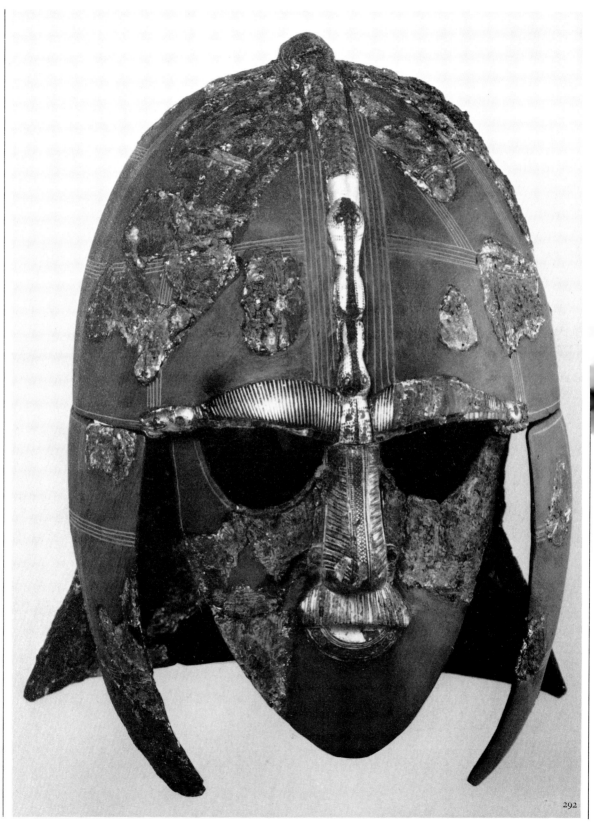

292 Helmet sixth century AD

H (restored) 31·8 cm. Circumference at brow level (restored) 74·6 cm.

Helmet, consisting of a cap, cheek-pieces, mask and neck-guard of iron, all originally covered with panels of tinned bronze sheeting stamped with figural subjects or animal interlace. The helmet has an iron crest and bronze eyebrows all inlaid with silver wires. Each eyebrow terminates in a small gilt-bronze boar's head, and the under-edge of each brow is picked out with a line of small, square-cut garnets, set in metal cells. The nose and mouth of the mask are in gilt-bronze with cast details.

Provenance: Sutton Hoo, near Woodbridge, Suffolk.
Bibl. Bruce-Mitford, *SH*, pp. 30–1.
BM (M & LA) 1939.10–10.29. Inv. 93. Presented by Mrs E. M. Pretty, JP.

The silver and gold helmet, enhanced by the glitter of its gems, with living eyes behind its mask, must have been an awe-inspiring spectacle. It is a most dramatic object, different from all the similar Swedish-found helmets and unique in this country. At the same time resemblances in design between the northern 'Vendel' group of helmets and the products of Constantinian workshops help to clinch the origins of the northern group in the products of the late Roman workshops. The latter products include, of course, the helmet found at Conceşti in Romania (no. 297).

293

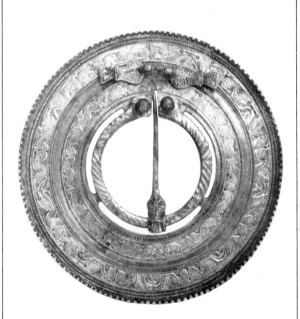

Anglo-Saxon and Germanic Jewellery

Germanic jewellery at its best is unexcelled in technical virtuosity and in bold and complex designs. In an age when jewellery was to a large extent portable wealth and the expression of its owner's rank and status, it was natural that it should take on eye-catching forms. To this end the most striking feature of the Germanic jewellery is its dramatic use of polychrome effects. In particular the inlay of precious stones, especially garnets and other materials, reaches an importance hardly matched anywhere else before modern times. The gold and garnet dazzle of the Sutton Hoo jewellery, which is technically unsurpassed in the formal complexity of the cut garnets, its use of new inlay techniques, such as the 'mock-champlevé' or lidded cloison in the zoomorphic interlace on the shoulder clasps, and the virtuoso use of all-over cloisonné inlay, represents a high point; but gem inlay was a technique widespread amongst the Germanic people which attained high standards wherever it was used.

Other important aspects of the polychrome style are the various metal finishes such as gilding, silver-plating, tinning, and niello inlay, all of which were used to give rich effects of contrast such as may be seen on the Sarre quoit brooch, with its alternating gilded and plain silver zoning (no. 293). Filigree and granulation in gold are also important techniques for this period and may often be used to develop zoomorphic motifs, the other principal feature of this jewellery.

This type of decoration developed in fifth-century Europe from zoomorphic details in late Roman metalwork, notably the metal fittings from military belts which had a wide currency about and beyond the frontiers. It became a highly sophisticated and formalized style, which was to fuel western European art in many ways for the next six hundred years.

As with the animal style, the techniques used by the Germanic jewellers were mostly learnt from the Roman workshops, and developed to suit their special needs. In form, too, many of the pieces were derived from Roman prototypes. The ability to absorb and transform the products and styles of other cultures is a continuing feature of this jewellery.

Finally, this rich and splendid jewellery was not only an indication of wealth and rank, but also very often functional. The paired brooches worn on the shoulders by Anglo-Saxon women were not only decorative; they pinned up and adjusted the tubular dress at the shoulders. The large, handsome buckles worn by the men clasped broad belts around the tunic, while very small buckles, sometimes richly decorated, were used on gartering and shoes.

293 Silver-gilt brooch Anglo-Saxon, mid-fifth century AD

D 7·7 cm.
Silver-gilt quoit brooch decorated with concentric zones of engraved animal ornament and three-dimensional doves.
Provenance: From a grave in the Anglo-Saxon cemetery at Sarre, Kent, England.
Bibl. Hawkes, *Archaeologia* 98 (1961), pp. 30–2; Evison, *FCI*, pp. 62, 65, 125, pl. 12a.
BM (M & LA) 93.6–1.219. Durden Collection.

This brooch is the finest example of a type associated with a variety of zoomorphic decoration derived from Late Roman ornament, and fashionable in the early years of the Anglo-Saxon settlement of England.

294 Silver-gilt brooch Anglo-Saxon, sixth century AD
L 13·85 cm. W 6·6 cm.
Silver-gilt square-headed brooch with zoomorphic (Anglo-Saxon Style I) and geometric decoration on head-and foot-plates. The borders delineating the main fields of ornament bear dogtoothed niello inlay arranged to give the effect of a zigzag. Other decoration is cast and subsequently finished off.
Provenance: Anglo-Saxon cemetery, Chessel Down, Isle of Wight, England.
Bibl. Leeds, *ASSB*, pp. 11–16; Hillier, *IoW*, no. 27.
BM (M & LA) 1867.7–29.5.

The brooch is an important early example of Anglo-Saxon Style I animal ornament.

295 Gold pendant late seventh century AD
L 3·85 cm. (max.). W 2·2 cm. (max.).
Gold, with beaded wire edging and grooved suspension loop, containing irregularly shaped garnet cameo carved in high relief with head of bearded man in Phrygian cap, facing left.
Provenance: Epsom, Surrey, England.
Bibl. Henig, *REG*, (1974), no. 734, pl. XLVI.
BM (M & LA) 1970.3–1.1.

This pendant belongs typologically to a group of Anglo-Saxon pendants, set with cabochon garnets, which appear

296

towards the end of the seventh century as one of the latest types of object to be found with the dead before Christian practice finally put an end to this pagan custom. The presence of a cameo in such a pendant is unique, and though the material, garnet, is characteristically Germanic, cameo-carving is certainly not. Stylistically it seems possible that this is a late antique cameo reset in the seventh century.

296 Silver amphora *c.* AD 400
H 42·4 cm.
Large silver amphora, the two handles being modelled in the round as a pair of prancing centaurs. Most of the surface is richly decorated in relief. The straight, slender mouth has scale decoration, and the lower part of the neck is surrounded by a wreath-like moulding. The main zone of decoration is an Amazonomachy, a battle scene featuring mounted Amazon warriors. Beneath this is a zone decorated with Nereids and sea monsters. The foot of the amphora is edged with raised beads.
Provenance: Conceşti, Romania.
Bibl. Matzulewitsch, *Byz. Ant.*, p. 131 ff., pls 36–43.
Leningrad, State Hermitage Museum.

Two plain amphorae were found in the Esquiline Treasure, but the type was nevertheless rare in the period. In many ways the Conceşti piece seems to hark back to Graeco-Persian vessels of the fourth century BC, and it was probably made in some eastern workshop where such early vessels might still be a source of inspiration. It ranks as one of the most remarkable pieces of late antique plate.

297

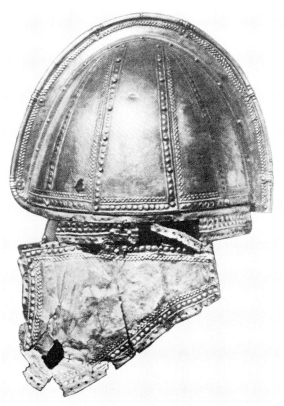

297 Silver-covered helmet *c.* AD 400–10
L 22·2 cm. W 16·5 cm. H 20·5 cm.
Helmet, the cap consisting of six parts: four triangular plates, the cross-piece which holds these together, and a high peak which holds the side-pieces in position lengthways. All these parts, which are of iron, are covered with silver 1 mm thick, as are the two cheek-pieces.
Provenance: Grave at Conceşti, Romania.
Bibl. Matzulewitsch, *Byz. Ant.*, p. 123 ff., pl. 49; Skalon, *Sp. Gar.*, p. 91 ff. For the Hunnish objects found with the helmet, and for the date of the burial, see Alföldi, *Arch. Hung.* 9 (1932), and Werner, *BAAR* 38, N. F. (1956).
Leningrad, State Hermitage Museum, 2160/37.

The helmet comes from a princely, probably Hunnish, grave of the first decade of the fifth century. It is of the type introduced into the Roman army by the Emperor Constantine from the Sassanian empire. Constantine himself received, as a wedding present from Fausta, '*galeam auro gemmisque radiantem et pennis pulchrae alitis eminentem*', which he wore at the battle of the Milvian Bridge against Maxentius.

298 Silver brooch early seventh century AD
L 16·5 cm. W 9·5 cm.
Cast silver, gilt and nielloed brooch with semicircular, radiate head. Around the head-plate, a row of animal masks; inner field of head-plate contains two intertwined serpents in profile, each biting own body; on each side of bow, abstract interlace pattern; two pairs of interlaced serpents in profile symmetrically set on body of brooch. Two pairs of profile birds' heads with curved beaks set on edge of body, lower pair (of which one survives) biting on to animal mask, as seen from front. Eyes, tusks and muzzle of latter animal strongly defined, but when viewed from side, each half of mask can be seen as head in profile. Pair of conjoined, upward-facing animals at foot of brooch. Pin catch on back in form of animal mask and body seen from above.
Provenance: Possibly from Tuscany, Italy.
Bibl. B. Salin, *Altgermanische Thierornamentik* (1904); Fuchs and Werner, *Lang. Fib.*, pl. 20, A84; *ASFT*, p. 154, fig. 208.
BM (M & L) 51.8–6.10.

A profusion of animal motifs over the brooch, executed in the 'Animal Style II', fills every available surface. The complex interlacing and the several possible ways of viewing some elements of the design are characteristic of the 'puzzle' quality of much animal art of the period.

299 Gold pendant (bracteate) sixth century AD
D 3·6 cm.
Sheet gold pendant (bracteate) with stamped decoration about central roundel executed in repoussé. Suspension loop and rim enriched with filigree gold wire, and part of surface with filigree wire and granulation.
Provenance: Probably Gotland, Sweden.
Bibl. M. Mackeprang, *De Nordiske Guldbrakteater* (1952), no. 197, pl. 14, no. 13.
BM (M & LA) 1921.11–1.365. Curle Collection.

This piece, and later bracteates, draw inspiration from late-Roman gold coins or medallions. Gradually the original horse and rider motif became increasingly stylized, abstract, and combined with elements from Scandinavian mythology. This sixth-century piece clearly depicts a horse galloping left, with an anthropomorphic face in profile above, wearing an elaborate head-dress or coiffure; a bird is seen hovering above, facing right. The class of gold bracteates, widely spread throughout Scandinavia and known in England, were modified to Germanic taste. Much Germanic art of the fourth to seventh centuries, like this bracteate, drew heavily on a range of late Roman decorative motifs.

300 Silver brooch late fourth or early fifth century AD
L 6·8 cm. W 4·4 cm.
Sheet silver bow brooch with semicircular head-plate and lozenge-shaped foot. Twisted silver wire is bent around the top and bottom of the bow. The pin is of silver, and the silver side knobs are supported on two horizontal iron rods, behind the head-plate, wound around with silver wire. This example is representative of a comparatively large group of sheet silver fibulae of this period.
Provenance: Crimea, USSR.
Bibl. For comparative material, see Salin, *Alt. Thier.*
BM (M & LA) 1910.7–12.51.

Treasures from Malaia Pereschepina and Klimova

Rome and Persia had a common frontier from the time Syria became a Roman province in the second century BC. The general line of the frontier ran from the Caucasus through the high plateau of Armenia, down to the confluence of the Euphrates and the Kabur, then across the desert to the head of the Gulf of Akaba.

Neither empire could hope to destroy the other militarily; but they fought through century after century on this frontier for domination of the central zone, which was of crucial importance for the economy of them both. Much of the southern frontier, however, ran through thinly populated desert, and here each power tried to establish its own influence among the largely nomadic Arab tribes. The result was that two loose Arab confederations usually confronted one another in the desert zone, both of them often seeking to play off the great powers against each other. The area to the north was under similarly fluctuating control. The Greek cities and the semi-Greek state of Bosporus on the northern and eastern shores of the Black Sea were recognized as an important link in the defensive system of the Roman Empire. Corn from Bosporus was shipped to the Roman armies, especially those of Pontus, Cappadocia, and Armenia. In payment the king received an annual subsidy from the governor of Bithynia.

From the steppes of the Crimea corn was shipped to Olbia and thence to Greece and to the armies of the Danube, while some was bought up by the merchants of Chersonesus. Not very different probably, was the life of the tribes in the peninsula of Taman, on the river Kuban, on the shores of the Sea of Azov and on the river Don.

The population of the Greek cities was chiefly a population of landowners and merchants. There is no doubt, however, that the population of the cities formed only a small minority even within their own territories, and that Hellenism and Hellenization were not advancing but retreating on the shores of the Black Sea, the Iranian elements gradually invading and Iranizing even the city population. This mixture of influences is demonstrated in the hoards of precious plate from what is now Soviet territory, which contain both late-Roman and Sassanian pieces in the same groups. They reached South Russia in the course of trade with the two great empires.

Two mixed hoards of this type are represented in the exhibition. The Malaia Pereschepina Treasure was found in 1912 at the village of that name in the Poltava district. The Klimova Treasure was found in 1907 in the neighbourhood of the village of Klimova (the Solikamsk district of the Perm region). The treasure was found in two parts, the first including the goatherd dish, a silver bucket and three Sassanian silver dishes, while the second find included two large dishes, each with a niello cross in a wreath, and a silver dish with a rosette motif in the centre.

The Malaia Pereschepina Treasure

Found in 1912 at the village of Malaia Pereshchepina in the Poltava district, South Russia, (including Dodd, *BSS*, nos. 2, 30, 31, 73, 79) as part of a very large treasure of gold and silver objects, some made in Constantinople, some in Persia and some perhaps in the Black Sea area.

301 Silver paten AD 491–518
H 1·8 cm (footring). D 31·8 cm (footring), 61 cm (dish). WT 6224 g.
Large silver paten with design of vine, birds and chalices around the rim. In the centre is a gilded chi-rho monogram, with the gilded letters alpha and omega on either side; surrounding this, within the rim, the inscription: + EX ANTIQVIS RENOVATVM EST PER PATERNVM REVERENTISS(imum) EPISC(opum) NOSTRVM AMEN (Restored from the antique by Paternus, our reverend Bishop). The dish is restored from fragments soldered together and mounted on a metal frame. *Renovatum* could mean actual reconstruction or merely the use of old materials. Superimposed on the repoussé ornament of the rim are oval and cruciform settings for gems, which have been soldered on. There is a secondary monogram possibly referring to John the Paphlagonian, *comes sacrarum largitionum* in AD 498, and inside the base is a dotted inscription referring to the weight of silver and gold used in the manufacture of the dish.
Provenance: Malaia Pereschepina, Poltava Province, USSR.
Bibl. Matzulewitsch, *Byz. Ant.*, p. 5, no. 6, p. 101 ff., pls 26–7; Dodd, *BSS*, p. 54, no. 2; Banck, *BACU*, nos. 71–3. Leningrad, State Hermitage Museum. ω 827. Acquired in 1914 through the Archaeological Commission.

Paternus has been identified with the Paternus who was bishop of Tomi in the first quarter of the sixth century. On the evidence of the stamps, which are from the reign of Anastasius I, the plate was made in Constantinople. Changes were subsequently carried out in the decoration of the rim; but, as Matzulewitsch maintains, these are not the 'renovations' to which the inscription refers.

302 Silver bowl Sassanian, fifth–sixth century AD
D 14·9 cm. WT 470 g.
Lobed silver bowl, parcel-gilt, with ring foot and repoussé decoration: on the inside, a pheasant in the centre, and on the outside, musicians, animals, birds, fish and plants, represented separately on the lobes.
Provenance: Malaia Pereschepina, Poltava Province, USSR.
Bibl. Orbeli and Trever, *SM*, pls 36–8.
Leningrad, State Hermitage Museum.

Many of the realistic animals which, alone or with others of their kind, constitute the theme of a score of designs, may not have had any symbolic significance, being represented simply because the Sassanians enjoyed and had a sympathetic understanding of animals.

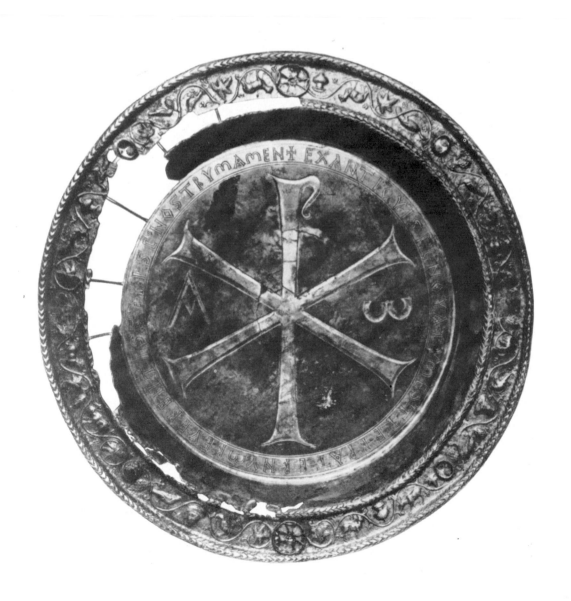

The Klimova Treasure

The treasure was found in 1907 in the neighbourhood of the village of Klimova (the Solikamsk district of the Perm region). It was found in two parts, the first find including the goatherd dish, a silver bucket and three Sassanian silver dishes, while the second portion included two large silver dishes, each with a niello cross in a wreath, and a silver dish with a rosette motif in the centre.

303 Silver dish: herdsman and goats AD 527–565
D 9·2 cm (footring), 23·8 cm (dish). WT 1380 g.
Flat silver dish on a footring, with relief decoration. The scene shows a goatherd seated on a stone bench, facing right, a curly-coated dog at his feet. The right side of the scene is occupied by two goats, one lying down and one standing, facing left. There is a tree in the background, and several smaller plants. The border of the dish is decorated with slightly curling acanthus leaves in relief, and edged with a narrow band of rope pattern. The reverse is engraved with four ornamental compositions of acanthus scrolls issuing from a vase and terminating in rosettes. There are five control stamps of the Emperor Justinian on the base.
Provenance: Klimova, Perm Province, USSR.
Bibl. Matzulewitsch, *Byz. Ant.*, p. 4, p. 112 ff. and pl. 31 ff.; Dodd, *BSS*; p. 70, no. 9; Banck, *BACU*, nos 59–61.
Leningrad, State Hermitage Museum. ω 277.

The main stamps date this piece to the reign of Justinian. There is also a secondary monogram, probably belonging to Peter (?Barsymes), *comes sacrarum largitionum* in AD 542. The plate was found in 1907 with Dodd, *BSS*, nos. 36 and 100.

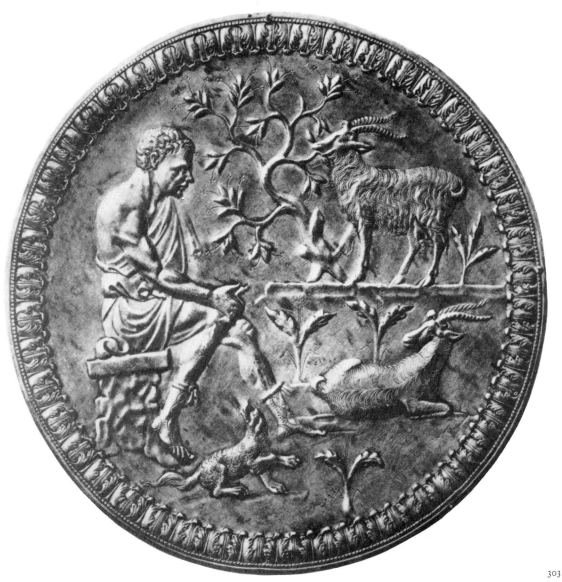

303

304 Silver dish Sassanian, fourth century AD
D 21·7 cm. WT 645 g.
Silver dish, parcel-gilt, with scene in applied cast elements
and chasing and engraving, of a king, probably Shapur III
(AD 383–388), on foot and facing half right, killing a leopard
with a sword.
Provenance: Klimova, Perm Province, USSR.
Bibl. Smirnov, *VS,* no. 308, pl. CXXII; Orbeli and Trever,
SM, pl. 7; Pope, *SPA,* p. 725, pl. 205.
Leningrad, State Hermitage Museum.

 Only one king appears on the Sassanian rock sculptures as a
hunter, in the grotto at Taq-i-Rustan; but hunters on the
silver plates are numerous. The reason is that a rock relief was
designed as an official representation, while the silver vessels
were for the most part intended for private life, for use at
festivities in the circle of intimate friends and guests. Hence
they recall the principal private amusements of the Sassanian
kings and their vassals, of which the chief was hunting.

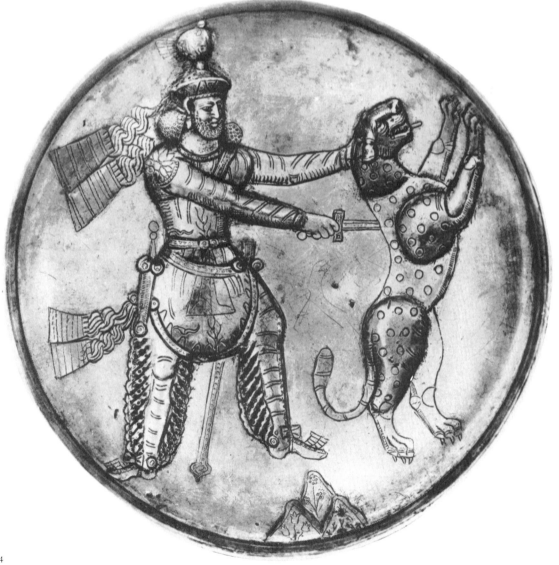

304

Sassanian Silver Vessels

305 Silver dish Sassanian, third century AD
H 4·4 cm. D 18 cm. WT 394·75 g.

Silver dish, parcel-gilt, plain on the outside with a ring foot, and decorated on the inside with a scene of a king, probably Shapur I (AD 240–272), hunting stags. The king, bearded and wearing a crown, rides one stag to the right and grasps an antler with his left hand while stabbing the animal in the neck with his right. A second stag lies below.

Provenance : Said to be from Asia Minor.

Bibl. Dalton, *OT*, no. 206, pl. XXXVI; Pope, *SPA*, pl. 206; Erdmann, *KI*, pl. 59; Barnett, *FM*, no. 36.

BM (WAA) 124091.

This is possibly one of the earliest of many silver dishes showing royal hunting scenes.

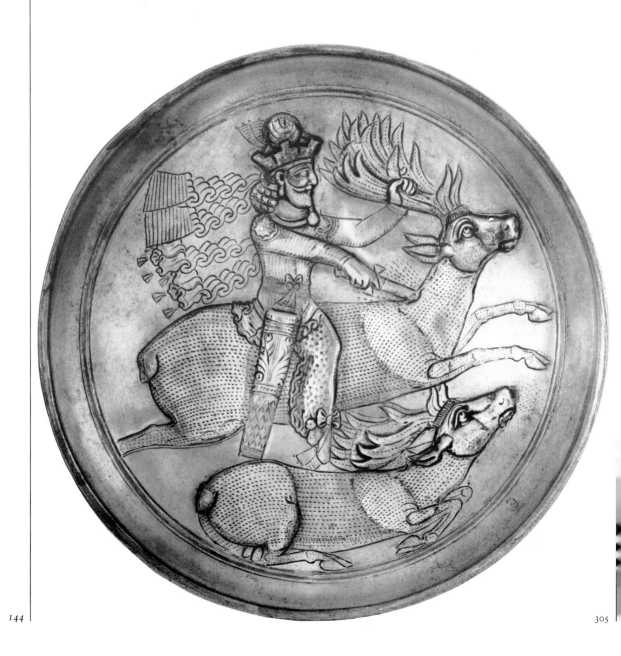

306 Silver dish Sassanian, fourth century AD
D 23·7 cm. WT 523·4 g.

Silver dish with embossed decoration showing two investiture scenes: (above) a seated deity, perhaps Mithra, holds out the ring of authority to a standing figure; and (below) a standing figure with a bow receives a ring from a seated female deity. Lukonin has suggested that the investitures are to the office of Kushanshah, or governor of the eastern provinces, and that the two central figures are: (above) Ardashir II (AD 379–383), who held the office before becoming king; and (below) his son Peroz, who succeeded him as Kushanshah. A wide border (partly lost) shows a ruler reclining on a couch, faced by his queen and surrounded by his family and courtiers.

Provenance: Obtained in Rawalpindi.

Bibl. Smirnov, *VS*, no. 39, pl. XVI; Dalton, *OT*, no. 208, pl. XXXVIII; Pope, *SPA*, pl. 239; V. G. Lukonin, *Epigrafika Vostoka* 18 (Moscow–Leningrad, 1967), pp. 28–9, fig. 6.

BM (WAA) 124093. Bequeathed by Sir Augustus Wollaston Franks.

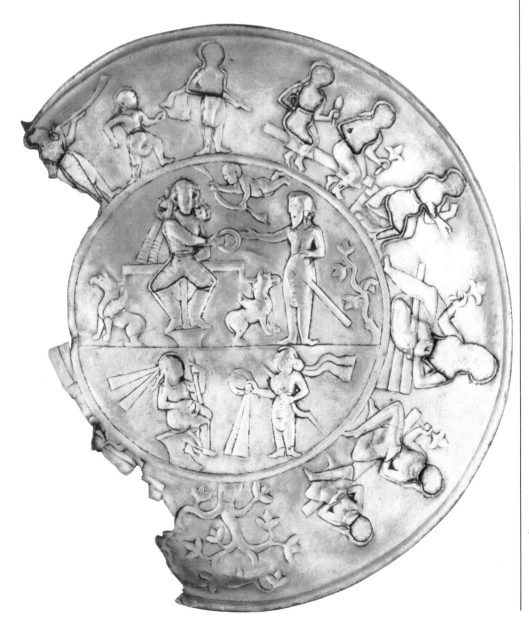

307 Silver dish Sassanian, fifth century AD

D 27 cm. WT 937·3 g.

Silver dish, parcel–gilt, plain on the outside, originally with a ring foot, now missing, and decorated on the inside with a scene of a king, probably Varahran V (Bahram Gur, AD 421–439). The king, bearded and wearing a crown, rides a horse to the right, holding a lion cub in his left hand, and striking a lion with a sword in his right hand. Another lion leaps up towards the cub.

Bibl. Smirnov, *VS,* no. 54, pl. XXVI; Dalton, *OT,* no. 207, pl. XXXVII; Erdmann, *KI,* pl. 66; Pope, *SPA,* pl. 231.A; Orbeli and Trever, *SM,* pl. 10, show a nineteenth-century copy of this dish, now in the Hermitage Museum,

BM (WAA) 124092. Formerly in the collection of General Sir Alexander Cunningham. Bequeathed by Sir Augustus Wollaston Franks.

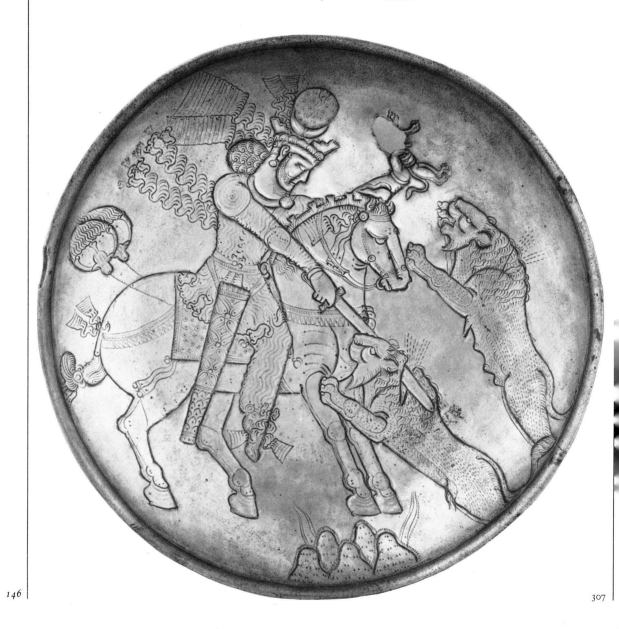

308 Silver dish Sassanian, fifth century AD
D 22·1 cm. WT 770 g.
Silver dish, parcel-gilt, decorated with chasing and applied
repoussé and with niello inlays. It shows a scene of a king,
probably Peroz (AD 459–484), riding a horse to the right with
drawn bow, hunting four rams.
Provenance: Said to be from Qazvin.
Bibl. MMAB 29 (1934), pp. 74–7, figs 1–2; Harper, *ANEA*,
fig. 59; Pope, *SPA*, pl. 213; Erdmann, *KI*, pl. 63; Grabar, *SS*,
no. 2.
New York, Metropolitan Museum of Art. 34.33. Fletcher
Fund.

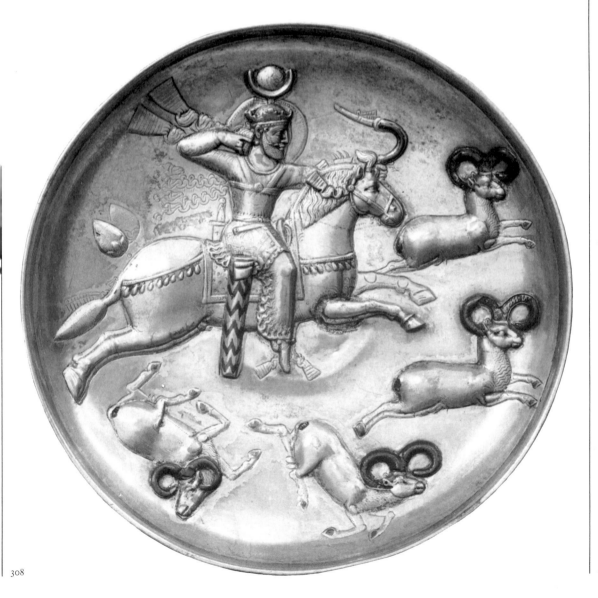

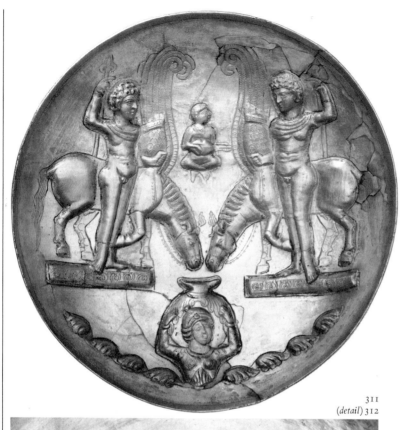

311
(detail) 312

314

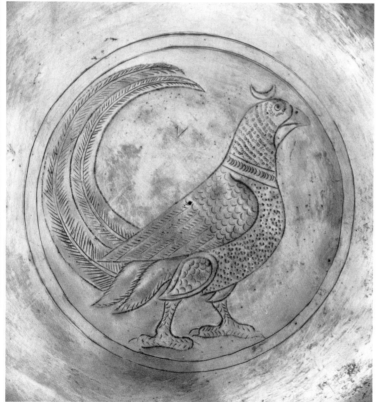

309 Silver dish Sassanian, fifth–sixth century AD
D 26 cm. WT 985·6 g.
Silver dish, parcel-gilt, with scene in repoussé of a king, probably either Kavad I (AD 488–531) or Khusro I (AD 531–579). The king is shown full face, seated on a throne flanked by courtiers. In the exergue he appears riding a horse to the left while firing an arrow over his shoulder at three rams.
Provenance: Strelka, Perm Province, USSR.
Bibl. Orbeli and Trever, *SM*, pl. 13; Pope, *SPA*, pl. 239.A.
Leningrad, State Hermitage Museum.

The Sassanian kings set great store by the preservation of portraits of themselves and their ancestors. At the death of each king a picture depicting an important moment in his career was added to a collection in the royal treasury. Hamza al-Isfahani (died AD 961–971) saw a book of such portraits, and, though the *Book of Kings* has now vanished, surviving rock-reliefs and the scenes on silver plates give some idea of the representations it contained.

310 Silver dish Sassanian, sixth–seventh century AD
D 30·5 cm.
Silver dish, parcel-gilt, with scene in repoussé of a king, possibly Khusro II (AD 591–628), riding a horse to the right with drawn bow, hunting boars, stags, rams and a gazelle.
Provenance: Russia.
Bibl. Smirnov, *VS*, no. 59, pl. XXXI; Pope, *SPA*, pp. 724 and 762, pl. 214; Ghirshman, *P & S*, fig. 252.
Paris, Bibliothèque Nationale, Cabinet des Médailles.
Colour plate.

311 Silver dish Sassanian, fourth or early fifth century AD
D 21·4 cm. WT 574 g.
Silver dish, parcel-gilt, decorated with chasing and applied repoussé. It shows a scene of two nude youths beside winged horses facing inwards and flanking a seated lute player. Below, a female figure rises from a stylized acanthus leaf border.
Bibl. Harper, *MMAB* 23 (1964–5), pp. 186–95, fig. 1; Grabar, *SS*, no. 25.
New York, Metropolitan Museum of Art. 63.152. Fletcher Fund.

312 Silver bowl Sassanian, fourth–fifth century AD
H 8·5 cm. D 16·9 cm. WT 442·9 g.
Footed silver bowl with external fluting and central medallion decorated with an engraved pheasant.
Bibl. Barnett and Curtis, *BMQ* 37 (1973), p. 127, pl. LVIII.a.
BM (WAA) 133033.

313 Silver bowl Sassanian, fifth century AD
H 3·8 cm. D 15·2 cm. WT 226·05 g.
Shallow bowl, plain on the inside, the outside decorated in relief with four medallions. These contain (anticlockwise): (a) a clothed human figure holding a vessel and with one foot on a sphere, facing (to right) a bird on a pedestal altar; (b) a similar figure facing (to left) a plant behind a vertical rod; (c) (damaged) a similar figure holding a shallow bowl, facing (to left) a plant; (d) a bearded man in a kilt and holding a staff and basket, facing (to left) a crouching hare. Between the medallions are floral decorations.
Bibl. Dalton, *OT*, no. 202, pl. XXXII.
BM (WAA) 124088.

314 Silver dish Sassanian, fifth–sixth century AD
L 20 cm. W 9·5 cm. H 9·8 cm. WT 90·05 g.
Elliptical silver dish with central medallion decorated with an engraved repoussé pheasant.
BM (WAA) 135700.

315 Silver bowl Sassanian, seventh century AD
L 29·1 cm. WT 663 g.
Footed bowl, parcel-gilt, in the form of a lobed ellipse decorated in repoussé with two dancing girls, one playing clappers, the other holding a shawl over her head, and two crouching stags. A floral pattern runs round the rim and a running grapevine pattern separates the dancing girls and the stags.
Provenance: Sloudka, Perm Province, USSR.
Bibl. Smirnov, *VS*, no. 78, pl. XLV; Orbeli and Trever, *SM*, pl. 58; Pope, *SPA*, p. 747, pl. 221.A–B.
Leningrad, State Hermitage Museum.

There are numerous examples of Sassanian oval or boat-shaped dishes. Their use is uncertain; but bowls such as this may have served to hold the traditional gift of seven different fruits presented on New Year's Day.

315

316 Silver dish late seventh–early eighth century AD
D 19·7 cm. WT 737 g.

Shallow dish with ring foot. The interior is carved in relief, with some relief elements soldered on to the low relief. The ground is gilded. The decoration shows a festal scene in a garden. To the right a grapevine springs from a pool and curves along the upper edge of the dish. In the centre is a couch, on which a prince reclines; to his left a woman is seated oriental fashion on the couch. To the right stand two male figures, one with arms crossed on his chest, the other playing a lute. To the left of the last another standing male figure blows a horn. Various objects are seen in the foreground: from left to right a palm branch, a cabinet with two ewers on the lower shelf, a water skin, a vase suspended from three sticks, a heap of flowers, and a wreath with the ends folded over a stick. A Pehlevi inscription is engraved to the right of the prince's head.

Provenance: Mazanderan, Iran.

Bibl. Smirnov, *VS*, pl. XXXVII; Dalton, *OT*, pp. vi and 66 ff., no. 211, pl. XXXIX; Herzfeld, *Arch. Mitt.* I 4, p. 148 ff. BM (OA) 1963.12–10.3. Bequeathed by Sir Augustus Wollaston Franks.

The dish was probably made in northern Iran where the Sassanian style survived into the first two Islamic centuries. Herzfeld reads the Pehlevi inscription as Anōszād, the name of a son of Khusro I (AD 531–578), maintaining that this name applies to the princely figure and not to the silversmith.

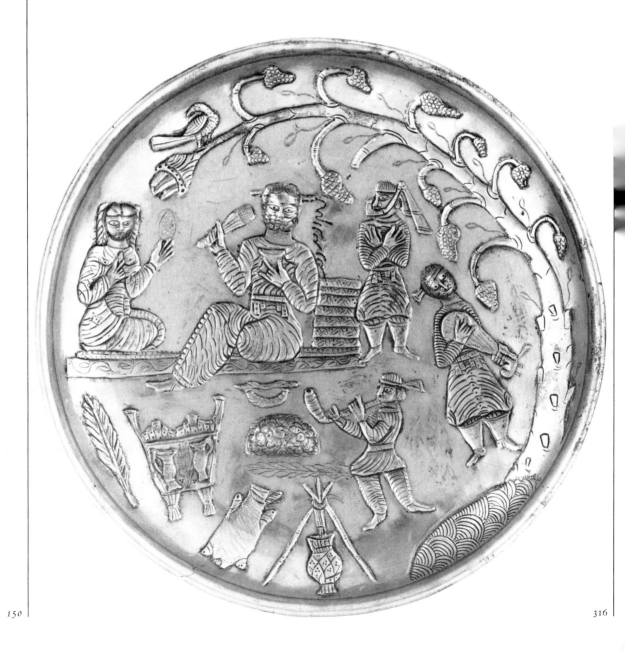

317 Silver dish Sassanian, seventh–eighth century AD
H 4 cm. D 19·3 cm. WT 541·5 g.
Silver dish, parcel-gilt, with ring base and, on the inside, raised and chased decoration of the *senmurw*, a creature with the forepart of a dog and the tail of a bird.
Provenance: Obtained in northern India.
Bibl. Dalton, *OT*, no. 210, pl. XL; Pope, *SPA*, pl. 227.
BM (WAA) 124095. Presented by the National Art Collections Fund.

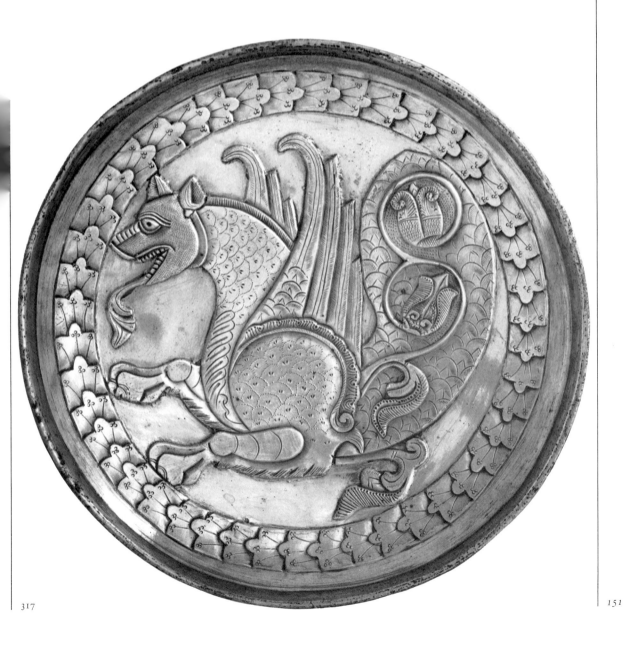

317

318 ▷
320 321

319

318 Silver vase Sassanian, fifth–sixth century AD
H 17·3 cm. WT 116·9 g.
Silver vase, parcel-gilt, decorated in chasing and repoussé
with four dancing girls framed in a stylized colonnade.
Provenance: Limarovka, Kharkhov Province, USSR.
Bibl. Smirnov, *VS*, no. 80, pl. XLVI; Orbeli and Trever,
SM, pl. 45; Erdmann, *KI*, pl. 80.
Leningrad, State Hermitage Museum.

The attributes of the women show that the reference is to
the cult of Anahit. The goddess is one of the Avestic deities
who are represented in the rock reliefs as participants in the
theme of the Investiture of the King.

319 Silver rhyton Sassanian, fifth–sixth century AD
H 31·7 cm.
Silver rhyton, parcel-gilt, raised and chased, in the form of a
goat's head.
Provenance: Choniakow, Ostrog District, Poland.
Bibl. Pope, *SPA*, pl. 109; Ettinghausen, *Ars Islamica* 7 (1940),
pp. 114–15, fig. 13; Grabar, *SS*, no. 48.
New York, Metropolitan Museum of Art. 47.100.82.
Rogers Fund.

320 Silver vase Sassanian, fifth–sixth century AD
H 16 cm. WT 871·3 g.
Silver vase, parcel-gilt, decorated in repoussé with dancing
girls framed in a stylized colonnade.

Provenance: Perm Province, USSR.
Bibl. Orbeli and Trever, *SM*, pls. 46–7; Pope, *SPA*, p. 735.
Leningrad, State Hermitage Museum.

The attributes – doves, lotus flowers, pomegranates – are
all those of the goddess Anahit in her aspect as the patroness of
love.

321 Silver jug Sassanian, sixth century AD
H 33 cm. WT 1041 g.
Silver jug, parcel-gilt, with a globular body on a high foot,
and a flared neck-spout. The decoration, in repoussé and
engraving, consists of a mythical creature, the *senmurw*, on
each side within a medallion. There is a leaf pattern round the
handle, and stylized flowers on the front and the lid. The
senmurw had the forepart of a dog and the tail of a bird.
Provenance: Pavlovka, Kharkhov Province, USSR.
Bibl. Smirnov, *VS*, no. 83, pl. XLIX; Orbeli and Trever,
SM, pl. 48; Pope, *SPA*, p. 737, pl. 226; Erdmann, *KI*, pl. 77.
Leningrad, State Hermitage Museum.

The *senmurw* was an associate of the divine hero
Verethragna, who in some phases was almost merged with
the older divinity Mithra, god of sun and light. The animal
was a favourite motif of the period, not only on metal
objects, but also on stucco and textiles. Gold and silver jugs
are comparatively rare; but the form of this one is typical of
those which do occur.

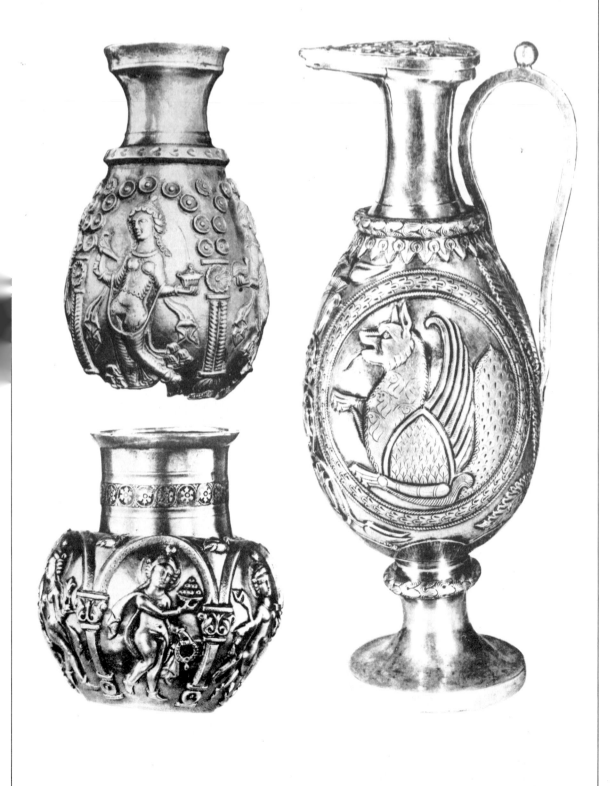

322 Silver ewer Sassanian, sixth–seventh century AD
H 34·1 cm. WT 1546 g.
Silver ewer, parcel-gilt, decorated in repoussé with dancing
girls framed in a stylized colonnade.
Bibl. MMAB 26 (1967–8), p. 52 and fig.; Harper, *ANEA*,
fig. 61; Brunner, *MMJ* 9 (1974), p. 118, fig. 6.
New York, Metropolitan Museum of Art. 67.10. Rogers
Fund.

323 Silver vase Sassanian, sixth–seventh century AD
H 18·5 cm. D 10·7 cm. WT 592·4 g.
Silver vase, parcel-gilt, with embossed and traced decoration
of two grapevines growing among flowers, with birds and a
fox between the branches. Between the vines are two naked
boys, one cutting a bunch, and the other carrying a basket of
grapes. Above is a row of embossed knobs. The base is
pierced like a strainer.

Provenance: Mazanderan, Iran.
Bibl. Smirnov, *VS*, no. 86, pl. LII; Dalton, *OT*, no. 209,
pl. XXXIX.
BM (WAA) 124094. Bequeathed by Sir Augustus Wollaston
Franks.

324 Silver ewer Sassanian, sixth–seventh century AD
H 34 cm.
Silver ewer decorated in chasing and repoussé. On each side is
a scene of two lions rearing up on their hind legs with their
bodies crossed; below the spout, separating the two lion
compositions, is a stylized tree.
Provenance: Russia.
Bibl. Smirnov, *VS*, no. 85, pl. LI; Erdmann, *KI*, pl. 76;
Ghirshman, *P & S*, fig. 404; Porada, *AI*, fig. 119.
Paris, Bibliothèque Nationale, Cabinet des Médailles.
Colour plate.

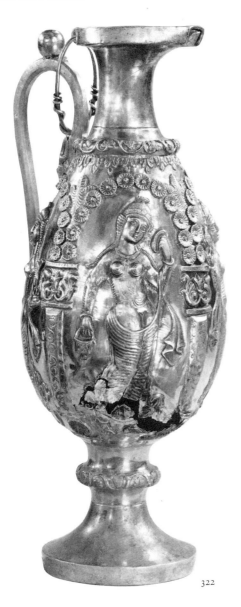

322

323

Sassanian Arms and Armour

325 Silver boss Sassanian, fourth century AD
H 5·9 cm. D 15·9 cm. WT 597·6 g.
Heavy silver boss, parcel-gilt, embossed and chased with the
face of a lion. The rim is pierced with four holes, one of them
still containing a rivet, for attachment to some other object,
probably a shield.
Bibl. Barnett and Curtis, *BMQ* 37 (1973), p. 127, pl. LVII.c.
BM (WAA) 134358.

325

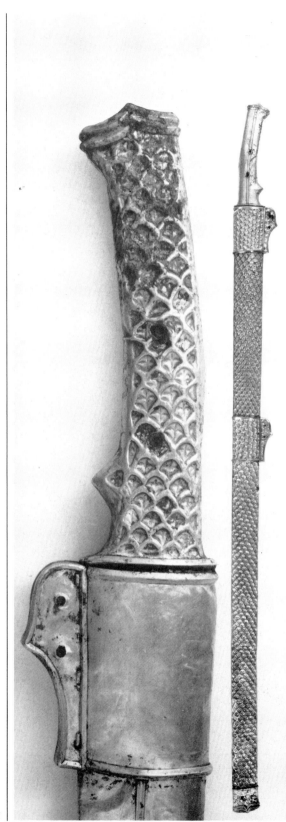

326 Sword with silver scabbard Sassanian, sixth century
AD
L 108 cm.
Iron sword with silver hilt and scabbard decorated with
applied wire spirals.
Provenance: Said to be from north-west Persia.
Bibl. Barnett and Curtis, *BMQ* 37 (1973), p. 127, pl. LIX.a.
BM (WAA) 135158.

327 Sword with gold scabbard Sassanian, sixth–seventh
century AD
L 106 cm. W 7 cm.
Iron sword with gold hilt and scabbard decorated on one side
with a repoussé scallop pattern.
BM (WAA) 135738.

328 Sword with silver scabbard Sassanian, sixth–seventh
century AD
L 107 cm.
Iron sword with silver hilt and scabbard, partially decorated
on one side with a repoussé scallop pattern, and on the other
with applied wire spirals.
BM (WAA) 135739 and 135747.

329 Silver strip Sassanian, third–fourth century AD
L 17·8 cm. W 4·1 cm. WT 22 g.
Silver strip with holes pierced at each end for attachment,
perhaps to furniture or clothing, and repoussé decoration of a
boar charging to the right and confronted from each end by a
dog.
Provenance: Obtained in Persia.
Bibl. Gadd, *BMQ* 7 (1932–3), p. 48, pl. XX.c.
BM (WAA) 123063.

330 Silver head Sassanian, *c.* fourth century AD
W 23 cm. H 40 cm.
Silver head, parcel-gilt, hammered from a single sheet and
decorated with chasing and repoussé to show the head of a
king, probably Shapur II (AD 309–379), with beard and
moustache and curled hair, wearing a crown.
Bibl. Harper, *MMAB* 25 (1966–7), pp. 136–46, fig. 1;
Lefferts, *MMAB* 25 (1966–7), pp. 147–51; Harper, *ANEA*,
fig. 61; Grabar, *SS*, no. 50.
New York, Metropolitan Museum of Art. 65.126. Fletcher
Fund.
 This head is the only one of its kind known from Sassanian
times.

◁ 327

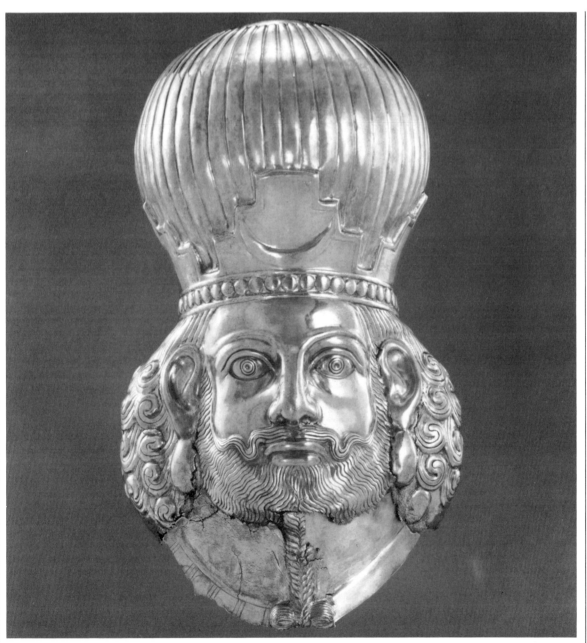

330 △ ▽ 329

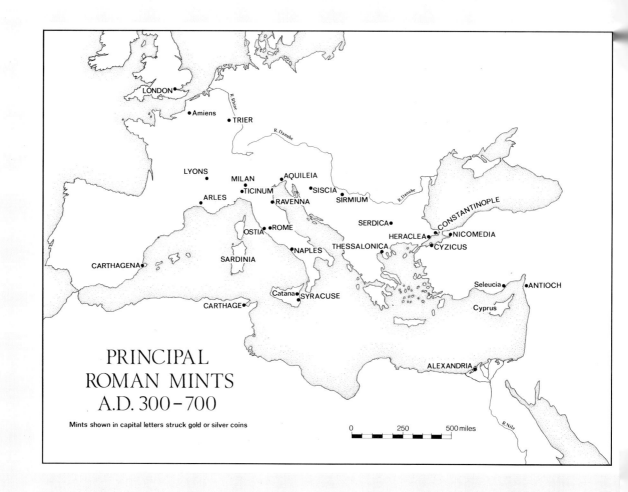

PRINCIPAL
ROMAN MINTS
A.D. 300–700

Mints shown in capital letters struck gold or silver coins

LONDON

Amiens

TRIER

R. Rhine

R. Danube

LYONS

MILAN

AQUILEIA

TICINUM

SISCIA

ARLES

RAVENNA

SIRMIUM

R. Danube

SERDICA

CONSTANTINOPLE

OSTIA

ROME

HERACLEA

NICOMEDIA

THESSALONICA

CYZICUS

CARTHAGENA

NAPLES

SARDINIA

Catana

SYRACUSE

Seleucia

ANTIOCH

CARTHAGE

Cyprus

ALEXANDRIA

R. Nile

0 250 500 miles

COINAGE AND CURRENCY
AD 300-700

In the early days of the Roman Empire, its coinage of gold, silver, brass and copper was elaborately constructed, in order to provide a series of denominations appropriate to every circumstance. The fixed relationship between the coins of different metals suggests a very advanced concept of currency. In practice, quite another state of affairs prevailed. Gold commanded a premium over silver, and silver over the base metals. Coins in different metals were not in fact freely exchangeable against one another, except through the intermediary of the money-changer.

The last remnants of the early system vanished in the monetary crisis of the 260s; thereafter, the Empire went on to a kind of gold standard. The gold coinage, in terms of which most payments by and to the State were reckoned, remained stable; the base metal coinages of everyday transactions varied in their relationship to the gold according to economic circumstances, and were themselves assessed in terms of the *denarius*. This had once been a valuable silver coin; now it was just a notional unit of account whose value was continually falling.

Due to its essential place in government finance, gold coinage was issued regularly and, in comparison with the early Empire, copiously. Silver coinage, on the other hand, once the basic component of military pay, now languished. One of the reforms of Diocletian (AD 284–305) had been the revival of a coin equivalent to the old silver *denarius*; its issue virtually ceased within a year or two of his death. About the year 358, Constantius II (AD 337–361) reformed the silver coinage, and it was issued in large amounts down to about 400, when again it virtually ceased. In Italy, modest issues of very small coins recommenced under Libius Severus (AD 461–465), and continued through the period of Ostrogothic rule and under the imperial reconquest into the reign of Justin II (AD 565–578), after which they fell away once more. In the East, it appears to have been the church plate furnished for Heraclius's crusade against the Persians that provided the silver for the extensive issues of 615 to about 660.

Coinage in the base metals had a more complex history; it was the direct descendant of the silver coinage, ruined by debasement in the third century. During the first half of the fourth century it not only retained an intentional and significant proportion of silver, but when issued had a silvery appearance. The importance of this silver component may be readily appreciated in a period when silver was one hundred times as valuable as copper. Even an addition of 1% would double the metallic value of a coin, and many issues contained 2% or 3%. A law of Constans (AD 337–350) denounces those who melted down his coin in order to extract the silver. From the time of Valentinian I (AD 364–375) however, analyses show that such base silver alloys were no longer used, and that bronze alone was employed.

Since so many of its payments were made in gold, the late Roman government attached great importance to its acquisition and recovery. Not only did provincial officials have the responsibility of converting the numerous small contributions of

humble taxpayers into gold before despatch to the Treasury, but more was demanded by compulsory purchase. Gold miners were so hard-pressed that they welcomed the coming of the Goths to the Balkans, as a lightening of their intolerable burdens. Once issued, an elaborate organization existed for the repurchase of gold coin by government agents and, after 366, the central Treasury no longer accepted its issues in individual pieces; they were taken back only when converted into carefully refined and weighed bars. Gold coins made after this reform usually bear the letters OB, an abbreviation denoting fine gold.

From the early part of the reign of Constantine I (the Great, AD 306–337) the standard gold coin of the Empire was the *solidus*. *Solidi* weighing 1/72 of a Roman pound, i.e. pieces of about 4·50 g, made of fine gold, continued to be struck down to the eleventh century. They achieved thereby a reputation in international trade rivalled by few other coinages. 'The second sign of sovereignty that God has given to the Romans', wrote an admiring traveller of the sixth century, 'is that all nations use their [gold] coinage for trade'. Examples are found from Ireland and Scandinavia to China and India. Even the Sassanian kings of Persia issued virtually no gold coinage, in spite of their massive issues of silver. Not all *solidi* were of an equal standard. The usurper Magnentius (AD 350–353) issued many of a slightly inferior weight, and because of the number of defective coins in circulation, Julian the Apostate (AD 361–363) ordered the appointment of an official coin-weigher in each city. Periodic issues of light-weight *solidi* were resumed in the later sixth and seventh centuries, and again in the tenth century onwards. The reason for this is not known.

The scale of values in the ancient world was very different from our own. One gold *solidus* was enough to furnish bare subsistence for a year; four or five provided a soldier's annual ration, while six or seven brought a decent if humble standard of living. It was naturally more costly to live in a city than in the country, and all manufactured goods were very expensive. A modest suit of clothes, for example, is recorded to have cost one *solidus*.

The designs on late Roman gold coins show a very limited range of motifs. All bear the head of the reigning emperor or of a member of his family. On the reverse side, the victoriousness of the emperor is the abiding theme. In the early Empire, a much wider range of designs had been created, to build up a picture of imperial aspirations and achievements. By the fourth century, the State seems to have reached the conclusion that only the most basic message could be conveyed to the public through coin-types. During the fifth century, designs became stereotyped for long periods. In the seventh century, they became more overtly religious. Heraclius (AD 610–641) and his successors displayed the great jewelled cross which stood on the site of the Crucifixion, while Justinian II (AD 685–711) introduced for the first time the bust of Jesus Christ, 'King of Kings', relegating himself to the reverse side. During the fourth and first half of the fifth centuries, a frequent feature of the design of both gold and silver coins was the wreath bearing imperial *vota*, the prayers which were offered every fifth year for the continuance of the emperor's rule. They were celebrated by the payment of special bonuses to the army, and by the receipt of additional taxes, nominally free-will gifts from a rejoicing public!

During the early Empire, the issue of multiples of the normal gold and silver coinage was infrequent. The practice increased in the third century, and by the start of the fourth century, magnificent pieces were regularly struck to a systematic range of weights. At first, they are usually found within the Empire, and were presumably presented to high-ranking officers. After the middle of the fourth century, however, they often occur beyond the frontiers, suggesting presentation to barbarian chiefs; a well-known reference in Gregory of Tours describes the gold medallions, each one pound in weight, sent by Tiberius Constantine (AD 578–582) to King Chilperic of the Franks.

At the start of the fourth century, the only coinage within the Mediterranean world, apart from those of the Roman Empire and the Sassanian kingdom, was that of the kingdom of Axum. Its handsome, if stylized, coinage consisted of gold, supplemented by silver and bronze. Portions of the design on some of the silver and bronze pieces are inlaid with gold. It had a limited circulation in parts of Ethiopia and Somalia, and the Yemen, and extended from the third into the eighth century.

The coinage of the barbarian peoples of the West arose in the troubled years of the early fifth century. Of the many usurpers of that period, Constantine III (AD 407–411) was the candidate of the Roman army in Britain, while Priscus Attalus (AD 409–411) and Jovinus (AD 411–413) were the nominees of different groups of barbarians. In 418 the Visigoths abandoned Attalus their protégé to the Roman government, and soon afterwards began to coin gold and silver in imitation of the imperial issues of Honorius (AD 393–423) of the Ravenna mint. In the time of Valentinian III (AD 425–455) and his successors, Visigothic *solidi* became lighter and baser than their imperial prototypes; law codes and literature alike discriminate against them. In the early sixth century, under Ostrogothic influence, their coinage underwent a great improvement. By now it consisted largely of *tremisses*, thirds of the *solidus*. Towards the end of the century, King Leuvigild (AD 568–586) began to inscribe his own name on the coinage, and regal issues, usually also bearing the place of mintage, continued down to the fall of the kingdom to the Arabs in the early eighth century.

In Africa, the Vandals struck silver coins bearing the names of their kings from Gunthamund (AD 484–496) to Gelimer (AD 530–533); strangely, no gold is attributable to them. In central Gaul the Burgundians struck gold and a very few silver and copper coins down to the fall of the kingdom in 532. The gold coins were copies of the contemporary issues of Anastasius (AD 491–518), Justin I (AD 518–527) and Justinian I (AD 527–565), but were additionally inscribed with the monograms of the kings. Further to the north, a series of tiny silver pieces of the late fifth and early sixth centuries is ascribed to the Franks, but the main volume of their coinage did not begin until the 530s. A remarkable issue of this period is the gold coinage of King Theudebert I (AD 534–548), of imperial type, but with the name and title of the king. After about 570, the Frankish coinage underwent a change. A very distinctive coinage was struck in Provence in the name of the Emperor down to about 615, and after that in the name of the Frankish king almost to the end of the seventh century. Throughout the rest of the Frankish realm, very little coinage bearing the names of the kings was struck; most coins carry the names of the places where they were minted and those of the moneyers responsible. At first, Frankish coins, like those of the Burgundians, were of good gold. After 600 however, they became steadily baser, falling to no more than 25% gold. In the course of the seventh century, the gold coin was increasingly replaced by small silver pieces; some of these are inscribed DENARIVS, and are the direct ancestors of the medieval penny.

The Ostrogoths in Italy struck an extensive coinage in gold and silver. This bore on the obverse the name of the emperor, and the name or monogram of the Ostrogothic king on the reverse. During Justinian's war of reconquest, the Ostrogothic kings Totila (AD 541–552) and Theia (AD 552–553) repudiated the use of his name, employing instead that of the long-dead Anastasius (AD 491–517). After their invasion of Italy in 568, the Lombards struck imitations of contemporary imperial coinage, but issues attributable to specific places and rulers did not begin until about 700.

In the reconquered provinces of Africa and Italy, Justinian I (AD 527–565) established mints which issued imperial coin. Towards the end of the sixth century, *solidi* struck in Africa began to be minted on characteristic small, thick blanks. After the fall of Carthage to the Arabs in 698 this coinage was continued for a while in

Sardinia, while its form was adopted by the conquerors for their first issues in Africa and Spain. Imperial coinage in Italy was as fragmented as the province itself; after the middle of the seventh century Ravenna, the seat of the governor-general, gave way to Syracuse in Sicily as the principal mint. During the sixth and early seventh centuries, Ravenna issued an extensive series of small silver coins; an unusual feature of many is the mark of value, expressed in *nummi*, the official unit of account.

The coinages of the Arabs derived directly from that of the conquered peoples. The silver coinage of the Sassanian kings was directly copied, sometimes with the addition of a short inscription. Little gold was made until the very end of the seventh century, when the introduction by Justinian II (AD 685–711) of the bust of Christ on to the coinage made Roman *solidi* unacceptable. Abd-al-Malik then created the characteristic gold *dinar*, with nothing but inscriptions on both sides, which set the pattern for Muslim coinages into the Middle Ages and beyond.

By the year 700, the Romans' virtual monopoly of coinage in the Mediterranean basin had long been broken. In the West, Visigoths, Lombards and Franks had their national coinages; even in Britain, there was an ever-growing volume of coinage, following the Frankish metrology though not its types. Throughout the lands which they had taken, the Arabs were producing a distinctively Islamic currency.

389 Constantine I (AD 317–337)
458 Constantius II (AD 337–361)
528 Eugenius (AD 392–394)
700 Theodebert (AD 534–548)
709 Justinian I (AD 527–565)
718 Phocas (AD 602–610)
775 Tiberius III (AD 698–711)
852 Leo I (AD 457–474)

389

458

528

852

709

700

718

775

1 The Rise of Constantine the Great, c. 312

In 312 Italy and Africa were held by Maxentius, who had been proclaimed as emperor after a revolt in 306. He was regarded as a public enemy by the three emperors (Maximinus II, Constantine and Licinius I) who jointly ruled the rest of the Empire. Constantine invaded Italy from Gaul in 312 and defeated Maxentius at the battle of the Milvian Bridge. Subsequently he arranged the marriage of his half-sister to Licinius, and fear of this alliance prompted Maximinus to invade the Balkans in 313. He was defeated near Heraclea by Licinius, who then took over the East.

Relations between Constantine and Licinius deteriorated and war broke out in 314. When peace was made in the same year, Licinius lost most of his European territories. An uneasy peace followed, during which (in 317) Licinius's son, Licinius II, and Constantine's sons Crispus and Constantine II were proclaimed as junior emperors or Caesars. In 324, however, war broke out again and ended in the same year with Licinius's final defeat. Constantine was left as the sole ruler of the Empire.

In the Late Empire coins were made at many mints. Each struck coins in the name of the emperor who controlled it and in the names of the other emperors he recognized: Constantine's mints struck for Licinius and Maximinus (**340, 341, 364–7**) as well as for himself.

Silver coinage was sparse in the early fourth century, but gold was coined regularly. Constantine introduced a new gold coin, the solidus, in Gaul in about 310, and it replaced the previous heavier gold coin (the 'aureus') in Italy (in 312) and the East (in 324) when he took them over. Gold medallions or multiple coins were also made, for instance to celebrate the proclamation of the Caesars in 317 (**373, 375**).

The reverse types of the coins are varied; they may represent deities or personifications like Victory, or sometimes contemporary events (e.g. Constantine's victories over the Alamanni and the Franci across the Rhine: **336, 337**). Several of the reverse types used by Maxentius stress his position as ruler of the traditional capital, Rome: the wolf and twins appear (**346, 349–51**) and Rome presents the empire (symbolized by a globe) to Maxentius (**342**).

The West: Constantine

331– Constantine. Gold solidi. Mint of Trier.
337 *RIC* vi, Trier 811; 815; 816; 819; 821; 823; 824.
338 Gold solidus of Constantine I (AD 306–337), AD 310–12. Mint of Trier.
 D 17·5 mm. WT 4·63 g.
 Obv. CONSTANTINVS P F AVG. Head of Constantine I crowned with a laurel wreath, facing right.
 Rev. FELICITAS REIPVBLICAE. The emperor seated on a platform between two officers, facing left; below are three kneeling figures.
 Mint mark: PTR.
 Bibl. RIC vi, Trier 810.
 BM (C & M) R 0149. Bequeathed by C. M. Cracherode (1799).
339 Maximinus II. Silver coin. Mint of Trier.
 RIC vi, Trier 826.
340 Licinius. Silver coin. Mint of Trier.
 RIC vi, Trier 825 (=*RIC* vii, Trier 212).
341 Constantine. Silver coin. Mint of Trier.
 RIC vi, Trier 208A.

Maxentius

342 Electrotype of gold medallion (= 8 aurei). Mint of Rome.
 RIC vi, Rome 173.
343 Gold medallion (= 4 aurei). Mint of Rome.
 RIC vi, Rome 172.
344, Aurei. Mint of Rome.
345 *RIC* vi, Rome 180; 183.
346 Aureus of Maxentius (AD 306–312), AD 308–12. Mint of Ostia.
 D 18 mm. WT 5·55 g.
 Obv. MAXENTIVS P F AVG. Bust of Maxentius, full face and draped.
 Rev. TEMPORVM FELICITAS AVG N. She-wolf with the twins Romulus and Remus.
 Mint mark: POST
 Bibl. RIC vi, Ostia 5.
 BM (C & M) R 0243. George III Collection.

347 Aureus. Mint of Ostia.
 RIC vi, Ostia 6.
348– Silver coins. Mint of Rome.
350 *RIC* vi, Rome 187; 189; 190.
351, Silver coins. Mint of Ostia.
352 *RIC* vi, Ostia 11; 13.

The Balkans: Licinius

353 Aureus. Mint of Siscia.
 RIC vii, Siscia 18.
354 Aureus. Mint of Thessalonica.
 RIC vii, Thessalonica 43.
355 Aureus. Mint of Heraclea.
 RIC vii, Heraclea 4.

The East: Maximinus II

356, Aurei. Mint of Nicomedia.
357 *RIC* vii, Nicomedia 62; 63.
358 Aureus. Mint of Antioch.
 RIC vii, Antioch 127a.
359 Aureus of Maximinus II (AD 309–313), AD 310–11. Mint of Antioch.
 D 20 mm. WT 5·33 g.
 Obv. MAXIMINVS P F AVG. Head of Maximinus II crowned with a laurel wreath, facing right.
 Rev. Within wreath: X MAXIMINI AVG.
 Mint mark: SMA
 Bibl. RIC vi, Antioch 131.
 BM (C & M) 1864-11-28-169. E. Wigan Gift.

Constantine in Italy after the Defeat of Maxentius

360 Constantine. Gold solidus. Mint of Rome.
 RIC vi, p. 688.
361 Constantine. Gold half-solidus. Mint of Rome.
 RIC vi, p. 688, but half-solidus instead of solidus.
362 Constantine, Gold medallion (= 2 solidi). Mint of Ostia.
 RIC vi, Ostia 65.
363 Constantine. Gold solidus. Mint of Ostia.
 RIC vi, Ostia 69.
364 Licinius. Gold solidus. Mint of Rome.
 RIC vi, Rome 283.
365 Licinius. Gold half-solidus. Mint of Ostia.
 RIC vi, Ostia 71.
366 Maximinus II. Gold solidus. Mint of Rome.
 RIC vi, Rome 285b.
367 Maximinus II. Gold solidus. Mint of Ostia.
 RIC vi, Ostia 68.

Licinius in the Balkans and the East after the Defeat of Maxentius

368 Licinius. Aureus. Mint of Serdica.
 RIC vii, Serdica 3.
369 Constantine. Aureus. Mint of Serdica.
 RIC vii, Serdica 4.
370 Licinius. Aureus. Mint of Heraclea.
 RIC vii, Heraclea 9.
371, Licinius. Aurei. Mint of Nicomedia.
372 *RIC* vii, Nicomedia 4; 10.
373 Multiple (4×) aureus of Licinius I (AD 308–324) and Licinius II, Caesar (AD 317–324), c. AD 320. Mint of Nicomedia.
 D 34 mm. WT 21·06 g.
 Obv. DD NN LICINVS · P · F · AVG · ET · LICINIVS · CAESAR. Busts of Licinius I and Licinius II, Caesar, full face and haloed, draped and wearing cuirasses.
 Rev. IOVI CONSERVATORI LICINIORVM AVG ET CAES. Jupiter seated, full face, holding figure of Victory upon globe and sceptre; at his feet is an eagle with a wreath.
 Mint mark: in field Δ; in exergue SMN
 Bibl. RIC vii, Nicomedia 37.
 Paris, Bibliothèque Nationale, Cabinet des Mèdailles.
 Colour plate.

374 Licinius. Aureus. Mint of Antioch.
RIC vii, Antioch 2.

Constantine in the Balkans after the First War with Licinius

375 Gold multiple ($1\frac{1}{2}\times$) solidus of Constantine I (AD 306–337), AD 317. Mint of Siscia.
D 22 mm. WT 6·64 g.
Obv. IMP CONSTANTINVS P F AVG. Draped bust of Constantine I, wearing a radiate crown and a cuirass, facing right.
Rev. CRISPVS ET CONSTANTINVS IVN NOBB CAESS. Confronted busts of the Caesars Crispus and Constantine (II).
Mint mark: SIS
Bibl. RIC vii, Siscia 26.
BM (C & M) 1864-11-28-192. E. Wigan Gift.

376 Constantine. Gold solidus. Mint of Siscia.
RIC vii, Siscia 29.

377 Gold multiple ($1\frac{1}{2}\times$) solidus of Constantine II (AD 317–340), AD 320. Mint of Sirmium.
D 22 mm. WT 6·51 g.
Obv. D N CONSTANTINVS IVN NOB CAES. Bust of Constantine II as Caesar, wearing a cuirass and draped, crowned with a laurel wreath and facing right.
Rev. PRINCIPI IVVENTVTIS. Constantine II and three standards.
Mint mark: SIRM
Bibl. RIC vii, Sirmium 2.
BM (C & M) 1864-11-28-198. E. Wigan Gift.

378 Gold solidus of Constantine I (AD 306–337), AD 321. Mint of Sirmium.
D 18 mm. WT 4·33 g.
Obv. CONSTANTINVS P F AVG. Bust of Constantine I, wearing a cuirass and draped, crowned with a laurel wreath and facing right.
Rev. SOLI INVICTO COMITI. The god Sol crowning the Emperor.
Mint mark: SIRM
Bibl. RIC vii, Sirmium 21.
BM (C & M) R 0160. George III Collection.

379 Constantine. Gold solidi. Mint of Sirmium.
RIC vii, Sirmium 8.

380, Constantine. Gold solidi. Mint of Thessalonica.
381 *RIC* vii, Thessalonica 8; 11.

338

346

 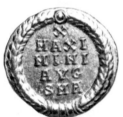 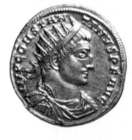

359 △ ▽ 377

375 △ ▽ 378

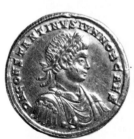 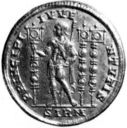 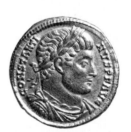 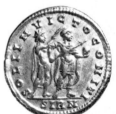

2 The House of Constantine, c. 337

After the defeat of Licinius in 324, Constantine the Great was the sole ruler of the Roman Empire for thirteen years. He was assisted by his sons Crispus (until 326), Constantine II, Constantius and Constans, and by his nephews Dalmatius and Hannibalian. They all held the rank of Caesar, except for Hannibalian who was appointed King (*Rex*) of Armenia in 335 to emphasize Roman claims in the East against Persia. (The unique silver coin of Hannibalian (**395**) gives him his title *rex* on the obverse.) In the same way the Caesars each had responsibility for a part of the Empire under the direction of Constantine who resided at his new capital at Constantinople.

Constantine died on 22 May 337. Since the army wanted only the sons of Constantine to rule, Dalmatius and Hanniballian were soon killed and the Empire was divided between the three sons.

In 340 Constantine II attacked his brother Constans, but he was killed and Constans took over his part of the Empire. Constans and Constantius were left as the joint rulers of the Empire.

Silver was coined in two denominations, the *siliqua* and the *miliarensis*, but still only in small quantities. Multiple coins were struck in gold and silver and celebrate a number of events: Constantine II's victory over the Sarmatians (**383**), the conferment of the rank of *Augusta* on Constantine's wife Fausta (**385**) and the adoption of the title *Augustus* by one of the Caesars on Constantine's death (**409**). The three sons are shown together as joint emperors in 337–340 (**412**), and the two surviving brothers are later portrayed during one of their joint consulships (**431**).

Some obverses portray the Emperor or one of his family looking upwards with raised eyes and this was interpreted by a contemporary writer as an attitude of prayer, a reflection of Constantine's conversion to Christianity.

Constantine and his Family

382 Constantine. Solidus. Mint of Trier.
RIC vii, Trier 503.

383 Gold multiple (3×) solidus of Constantine II (AD 317–340), AD 332–333. Mint of Trier.
D 31 mm. WT 19·70 g.
Obv. FL CL CONSTANTINVS IVN NOB CAES. Bust of Constantine II as Caesar, crowned with a laurel wreath, draped and wearing a cuirass, facing right.
Rev. PRINCIPIA IVVENTVTIS. Constantine II and suppliant. In exergue: SARMATIA.
Mint mark: TR
Bibl. RIC vii, Trier 532; *BMC RM,* Constantine II 1.
BM (C & M) Number as *BMC RM.* George III Collection.

384 Gold double solidus of Crispus, Caesar (AD 317–326), AD 324. Mint of Trier.
D 24 mm. WT 8·70 g.
Obv. FL IVL CRISPVS NOB CAES. Bust of Crispus crowned with a laurel wreath and facing left, wearing consular robes and holding a sceptre.
Rev. FELIX PROGENIES CONSTANTINI AVG. The two Caesars (Crispus and Constantine II) with Fausta, wife of Constantine I.
Mint mark: PTR
Bibl. RIC vii, Trier 442.
BM (C & M) 1896-6-8-102. H. Montagu Collection.

385 Gold double solidus of Fausta, wife of Constantine I (AD 306–337), AD 324. Mint of Trier.
D 24 mm. WT 8·79 g.
Obv. FLAVIA MAXIMA FAVSTA AVGVSTA. Bust of Fausta, wife of Constantine I, with waved hair, wearing a mantle and pearls.
Rev. PIETAS AVGVSTAE. The Empress with baby, accompanied by figures of Felicitas, Pietas and two genii.
Mint mark: PTR
Bibl RIC vii, Trier 443.
BM (C & M) 1896-6-8-100. H. Montagu Collection.

386 Constantius II. Solidus. Mint of Aquileia.
RIC vii, Aquileia 117.

387 Crispus. Silver miliarensis. Mint of Aquileia.
RIC vii, Aquileia 81.

388 Constantine II. Silver siliqua. Mint of Rome.
RIC vii, Rome 380.

389 Gold multiple (1½×) solidus of Constantine I (AD 306–337), AD 326–327. Mint of Siscia.
D 24 mm. WT 6·81 g.
Obv. Head of Constantine I, wearing a diadem and facing right, looking upwards.
Rev. GLORIA CONSTANTINI AVG. The Emperor and two captives. [Reverse not illustrated]
Mint mark: SIS
Bibl. RIC vii, Siscia 206.
BM (C & M) R 0244. George III Collection.

390 Constantius II. Silver siliqua. Mint of Siscia.
RIC vii, Siscia 234.

391 Gold solidus of Helena, mother of Constantine I (AD 306–337), AD 324–325. Mint of Sirmium.
D 20 mm. WT 4·60 g.
Obv. FL HELENA AVGVSTA. Bust of Helena, mother of Constantine I, in a diadem and a mantle, wearing a necklace and facing right.
Rev. SECVRITAS REIPVBLICE. The empress holding branch.
Mint mark: SIRM
Bibl. RIC vii, Sirmium 60.
BM (C & M) 1864-11-28-194. E. Wigan Gift.

392 Gold triple solidus of Constantine I (AD 306–337), AD 326. Mint of Thessalonica.
D 32 mm. WT 13·23 g.
Obv. D N CONSTANTINVS MAX AVG. Bust of Constantine I crowned with a laurel wreath and facing right, wearing consular robes and holding a globe and a sceptre.
Rev. SENATVS. The Emperor holding globe and sceptre.
Mint mark: SMTS
Bibl. RIC vii, Thessalonia 149; *BMC RM,* Constantine I, 1.
BM (C & M) 1844-10-15-308. T. Thomas Collection.
Colour plate.

393 Constantine II. Solidus. Mint of Thessalonica.
RIC vii, Thessalonica 190.

394 Dalmatius. Silver siliqua. Mint of Heraclea.
RIC vii, Heraclea 147.

395 Silver siliqua of Hanniballianus, Rex (AD 335–337), c. AD 335. Mint of Constantinople.
D 18 mm. WT 3·03 g.
Obv. FL ANNIBALIANO REGI. Bust of Hanniballianus, Rex, draped and wearing a cuirass, facing right.
Rev. FELICITAS PVBLICA. Personification of river Euphrates reclining, facing left, and holding fish and rudder.
Mint mark: CONS
Bibl. RIC vii, Const. 100.
Paris, Bibliothèque Nationale, Cabinet des Mèdailles.
Colour plate.

396 Constantine. Solidus. Mint of Constantinople.
RIC vii, Const. 108.

397 Constantius. Gold medallion (= 4½ solidi). Mint of Constantinople.
RIC vii, Const. 66.

398 Constantine. Silver miliarensis. Mint of Constantinople.
RIC vii, Const. 58.

399 Dalmatius. Solidus. Mint of Constantinople.
RIC vii, Const. 98.

400 Crispus. Silver miliarensis. Mint of Nicomedia.
RIC vii, Nicomedia 89.

401 Constantine. Gold medallion (=1½ solidi). Mint of Nicomedia.
RIC vii, Nicomedia 132.

402 Constantine II. Gold medallion (= 2 solidi). Mint of Nicomedia.
RIC vii, Nicomedia 119.

403 Constantine. Solidus. Mint of Antioch.
RIC vii, Antioch 48.

404 Gold solidus of Crispus, Caesar (AD 317–326), AD 324. Mint of Antioch.
D 18 mm. WT 4·48 g.
Obv. FL IVL CRISPVS NOB CAES. Bust of Crispus, Caesar, crowned with a laurel wreath and nude, holding a spear and a shield, facing left.
Rev. PRINCIPI IVVENTVTIS. Crispus holding globe and sceptre.
Mint mark: SMAN
Bibl. RIC vii, Antioch 42.
BM (C & M) 1874-7-15-131.

405 Constantine. Solidus. Mint of Antioch.
RIC vii, Antioch 100.

383

384

385

391

404

The Three Sons of Constantine (337–340)

406 Constantine II. Solidus. Mint of Trier.
RIC viii, Trier 12.

407 Constantine II. Half-solidus. Mint of Trier.
RIC viii, Trier 16.

408 Constantine II. Silver miliarensis. Mint of Trier.
RIC viii, Trier 21.

409 Silver medallion or multiple (4×) siliqua of Constantine II (AD 337–340), AD 337. Mint of Siscia.
D 38 mm. WT 12·80 g.
Obv. AVGVSTVS. Head, possibly of Constantine II, crowned with a laurel wreath and facing right.
Rev. Within laurel wreath: CAESAR
Mint mark: SIS
Bibl. RIC vii, Siscia 259; *BMC RM*, Constantine II 2.
BM (C & M) Number as *BMC RM*. Wellington Collection.

410 Constans. Solidus. Mint of Siscia.
C 108.

411 Constans. Silver medallion. Mint of Thessalonica.
BMC RM, Constans 2.

412 Constans. Gold medallion (= 4½ solidi). Mint of Thessalonica.
BMC RM, Constans 1.

413 Constans. Gold medallion (= 1½ solidi). Mint of Thessalonica.

414 Constans. Solidus. Mint of Heraclea.

415 Constantius II. Solidus. Mint of Constantinople.

416 Constantius II. Solidus. Mint of Nicomedia.

417 Constantius II. Solidus. Mint of Antioch.
Cf. C 76.

418 Constantius II. Silver siliqua. Mint of Antioch.

Constantius II and Constans (340–350)

419 Constans. Solidus. Mint of Trier.
RIC viii, Trier 129.

420 Constantius. Aureus. Mint of Trier.
RIC viii, Trier 130.

421, Constans. Silver miliarenses. Mint of Trier.
422 *RIC* viii, Trier 158; 172.

423 Constans. Silver miliarensis. Mint of Lyon.
RIC viii, Lyons 33.

424 Constantius II. Silver siliqua. Mint of Arles.
RIC viii, Arles 69.

425 Constans. Silver siliqua. Mint of Rome.
RIC viii, Rome 62.

426 Constans. Silver miliarensis. Mint of Aquileia.
RIC viii, Aquileia 63.

427 Constans. Gold medallion (= 1½ solidi). Mint of Siscia.
C 168.

428 Constantius II. Silver medallion. Mint of Siscia.
BMC RM, Constantius II 5.

429 Constans. Silver medallion. Mint of Thessalonica.
BMC RM, Constans 3.

430 Constantius II. Silver siliqua. Mint of Constantinople.
Cf. C 342.

431 Gold multiple (1½ ×) solidus of Constantius II (AD 337–361), AD 342–347. Mint of Antioch.
D 25 mm. WT 6·79 g.
Obv. CONSTANTIVS AVGVSTVS. Bust of Constantius II crowned with a diadem, wearing consular robes, holding a sceptre and a globe, facing right.
Rev. DD NN CONSTANTIVS ET CONSTANS AVGG. The two emperors Constantius II and Constans.
Mint mark: SMANT
BM (C & M) 1930-9-5-1.

432 Constantius II. Gold medallion (= 4½ solidi). Mint of Antioch.
BMC RM, Constantius II 3.

3 The Supremacy of Constantius II, c. 350

Constans and Constantius ruled together until 350, when the revolt of Magnentius broke out in Gaul. Constans was killed by Magnentius, who together with his brother Decentius (whom he appointed *Caesar* in 351) held an independent empire in the West.

In the spring of 350 Vetranio had allowed himself to be proclaimed emperor in the north Balkans, probably so that Magnentius would not gain control there. After a reign of only nine months he abdicated in favour of Constantius. Constantius refused to treat with Magnentius, his brother's murderer, and eventually defeated him in 353. Helped by his cousins Constantius Gallus and Julian, he was sole ruler of the Empire for eight years until his death in 361.

Magnentius' portrait is seldom diademed, and although it became usual in the 350s to portray Caesars without the diadem (e.g. Gallus: **465, 467**), it remains obscure why Magnentius, an *Augustus*, so rarely wears it. The standard reverse type of his solidi takes advantage of the unpopularity of Constans and justifies his usurpation by connecting his victory (VICTORIA AVGVSTI) with liberty (LIBERTAS ROMANORUM: **435, 440**). Some of his latest solidi were struck at a reduced weight (**435, 439**), presumably because he ran short of gold. During the last months of Magnentius' reign in Gaul, his principal mint city, Trier, rebelled from him and struck coins in the name of Constantius (**464**).

Late in the reign of Constantius a new obverse appears with an almost facing head of the emperor, who wears a helmet and holds a spear and a shield (**466, 468, 477**). This type became standard for Eastern emperors of the fifth century and is the precursor of the fully facing heads on the coins of their sixth-century successors.

The Revolt of Magnentius in the West

433 Magnentius. Solidus. Mint of Trier.
RIC viii, Trier 247.

434 Decentius. Solidus. Mint of Trier.
RIC viii, Trier 278.

435 Gold solidus of Magnentius (AD 350–353), AD 351–353. Mint of Trier.
D 22 mm. WT 3·75 g.
Obv. D N MAGNENTIVS P F AVG. Bust of Magnentius, bareheaded, draped and wearing a cuirass, facing right.
Rev. VICTORIA AVG LIB ROMANOR. Figures of Victory and Libertas.
Mint mark: TR
Bibl. RIC viii, Trier 291.
BM (C & M) 1964-12-3-158. Bequeathed by Sir Allen George Clark.

436 Magnentius. Silver medallion. Mint of Trier.
RIC viii, Trier 255.

437 Magnentius. Silver siliqua. Mint of Trier.
RIC viii, Trier.

438 Decentius. Silver miliarensis. Mint of Trier.
RIC viii, Trier 303.

439 Magnentius. Solidus. Mint of Lyon.
RIC viii, Lyons 119.

440 Magnentius. Solidus. Mint of Arles.
RIC viii, Arles 132.

441 Decentius. Silver miliarensis. Mint of Arles.
RIC viii, Arles 162.

442 Magnentius. Solidus. Mint of Rome.
RIC viii, Rome 162.

443 Gold solidus of Decentius, Caesar (AD 351–353), AD 351–353. Mint of Rome.
D 22 mm. WT 4·39 g.
Obv. MAG DECENTIVS · N · CS. Bust of Decentius, bareheaded, draped and wearing a cuirass, facing right.
Rev. VICTORIA · AVG · LIB · ROMANOR. Figures of Victory and Libertas.
Mint mark: RE (double struck)
Bibl. RIC viii, Rome 172.
BM (C & M) 1968-11-4-16.

444 Magnentius. Solidus. Mint of Aquileia.
RIC viii, Aquileia 124.

445, Magnentius. Silver miliarenses. Mint of Aquileia.
446 *RIC* viii, Aquileia 142; 145.

The Usurpation of Vetranio

447 Vetranio. Solidus. Mint of Siscia.
C 7.

448 Silver miliarensis of Vetranio (AD 350), AD 350. Mint of Siscia.
D 26 mm. WT 4·90 g.
Obv. D N VETRANIO P F AVG. Bust of Vetranio crowned with a

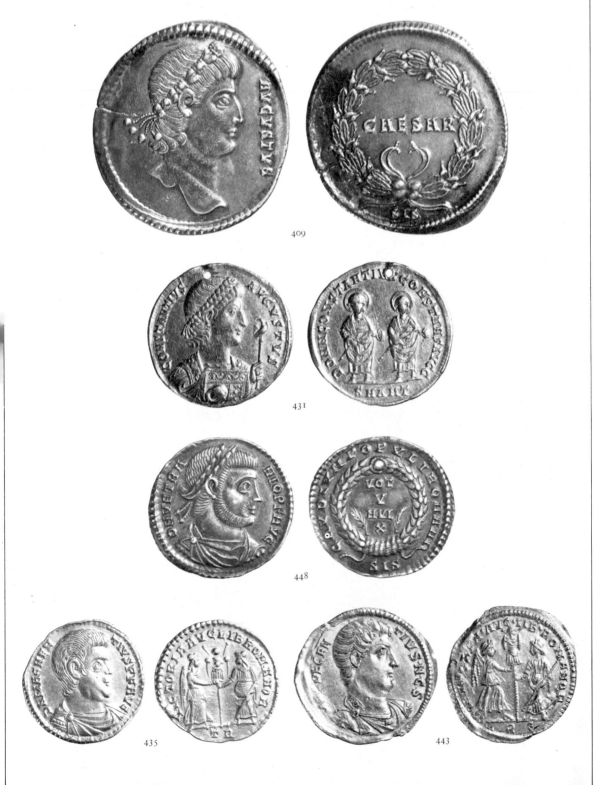

409

431

448

435

443

laurel wreath, draped and wearing a cuirass, facing right.
Rev. GAVDIVM POPVLI ROMANI. Within wreath: VOT V MVL X.
Mint mark: SIS
BM (C & M) 1888-7-5-1.

449 Vetranio. Silver siliqua. Mint of Siscia.
C 9.

450 Constantius. Silver siliqua. Mint of Siscia.
C 8.

Constantius II and (from 351) Gallus in the East

451 Constantius II. Solidus. Mint of Heraclea.
C 110.

452, 453 Constantius II. Solidi. Mint of Constantinople.
C 108; 125.

454 Constantius II. Silver miliarensis. Mint of Constantinople.
Cf. C 326.

455 Gallus. Silver siliqua. Mint of Constantinople.
Cf. C 58.

456 Constantius II. Solidus. Mint of Nicomedia.
C 108.

457 Gallus. Solidus. Mint of Nicomedia.

458 Gold multiple (4½ ×) solidus of Constantius II (AD 337–361), AD 355–361. Mint of Nicomedia.
D 38 mm. WT 20·22 g.
Obv. D N CONSTANTIVS MAX AVG. Bust of Constantius II, three-quarters facing, helmeted and wearing a cuirass, holding figure of Victory upon globe, and spear.
Rev. GLORIA ROMANORVM. Figure of Constantinopolis. [Reverse not illustrated.]
Mint mark: SMN
Bibl. C 136.
BM (C & M) 1845-1-9-118.

459 Gold solidus of Constantius II (AD 337–361), AD 347–355. Mint of Antioch.
D 21 mm. WT 4·41 g.
Obv. FL IVL CONSTANTIVS PERP AVG. Bust of Constantius II crowned with a diadem, draped and wearing a cuirass, facing right.
Rev. GLORIA REIPVBLICAE. The Emperor on horseback and the figure of the State.
Mint mark: SMANI
Bibl. Cf. C 107.
BM (C & M) 1967-7-3-1.

460 Gold multiple (2 ×) solidus of Constantius II (AD 337–361). AD 355–361. Mint of Antioch.
D 29 mm. WT 8·90 g.
Obv. FL IVL CONSTANTIVS PERP AVG. Bust of Constantius II crowned with a diadem, draped and wearing a cuirass, facing left.
Rev. GLORIA ROMANORVM. Figures of Roma and Constantinopolis.
Mint mark: · SMANT ·
Bibl. C 133.
BM (C & M) 1867-1-1-917. Duc de Blacas Gift.

461 Constantius II. Gold medallion (= 1½ solidi). Mint of Antioch.
C 79.

462 Aureus of Constantius II (AD 337–361), AD 355–361. Mint of Antioch.
D 23 mm. WT 5·22 g.
Obv. FL IVL CONSTANTIVS PERP AVG. Bust of Constantius II crowned with a diadem, draped and wearing a cuirass, facing left.
Rev. GLORIA ROMANORVM. The Emperor in a quadriga.
Mint mark: SMANT
Bibl. C 137.
BM (C & M) 1867-1-1-918. Duc de Blacas Gift.

463 Gallus. Gold 1½ scripulum. Mint of Antioch.
Cf. C 42.

The Revolt of Trier against Magnentius

464 Constantius. Solidus. Mint of Trier.
RIC viii, Trier 329.

Constantius II in the West after the Defeat of Magnentius and the Abdication of Vetranio

465 Gallus. Solidus. Mint of Trier.
RIC viii, Trier 347.

466 Constantius II. Solidus. Mint of Lyon.
RIC viii, Lyons 178.

467 Gallus. Silver siliqua. Mint of Lyon.
RIC viii, Lyons 181.

468 Constantius II. Solidus. Mint of Arles.
RIC viii, Arles 233.

469 Gallus. Silver siliqua. Mint of Arles.
RIC viii, Arles 204.

470 Constantius II. Solidus. Mint of Rome.
RIC viii, Rome 227.

471 Constantius II. Silver miliarensis. Mint of Rome.
RIC viii, Rome 239.

472 Constantius II. Solidus. Mint of Aquileia.
RIC viii, Aquileia 210.

473 Constantius II. Silver miliarensis. Mint of Aquileia.
RIC viii, Aquileia 182.

474 Constantius II. Solidus. Mint of Milan.
RIC viii, Milan 2.

475 Constantius II. Solidus. Mint of Siscia.
C 124.

476 Constantius II. Silver siliqua. Mint of Siscia.
C 341.

477 Gold solidus of Constantius II (AD 337–361), AD 355–361. Mint of Sirmium.
D 20 mm. WT 4·30 g.
Obv. FL IVL CONSTANTIVS PERP AVG. Bust of Constantius II, helmeted and three-quarters facing, wearing a cuirass, with spear and shield.
Rev. GLORIA REIPVBLICAE. Figures of Roma and Constantinopolis holding wreath inscribed VOT XXX MVLT XXX.
Mint mark: · SIRM and branch.
Bibl. Cf. C 123.
BM (C & M) 1860-3-29-67. Count de Salis Gift.

478 Constantius II. Silver miliarensis. Mint of Sirmium.
C 73.

479 Gallus. Silver siliqua. Mint of Sirmium.
C 56.

480 Constantius II. Solidus. Mint of Thessalonica.
C 122.

481 Constantius II. Silver miliarensis. Mint of Thessalonica.

482 Gallus. Silver miliarensis. Mint of Thessalonica.

4 Theodosius I, *c*. 383

The dynasty of Constantine was succeeded by that of Valentinian, but by 378 only Valentinian's sons Gratian and the seven-year-old Valentinian II survived as emperors. Gratian realized that he could not manage the Empire alone and proclaimed Theodosius as emperor in 379, giving him responsibility for part of the Balkans and the East.

In 383 Magnus Maximus was proclaimed emperor by the army in Britain. He seized Gaul and killed Gratian. He was recognized by Theodosius, and in *c*. 387 proclaimed his son Victor as his co-emperor. His invasion of Italy in this year prompted Theodosius to intervene against him; he was defeated and executed in 388.

Theodosius remained in Italy for three years, but in 391 he returned to Constantinople, leaving Valentinian to rule in the West. In the following year Valentinian was killed and Eugenius was proclaimed as Emperor of the West, but two years later Theodosius marched west and defeated him.

For the first time since the third century there was a plentiful silver coinage, struck in both the denominations, miliarensis and siliqua. Two important innovations were made in the gold coinage. A new denomination, the third of a solidus or tremissis, was introduced in 383, and subsequently became second only to the solidus in importance (**509**, **520**). Secondly, the minting of gold coins was confined to mint cities where the emperor was present. Taxes were collected in solidi which were melted down into gold bars (**533–6**). The bars were sent to the imperial residence where they would be turned into coin as need arose. Some of the coins consequently have

the letters COM (**520**, **529**), short for *comitatus* and referring to the emperor's household and presence in the mint city.

A few coins of the usurper Magnus Maximus were minted in London and therefore have on the reverse the abbreviation AVG, which stands for *Augusta*, the name of London at the time (**504–5**).

Gaul: Gratian (until 383)

483 Gold medallion (= 4½ solidi). Mint of Trier.
RIC ix, Trier 38.

484 Gold double solidus of Gratian (AD 367–383), AD 375–378. Mint of Trier.
D 26 mm. WT 8·97 g.
Obv. D N GRATIANVS P F AVG. Bust of Gratian crowned with a diadem, draped and wearing a cuirass, facing right.
Rev. GLORIA ROMANORVM. Figures of Roma and Constantinopolis.
Mint mark: TROBT
Bibl. RIC ix, Trier 36a.

BM (C & M) 1860-3-29-129. Count de Salis Gift.
485 Solidus. Mint of Trier.
RIC ix, Trier 496.
486 Silver miliarensis. Mint of Trier.
RIC ix, Trier 53a.
487 Silver siliqua. Mint of Trier.
RIC ix, Trier 58a.
488, Silver siliquae. Mint of Lyon.
489 *RIC* ix, Lyons 26; 27.
490 Solidus. Mint of Arles.
RIC ix, Arles 10a.

Italy and the Balkans: Valentinian II (until 387)

491 Solidus. Mint of Milan.
RIC ix, Mediolanum 5e.
492 Solidus. Mint of Aquileia.
RIC ix, Aquileia 21d.

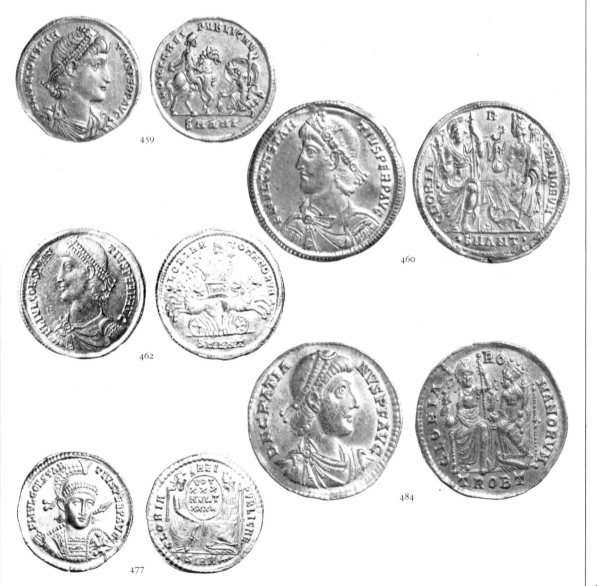

459

460

462

484

477

493 Silver miliarensis of Valentinian II (AD 375–392), AD 378–383.
Mint of Aquileia.
D 23 mm. WT 4·43 g.
Obv. D N VALENTINIANVS IVN P F AVG. Bust of Valentinian II
crowned with a diadem, draped and wearing a cuirass, facing
right.
Rev. VIRTVS EXERCITVS. The Emperor with shield and
standard.
Mint mark: AQPS
Bibl. RIC ix, Aquileia 23b.
BM (C & M) 1954-5-8-5. C. B. Wood Gift.

493

494, Silver siliquae. Mint of Aquileia.
495 RIC ix, Aquileia 26b; 28c.·
496 Silver miliarensis. Mint of Rome.
RIC ix, Rome 33b.
497 Silver siliqua. Mint of Rome.
RIC ix, Rome 35b.
498 Silver siliqua. Mint of Siscia.
RIC ix, Siscia 24a.

The East: Theodosius I

499 Solidus. Mint of Thessalonica.
RIC ix, Thessalonica 34c.
500, Solidi. Mint of Constantinople.
501 RIC ix, Const. 45d; 47b.
502 Gold solidus of Aelia Flaccilla, wife of Theodosius I (AD 379–
395), AD 383. Mint of Constantinople.
D 20 mm. WT 4·47 g.
Obv. AEL FLACCILLA AVG. Bust of Aelia Flaccilla, draped and
wearing a mantle, with elaborate headdress, facing right.
Rev. Figure of Victory inscribing a *chi-rho* on a shield.
Mint mark: CONOB
Bibl. RIC ix, Const. 49.
BM (C & M) 1867-1-1-945. Duc de Blacas Gift.

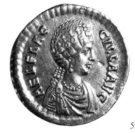

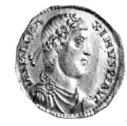
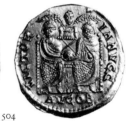

502

503 Silver siliqua. Mint of Constantinople.
RIC ix, Const. 51b.

The Revolt of Maximus in Gaul and Britain

504 Gold solidus of Magnus Maximus (AD 383–388). Mint of
Londinium.
D 21 mm. WT 4·44 g.
Obv. D N MAG MAXIMVS P F AVG. Bust of Magnus Maximus
crowned with a diadem, draped and wearing a cuirass,
facing right.
Rev. VICTORIA AVGG. The two emperors and figure of
Victory.
Mint mark: AVGOB
Bibl. RIC ix, Londinium 2b.
BM (C & M) 1865-8-9-5.

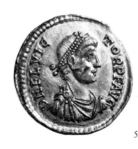

504

505 Maximus. Silver siliqua. Mint of London (*Augusta*).
RIC ix, London 3.
506 Gold solidus of Flavius Victor (AD 387–388). Mint of Trier.
D 21 mm. WT 4·49 g.
Obv. D N FL VICTOR P F AVG. Bust of Flavius Victor crowned
with a diadem, draped and wearing a cuirass, facing right.
Rev. BONO REIPVBLICE NATI. The two emperors and figure of
Victory.
Mint mark: TROB
Bibl. RIC ix, Trier 75.
BM (C & M) R 0280. George III Collection.

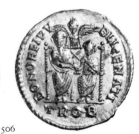

506

507, Maximus. Solidi. Mint of Trier.
508 RIC ix, Trier 76; 77b.
509 Maximus. Gold tremissis. Mint of Trier.
RIC ix, Trier 79a.
510 Maximus. Silver miliarensis. Mint of Trier.
RIC ix, Trier 82.
511 Maximus. Silver siliqua. Mint of Trier.
RIC ix, Trier 83b.
512 Victor. Silver siliqua. Mint of Trier.
RIC ix, Trier 84d.
513 Maximus. Solidus. Mint of Arles.
RIC ix, Arles 25.

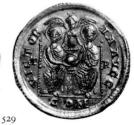

529

Maximus' Invasion of Italy (387–8)

514 Victor. Solidus. Mint of Milan.
RIC ix, Mediolanum 15.

515 Maximus. Silver siliqua. Mint of Milan.
RIC ix, Mediolanum 19a.

516 Victor. Silver siliqua. Mint of Milan.
RIC ix, Mediolanum 19b.

517 Maximus. Silver siliqua. Mint of Aquileia.
RIC ix, Aquileia 53a.

518 Victor. Silver siliqua. Mint of Aquileia.
RIC ix, Aquileia 54b.

Valentinian II in the West: 388–392

519 Valentinian. Solidus. Mint of Trier.
RIC ix, Trier 90a.

520 Theodosius. Gold tremissis. Mint of Trier.
RIC ix, Trier 92a.

521 Valentinian. Silver miliarensis. Mint of Trier.
RIC ix, Trier 93a.

522, Valentinian. Silver siliquae. Mint of Trier.
523 *RIC* ix, Trier 94a; 95a.

524 Valentinian. Solidus. Mint of Lyon.
RIC ix, Lyons 38a.

525 Valentinian. Silver miliarensis. Mint of Lyon.
RIC ix, Lyons 40.

526 Valentinian. Silver siliqua. Mint of Lyon.
RIC ix, Lyons 43a.

527 Valentinian. Solidus. Mint of Milan.
RIC ix, Mediolanum 7e.

The Revolt of Eugenius

528 Gold multiple (2×) solidus of Eugenius (AD 392–394),
AD 392–394. Mint of Trier.
D 27 mm. WT 8·89 g.
Obv. D N EVGENIVS P F AVG. Bust of Eugenius crowned with a
diadem, draped and wearing a cuirass, facing right.
Rev. GLORIA ROMANORVM. Figures of Roma and
Constantinopolis. [Reverse not illustrated.]
Mint mark: in field TIR; in exergue COM
Bibl. RIC ix, Trier 99.
BM (C & M) 1867-1-1-947. Duc de Blacas Gift.
See page 162

529 Gold solidus of Eugenius (AD 392–394), AD 392–394. Mint of
Trier.
D 20 mm. WT 4·51 g.
Obv. D N EVGENIVS P F AVG. Bust of Eugenius crowned with a
diadem, draped and wearing a cuirass, facing right.
Rev. VICTORIA AVGG. The two emperors and figure of
Victory.
Mint mark: in field TIR; in exergue COM
Bibl. RIC ix, Trier 101.
BM (C & M) 1860-3-29-150. Count de Salis Gift.

530 Silver miliarensis. Mint of Trier.
RIC ix, Trier 105.

531 Solidus. Mint of Lyon.
RIC ix, Lyons 45.

532 Solidus. Mint of Milan.
RIC ix, Mediolanum 28.

Roman Gold Bars

533 Gold bar, Roman, late fourth century AD
L 183 mm. W 18·5 mm. H 8·5 mm. WT 345 g.
Stamped gold bar with two stamps.
Provenance: Aboukir, Egypt.
Bibl. Proc. Soc. Ant. (1904), 1–8, no. A; Baratte, F. Quelques
remarques à propos des lingots d'or et d'argent du bas empire.
Frappe et ateliers monetaires dans l'antiquité et moyen age.
Belgrade National Museum 1976; no. 6.
BM (C & M) 1904-5-30-1.

534 Gold bar, Roman, late fourth century AD
L 187 mm. W 18·5 mm. H 7·5 mm. WT 343 g.

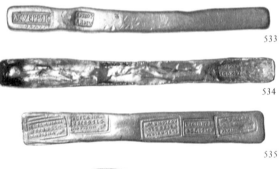

533
534
535
536

Stamped gold bar.
Provenance: Aboukir, Egypt.
Bibl. Proc. Soc. Ant. (1904), 1–8, no. B; Baratte, *op. cit.* no. 7.
BM (C & M) 1904-5-30-2.

535 Gold bar, Roman, late fourth century AD
L 167 mm. W 24 mm. H 9 mm. WT 476·2 g.
Stamped gold bar with one inscription repeated four times,
and a second stamp only once.
Provenance: Kronstadt, Transylvania.
Bibl. ZfN (1888), 351–8; Baratte, *op. cit.* no. 14.
BM (C & M) 1894-12-7-1.

536 Gold bar, Roman, late fourth century AD
L 58 mm. W 22 mm. H 7 mm. WT 133·7 g.
One-third of gold bar with a stamp.
Provenance: Kronstadt, Transylvania.
Bibl. ZfN (1888); Baratte, *op. cit.* no. 15.
BM (C & M) 1894-12-7-2

5 The Division of the Empire and the Early Barbarian Invasions, c. 407

When Theodosius died in 395 the Empire was divided between East
and West, and this division remained until the fall of the West. The
East was ruled by Theodosius' young son Arcadius, the puppet of a
series of palace officials. His brother Honorius, ruler of the West, was
similarly manipulated, at first by Stilicho and then by Constantius.
Constantius was proclaimed as co-emperor in 421, but he died in the
same year.

The Empire was no longer able to resist the attacks of the
barbarians, and it was ravaged by the Vandals, Burgundians and
Visigoths. In Rome, Priscus Attalus was set up as Emperor by the
Visigothic king Alaric, but the Visigoths soon retired from Italy and
the Emperor Honorius had to allow them to settle in western France.
Amid this chaos several usurpers appeared. Constantine III was
proclaimed in Britain, and he held Gaul and Spain before his defeat.
For two years (411–413) Jovinus and his brother Sebastian were
established in Gaul by the Burgundians. When Honorius died in 423
Johannes was proclaimed as Emperor of the West and ruled for two
years.

The division of the Empire was reflected in the coins. Eastern solidi
usually had a facing bust of the emperor, wearing a helmet and
holding a spear and a shield (**560–4**), but in the West he was normally
shown in profile. The reverses also varied: in the West the
triumphant emperor tramples down a conquered barbarian, but in
the East the personification of the capital Constantinople is often
shown. Despite these differences the coins were legal tender in both
parts of the Empire, since it remained in theory a unity; similarly, a
mint would usually strike coins for both emperors, wherever it was
situated.

The barbarian invasion caused Honorius to change his capital
from Milan to Ravenna, and the move naturally included the mint.
Thereafter Ravenna remained the most important mint in the
Western Empire. The first imitative barbarian coins were produced
at this time, copying gold and silver coins of Honorius from the
Ravenna mint (**582–3**), and they are probably to be attributed to the
Visigoths in western France.

The Western Empire: Honorius

537 Silver siliqua. Mint of Trier.
Num. Chron. 1959, 5

538 Solidus. Mint of Arles.
C 44.

539 Gold multiple ($4\frac{1}{2}\times$) solidus of Honorius (AD 393–423), AD 404. Mint of Rome.
D 36 mm. WT 21·29 g.
Obv. D N HONORIVS P F AVG. Bust of Honorius crowned with a diadem, draped and wearing a cuirass, facing right.
Rev. GLORIA ROMANORVM. Figure of Roma enthroned.
Mint mark: in field RIM; in exergue COM[OB]
Bibl. C 9.
BM (C & M) 1867-1-1-952. Duc de Blacas Gift.
Colour plate.

540 Solidus. Mint of Rome.
C 44.

541 Silver medallion. Mint of Rome.
C 34.

542 Silver miliarensis. Mint of Rome.
C 57.

543 Silver siliqua. Mint of Rome.
C 59.

544 Silver half-siliqua. Mint of Rome.

545 Gold medallion. (= $1\frac{1}{2}$ solidi). Mint of Milan.
C 1.

546 Solidus. Mint of Milan.
C 44.

547 Gold semissis of Honorius (AD 393–423), AD 398. Mint of Milan.
D 15 mm. WT 2·01 g.
Obv. D N HONORIVS P F AVG. Bust of Honorius crowned with a diadem, draped and wearing a cuirass, facing right.
Rev. VICTORIA AVGVSTORVM. Figure of Victory inscribing VOT V MVLT on shield supported by a genius.
Mint mark: in field MID; in exergue COMOB
BM (C & M) 1896-6-8-119.

548 Silver miliarensis. Mint of Milan.
C 62.

549, Silver siliquae. Mint of Milan.
550 *C* 59; 63.

551 Silver half-siliqua. Mint of Milan.
C 38.

552 Solidus. Mint of Ravenna.
C 43.

553 Gold solidus of Honorius (AD 393–423), AD 422. Mint of Ravenna.
D 20 mm. WT 4·45 g.
Obv. D N HONORIVS P F AVG. Bust of Honorius, full face and helmeted, with spear and shield inscribed with *chi-rho* monogram.
Rev. Figures of Roma and Virtus holding a shield inscribed VOT XXX MVLT XXXX.
Mint mark: in field RIV, in exergue COMOB
Bibl. C 73.
BM (C & M) 1935-11-17-761. T. G. Barnett Bequest.

554 Gold tremissis. Mint of Ravenna.
C 47.

555 Silver siliqua. Mint of Ravenna.
C 70.

556 Silver half-siliqua. Mint of Ravenna.
C 35.

557 Solidus. Mint of Aquileia.
C 44.

558 Silver siliqua. Mint of Aquileia.
C 59.

559 Constantius III. Solidus. Mint of Ravenna.
C 1.

The Eastern Empire: Arcadius

560 Arcadius. Solidus. Mint of Constantinople.

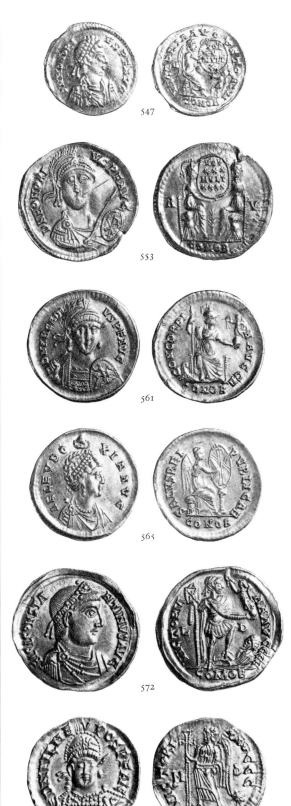

547

553

561

565

572

588

561 Gold solidus of Arcadius (AD 383–408), AD 385–402. Mint of Constantinople.
D 20 mm. WT 4·44 g.
Obv. D N ARCADIVS P F AVG. Bust of Arcadius, full face and helmeted, with spear and shield.
Rev. CONCORDIA AVGG ⊿ Figure of Constantinopolis with Victory.
Mint mark: CONOB
Bibl. S. 11.
BM (C & M) R 0321.

562 Arcadius. Solidus. Mint of Constantinople.

563, Theodosius II, the son of Arcadius. Solidi. Mint of
564 Constantinople.
Cf. S 2, and *Num. Chron.* 1959, 15.

565 Gold solidus of Eudoxia, wife of Arcadius (AD 383–408), AD 400–404. Mint of Constantinople.
D 20 mm. WT 4·47 g.
Obv. AEL EVDOXIA AVG. Bust of Eudoxia, draped, with necklace and ornate hairstyle.
Rev. SALVS REIPVBLICAE. Figure of Victory inscribing chi-rho on shield.
Mint mark: CONOB
Bibl. S. 3.
BM (C & M) 1864-11-28-209. E. Wigan Gift.

566 Eudoxia. Gold tremissis. Mint of Constantinople.

Priscus Attalus (409–410)

567 Solidus. Mint of Rome.
C 3.

568 Gold tremissis. Mint of Rome.
C 4.

569 Silver multiple (24 siliquae) of Priscus Attalus (AD 409–410, 414–415), AD 409–410. Mint of Rome.
D 49 mm. WT 77·98 g.
Obv. PRISCVS ATTALVS P F AVG. Bust of Priscus Attalus crowned with a diadem, draped and wearing a cuirass, facing right.
Rev. INVICTA ROMA AETERNA. Figure of Roma with Victory.
Mint mark: RMPS
Bibl. BMC RM, Prisc. Att. 1; *C* 5.
BM (C & M) BMC 1.
Colour plate.

570 Silver siliqua. Mint of Rome.
C 7.

Constantine III (407–411)

571 Solidus. Mint of Trier.
C 5.

572 Gold solidus of Constantine III (AD 407–411), AD 407–408. Mint of Lugdunum.
D 20 mm. WT 4·50 g.
Obv. FL CL CONSTANTINVS AVG. Bust of Constantine III crowned with a diadem, draped and wearing a cuirass, facing right.
Rev. VICTORIA AAAVGGGG. The emperor with his foot on a captive.
Mint mark: in field LID; in exergue COMOB
Bibl. C 6.
BM (C & M) 1860-3-29-198. Count de Salis Gift.

573 Silver siliqua. Mint of Lyon.
Cf. C 7.

574 Solidus. Mint of Arles.
C 5.

Jovinus and Sebastian (411–413)

575 Jovinus. Solidus. Mint of Trier.
C 5.

576 Jovinus. Solidus. Mint of Lyon.
C 1.

577 Jovinus. Solidus. Mint of Arles.
C 1.

578 Jovinus. Silver siliqua. Mint of Arles.
C 2.

579 Sebastian. Silver siliqua. Mint of Arles.
C 1.

Johannes (423–425)

580 Solidus. Mint of Ravenna.
C 4.

581 Silver siliqua. Mint of Ravenna.
C 9.

The Visigoths (?)

582 Imitation of a solidus of Honorius of the mint of Ravenna.
CENB 1974, 25.1.

583 Imitation of a silver siliqua of Honorius of the mint of Ravenna.
CENB 1974, 25.5.

6 The End of the Western Empire, *c.* 475

Julius Nepos was installed as Emperor of the West in 474, but he was ousted by Romulus Augustus in the next year. Romulus' reign lasted only a year and he was deposed in 476 when the barbarians who had been enrolled in the Roman army mutinied and elected Odovacar their king. Odovacar became the effective ruler of Italy, but he still recognized Zeno as Emperor in the East and probably restored Nepos as Emperor of the West. Nepos' death in 480 marked the end of the western empire and there was subsequently no western emperor until Charlemagne's coronation in 800.

At this time, the late fifth century, Africa was held by the Vandals and central France by the Burgundians. The Visigoths had extended their kingdom to the Loire in the north and throughout nearly all of Spain, except for one corner where the Suevi held out against them.

The barbarian tribes had no tradition of coinage and, as the first coins they saw were Roman, their coins have the same denominations and copy Roman designs. The consequent appearance of the emperor on the obverse sometimes meant that they acknowledged his theoretical sovereignty (e.g. the coins struck by Odovacar for Nepos and Zeno: (**605, 606, 608–16**), but not always. It seems to have been recognized at the time that to be an acceptable piece of currency a gold coin at least had to bear the emperor's head. These imitative coins (mainly of gold) were produced only by tribes which had settled within the boundaries of the old Empire. Their attribution is usually based on provenance, e.g. for the Visigoths and the Suevi, but sometimes their origins are obscure, when no provenance is known (**602–4**).

The West: Julius Nepos and Romulus Augustus

584 Nepos. Solidus. Mint of Arles.
C 6.

585 Nepos. Tremissis. Mint of Arles.
C 23.

586 Nepos. Solidus. Mint of Rome.
C 5.

587 Nepos. Tremissis. Mint of Rome.
C 16.

588 Gold solidus of Julius Nepos (AD 474–475, 476–480), AD 474–475. Mint of Milan.
D 19 mm. WT 4·41 g.
Obv. D N IVL NEPOS P F AVG. Bust of Julius Nepos, full face, with spear and shield.
Rev. VICTORIA AVGGG.* Long cross supported by figure of Victory.
Mint mark: in field MID; in exergue COMOB
Bibl. C 5.
BM (C & M) 1860-3-29-279. Count de Salis Gift.

589 Nepos. Tremissis. Mint of Milan.
C 16.

590 Nepos. Solidus. Mint of Ravenna.
C 6.

591 Nepos. Silver siliqua. Mint of Ravenna.
Cf. C 13.

592 Nepos. Silver half-siliqua. Mint of Ravenna.
C 15.

593 Romulus. Electrotype of solidus from the mint of Arles.
C 4.

594 Romulus. Tremissis. Mint of Arles.
Cf. C 10.

595 Gold solidus of Romulus Augustus (AD 475–476), AD 475–476. Mint of Milan.
D 20 mm. WT 4·41 g.
Obv. D N ROMVLVS AGVSTVS P F AVG. Bust of Romulus Augustus, full face, with spear and shield.
Obv. VICTORIA AVGGG :. Long cross supported by figure of Victory.
Mint mark: in field ★; in exergue COMOB
Bibl. C 5.
BM (C & M) 1874-7-14-8.
Colour plate.

596 Romulus. Tremissis. Mint of Rome.
C 10.

The Burgundians (?)

597 Imitation of a solidus of Valentinian III of the Rome mint.
BMC Vand., Gaiseric 2.

The Suevi

598 Gold tremissis (Suevian) of Valentinian III (AD 425–455). Later fifth century.
D 15 mm. WT 1·40 g.
Obv. Blundered legend. Bust of Valentinian III crowned with a diadem, wearing a cuirass and facing right.
Rev. Cross within a wreath inside a geometrical design; above, the inscription CONOB.
Mint mark: See under reverse.
Bibl. Reinhart (1942), fig. 2.25.
BM (C & M) B 10320. Count de Salis Gift.

The Visigoths

599–601 Imitative tremisses in the name of Julius Nepos.
Reinhart (1938), 114; 105..

Uncertain

602, 603 Imitations of solidi of Zeno.

604 Imitation of a solidus of Julius Nepos.

The Italian Kingdom of Odovacar

605 Gold solidus of Julius Nepos (AD 474–475 (480)), AD 476–480. Mint of Milan
D 20 mm. WT 4·31 g.
Obv. D N IVL NEPOS P F AVG. Bust of Julius Nepos, full face, with spear and shield.
Rev. VICTORIA AVGGG. Long cross supported by figure of Victory.
Mint mark: in field MID, in exergue COMOB
Bibl. C 5.
BM (C & M) 1864-11-28-206. E. Wigan Gift.

606 Nepos. Tremissis. Mint of Milan.
C 16.

607 Silver half-siliqua of Odovacar (AD 476–493), AD 476–493. Mint of Ravenna.
D 12 mm. WT 0·81 g.
Obv. FL OD [OV] AC. Bust of Odovacar, bareheaded, draped and wearing a cuirass, facing right.
Rev. Within wreath: a monogram.
Mint mark: RV
Bibl. BMC Vand., Odovacar 9.
BM (C & M) 1882-4-5-1.

608 Zeno. Solidus. Mint of Rome.
S 1.

609 Gold tremissis of Zeno (AD 474–491), AD 480–491. Mint of Milan.
D 13 mm. WT 1·42 g.
Obv. D N ZENO PERP F AVG. Bust of Zeno crowned with a diadem, draped and wearing a cuirass, facing right.
Rev. Cross within a wreath.
Mint mark: COMOB
Bibl. S 7.
BM (C & M) R 0359.

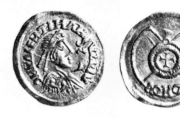

598

605

607

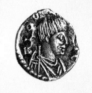

609 △ ▽ 616

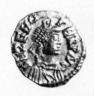

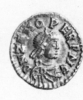

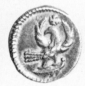

610– Zeno. Solidi. Mint of Ravenna.
612 S 1; BMC Vand., Odovacar 2.
613 Zeno. Tremissis. Mint of Ravenna.
S 7.
614 Zeno. Solidus. Mint of Milan.
Cf. S 1.
615 Zeno. Tremissis. Mint of Milan.
Cf. MDC, pl. VIII, 15.
616 Silver half-siliqua of Zeno (AD 474–491), AD 480–491. Mint of Milan.
D 13 mm. WT 0·94 g.
Obv. D N ZENO PERP AVG. Bust of Zeno crowned with a diadem, draped and wearing a cuirass, facing right.
Rev. Eagle with a cross above.
Bibl. S 13.
BM (C & M) 1906-11-3-2. Parkes Weber Gift.

The Eastern Empire: Zeno

617, Solidi. Mint of Constantinople.
618 S 5.
619 Gold solidus of Zeno (AD 474–491), c. AD 485–491. Mint of Constantinople.
D 20 mm. WT 4·06 g.
Obv. D N ZENO PERP AVG. Bust of Zeno, full face, with spear and shield.
Rev. VICTORIA AVGGGH. Long cross supported by figure of Victory.
Mint mark: in field ★; in exergue CONOB
Bibl. S 1.
BM (C & M) 1867-1-1-1004. Duc de Blacas Gift.
620, Semisses. Mint of Constantinople.
621 S 3.
622 Tremissis. Mint of Constantinople.
S 6.
623 Ariadne, wife of Zeno. Tremissis. Mint of Constantinople.
S 2.
624 Silver miliarensis. Mint of Thessalonica.
Cf. S 12.

7 The Barbarian Kingdoms, c. 500

In 488 the Emperor Zeno authorized the Ostrogothic king Theoderic to reconquer the Italian kingdom of Odovacar for him, and after a four-year campaign Theoderic was successful. He remained king in Italy for thirty-three years and even ruled Visigothic Spain in the name of his grandson. His reign was a period of peace and conciliation and allowed a flourishing of prosperity and culture.

The territory of the other barbarian kingdoms remained much the same, although the Vandals seem to have lost most of Sicily. The most important development was the growth of the power of the Franks. Their king Clovis defeated the last remnant of the Roman Empire in northern France, and in 507 he deprived the Visigoths of most of their realm in France.

619

The splendid medallion of Theoderic (**637**) carries his only known portrait. His other coins were struck in the names of the contemporary emperor, although some of his solidi have his monogram at the end of the reverse legend (**640, 645**).

The coins of the Burgundians were also struck in the name of the emperor, and are characterized by the monogram of the king next to the figure of Victory on the reverse (**652–4**).

The Visigoths continued to strike gold coins, but new types appeared on the tremisses. On the reverse a figure of Victory was portrayed in a peculiar style, and on the obverse a cross was placed on the emperor's breast (**657–9**).

The Vandals made no gold coins. Their silver coins were of three denominations: 100, 50 and 25 denarii (DN). Their coins are unusual inasmuch as they regularly have their own king and not the emperor on the obverse.

The Empire: Anastasius (491–518)

625 Gold solidus of Anastasius I (AD 491–518), AD 491–498. Mint of Constantinople.
D 20 mm. WT 4·50 g.
Obv. D N ANASTASIVS PP AVC. Bust of Anastasius I, full face, with spear and shield.
Rev. VICTORIA AVCCC B. Long cross supported by figure of Victory.
Mint mark: in field ★; in exergue CONOB
Bibl. DOC, 3b.
BM (C & M) B 6723.
Colour plate.
626, Solidi. Mint of Constantinople.
629 DOC 3i.2; BMC Byz. 1; DOC 7c; 7f.
630, Semisses. Mint of Constantinople.
631 BMC Byz. 6; 8.
632, Tremisses. Mint of Constantinople.
633 BMC Byz. 10; 12.
634 Silver siliqua. Mint of Constantinople.
BMC Byz. 16; DOC 13.
635, Solidi. Mint of Thessalonica.
636 DOC 27.

The Ostrogothic Kingdom

637 Theoderic (493–526). Electrotype of gold medallion (= 3 solidi). Mint of Rome.
BMC Vand., p. 54.
638, Theoderic. Solidi in the name of Anastasius. Mint of Rome.
640 BMC Vand., Theoderic 61; 65; MDC 68, 6; 4.
639 Gold solidus of Theoderic, king of the Ostrogoths (AD 491–518), c. AD 493–518. Mint of Rome.
D 19 mm. WT 4·25 g.
Obv. D N ANASTASIVS P F AVG. Bust of Anastasius I, full face, with spear and shield.
Rev. VICTOPIA AVCCC O. Long cross supported by figure of Victory.
Mint mark: in field RM ★; in exergue COMOB
Bibl. BMC Vand., Theoderic 63; Carson MDC 68, no. 5.
BM (C & M) 1846-2-4-2.

639

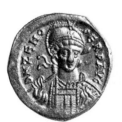 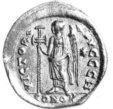 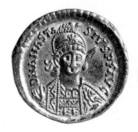 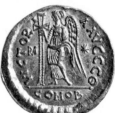

641 Theoderic. Tremissis in the name of Anastasius. Mint of Rome.
BMC Vand., Theoderic 6; Carson *MDC* 69, 11.

642, Theoderic. Silver half-siliquae in the name of Anastasius.
643 Mint of Rome.
BMC Vand., Theoderic 19; 20; *MDC* 72, 21; 22.

644 Theoderic. Silver quarter-siliqua in the name of Anastasius. Mint of Rome.
BMC Vand., Theoderic 23; *MDC* 72, 23.

645 Theoderic. Solidus in the name of Anastasius. Mint of Ravenna.
BMC Vand., Theoderic 3; *MDC* 67, 3.

646, Theoderic. Solidi in the name of Anastasius. Mint of Milan.
647 *BMC Vand.*, Theoderic 83; *MDC* 67, 2; 1.

648 Gold tremissis of Theoderic, king of the Ostrogoths (AD 491–518), *c.* AD 493–518. Mint of Milan.
D 15 mm. WT 1·45 g.
Obv. D N ANASTASIVS PP AVG. Bust of Anastasius I crowned with a diadem, draped and wearing a cuirass, facing right.
Rev. VICTORIA AVGOSTORVM. Figure of Victory with wreath and globe with cross.
Mint mark: in field ★; in exergue CONOB
Bibl. BMC Vand., Theoderic 5; *MDC* 68, no. 9.
BM (C & M) Theoderic 5. Count de Salis Gift.

649 Theoderic. Silver half-siliquae in the name of Anastasius. Mint of Milan.
Cf. BMC Vand., Theoderic 73; *MDC* 71, 20.

650 Silver quarter-siliqua of Theoderic, king of the Ostrogoths (AD 493–526), *c.* AD 500–505. Mint of Milan.
D 13 mm. WT 0·86 g.
Obv. D N ANASTASIVS PP AVC (inverted and retrograde). Bust of Anastasius I crowned with a diadem, wearing a cuirass and facing right.
Rev. M INVITA ROMA C and complex monogram.
Bibl. BMC Vand., Theoderic 81; *MDC* 71, 18.
BM (C & M) 1844-4-25-2597. Duke of Devonshire Collection.

The Burgundian Kingdom

651 Gundobad. (473–516). Solidus in the name of Anastasius.
E and S I, 37.

652 Gundobad. Tremissis in the name of Anastasius.
E and S I, 37.

653 Gundobad. Silver coin in the name of Anastasius.
E and S I, 38, type 1.

654 Sigismund (516–524). Solidus in the name of Anastasius.
E and S I, 39.

655 Gold tremissis of Sigismund, king of the Burgundians (AD 516–524), AD 516–518.
D 13 mm. WT 1·49 g.
Obv. D N ANASTASIVS PR. Bust of Anastasius I crowned with a diadem, draped and wearing a cuirass, facing right.
Rev. VICTORIA AVCTOVA. Figure of Victory with wreath.
Mint mark: Monogram above COM.
Bibl. E and S I, 39.
BM (C & M) 1860-3-30-1011. Count de Salis Gift.

The Visigothic Kingdom

656 Imitative solidus in the name of Anastasius.
Cf. Reinhart (1938), pl. 7, 129.

657, Imitative tremisses in the name of Anastasius.
658 *Cf.* Reinhart (1938), pl. 7, 133.

659 Gold tremissis (Visigothic) of Anastasius I (AD 491–518), *c.* AD 500.
D 13 mm. WT 1·45 g.
Obv. Blundered legend. Bust of Anastasius I, wearing a cuirass and with a cross on his breast, facing right.
Rev. Blundered legend. Figure of Victory with wreath and palm.
Mint mark: COΛOB
BM (C & M) B 10325. Count de Salis Gift.

Uncertain

660 Imitative solidus in the name of Anastasius.

648

650

655

659

662

689

691

The Vandal Kingdom

661 Gunthamund. (484–496). Silver 100 denarii.
BMC Vand., Gunthamund 1.

662 Silver 50 denarius of Gunthamund, king of the Vandals
(AD 484–496), AD 484–496.
D 13 mm. WT 1·13 g.
Obv. D N RX GVNTHA. Bust of Gunthamund crowned with a
diadem, draped and wearing a cuirass, facing right.
Rev. Within ornamental wreath. D · N.
Bibl. BMC Vand., Gunthamund 3.
BM (C & M) 1855-6-12-481.

663 Gunthamund. Silver 25 denarii.
BMC Vand., Gunthamund 8.

664, Trasamund (496–523). Silver 50 denarii.
665 *BMC Vand.*, Thrasamund 10; 11.

8 The Reconquest of the West, c. 533

The Emperor Justinian embarked on a series of wars to win back the
Western Empire. He may have been partly motivated by a religious
zeal to bring the barbarian heretics (they were all Arians except the
Franks) to Catholicism and partly prompted by his sense of the
glorious past of Rome to wish to restore her Empire. The Vandals in
Africa were soon crushed (534), but Justinian's invasion of
Ostrogothic Italy was less successful as a result of the counter attacks
of the king Totila, and dragged on for twenty years until the
Ostrogoths were finally defeated. An internal dispute among the
Visigoths in Spain provided an opportunity for intervention (551),
and Justinian seized and held the south.

In the north the power of the Franks continued to grow. They
defeated the Burgundians in 534, and acquired Provence from the
Ostrogoths a few years later. One of their kings, Theodebert,
interfered in the war between the Ostrogoths and Justinian, and even
had hopes of leading a coalition of barbarians against the Eastern
Empire.

The huge gold medallion of Justinian (**674**) was thought by
Byzantine historians to have been struck for the triumph held to
celebrate the Vandals' defeat by his general Belisarius, but their view
is not beyond doubt.

The Ostrogoths made fewer gold coins than before, but more
silver. Their coins usually had the contemporary emperor on the
obverse, but during the reigns of Totila and Theia he was replaced by
the long dead Anastasius (**689–690, 692**), and in one case by Totila
himself (**691**). These changes reflect the bad relations between the
Ostrogoths and Justinian as a result of his campaigns against them.

The main issues of Frankish coins begin in this period, and most of
them were imitative. A striking exception occurs for Theodebert,
whose imperial ambitions led him to usurp the emperor's place on
the obverse of coins and instead to put his own name and portrait
there (**698–700**).

A remarkable solidus from the mint of Carthage (**703**) bears the
inscription AΦP, the first three letters of 'Africa' in Greek, and this
may have been one of the first coins minted at Carthage after
Justinian's reconquest of Africa.

The Empire: Justinian

666, Solidi. Mint of Constantinople.
667 *BMC Byz.* 3; 5.
668, Semisses. Mint of Constantinople.
669 *BMC Byz.* 19; 21.
670, Tremisses. Mint of Constantinople.
671 *BMC Byz.* 22; 24.
672, Silver 2 siliquae. Mint of Constantinople.
673 *BMC Byz.* 26; 27 and *DOC* 23.
674 Electrotype of gold medallion of Justinian I (AD 527–565),
c. AD 534. Mint of Constantinople.
D 81 mm.
Obv. D N IVSTINIIANVS PP AVC. Bust of Justinian I, full face,
with spear and shield.
Rev. SALVS ET CLORIA ROMANORVM. The emperor on
horseback preceded by figure of Victory.

Mint mark: in field ★; in exergue CONOB
Provenance: Caesarea, Cappadocia.
Bibl. BMC Byz. I, p. 25.
BM (C & M)
Colour plate.

The Vandal Kingdom

675, Gelimer (530–533). Silver 50 denarii.
676 *BMC Vand.*, Gelimer 1; 3.

The Ostrogothic Kingdom

677 Athalaric (526–534). Solidus in the name of Justinian. Mint of
Rome.
BMC Vand., Athalaric 1.

678 Athalaric. Tremissis in the name of Justinian. Mint of Rome.
BMC Vand., Athalaric 10.

679 Athalaric. Silver half-siliqua in the name of Justin. Mint of
Rome.
BMC Vand., Athalaric 27.

680 Athalaric. Silver quarter-siliqua in the name of Justin. Mint
of Rome.
BMC Vand., Athalaric 28.

681 Athalaric. Silver half-siliqua in the name of Justinian. Mint of
Ravenna.
BMC Vand., Athalaric 30.

682 Athalaric. Silver quarter-siliqua in the name of Justinian.
Mint of Ravenna.
BMC Vand., Athalaric 35.

683 Theodahad (534–536). Silver half-siliqua in the name of
Justinian. Mint of Ravenna.
BMC Vand., Theodahad 1.

684 Theodahad. Silver quarter-siliqua in the name of Justinian.
Mint of Ravenna.
BMC Vand., Theodahad 6.

685 Witigis (536–540). Tremissis in the name of Justinian. Mint
of Ravenna.

686 Witigis. Silver half-siliqua in the name of Justinian. Mint of
Ravenna.
BMC Vand., Witigis 1.

687, Witigis. Silver quarter-siliquae in the name of Justinian. Mint
688 of Ravenna.
BMC Vand., Witigis 8; 9.

689 Gold tremissis of Totila king of the Ostrogoths (AD 541–552),
AD 541–552. Mint of Ticinum.
D 14 mm. WT 1·31 g.
Obv. D N ANASTASIVS P P AVC. Bust of Anastasius I crowned
with a diadem, draped and wearing a cuirass, facing right.
Rev. VICTORIA AVCVSTORVM. Figure of Victory with wreath
and cross.
Mint mark: in field ★; in exergue COMOB
Bibl. BMC Vand., Totila 2.
BM (C & M) Totila 2. Count de Salis Gift.

690 Totila. Silver half-siliqua in the name of Anastasius. Mint of
Pavia.
BMC Vand., Totila 14.

691 Silver half-siliqua of Totila, king of the Ostrogoths
(AD 541–552), c. AD 549. Mint of Ticinum.
D 13 mm. WT 1·42 g.
Obv. D N BADVILA RIX. Bust of Totila crowned with a diadem,
wearing a cuirass and facing right.
Rev. Within wreath: D N BADVILA REX.
Bibl. BMC Vand., Totila 23.
BM (C & M) 1847-11-8-378.

692 Theia (552–553). Silver half-siliqua in the name of
Anastasius. Mint of Pavia.
BMC Vand., Theia 11.

The Burgundian Kingdom

693, Gondemar (524–532). Tremisses in the name of Justinian.
694

The Visigothic Kingdom

695 Gold solidus (Visigothic) of Justinian I (AD 527–565), c. AD 550.
D 21 mm. WT 4·01 g.
Obv. Blundered legend. Bust of Justinian I, full face, with spear and decorated shield.
Rev. Blundered legend. Stylized figure of Victory with long cross.
Mint mark: in field ★; in exergue COMO
BM (C & M) 1865-3-23-16. Count de Salis Gift.

696, Imitative tremisses in the name of Justinian.
697 *Cf.* Mateu y Llopis, pl. IV, 37.

The Franks

698 Gold solidus of Theodebert, king of the Merovingians (AD 534–568), AD 534–548. Mint of Cologne(?).
D 20 mm. WT 4·42 g.
Obv. D N THEODEBERTVS VI. Bust of Theodebert, full face, with spear and shield.
Rev. VICTORIA AVCCI. The Emperor (AD 527–565), holding palm and figure of Victory, trampling on an enemy.
Mint mark: in field COL, ★, V
Bibl. Prou, 56.
BM (C & M) 1848-8-19-164.

699 Theodebert, Tremissis.
Cf. Prou, 54.

700 Gold solidus of Theodebert, king of the Merovingians (AD 534–548), AD 534–548. Mint of Toul(?).
D 19 mm. WT 4·42 g.
Obv. D N THEODEBERTVS VICTOR. Bust of Theodebert, full face, with spear.
Rev. VICTORA AVCCI. Figure of Victory holding long cross and globe with cross. [Reverse not illustrated.]
Mint mark: in field ★ T; in exergue ICONOB
Bibl. Prou 51.
BM (C & M) B 10331. Count de Salis Gift.
See page 162.

701, Imitative tremisses in the name of Justinian.
702 *Cunobelin* (1967), 25; *BMC Vand.*, Athalaric 14 (corrected).

The Reconquest of the West by Justinian

Africa

703– Solidi. Mint of Carthage.
705 *RN* (1962), 167, and Morrison, pp. 66 and 102; *DOC* 277c; cf. *DOC* 278.

706, Silver half-siliquae. Mint of Carthage.
707 *BMC Byz.* 351; *DOC* 280.1; *BMC Vand.*, Matasuntha 5.

708 Silver quarter-siliqua. Mint of Carthage.
BMC Byz., 357.

Italy

709 Gold solidus of Justinian I (AD 527–565), AD 538–546. Mint of Rome.
D 21 mm. WT 4·44 g.
Obv. D N IVSTINIANVS PP AVC. Bust of Justinian I, full face, holding globe with cross.
Rev. VICTORIA AVCCC. Figure of Victory holding long cross and globe with cross. [Reverse not illustrated.]
Mint mark: in field ★; in exergue CONOB
Bibl. BMC Vand., p. 111, no. 26.
BM (C & M) 1843-1-15-29.
See page 162.

710, Tremisses. Mint of Rome.
711 *BMC Vand.*, p. 111, no. 29; *BMC Vand.*, Athalaric 21.

712 Silver half-siliqua. Mint of Rome.
BMC Vand., p. 117, no. 70.

713 Solidus. Mint of Ravenna.
BMC Vand., p. 114, no. 38.

714 Semissis. Mint of Ravenna.
BMC Byz. 20.

715 Tremissis. Mint of Ravenna.
BMC Vand., p. 115, no. 48.

716 Silver 250 nummi. Mint of Ravenna.
BMC Vand., p. 115, no. 51.

Southern Spain

717 Tremissis.
DOC 37b.

9 Heraclius and the Persians, c. 615

The successors of Justinian were preoccupied with wars against Persia. When the mutinous army declared Phocas (602–610) as emperor the Persian king Khusro II invaded the Empire, ostensibly to depose the usurper Phocas and avenge his predecessor.

Phocas' reign was ended by Heraclius, the son of the Roman commander in Africa, who ruled for some thirty years, helped by his two sons Heraclius Constantine and Heraclonas. The new emperor at first brought little relief. The Balkans were overrun by the Avars, and the enclave in Spain was lost to the Visigoths. Most of Italy had been conquered by the Lombards, and to preserve its coastal outposts in Italy the Empire had to pay large quantities of gold to the Franks to attack the Lombards. Khusro II penetrated as far as the Bosporus in the north and Jerusalem and Egypt in the south, but he was driven out of the Empire by Heraclius in a series of brilliant campaigns in 622–629. Towards the end of Heraclius' reign, however, a new power appeared in the East: the Arabs.

A national coinage of the Visigoths began in the late sixth century, when they replaced their imitative coinage with coins bearing the portrait and name of the king (**751–3**).

Frankish coinage was diverse in nature. Most of the coins were tremisses and, although some have the king's name (**754**), many have only the signature of a moneyer and the name of the mint (**761, 762**). In Provence, however, solidi and tremisses were made in the name of the emperors (**755–8**), perhaps from gold paid to the Franks by the Empire. From about 613 the emperor was replaced by the Frankish king (**759, 760**).

The Persians minted gold only rarely, but they had a plentiful coinage of silver drachms made at a large number of mints throughout their empire. The coins conform to a standard pattern: on the obverse is a bust of the king and on the reverse a Zoroastrian fire altar.

The Empire: Phocas (602–610) and Heraclius (610–641)

718 Gold solidus of Phocas (AD 602–610), AD 607–610. Mint of Constantinople.
D 20 mm. WT 4·50 g.
Obv. ∝NN FOCAS PERP AVC. Bust of Phocas, full face, with crown surmounted by cross.
Rev. VICTORIA AVSYε. Figure of Victory with long cross and globe with cross. [Reverse not illustrated.]
Mint mark: CONOB
Bibl. BMC Byz. 6.
BM (C & M) B 7421. Given by Colonel de Bosset.
See page 162.

719 Phocas. Solidus. Mint of Constantinople.
BMC Byz. 1.

720 Phocas. Semissis. Mint of Constantinople.
BMC Byz. 29.

721 Phocas. Tremissis. Mint of Constantinople.
BMC Byz. 33.

722 Heraclius. Solidus. Mint of Constantinople.
BMC Byz. 4; *DOC* 2: 1a.1.

723 Gold solidus of Heraclius (AD 610–641), AD 610–613. Mint of Constantinople.
D 19 mm. WT 4·39 g.
Obv. ∝N ΝεRACLIVS PP AVC. Bust of Heraclius, full face, with cross and plume.
Rev. VICTORIA AVSYε. Cross on stepped base.
Mint mark: CONOB

695

698

724

738

743

Bibl. BMC *Byz.* 7; DOC 2: 3b.2.
BM (C & M) Heraclius 7. Count de Salis Gift.
Colour plate.

724　Gold solidus of Heraclius (AD 610–641), *c.* AD 632–635. Mint of Constantinople.
D 19 mm. WT 4·45 g.
Obv. Standing figures of Heraclius between Heraclonas (AD 638–641) and Heraclius Constantine (AD 613–641).
Rev. VICTORIA AVG**YH**. Cross on stepped base.
Mint mark: in field ★ and monogram; in exergue CONOB
Bibl. BMC *Byz.* 48; DOC 2: 33e.
BM (C & M) 1904-5-11-327.

725, Heraclius and his two sons. Solidi. Mint of Constantinople.
726　BMC *Byz.* 63; 55. DOC 2: 39d; 41(b).

727　Heraclius. Semissis. Mint of Constantinople.
BMC *Byz.* 88. DOC 2: 52b.1.

728　Heraclius. Tremissis. Mint of Constantinople.
BMC *Byz.* 95. DOC 2: 54.1.

729　Heraclius and his two sons. Silver hexagram. Mint of Constantinople.
BMC *Byz.* 108; DOC 2: 68.

730　Phocas. Solidus. Mint of Thessalonica(?).
BMC *Byz.* 153.

731　Phocas. Semissis. Mint of Thessalonica(?).
BMC *Byz.* 154.

732　Heraclius. Solidus. Uncertain mint.
BMC *Byz.* 2; DOC 2:3a.

733　Phocas. Solidus. Mint of Alexandria.

734, Heraclius and his father. Solidi. Mint of Alexandria.
735　BMC *Byz.* 337; 339.

736　Heraclius. Solidus. Mint of Alexandria.
BMC *Byz.* 1.

737　Phocas. Silver 200 nummi (?). Mint of Carthage.
BMC *Byz.* 135.

738　Gold solidus of Heraclius (AD 610–641), AD 608/9. Mint of Carthage.
D 16 mm. WT 4·37 g.
Obv. DM N H**ᴇ**RACAI CONSVAI IB.Busts of Heraclius and his father in consular robes; between them is a cross.
Rev. VICTORIA CONSVAI IB. Cross on stepped base.
Mint mark: CONOB
Bibl. BMC *Byz.* 338.
BM (C & M) 1867-1-1-1034. Duc de Blacas Gift.

739　Heraclius. Silver 200 nummi (?). Mint of Carthage.
BMC *Byz.* 341.

740, Heraclius. Solidi. Mint of Carthage.
741　*Cf.* DOC 2:202; BMC *Byz.* 323.

742　Phocas. Tremissis. Minted in Spain.
DOC 2:136.

743　Gold tremissis of Heraclius (AD 610–641), AD 610–*c.* 625. Spanish mint.
D 17 mm. WT 1·36 g.
Obv. D N **ᴇ**RACLIVS PP ∝VT. Bust of Heraclius crowned with a diadem, wearing a cuirass and facing right.
Rev. VICTORIA AVCVTI. Cross on stepped base flanked by A and ω.
Mint mark: CONOB
Bibl. DOC 2: 312.
BM (C & M) B 7471. Count de Salis Gift.

744　Phocas. Solidus. Mint of Ravenna.
BMC *Byz.* 149.

745　Phocas. Tremissis. Mint of Ravenna.
BMC *Byz.* 156.

746　Heraclius. Solidus. Mint of Ravenna.
BMC *Byz.* 424; DOC 2:270.

747　Heraclius. Semissis. Mint of Ravenna.

The Lombards

748, Imitative tremisses in the name of Maurice Tiberius.
749　BMC *Vand.* Lombards 22; 25.

750　Imitative 250 nummi in the name of Maurice Tiberius.
BMC *Vand.* Lombards 30.

The Visigothic Kingdom

751 Gold tremissis (Visigothic) of Wittiric (AD 603–609).
D 19 mm. WT 1·44 g.
Obv. + WITTIRICVS REX. Bust of Wittiric, full face.
Rev. + PIVS ELIBERRI. Bust full face.
Bibl. Miles, *C. Vis.*, 139 (a).
BM (C & M) 1849-6-20-11.

752, Gundemar (609-612). Tremisses. Mint of Tirasone.
753 Miles, *C.Vis.* 165(a); 165(b).

The Franks

754 Theodebert II (584–612). Tremissis.
Sutton Hoo p. 609, no. 2.

755 Tremissis in the name of Maurice Tiberius. Mint of Marseilles.
Num. Chron. (1954), 125, no. 29.

756 Solidus in the name of Phocas. Mint of Marseilles.
Num. Chron. (1954), 128, no. 71.

757 Electrotype of solidus in the name of Heraclius. Mint of Marseilles.
Num. Chron. (1954), 129, no. 75.

758 Tremissis in the name of Heraclius. Mint of Viviers.
Num. Chron. (1954), 129, no. 78.

759 Gold solidus (Merovingian) of Chlotar I, *c.* AD 615–629.
D 22 mm. WT 3·75 g.
Obv. CHLOTARIVS REX. Bust of Chlotar I crowned with a diadem, draped and facing right.
Rev. V CLOTARIVS (? – inverted and retrograde) VICTVRIA. Cross on base above globe.
Mint mark: MIA
 XIXI
Bibl. RNB (1867), 155; *Num. Chron.* (1954), 119.
BM (C & M) 1848-8-19-165.

760 Chlotar II. Tremissis. Mint of Marseilles.
Cf. RNB (1867), 155, no. 10; *Num. Chron.* (1954), 119.

761 Gold tremissis (Merovingian) of Elegius, *c.* AD 630. Mint of Paris.
D 11 mm. WT 1·26 g.
Obv. PARISIVS. Bust of Emperor crowned with a diadem, wearing a cuirass and facing right.
Rev. ELEGIVS MONE. *Croix ancrée* on globe.
Bibl. cf. Prou, *Monn. Mér.*, 707 ff.
BM (C & M) B 10336. Count de Salis Gift.

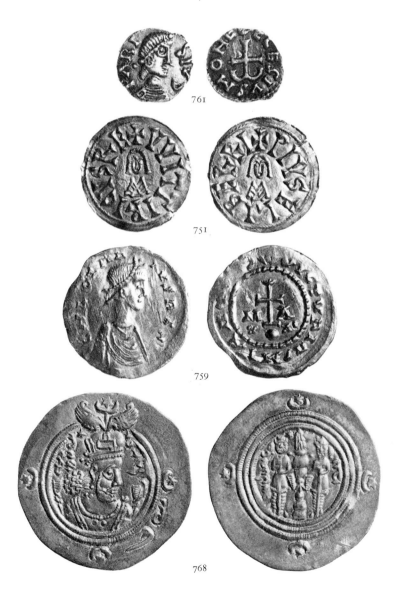

761

751

759

768

762 Tremissis of the moneyer Ansoaldus. Mint of Metz.
 Cf. Prou, 937 ff.

The Sassanian Kings of Persia

763 Khusro I (531–579). Gold dinar.
 Göbl, *Sass. Num.* pl. 12, 199; Paruck, *Sas. Coins*, 432.

764 Gold 1½ dinar (Sassanian) of Khusro II (AD 591–628), AD 610.
 D 21 mm. WT 6·53 g.
 Obv. Legend reads: 'Khusro, King of Kings, his splendour
 has grown'. Bust of Khusro II with crown and diadem,
 wearing a necklace and facing right.
 Rev. Legend reads: '21, ?Iran has strengthened'. Bust of
 Anahit (?) in flame nimbus.
 Bibl. Cf Göbl, Sass. Num., pl. 14, no. 217; Paruck, *Sass. Coins,*
 456.
 BM (C & M) 1923-11-5-58.
 Colour plate.

765 Khusro II. Silver drachm. Mint of Bishapur.
 Cf. Paruck, *Sas. Coins,* p. 486, no. 8, but year 1.

766 Khusro II. Silver drachm. Mint of Rayy.
 Cf. Göbl, *Sass. Num.* pl. 13, no. 209, but year 21.

767 Khusro II. Silver drachm. Mint of Marv.
 Cf. Paruck, *Sas. Coins,* p. 491, no. 43, but year 23.

768 Silver drachm (Sassanian) of Khusro II (AD 591–628), AD 613.
 D 30 mm. WT 4·11 g.
 Obv. Legend reads: 'Khusro, his splendour has grown'. Bust
 of Khusro II with crown and diadem, wearing a necklace and
 facing right.
 Rev. Legend reads: '24, Istaktir'. Fire altar with two
 attendants.
 *Bibl. Cf.*Paruck, *Sas. Coins,* 450, but year 24.
 BM (C & M) 1913-4-11-171.

769 Khusro II. Silver drachm. Mint of Susa.
 Cf. Paruck, *Sas. Coins,* p. 489, no. 33, but year 27.

10 The Rise of Islam, *c.* 700

During the seventh century the Arabs enveloped the Middle East
with startling rapidity. They invaded the Persian empire and overran
it by 652. They had already conquered Syria, and in 642 Egypt and
Cyrenaica fell to them. Their conquests were extended along the
whole of North Africa: they took Carthage in 697 and crushed the
Visigoths in Spain in 711–713. This relentless advance in the West
was halted only with their defeat by the Franks at Poitiers in 732. In
the East they made annual invasions of Asia Minor which culminated
in the siege of Constantinople in 716/7. Only Byzantine naval
superiority saved the Empire and enabled it to survive in Asia Minor
and part of the Balkans.

Four centuries after the reign of Constantine, the Mediterranean
had changed from a single world united under the Roman Empire to
one divided into three between the Umaiyad Caliphate, the
Byzantine Empire and the Christian kingdoms of western Europe.

In England the seventh century saw the beginning of Anglo-
Saxon coinage. Shortly after 630 gold tremisses were produced, and
as these often imitate much earlier Roman coins (compare **805** with
485) the choice of types may have been influenced by the discovery
of hoards of Roman coins.

The Arabs at first imitated the coins of the areas they conquered,
often with significant modifications. The crosses are removed from
the crowns of the three emperors, and the cross on steps is modified
(compare **809** with **724–6**). In response to Justinian's coins describing
him as 'Servant of Christ' (**771, 779**) the Arabs turned the figure of
the emperor into the Umaiyad caliph whom the legend describes as
'Servant of God' (**808**).

The breaking of relations between Empire and Caliphate brought
an end to the imitations and in 696 the Arabs replaced the figure types
on their coins with quotations taken from the Koran. The
denominations, however, were still derived from the imperial
coinage, e.g. a dinar was only slightly lighter than a solidus.

The Empire

770 Justinian II (685–695). Solidus. Mint of Constantinople.
 BMC Byz. 10; *DOC* 2: 60.

771 Gold solidus of Justinian II (AD 680–695, 705–711),
 AD 692–695. Mint of Constantinople.
 D 20 mm. WT 4·36 g.
 Obv. ihs CRISTOS REX REGNANTIUM. Bust of Christ, full face.
 Rev. D IUSTINIANUS SERV CRISTI⊖. Justinian II holding cross on
 stepped base and akakia.
 Mint mark: CONOP
 Bibl. BMC Byz. 14; *DOC* 2: 7g.l.
 BM (C & M) 1852-9-2-23. H. O. C. Borrell Gift.
 Colour plate.

772 Justinian II. Tremissis. Mint of Constantinople.
 BMC Byz. 22; *DOC* 2: 14.1.

773 Justinian II. Silver hexagram. Mint of Constantinople.
 BMC Byz. 27; *DOC* 2: 17.

774 Leontius (695–698). Solidus. Mint of Constantinople.
 BMC Byz. 2; *DOC* 2: 1g.1.

775 Gold solidus of Tiberius III (AD 698–711), AD 698–705. Mint
 of Constantinople.
 Obv. D. D TIBERIUS PE AV. Bust of Tiberius III, full face,
 wearing crown and holding spear and shield.
 Rev. VICTORIA AVGAS. Cross on stepped base. [Reverse not
 illustrated.]
 Mint mark: CONOB
 Bibl. BMC Byz. 4; *DOC* 2:1c.
 BM (C & M) Tiberius III 4. George III Collection.
 See page 162.

776 Tiberius III. Semissis. Mint of Constantinople.
 BMC Byz. 7; *DOC* 2:3.1.

777 Tiberius III. Tremissis. Mint of Constantinople.
 BMC Byz. 8; *DOC* 2:4.1.

778 Justinian II. Solidus. Mint of Carthage.
 BMC Byz. 30; *DOC* 2:28.

779 Justinian II. Solidus. Mint of Sardinia.
 BMC Byz. 31; *DOC* 2:37.

780 Tiberius III. Solidus. Mint of Sardinia.
 BMC Byz. 10; *DOC* 2:15.

781 Justinian II. Solidus. Mint of Sicily.
 BMC Byz. 35; *DOC* 2:41a.2.

782 Justinian II. Tremissis. Mint of Sicily.
 BMC Byz. 42; *DOC* 2:51.

783 Leontius. Solidus. Mint of Sicily.
 BMC Byz. (Leo III), 17; *DOC* 2: 13.2

784 Tiberius III. Solidus. Mint of Sicily.
 BMC Byz. 12; *DOC* 2: 21(b).

785 Tiberius III. Tremissis. Mint of Sicily.
 BMC Byz. 14; *DOC* 2: 29a.

786 Justinian II. Solidus. Mint of Naples.
 BMC Byz. 52; *DOC* 2: 73.

787 Justinian II. Tremissis. Mint of Naples.
 BMC Byz. 63; *DOC* 2: 75c.

788 Leontius. Tremissis. Mint of Naples.
 BMC Byz. (Leo III), 65; *DOC* 2: 19.

789 Justinian II. Solidus. Mint of Rome or Ravenna.
 BMC Byz. 56; *DOC* 2: 76.

790 Justinian II. Tremissis. Mint of Rome or Ravenna.
 BMC Byz. 54; *DOC* 2: 71.

791, Leontius. Solidi. Mint of Rome.
792 *BMC Byz.* (Leo III), 24; 56. *DOC* 2: 26; 20.

The Franks

793 Childebert (656–657). Solidus. Mint of Marseilles.

The Visigothic Kingdom

794 Egica (687–702). Tremissis. Mint of Cordova.
 Miles, *C. Vis.* 440 (c).

795 Egica and Wittiza (698–702). Tremissis. Mint of Seville.
 Miles, *C. Vis.* 480 (c).

796 Egica and Wittiza. Tremissis. Mint of Gerona.
 Miles, *C. Vis.* 463 (a).

797 Egica and Wittiza. Tremissis. Mint of Narbonne.
 Miles, *C. Vis.* 455 (a).

798 Wittiza (698–710). Tremissis. Mint of Toledo.
 Miles, *C. Vis.* 499 (a).

The Lombardic Kingdom

799 Cunicpert (688–700). Tremisses.
BMC Vand., Cunincpert 1.

800 Gold tremissis (Lombardic) of Cunincpert (AD 688–700).
D 18 mm. WT 1·35 g.
Obv. D И CVИИICPE RX. Bust of Cunincpert crowned with a diadem, draped and wearing a cuirass, facing right.
Rev. SCS MIHAHIL. St Michael with long cross.
Mint mark: M
Bibl. BMC Vand., Cunincpert 2.
BM (C & M) Cunincpert 2.

801 Aripert (701–712). Tremissis.
BMC Vand., Aripert 1.

The Lombardic Duchy of Beneventum

802, 803 Romoald II (706–731). Solidi in the name of Justinian II.
BMC Vand., Romoald II 1; II 4.

804, 805 Romoald II. Tremisses in the name of Justinian II.
BMC Vand., Romoald II 7; II 11.

Anglo-Saxon England

806, 808 Gold tremisses.
Keary and Grueber, *A–S*, 3; Peada 2.

807 Gold tremissis. (Anglo-Saxon), *c.* AD 645.
D 12 mm. WT 1·24 g.
Obv. Bust wearing a radiate crown, draped and facing right.
Rev. Clasped hands; above them, a monogram, below them ΘIN.
Mint mark: +
Bibl. North, *Eng. Ham.* I, 16.
BM (C & M) 1903-10-5-1.

The Umaiyad Caliphate

809 Gold dinar (Arab-Byzantine), AD 695–696.
D 19 mm. WT 4 g.
Obv. Standing caliph.

Rev. Globe surmounting pole on base and three steps.
Bibl. Cf. Walker, *Muh.*, 42, P. 13.
BM (C & M) 1954-10-11-2.

810 Gold dinar.
Cf. Walker, *Muh.* 18, B.2.

811 Gold dinar. Minted in Africa.
Walker, *Muh.* 143.

812 Gold half-dinar. Minted in Africa.
Walker, *Muh.* 144.

813 Gold third-dinar. Minted in Africa.
Walker, *Muh.* 147.

814 Gold dinar. Minted in Spain.
Cf. Walker, *Muh.* 79, P. 51.

815 Gold half-dinar. Minted in Africa.
Walker, *Muh.* 182.

816 Gold dinar. Mint of Damascus.
Walker, *Muh.* 186.

817 Gold third-dinar.
Walker, *Muh.* 222.

818 Silver dirham. Mint of Damascus.
Walker, *Muh.* 374a.

819 Silver dirham (Umaiyad) AD 706/7. Mint of Wasit.
D 28 mm. WT 2·89 g.
Obv. Legend in field reads: 'There is no God but God alone; He has no associates'. The margin reads: 'In the name of God, this dirham was struck at Wasit in the year 88'.
Rev. Legend in field reads: 'God is one, God is eternal; He begets not neither is He begotten'. The margin reads: 'Muhammad is the Brother of God, who hath sent him with guidance and the religion of truth to make it victorious over all other religions, averse though the idolaters be'.
Bibl. Walker, *Muh.* 530.
BM (C & M) 1853-12-19-15.

820 Silver dirham. Mint of Kairouan, Africa.
Walker, *Muh.* 280.

821 Silver dirham. Mint of Cordova.
Walker, *Muh.* 290.

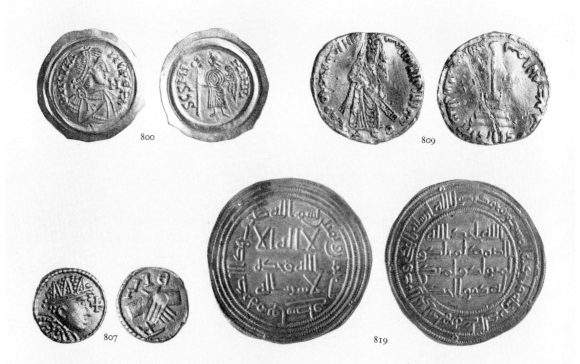

800

809

807

819

822 Gold solidus of Constantius II (AD 337–361), AD 357. Mint of
Rome.
D 21 mm. WT 4·40 g.
Obv. FL IVL CONSTANTIVS PERP AVG. Bust of Constantius II
wearing consular robes, facing left.
Rev. FELICITAS ROMANORVM. Figures of Roma and
Constantinopolis holding shield inscribed VOT XXXV MVLT
XXXX.
Mint mark: RSME and branch
Bibl. Cf. C 72.
BM (C & M) 1955-7-4-1.

823 Gold solidus of Julian II (AD 360–363), AD 363. Mint of
Antioch.
D 21 mm. WT 4·42 g.
Obv. FL CL IVLIANVS P F AVG. Bust of Julian II wearing consular
robes, facing left.
Rev. VIRTVS EXERCITVS ROMANORVM. The Emperor in
consular robes, full face and seated.
Mint mark: ANTA
BM (C & M) 1959-10-4-1.
Colour plate.

824, AD 363 Julian. Mint of Antioch.
825

826 AD 365 Valentinian. Mint of Siscia.
RIC ix, Siscia 1 (a).

827, AD 365 Valentinian. Mint of Thessalonica.
828 *RIC* ix, Thessalonica 3 (a) 1; 3 (a) 2.

829 AD 365 Valens. Mint of Siscia.
RIC ix, Siscia 1 (b).

830 AD 365 Valens. Mint of Thessalonica.
RIC ix, Thessalonica 3 (b) 2.

831 Gold solidus of Valentinian I (AD 364–375), AD 368. Mint of
Constantinople.
D 21 mm. WT 4·43 g.
Obv. D N VALENTINIANVS P F AVG. Bust of Valentinian I
wearing consular robes, facing left.
Rev. VOTA PVBLICA. The two emperors Valentinian I and
Valens in consular robes, seated and full face.
Mint mark: ★CONS
Bibl. RIC ix, Const. 29 (a).
BM (C & M) 1860-3-29-102. Count de Salis Gift.

832 AD 365 Valentinian. Mint of Nicomedia.
RIC ix, Nicomedia 16 (a).

833, AD 365 Valens. Mint of Nicomedia.
834 *RIC* ix, Nicomedia 16(b)5; 16(b)6.

835 AD 365 Valens. Mint of Antioch.
RIC ix, Antioch 23 (b).

836 AD 365 Valens. Mint of Constantinople.
RIC ix, Const. 29 (b).

837 AD 377 Gratian. Mint of Trier.
RIC ix, Trier 51.

838 *c.*AD 387 Valentinian II. Mint of Milan.
RIC ix, Mediolanum.

839 AD 393 Eugenius. Mint of Trier.
RIC ix, Trier 102.

840 AD 396 Honorius. Mint of Milan.
C 61.

841 AD 398 Honorius. Mint of Milan.
C 15.

842 Gold solidus of Honorius (AD 393–423), AD 422. Mint of
Ravenna.
D 19 mm. WT 4·45 g.
Obv. D N HONORIVS P F AVG. Bust of Honorius, full face and
wearing a crown, holding mappa and sceptre.
Rev. VOT XXX MVLT XXXX.
Mint mark: in field RIV; in exergue COMOB
Bibl. C 69.
BM (C & M) 1848-8-19-107. T. Thomas Collection.

843 AD 422 Theodosius II. Mint of Constantinople.

844 AD 430 Theodosius II, Mint of Constantinople.
ANSNM 153 (1965), 70, no. 111.

845 AD 435 Valentinian III. Mint of Rome.
C 41; *ANSNM* 153 (1965), 75, no. 121.

846 AD 435 Valentinian III. Mint of Ravenna.
C 41; *ANSNM* 153 (1965), 75, no. 120.

822

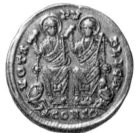

831 △ ▽ 842

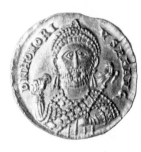

The Consular Solidi

The consulship was the only ancient Roman magistracy which survived with any importance into the late Empire. To hold the office was a mark of distinction bestowed only on the noblest aristocrats and most distinguished imperial officials; rather like modern 'honours' it was hard to attain and was sometimes held by the emperor and members of his family.

The most important function of the two annual consuls was the provision of games seven times a year, and the colossal expense involved (Justinian once spent the equivalent of 288,000 solidi) was probably the reason for the decline of the office. An insufficient number of men could be found with the necessary means, and the last subject to be consul held office in 541. Thereafter only the emperors assumed the office, usually in the year after their accession.

Several representations of late Roman consuls survive, mainly on ivory diptychs and (in the case of imperial consulships) coins. The most important elements of their costume were the *trabea* or special toga, the sceptre and the *mappa* or napkin which was used as the traditional signal to start the games.

The consular solidi, which may have been intended for distribution as presents at the consular games, document the development and changing rôle of the consular costume. The adaptation of the traditional costume to Christianity took place in 422 when Theodosius II replaced the sceptre with a short cross (**843**), which remains usual on the coins thereafter. Over a subsequent period of time the costume was absorbed into the imperial regalia.

After 541 only emperors held the consulship, so the wearing of consular dress was in practice restricted to them (**854–7**), at first only in the year of office but later for longer than the year. When the office itself died out in the seventh century, the emperor continued to wear the costume and, consequently, by about 700, it had lost its traditional consular association and become one of the standard forms of civil dress worn by the emperor (**858–60**).

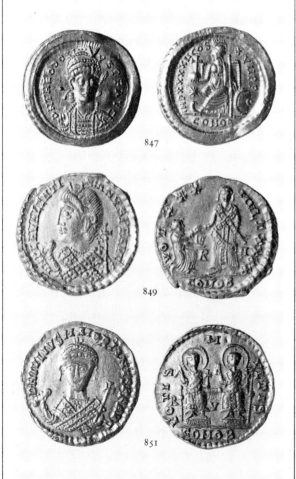

847

849

851

847 Gold solidus of Theodosius II (AD 402–450), AD 433. Mint of Constantinople.
D 21 mm. WT 4·41 g.
Obv. D N THEODOSIVS PF AVC. Bust of Theodosius II, full face, with spear and shield.
Rev. IMP XXXXVII COS XVII PP. Seated figure of Constantinopolis.
Mint mark: in field ★; in exergue CONOB
Bibl. ANSNM 153 (1965), 72–3.
BM (C & M) 1906-11-3-1. Parkes Weber Gift.

848 AD 455 Valentinian III. Mint of Rome.
C 44; ANSNM 153 (1965), 75, no. 124.

849 Gold solidus of Valentinian III (AD 425–455), AD 455. Mint of Rome.
D 21 mm. WT 4·46 g.
Obv. D N PLA VALENTINIANVS P F AVC. Bust of Valentinian III wearing consular robes, facing left.
Rev. VOT XXX MVLT XXXX. The emperor standing and raising kneeling figure.
Mint mark: in field R|M; in exergue COMOB
Bibl. C 44; ANSNM 153 (1965), 75, no. 124.
BM (C & M) 1867-1-1-966. Duc de Blacas Gift.

850 AD 458 Majorian. Mint of Ravenna.
C 12.

851 Gold solidus of Majorian (AD 457–461), AD 458. Mint of Ravenna.
D 20 mm. WT 4·36 g.
Obv. D N IVLIVS MAIORIANVS P F AVC. Bust of Majorian, full face, wearing a crown and consular robes.
Rev. VOTIS MVLTIS. The two emperors Majorian and Leo I in consular robes, seated and full face.
Mint mark: in field R|V; in exergue COMOB
Bibl. C 12.
BM (C & M) 1860-3-29-257. Count de Salis Gift.

852 Gold solidus of Leo I (AD 457–474), *c.* AD 460. Mint of Thessalonica. .
D 20 mm. WT 4·45 g.
Obv. D N LEO PERPET AVC. Bust of Leo wearing consular robes, facing left.
Rev. VICTORIA AVCCC. The emperor in consular robes, seated and full face. [Reverse not illustrated.]
Mint mark: in field ★; in exergue THSOB
Bibl. S 5.
BM (C & M) 1853-7-16-69.
See page 162.

853 *c.* AD 460 Leo. Mint of Thessalonica.
S 5.

854 AD 579 Tiberius II. Mint of Constantinople.
BMC Byz. 11; B & G, DOC 2.

855 AD 602 Maurice Tiberius. Mint of Constantinople.
BMC Byz. 1; DOC 2: 2c.

856,
857 AD 603 Phocas. Mint of Constantinople.
DOC 2: 3.2; Cf. 4a.

858 AD 692–695 Justinian II. Mint of Constantinople.
Cf. DOC 2: 7a.

859 AD 695–698 Leontius. Mint of Constantinople.
BMC Byz. (Leo III), 1; DOC 2: Leontius II 1f.

860 AD 705 Justinian II (second reign). Mint of Constantinople.
BMC Byz. 18, DOC 2: (second reign) 1.

861 AD 711–713 Philippicus. Mint of Constantinople.
BMC Byz. 2; Cf. DOC 2: 1f.

862 AD 713–715 Anastasius II. Mint of Constantinople.
BMC Byz. 3; DOC 2: 2d.

Late-Roman and Sassanian Silver Plate

The following eleven objects have kindly been lent by the State Hermitage Museum, Leningrad, in place of catalogue numbers 11, 153, 160, 161, 296, 297, 301, 303, 315, 318, and 320.

863 Silver dish with a rosette AD 527–65

D 19·8 cm. D (FOOT-RING) 8·7 cm. wt 240 g.

Silver dish, circular in shape, made of a single layer of silver and decorated with turning on the rim. It rests on a foot-ring. The central ornament consists of a swirling rosette with fourteen curved petals within a star-shaped rosette, encircled by a double band of turning. This design is surrounded by a band of four acanthus branches forming a garland. On the base are five control stamps of the reign of the Emperor Justinian. There is a crack between the rosette and the garland in the upper part of the dish. Slightly dented in several places.

Provenance: Ust-Kyshert, near Kungur, Government of Perm (renamed Molotov in 1942), USSR.

Bibl. Matzulewitsch, *Byz. Ant.*, p. 5, no. 7, pp. 76, 114, fig. 27, pl. 29; Dodd, *BSS*, no. 15; Banck, *Byz. Art*, no. 76.

Leningrad, State Hermitage Museum. No. *w.* 351. Formerly in the Letunov Collection and the Museum of Kungur. Acquired in 1926.

The dish was found in 1916 in a hoard of which the other objects, of local manufacture, date from the eighth–ninth centuries. The stamps belong late in the reign of Justinian (AD 527–65). The secondary monogram may belong to Julian, *comes sacrarum largitionum*, whose period of office is not known. Matzulewitsch indicates that the stamps were applied before the decoration was finished.

864 Silver dish with Venus in the tent of Anchises

c. AD 550

D 26·5 cm. wt 837 g.

Silver-gilt dish made of a single sheet of silver. It is shallow, has a foot-ring and a band of turning on the rim. The scene, lightly chased in low relief, probably represents Venus in the tent of Anchises. On the base are five control stamps of the reign of Justinian (AD 527–65). There is an inscription in Sogdian reading: 'Ruler of Bokhara Dazoi'; it is datable to the late sixth or early seventh century. There are deep dents in several places. The dish is broken through in the right-hand part. There are cracks at the sides and in the upper part. Some metal is lost, and the foot is crushed. There are scratches on the surface and only traces of gilding remain.

Provenance: Found in the neighbourhood of the village of Kopchiky (the Kungur district of the Urals region) in 1925.

Bibl. Matzulewitsch, *Byz. Ant.*, p. 3f., pp. 25–31, pl. 3 f.; Dodd, *BSS*, no. 16; Banck, *Byz. Art*, no. 77.

Leningrad, State Hermitage Museum. No. *w.* 350.

The stamps belong late in the reign of Justinian (AD 527–65). The secondary monogram may belong to Julian, *comes sacrarum largitionum*, whose period of office is not known. Anchises belonged in mythology to the younger branch of the Trojan royal house. Spoken of with respect in the *Iliad*, he is chiefly famed for his marriage with Aphrodite (Venus), while pasturing herds on the slopes of Mount Ida, from which union Aeneas was born.

865 Silver-gilt ewer AD 582–602 (reign of Maurice Tiberius)

H 25 cm. D (neck) 7·5 cm. D (body) 7·8–10 cm. wt 1335·3 g.

Eight-sided silver-gilt jug with handle. One end of the handle is attached to the back of the ewer in the middle part of the body; the other is joined to the rim by a lunate lip decorated with the heads of fishes. There is a thumb-piece ornamented with the head and front part of an animal. The base of the handle is adorned with a mask in repoussé. The base of the ewer takes the form of an eight-leaved rosette. The base bears five control stamps of the reign of Maurice Tiberius (AD 582–602). The handle is composed of two separate pieces and has been soldered onto the body anew. There is a crack along one of the ribs, which is slightly crushed. There is a dent and a break in the body and a horizontal crack along the rim. Very little gilding remains.

Provenance: Part of the hoard discovered at the village of Malaia Pereshchepina in the Poltava district in 1912.

Bibl. Matzulewitsch, *Byz. Ant.*, p. 6, no. 9, pp. 82–5, figs. 15–17, pl. 18; Dodd, *BSS*, no. 31; Banck, *Byz. Art*, nos. 67–8.

Leningrad, State Hermitage Museum. No. *w.* 826. Acquired in 1914 from the Archaeological Committee.

866 Silver dish with Athena deciding the quarrel of Ajax and Odysseus sixth century AD

D 26·6 cm. D (foot-ring) 10·8 cm. wt 219 g.

Circular dish made of a double sheet of silver. It rests on a low foot-ring and is decorated in repoussé with the scene of the quarrel between Ajax and Odysseus. To the left is Ajax , to the right Odysseus. Above is a half-figure, perhaps a shepherd, emerging from some hills. In the lower portion of the dish lies the armour of Achilles. The reverse is engraved with four ornamental compositions showing vine scrolls issuing from vases, with diverse birds (ducks, ibises etc.) and fruits (pears, apples, pomegranates etc.) in the scrolls.

Provenance: Found in about 1780 near the village of Sludka in the Perm region, USSR.

Bibl. Matzulewitsch, pp. 54–8, pl. 35, fig. 6; Banck, *Byz. Art*, nos. 65–6.

Leningrad, State Hermitage Museum. No. *w.* 279. Acquired in 1925. Formerly in the collection of S. G. Stroganov.

There is a resemblance between the armour on this piece and in the scenes from the life of David on the silver dishes found with the Cyprus Treasure. In the Trojan War Ajax and Odysseus were responsible for the death of Achilles. In the *Odyssey* (11. 543ff.) mention is made of his death in consequence of the arms of Achilles having been adjudged to Odysseus and not to Ajax after the death of their owner.

867 Silver dish with the scene of feeding a serpent sixth century AD

D 26 cm. wt 987 g.

Silver-gilt circular dish made of a double sheet of silver. The bottom shows traces of a foot-ring. The dish is worked in repoussé with a kneeling maenad holding a kantharos from which she feeds a serpent emerging from a cista. The segment in the lower portion of the dish displays the attributes of the cult: a bowl, a diptych, and a branch. The background is partially gilt. The reverse is engraved with the head of an old man, perhaps a personification of Oceanus, surrounded by a

frieze of sea-monsters. The foot-ring is missing. The dish is broken through and scratched in several places. There is a small hole in the upper part near the rim. The background gilding remains only in the middle.

Provenance: Acquired in Russia in 1873.

Bibl. Banck, *Byz. Art,* nos. 62–4.

Leningrad, State Hermitage Museum. No. w. 285. Acquired in 1911. Gift of M. G. Shcherbatova. Formerly in the collection of G. S. Stroganov who acquired it in 1873.

868 Silver dish with Silenus and a Maenad AD 613–29/30

D 25·7 cm. D (foot-ring) 11·7 cm. WT 1180 g.

Flat silver-gilt dish made of a double sheet of silver, resting on a foot-ring. The decoration consists of a band of turning on the rim, and a scene of Silenus and maenad dancing, executed in repoussé. Below the ground-line is a bunch of grapes and what may be a leaf. The background is gilt. On the base are five control stamps of the reign of Heraclius. The surface is slightly scratched.

Provenance: Found in 1878 with other pieces in the village of Kalganovka, near Solikamsk, in the Perm region.

Bibl. Matzulewitsch, *Byz. Ant.,* p. 3, no. 2, pp. 18–22, fig. 3, pl. 2; *Byz. Art,* 1958, no. 47; Dodd, *BSS,* no. 70; Banck, *Byz. Art,* nos. 88–89.

Leningrad, State Hermitage Museum. No. w. 282. Formerly in the collection of S. G. Stroganov. Acquired in 1925.

The stamps were applied before the decoration of the plate was finished since they are clearest where there are hollows on the bottom of the plate. A close parallel to this dish is the fragment of a silver dish with Silenus now in the Dumbarton Oaks Collection, Washington (Ross, 1962, pp. 9–10). The two figures are very similar indeed; but the fragment has stamps of the reign of Justinian (527–65). This suggests to Ross that models in the imperial workshops were used over a very long period of time.

869 Silver saucepan with fishing scenes AD 641–51

D 13·5 cm. H 6·3 cm. L (with handle) 26·7 cm. WT 875 g.

Silver-gilt saucepan with slightly bulbous sides, a flat bottom and a straight handle with an ornamental lunate lip at its junction with the rim. The rim is decorated with turning. The exterior of the body bears a repoussé frieze of fishermen with tridents, spears and nets; of fishes, birds, shells etc. The handle shows Neptune with one foot resting upon the back of a dolphin. The base has five control stamps of the Emperor Constans II. The interior is damaged in the areas of the fisherman and the octopus. Most of the gilding has disappeared.

Provenance: Thought by Matzulewitsch to have formed part of the treasure found in 1853 in the village of Peshnigort in the Solikamsk district of the Perm region.

Bibl. Matzulewitsch, *Byz. Ant.,* p. 6, no. 10, pp. 65–71, 75, pls. 12–15; Dodd, *BSS,* no. 77; Banck, *Byz. Art,* nos. 90–3.

Leningrad, State Hermitage Museum. No. w. 292. Acquired in 1927 from the 'Antikvariat' (Moscow). During the 1870s it was in the collection of M. A. Obolensky.

870 Sassanian silver dish with figure of Cybele *c.* AD 300

D 23 cm. WT 801·9 g.

Silver dish decorated in relief with a central medallion, showing a nude woman riding a lion, with an attendant,

surrounded by six smaller medallions containing (clockwise from the top) the forequarters of a bear, a horse, a boar, a lion, a bull and a lion, separated by shield bearers and vine patterns. On the reverse is a Sogdian inscription of the sixth–seventh century AD giving the name Farnach and the weight, in damaged characters, as – probably – 310 unspecified units.

Provenance: Nizhne-Shakharovka, Perm Province, USSR.

Bibl. Smirnov, *VS,* no. 36; K. V. Trever, *Pamyatniki Baktriiskogo Iskusstra* (Moscow-Leningrad, 1940), pl. 28; V. G. Lukonin, *Kultura Sasanidskogo Irana* (Moscow, 1969), fig. 21; B. I. Marshak, *Soghdian Silver* (Moscow, 1971), pl. 30. Leningrad, State Hermitage Museum. No. S. 74.

This dish shows an early stage of Sassanian metalwork when the style and many of the motifs were Roman. The central female depicts the goddess Cybele; but it is here possibly used to represent the Iranian goddess Anahita, a minor Zoroastrian divine figure. The inscription shows that this dish was the property of a Sogdian in Central Asia (approximately modern Uzbekistan). It eventually found its way north into Russia where it was found with another Sassanian dish in 1886.

871 Sassanian silver dish with Shapur II

fourth century AD

D 22·9 cm. WT 828 g.

Silver dish, partly gilt, decorated in relief and repoussé with a scene of Shapur II (AD 309–79) on horseback, hunting lions.

Provenance: Turusheva, Perm Province, USSR.

Bibl. Orbeli and Trever, *SM,* pl. 6; Pope, *SPA,* pl. 210; V. G. Lukonin, *Iran v epokhu pervykh sasanidor* (Leningrad, 1961), pl. xx.

Leningrad, State Hermitage Museum. No. S. 253.

872 Sassanian silver dish seventh century AD

D 20·3 cm. WT 824·4 g.

Silver dish, partly gilt, decorated in relief with a central medallion containing a pheasant, with a floral border framing four birds.

Provenance: Churinskaya, Vyatka Province, USSR.

Bibl. Smirnov, *VS,* no. 90; Orbeli and Trever, *SM,* pl. 28; Pope, *SPA,* pl. 215 B.

Leningrad, State Hermitage Museum. No. S. 18.

873 Sassanian silver dish with Anahita

seventh century AD

D 20 cm. WT 828 g.

Silver dish, partly gilt, with relief decoration showing a giant bird holding a nude woman, flanked by a nude archer, an axe-bearer and two stylized plants. A floral border with birds surrounds the scene. It is possible that the nude woman represents the Iranian goddess Anahita, a minor Zoroastrian divine figure.

Provenance: Cherdyni, Sverdlovsk Province, USSR.

Bibl. K. V. Trever, *Nouveaux plats sasanides de l'Ermitage* (Moscow-Leningrad, 1937), pl. III.

Leningrad, State Hermitage Museum. No. S. 217.

BIBLIOGRAPHY AND ABBREVIATIONS

ANSM *American Numismatic Society Numismatic Monographs.*

Ant. J. *Antiquaries Journal.*

Arch. Ael. *Archaeologia Aeliana.*

Arch. Anz. *Archäologischer Anzeiger.*

Arch. Esp. Arq. *Archivo Español de Arqueología.*

Arch. J. *Archaeological Journal.*

Arch. Mitt. I. *Archaeologische Mitteilungen aus Iran.*

ASPELIN, J. R., ANF. *Antiquités du Nord Finno-ougrien.* Helsinki, 1877.

Art. As. *Artibus Asiae.*

BAAR *Beiträge zur Archäologie des Attila-Reiches.*

BANCK, A., BACU. *Byzantine Art in the Collections of the USSR.* Leningrad, 1966.

BARNETT, R. D., and WISEMAN, D. J., FM. *Fifty Masterpieces of Ancient Near Eastern Art.* 2nd ed. London, 1969.

BECKWITH, J., BA. *Byzantine Art.* London, 1970.

BECKWITH, J., ECBA. *Early Christian and Byzantine Art.* London, 1970.

BMC Byz. WROTH, W., *Catalogue of the Imperial Byzantine Coins in the British Museum.* London, 1908.

BMC RM GRUEBER, H. A., *Roman Medallions in the British Museum.* London, 1874.

BMC Vand. WROTH, W., *Catalogue of the Coins of the Vandals, Ostrogoths and Lombards and of the Empires of Thessalonica, Nicaea and Trebizond in the British Museum.* London, 1911.

BMQ *British Museum Quarterly.*

BÖHME, H. W., Ger. Grab. *Germanische Grabfunde des 4. bis 5. Jahrhunderts zwischen unterer Elbe und Loire : Studien zur Chronologie und Bevölkerung Geschichte.* Munich, 1974. Veröffent ichung der Kommission zur Archäologischen Erforschung des spätrömischen Raetien der Bayer. Akad. d. Wiss.

BRAILSFORD, J. W., Ant. RB. *Guide to the Antiquities of Roman Britain.* 3rd ed. London, 1964; 4th ed. 1966.

BRAILSFORD, J. W., MT. *The Mildenhall Treasure: a Provisional Handbook.* London, 1947, 2nd ed. 1955.

BRUCE-MITFORD, R. L. S., SH. *The Sutton Hoo Ship-Burial: a Handbook.* 2nd ed. London, 1972.

BRUNN, P. M., *see RIC* vii.

Bull. NE. *Bulletin of the Near East Society.*

Burl. Mag. *Burlington Magazine.*

BUSHE-FOX, J. P., Rich. 4. *Fourth Report on the Excavation of the Roman Fort at Richborough, Kent.* Report of the Research Committee of the Society of Antiquaries, no. 16. Oxford, 1949.

BUSCHHAUSEN, H., Sp. Met. *Die spätrömischen Metallscrinia und frühchristlichen Reliquiäre.* Vienna, 1971.

C COHEN, H., *Description Historique des Monnaies Frappées sous l'Empire Romaine.* 2nd ed. Paris and London, 1880.

CARSON, R. A. G., ed., MDC. *Mints, Dies and Currency: Essays Dedicated to the Memory of Albert Baldwin.* London, 1971.

CENB *Cercle d'Etudes Numismatique, Bulletin.*

CIL 7. *Corpus Inscriptionum Latinarum,* vol. 7. Berlin, 1873.

COKER, T. C., Londes. Cat. *Catalogue of a Collection of Ancient and Mediaeval Rings and Personal Ornaments formed for Lady Londesborough.* (Privately printed). London, 1853.

CUNLIFFE, B. W., Rich. 5. *Fifth Report on the Excavation of the Roman Fort at Richborough, Kent.* Report of the Research Committee of the Society of Antiquaries, no. 23. Oxford, 1968.

CURLE, A. O., TT. *The Treasure of Traprain.* Glasgow, 1923.

DALTON, O. M., BAA. *Byzantine Art and Archaeology.* Oxford, 1906.

DALTON, O. M., EC Ant. *Guide to Early Christian Antiquities.* London, 1921.

DALTON, O. M., EC Cat. *Catalogue of Early Christian Antiquities.* London, 1901.

DALTON, O. M., *East Chr. East Christian Art.* London, 1925.

DALTON, O. M., OT. *The Treasure of the Oxus with Other Examples of Early Oriental Metalwork.* 3rd ed. London, 1964.

DE RIDDER, A., Bij. Ant. *Catalogue sommaire des Bijoux Antiques.* Paris, 1924.

DENNISON, W., GT. *A Gold Treasure of the Late Roman Period.* University of Michigan Studies (Humanistic Series), 12. Ann Arbor, Mich., 1918.

Deut. Jahrb. für Num. *Deutsches Jahrbuch für Numismatik.*

DOC BELLINGER, A. R., and GRIERSON, P., eds. *Catalogue of the Byzantine Coins in the Dumbarton Oaks Collection and in the Whittemore Collection,* vols 1 and 2. Washington, DC, 1966–.

DODD, E. C., BSS. *Byzantine Silver Stamps. Dumbarton Oaks Studies,* 7. Washington, DC, 1961.

DODD, E. C., BST. *Byzantine Silver Treasures.* Berne: Abegg-Stiftung, 1973.

DODD, E. C., DO Papers 18 (1964). 'Byzantine silver stamps: supplement I. New stamps from the reigns of Justin II and Constans II', *Dumbarton Oaks Papers* 18 (1964).

ECK, T., Vermand. *Les deux Cimetières gallo-romains de Vermand et de Saint-Quentin.* Paris, 1891.

ENGEL, A., and SERRURE, R., Num. MA. *Traité Numismatique du Moyen Âge.* Paris, 1891–1905.

ERDMANN, K., KI. *Die Kunst Irans zur Zeit der Sasaniden.* Berlin, 1943.

EVISON, V. I., FCI. *The Fifth Century Invasions South of the Thames.* London, 1965.

FAIRHOLT, F. W., Misc. Graph. *Miscellanea Graphica.* London, 1854–7.

FK. *Forschungen zur Kunstgeschichte und christlichen Archäologie,* vol. 2 : *Wandlungen christlicher Kunst im Mittelalter.* Berlin, 1953.

FROEHNER, W., Gol. *La Collection du Château de Goluchów.* Paris, 1897.

FUCHS, S., and WERNER, J., Lang. Fib. *Die Langobardischen Fibeln aus Italien.* Berlin, 1950.

GARRUCCI, R., AC. *Storia dell' Arte Cristiana.* 6 vols. Prato, 1881, 1872–80.

GHIRSHMAN, R., P & S. *Iran, Parthians and Sassanians.* London, 1962.

GNECCHI, F., Med. Rom. I *Medaglioni Romani,* vol. 1 : *Oro ed Argento.* Milan, 1912.

GÖBL, R., Sass. Num. *Sassanian Numismatics.* Brunswick, 1971.

GRABAR, O., SS. *Sassanian Silver.* Ann Arbor, Mich., 1967.

GRÜNHAGEN, W., Gr. Bod. *Der Schatzfund von Gross Bodungen Römisch-Germanische Forschungen,* 21. Berlin, 1954.

GUSMAN, P., ADR. *L'Art Décoratif de Rome.* Paris, 1908.

HARPER, P. O., *ANEA*. in V. E. Crawford, *et al., Ancient Near Eastern Art: the Metropolitan Museum of Art, Guide to the Collections*. New York, 1966.

HARPER, P. O., *PM*. in *La Persia nel Medioevo*. Rome, 1971.

HENIG, M., *REG. A Corpus of Roman Engraved Gemstones from British Sites*, British Archaeological Reports no. 8. Oxford, 1974.

HIGGINS, R. A., *GRJ. Greek and Roman Jewellery*. London, 1961.

HILLIER, G., *IoW. The History and Antiquities of the Isle of Wight*. London, 1855.

HULL, M. R., comp., *RE Cat. Catalogue of an Exhibition of Romano-British Antiquities*. Colchester, 1950.

Jahrb. Mainz Jahrbuch des Römisch-Germanischen Zentralmuseums Mainz.

JRS Journal of Roman Studies.

KEARY, C. F., and GRUEBER, H. A., *A–S. Catalogue of English Coins in the British Museum: Anglo-Saxon Series*. London, 1887–93.

KENT, J. P. C., *see RIC* viii.

LAUR-BELART, R., *SSK. Der spätrömische Silberschatz von Kaiseraugst, Aargau*. 3rd ed. Basel, 1967.

LEEDS, E. T., *ASSB. A Corpus of Early Anglo-Saxon Great Square-headed Brooches*. Oxford, 1949.

MARSHALL, F. H., *FR Cat. Catalogue of the Finger-rings, Greek, Etruscan and Roman, in the Departments of Antiquities in the British Museum*. London, 1907; repr. 1968.

MARSHALL, F. H., *J Cat. Catalogue of the Jewellery, Greek, Etruscan and Roman, in the Departments of Antiquities in the British Museum*. London, 1911; repr. 1969.

MATEU Y LLOPIS, F., *Mon. Vis. Las Monedas Visigodas del Museo Arqueológico Nacional*. Madrid, 1936.

MATZULEWITSCH, L., *Byz. Ant. Byzantinische Antike*. Berlin and Leipzig, 1929.

MILES, G. C., *C. Vis. The Coinage of the Visigoths in Spain*. New York, 1952.

Mitt. DAI Mitteilungen des Deutschen Archäologischen Instituts.

MMAB Metropolitan Museum of Art Bulletin.

MMAJ Metropolitan Museum of Art Journal.

MORRISON, C., *Monn. Byz. BN. Monnaies Byzantines de la Bibliothèque Nationale*. Paris, 1970.

MUKHERJEE, B. N., *Nana. Nana on Lion*. Calcutta, 1969.

NORDENFALK, C., *Sp. Zier. Die Spätantiken Zierbuchstaben*. Stockholm, 1970.

NORTH, J. J., *Eng. Ham. English Hammered Coinage*. 2 vols. London, 1963.

Num. Chron. Numismatic Chronicle.

Num. Zeit. Numismatische Zeitschrift.

ODOBESCO, A., *TP. Le Trésor de Pétrossa*, vol. 2. Paris, 1896.

ORBELI, I. A., and TREVER, K. V., *SM. Sassanidskii Metall*. Moscow and Leningrad, 1935.

OSTOIA, V. K., *TCMMA. Treasures from the Cloisters and the Metropolitan Museum of Art*. Los Angeles, 1970.

OVERBECK, B., *Argentum. Argentum Romanum: ein Schatzfund von spätrömischen Prunkgeschirr*. Munich, 1973.

PAINTER, K. S., *WN. The Water Newton Early Christian Silver*. London, 1977.

PARUCK, F. D. J., *Sas. Coins. Sassanian Coins*. Bombay, 1924.

PEARCE, J. W. E., *See RIC* ix.

POPE, A. U., *SPA. A Survey of Persian Art*, vol. 4. Oxford, 1938.

PORADA, E., *AI. Ancient Iran*. London, 1965.

Proc. Soc. Ant. Proceedings of the Society of Antiquaries.

PROU, M., *Monn. Mér. Les Monnaies Mérovingiennes: Catalogue des Monnaies Françaises de la Bibliothèque Nationale*. Paris, 1892.

RIC SUTHERLAND, C. H. V., and CARSON, R. A. G., *eds, The Roman Imperial Coinage*: vol. vi by C. H. V. Sutherland, London, 1967; vol. vii by P. M. Bruun, London, 1966; vol. viii by J. P. C. Kent, in the press; vol. ix by J. W. E. Pearce, London, 1951.

RICE, D. T., *ABE. Art of the Byzantine Era*. London, 1963.

Riv. Arch. Cr. Rivista di Archaeologia Cristiana.

RN Revue Numismatique.

RNB Revue de la Numismatique Belge.

Röm. Mitt. Römische Mitteilungen.

RORIMER, J. J., *MMAC. The Metropolitan Museum of Art: the Cloisters*. 3rd ed. New York, 1963.

RORIMER, J. J., *SAL*. 'The authenticity of the Chalice of Antioch', in D. Miner, ed., *Studies in Art and Literature for Belle da Costa Greene*. Princeton, 1954.

ROSENFELD, J. M., *DAK. Dynastic Art of the Kushans*. Berkeley and Los Angeles, 1967.

ROSS, M. C., *DO Cat.* 1 and 2. *Catalogue of the Byzantine and Early Medieval Antiquities in the Dumbarton Oaks Collection*, vols 1 and 2. Washington, DC, 1962, 1965.

SABATIER, J., *Monn. Byz. Or. Description Générale des Monnaies Byzantines Frappées sous les Empereurs d'Orient*. Paris and London, 1862.

SALIN, B., *Alt. Thier. Altgermanische Thierornamentik* Stockholm, 1904.

SARRE, F., *KAP. Die Kunst des alten Persien*. Berlin, 1922.

SCHOPPA, H., *KR. Die Kunst der Römerzeit in Gallien, Germanien und Britannien*. Munich and Berlin, 1957.

SKALON, K. M., *Sp. Gar*. in H. Klumbach, ed., *Spätrömische Gardehelme*. Munich, 1973.

SMIRNOV, Y. I., *VS. Vostochnoe Serebro*. St Petersburg, 1909.

SMITH, R. A., *Ant. Rom. A Guide to the Antiquities of Roman Britain*. London, 1922.

STRONG, D. E., *GSP. Greek and Roman Gold and Silver Plate*. London, 1966.

STRZYGOWSKI, J., *AIV. Altai-Iran und Völkerwanderung*, vol. 5. Leipzig, 1917.

STRZYGOWSKI, J., *CK. Coptische Kunst*. Vienna, 1904.

STYLIANOU, A. and J., *Lam. Treasures of Lambousa*. Nicosia, 1969.

SUTHERLAND, C. H. V., *see RIC* vi.

TOLSTOV, S. P., *DK. Drevnii Khorezm*. Moscow, 1948.

TOYNBEE, J. M. C., *AB. Art in Britain under the Romans*. Oxford, 1964.

TOYNBEE, J. M. C., *ARB. Art in Roman Britain*. London, 1962.

VDI Vestnik Drevnei Istorii.

VOLBACH, W. F., *ECA. Early Christian Art*. London, 1961.

WALKER, J., *Muh. A Catalogue of the Muhammedan Coins in the British Museum: Arab-Byzantine and Post-reform Umaiyad Coins*. London, 1956.

WALTERS, H. B., *SP Cat. Catalogue of the Silver Plate (Greek, Etruscan and Roman) in the British Museum*. London, 1921.

WILSON, D. M., *St Nin*. In A. Small, C. Thomas and D. M. Wilson, *St Ninian's Isle and its Treasure*. Oxford, 1973.

Zeit. für Num. Zeitschrift für Numismatik.